ROBERT DOISNEAU

A PHOTOGRAPHER'S LIFE

ROBERT DOISNEAU

A PHOTOGRAPHER'S LIFE

PETER HAMILTON

ABBEVILLE PRESS I PUBLISHERS I NEW YORK I LONDON I PARIS

This book is dedicated to the memory of
Juan Hamilton, 1909–1993
Robert Doisneau, 1912–1994

Front cover: La Dernier Valse du 14 juillet (Last Waltz on Bastille Day), *1949.*
Back cover: Near Kufstein, Tirol, Austria, 1957.
Front flap: Robert Doisneau in the banlieue, *Montrouge, 1949, photographer unknown.*
Back flap: Peter Hamilton in Doisneau's studio-apartment at Montrouge, September 16, 1993,
making the photograph reproduced in this volume as plate 455.

EDITOR: Barbara Einzig
DESIGNER: Celia Fuller
ASSISTANT EDITOR: Peter Donnhauser
PRODUCTION EDITOR: Owen Dugan
PRODUCTION MANAGER: Lou Bilka

First published in the United States of America in 1995 by Abbeville Press.

FIRST EDITION
2 4 6 8 10 9 7 5 3 1

Publisher's note: The publisher, working with the Doisneau family, has in the creation of this volume utilized original negatives and master prints produced under the supervision of Robert Doisneau, with retouching kept to an absolute minimum in accordance with the instructions of the photographer.

Library of Congress Cataloging-in-Publication Data
Hamilton, Peter.
Robert Doisneau : a photographer's life / Peter Hamilton.
p. cm.
Includes bibliographical references and index.
ISBN 0-7892-0020-1
1. Doisneau, Robert. 2. Photographers—France—Biography. 3. Photography, Artistic.
I. Title.
TR140.D64H36 1995
770′.92—dc20
[B] 95-31094

CONTENTS

PREFACE

[T]HE FIRST TIME I met Robert Doisneau, I arrived encumbered (as usual) with camera bag and unwieldy tripod, cassette recorder, and notebooks, along with a couple of books I wanted him to sign. We said *bonjour,* shook hands, I mumbled something about being *enchanté* to meet him. We were going to another room to conduct the interview: he simply picked up my heavy tripod without further ado and walked off with me. He was always like that, totally lacking the carapace of celebrity, always kindness itself, always concerned in the most profound sense with the well-being of his companions. Quite recently, one of his friends in Montrouge, Madame Figon (a neighbor since the 1930s), told me that she remembered seeing Robert going out often on commercial assignments "laden like a plumber" with so much equipment he could hardly walk. Once he had been struggling up the stairs at the RAPHO agency with his kit when all of a sudden somebody came up behind him and took the heavy camera bag he was toting. "It was Cartier-Bresson. He said, 'Do you mind if I help you?' I must have looked like an ant carrying an enormous load. I rather regret all that, because physical tiredness limits your sensitivity."

Later that day I made a portrait of him as we were talking, the first of many I would make over the next four years, until the last day we saw each other, just before he entered the hospital. Like the first, this last image (pl. 455) seems to me to capture the sense of complicity I felt immediately with him, and perhaps he with me. There were things I felt we shared—losing our mothers as children, spending our youths being trained as lettering artists, living in the suburbs of large cities.

Doisneau once said, apropos of his portrait sessions with Picasso, that he came away from the experience "lightly sprinkled with gold." During our first conversation I became aware that a similar effect was occurring for me, as I was drawn into the charmed circle of his acquaintance. He had the ability to make anybody feel they were an old friend after only a short time. I was later to discover that was how he had made so many of his pictures. Friends of his would recall that once you were with Doisneau you completely forgot that he was photographing you, so fascinated were you by what he had to say, by his natural charm. Without any malice, Doisneau stole your picture from under your nose. When I read that his friend Jacques Prévert had once described him as a *braconnier* (poacher), I thought at first that it was just a literary conceit. Only as I came to understand more about Prévert's total opposition to any intellectualization of his writing did I realize that he had captured the essence of Doisneau.

Prévert's insight into Robert's character explains in part why his photographs have such a strong and universal appeal, for he worked far more with his personality than with the apparatus of photography to record his images. In photographic parlance, film is referred to as a "sensitive medium." It took me a little while to appreciate it, but I eventually realized that for

Robert the concept was much broader than the simple interplay of physics and chemistry, and that trying to understand his approach had very little to do with how he used a camera and film. His perceptive sensibilities worked on several levels at the same time, and he recorded not just the latent image of his subjects with his camera, but other latencies: the sounds of their voices, the smell of the streets, the textures of the surroundings. He could—some sixty years after the event—still recall the exact location in the streets where a photograph was made, the first names of the people with whom he had exchanged a few words as the almost silent shutter of his battered Rolleiflex let the briefest flash of light onto the film. For at the same moment, the encounter left an indelible record in his memory.

Photography was Robert's chosen weapon in a struggle with mortality, or as he put it, "the refusal to entirely disappear." His photographs may seem deceptively simple, almost naively so, for he followed in the footsteps of Eugène Atget. Yet his vision, as conveyed there, is layered with complex meanings. He saw, in the unpromising surroundings of workaday Paris and his native *banlieue,* an exotic fauna apparent to almost no one else: ordinary people, workers, shopkeepers, lovers, families, children, the old, sideshow barkers, minor artists, eccentrics, barflies—even tramps and petty criminals. It may seem remarkable that a man who hated foreign travel—who once said, "If I leave my Montrouge I am lost"—could create an oeuvre of appeal to people throughout the world. But his obsession with a relatively precise terrain was proof of neither xenophobia nor narrow-mindedness, though it probably does explain why his work took so long to be recognized as being at the highest level of the art of photography. The simple fact is that Robert found so much within this narrow space that he could never exhaust its possibilities.

By a series of happy coincidences my first meeting with Robert, which I had hoped to turn into a collaboration on a short book about his work, evolved into the preparation of a major retrospective, presently touring the world, for Oxford's Museum of Modern Art. It allowed me to visit him often in Montrouge and to gain a deeper insight into his perspective and his manner of working. I tried to reconstruct his life for this book, as it was so obvious that it was his existence that he had photographed. The process involved a great many conversations, from which all quotations not otherwise credited derive. The book thus mimics the process by which Doisneau's pictures were made, for although some were taken without the knowledge of their subjects, and others were set up using models or friends, the vast majority could only be produced because Doisneau was willing—even eager—to be part of the social activity that they record, a participant-observer of the world in which he lived. That is why, in the end, a book like this can only scratch the surface of both his life and work, merely suggest its flavor, in the hope of whetting the appetite of the reader to look more closely at what Robert Doisneau made.

Because the period 1945–60 was so important for him, his experiences and friendships of that period overlap several chapters (four through seven), appearing to confound the chronology that is otherwise linear. Yet the richness of this period simply seemed to require a more thematic treatment. Such doubling back and crisscrossing perhaps reflects or mimics the course of Doisneau's career and influences: as he once said, his life was a series of fortuitous encounters, events spontaneously giving way to one another. With

any luck the order I have imposed upon that life in the writing of this book does not do great violence to its reality.

As the curator of his retrospective, and more recently as his biographer, I came to know Robert Doisneau both as a man and as a photographer. It is clear to me that few other photographers have *lived* their work in the same way. His pictures are the record of encounters with literally thousands of people, many in the suburbs near his home or in Paris itself, others among the literary and artistic elites of modern France, still others in towns and villages all over the country, where his work as a freelance photographer took him. All are the product of a very special vision.

I think that Robert, if he had lived to see this book appear, might have written a preface in which he gave some guidance to those inspired by his work to take up photography. I would therefore like to give him the last words, ones I found in an interview of 1972 with a young journalist, Patrick Cazals, with whom two decades later he would make a film about his life:

A lot of young people come to see me, all with grand ideals. Their hopes? Instant fame, a thousandth of a second, immediate success. The press photography world (and it's always there that they want to start) is cruel. They need to learn how to fish with a float, rather than with a fly. To have patience, to wait for something to bite, to stay three hours in the same spot. It's wrong to give them such high hopes. They go from Mickey Mouse and Tarzan to that. Straight into enormous disappointment. They ruin their families buying equipment and spending money on lab costs, but they end up without any technical expertise. They have cameras with light meters inside them, wonderful darkroom equipment . . . everything is easy nowadays. But nobody tells them how hard this business is, that you have to be ready to go at a moment's notice, and also to have personal convictions. Moreover, if a photo goes wrong, it's no great tragedy! You should be able to laugh at yourself, to be ironic about your own career, to be attentive as well, to eliminate the superfluous. And last of all, don't be in too much of a hurry—be generous with your time.

—PETER HAMILTON
Oxford, England, 1995

A Note on Captions

Doisneau did not establish definitive titles for his photographs, partly because they were a constantly evolving body of work, subject to continual revision. Never an exponent of the "full-frame" school of composition, for whom evidence of the picture's edge must be provided on each print, he was always happy to re-crop his images to fit whatever space seemed most appropriate, and his use of captions followed the same principle. Some photographs have had at least four or five titles. Toward the end of Robert's life, when the demands on his archive became more pressing, he catalogued the most popular images, giving them titles that were in some cases quite lyrical, but are hardly definitive. I have tried to use Doisneau's own titles and captions wherever possible, choosing those that seem best adapted to this book and appending where possible something he had written about the image or about its wider context.

CHILDHOOD

Pour mieux inscrire les décors

1912–1929

1

"*The* zone *was where you went either to play, to make love, or to commit suicide.*"

ROBERT DOISNEAU WILL always be the poet of Paris and of its *banlieue* (suburban fringe), the photographer of the city as it was in the first half of the twentieth century and as it no longer is except through his photographs. It has changed so fundamentally since the 1970s that many of Doisneau's pictures of the period 1930–60 would be impossible to reproduce today. The *décors* (scenes) that Doisneau was inspired to capture with his camera belong to the Paris of the late nineteenth and early twentieth centuries: these photographs are witnesses to a way of life that has all but disappeared, of streets and passages now destroyed, of a landscape irrevocably changed. His work constitutes a complex portrait of a living city and its outskirts, created during a key phase in its life-history.

In the latter half of the nineteenth century the reorganization and modernization of Paris, carried out by the engineer Georges-Eugène Haussmann under Napoleon III, created new middle-class *quartiers* (districts) in central Paris. Consequently many of the lower-working-class people who had been living in the old center found themselves pushed into the margin between the faubourgs and the edge of the banlieue, approximately the area now occupied by the *boulevard péripherique* that rings the modern city, the space between town and country popularly known as the *zone*. The fortifications that from 1841 encircled the city were situated in this hinterland, the land around them cleared as *zones de tir*—firing zones. The latter were also known as *zones non-constructibles,* for any construction of permanent dwellings was forbidden there. As the nineteenth century drew to a close the forts and city gates became obsolete, and the *zone* began to be populated by a shifting and marginal population. This lumpen proletariat set up their shacks, caravans, and an occasional wooden hut in the wasteland surrounding the city, creating a transitional area between Paris and the provinces. It was this environment that was photographed in 1912–13 by Eugène Atget, providing a vivid impression of what it looked like during Doisneau's childhood.

At the same time, the development of industry and commerce was creating a new demand for labor, met by successive waves of rural emigration. Savoyards built the *grands bâtiments* (great public structures), Auvergnats delivered coal and opened bistros. Of those included in the capital's census of 1866, nearly seventy percent had been born outside Paris. To begin with these newcomers followed the ancient pattern, aiming for the *vieux quartiers* (old town) in the center of the city, where, as one commentator noted in 1864, it was unusual for the poorest folk to stay in one lodging for more than three months.[1] Haussmann's development closed the center to emigrants, who then began to occupy the near suburbs—Belleville, Montmartre, Batignolles, La Chapelle, Bercy, etc. As these areas in turn became gentrified, poor people were pushed out farther—to St.-Denis, St.-Ouen, Boulogne, Issy-les-Moulineaux, Gentilly, and Montrouge. The banlieue became a magnet for the burgeoning urban proletariat and its attendant shopkeepers—bakers, cobblers, hat-makers, etc.—many of whom had been peasants only a generation before.

Gaston Doisneau, Robert's father, was born on January 23, 1885, in the small village of Raizeux in the *département* of Seine-et-Oise, where his father worked in a local quarry at Epernon that made cobble stones for the streets of Paris (pl. 5). When he retired after fifty years there, Doisneau's grandfather became woodcutter to the village. Robert remembered him as a jolly, round

1. *Page 9: One of Doisneau's early photographs, showing the newly constructed social housing (HBM). The picture was made using a borrowed Rolleiflex camera (1930; possibly for a commission from the municipality of Gentilly), from the wasteland's edge of the zone near Gentilly. In the photograph's composition Doisneau sets up a clear statement of what is happening in the banlieue, where the drab dereliction of the zone is to be replaced by the promise of a new architecture that lies on the horizon. The money he earned for this commission (which came through the influence of his uncle, who was the mayor) allowed Robert to buy his own Rolleiflex camera.*

man whose eyes would disappear into the wrinkles of his rotund face when he laughed, and whose pockets were always full of nuts to give to children. His son Gaston would soon leave the countryside, working initially in a bicycle shop in the nearby town of Rambouillet for a Monsieur Ridard (pl. 6). Coming to Paris, he lived in the Fifteenth Arrondissement and worked as a clerk at Bon Marché, before training as a roofing and plumbing estimator for Etablissements Duval, a small firm employing twenty workers in the town of Gentilly on the southwestern outskirts of Paris. Monsieur Duval had a house at Raizeux, and it was probably there that Gaston met and fell in love with Sylvie, the youngest daughter of his eventual boss. They were married on September 24, 1909, and three years later at 9:15 in the evening on April 14 their only child was born—Robert Sylvain Gaston Doisneau.

The family lived with Sylvie's parents at 21, rue de Raspail, a building that stands to this day but is now numbered 37 (see pl. 10) and, by curious coincidence, closely resembles that in *La Stricte Intimité* (pl. 137). The house was also workplace and warehouse for the Duval family plumbing and roofing business. Monsieur Duval himself was not an important man in town, but he was well established. His eldest daughter Zoë married Auguste Gratien, a local politician who later became a parliamentary *député* of the Radical party, mayor of Gentilly, and Conseiller Général. Robert liked neither this uncle nor his grandfather, whose favorite sayings included: "In life there are those who amount to something and those who don't." Robert's father undoubtedly fell into the second category, as at the death of Louis Duval it was Zoë and her husband who inherited the firm—keeping their brother-in-law on as a salaried bookkeeper.

Robert was always to remember his aunt Zoë sending him out one day when he was about six years old with her young maid, who had been told to take Robert to dancing class at Mademoiselle Alice's, the little private school that he attended. But no sooner had they turned the corner of the rue de Raspail than the girl made him trot along to the nearby fortifications at Porte de Gentilly:

> When we got there she met her boyfriend, a shifty type who hardly gave me a second glance: "You can go play over there!"
>
> She returned with her hair all rumpled up.
>
> "Swear to me you won't tell anyone."
>
> I would have let myself be cut in pieces rather than betray her. . . .
>
> Later, when the ribbons of her apron became too short, she was given the sack. Perhaps it was in recollection of this that I made my first pictures on the same spot where she had conceived her first child.[2]

It was an environment that inspired some of Doisneau's best photographs. Over a long period he documented the area in and around Gentilly with an almost obsessive devotion. The southern banlieue of Paris during the first quarter of the twentieth century was dotted with small factories, workshops, and the premises of minor trades, interspersed with market gardens—unlike the *banlieue nord,* where most of the large factories of the *région parisienne* were to be found. A little river called the Bièvre trickled through Gentilly, running alongside the Duval house in rue de Raspail. It had been

2. *Eugène Atget:* Poterne des Peupliers, Bd. Kellermann, 13ᵉ arrᵗ., *1913, from the album* Fortifications de Paris. *Atget's visualization of the* Poterne des Peupliers *with its poplar trees in full bloom contrasts strongly with Doisneau's early Rolleiflex pictures (1932) of boys playing near the stumps of the same trees, now dead or so cut down as to emphasize the desolation of the* zone.

3. *Eugène Atget:* Porte d'Italie. Zoniers, 13ᵉ arrᵗ., *1913, from the album* Zoniers. *Much as Doisneau would do some twenty years later, Atget photographed the marginal inhabitants of the zone— emigrants, rag-and-bone men, scrap-metal collectors, gypsies—and their makeshift accommodations, as in this photograph of families working outdoors by their* roulottes (caravans). *Because the* zones *were* non-constructibles, *only temporary or mobile dwellings were legally permitted, although by the time Atget made this photograph, there were increasing numbers of shacks and even some properly constructed* pavillons *in the area.*

4. *Eugène Atget:* Porte d'Italie. La Bièvre à la sortie de Paris, 13ᵉ arrᵗ., *1913, from the album* Fortifications de Paris. *Atget's picture shows one of the leather tanning works that discharged its effluent into the Bièvre just upstream from Gentilly at the time of Doisneau's childhood. The river flowed within a few yards of the Duval home in rue de Raspail, where Doisneau lived with his parents. The smell of the river pervaded the house and could have been partly responsible for his mother's poor state of health.*

2

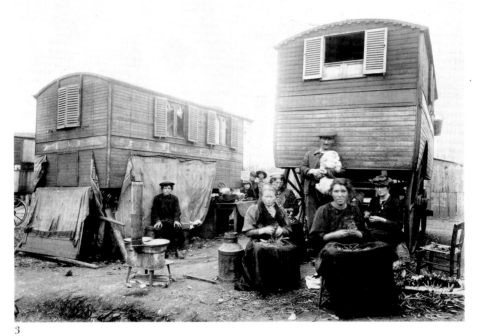

3

4

part of the route followed by pilgrims to Santiago de Compostela in the Middle Ages, but now the waste products from the small leather tanning works of the town flowed into it, and Robert remembered that to be able to bathe in clear water he had to walk for an hour, until he had nearly reached the prison at Frèsnes. Yet despite its smell and brown color, the river was a place of wonder and mystery for him.

The Bièvre was also inextricably connected in Doisneau's mind with his mother's illness, for during the 1914–18 war Sylvie contracted tuberculosis. Among Robert's most vivid memories was that of a wartime vacation with his mother—a woman who was "very pious, very mystical," someone "who gave me the sense of the marvelous"[3]—in a château at Mialaret in the Corrèze, belonging to some political associates of Auguste Gratien. The trip was undertaken in the hope that the change of air might improve his mother's health. Robert's father was away at the front. As he confided to the actress Sabine Azema during the television program they made in 1992:

> The château—it stands for the arrival of my father, for getting to know him. For the whole war I didn't have a father! My mother prayed for him. He was wounded, so she was very concerned about him, and then one day who should turn up but this skinny type with a mustache, and they told me, "It's your father." I didn't really have any idea of what a father was. And I wanted to surprise him.
>
> We went down by a little path to Viannon, as far as the river. I wanted to show him how skilled I was at catching lots of fish. And I really got into a state with my little fishing line—there were no trees, it was a grassy place. I cast, and the hook got lost in the grass. I had no spare, nothing. So my father, this man with a mustache, was bent over in the grass, with his hands that seemed so big, looking for the hook … and he couldn't find it.
>
> It's a terrible disappointment, you say to yourself, "There, now I've got a father, but he can't even find a hook! What does it matter if he goes back to the war or goes away!"[4]

Perhaps these memories indicate why water came to acquire an almost mystical quality for Doisneau, and led him to associate the passage of time with the thrill of angling: "Fishing gave me a feeling for water, for water flowing, for time passing. I always had this completely mad idea that it was impossible to stop this time, impossible to stop that water. It even flows at night when you're not watching!"[5]

The day of the armistice, November 11, 1918, "everybody went down into the street when the church bells began ringing. My mother, so happy that the war had ended, left me alone in the house. The steak that was cooking was left to burn on the gas. For me, the smell of burnt butter *is* the armistice."

Two years later his mother's health grew worse; a *guérisseur* (faith-healer)—resembling the character Toussaint in Jean Giono's novel *Le Chant du monde (The Song of the World)*—would make regular visits to the house, but it was all in vain. The day Sylvie died, the eight-year-old Robert was playing with his Meccano set in the courtyard at rue de Raspail. His aunts Zoë and Virginie came to get him: "Come quickly, come quickly to see your mother." On the second floor friends and family were in tears, wringing their hands.

5. *Robert Doisneau's grandfather Georges Doisneau, foreman in Monsieur Moulin's quarry at Epernon (Seine et Oise), front row, fourth from the left (about 1890).*

6. *Robert's father, Gaston Doisneau, worked for a time in the local bicycle firm of Ets. Ridard at Rambouillet, the town nearest to the family home in Raizeux (Seine et Oise).*

7. *The formal wedding-group portrait at the marriage of Doisneau's parents, Gaston Doisneau and Sylvie Duval, September 24, 1909. Monsieur Théophile and Madame Marie Duval, her parents, are seated on Sophie's left; Monsieur Louis and Madame Clémentine Doisneau, Gaston's parents, on his right. Auguste Gratien, local politician and the husband of Aunt Zoë, stands showing his profile, second from the right in the back row. Zoë stands fourth from left in the back row.*

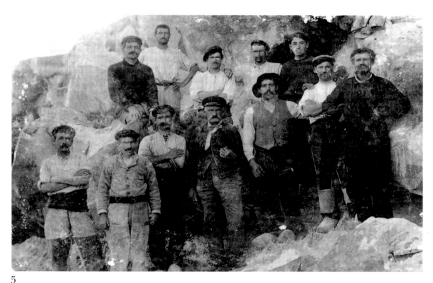

5

6

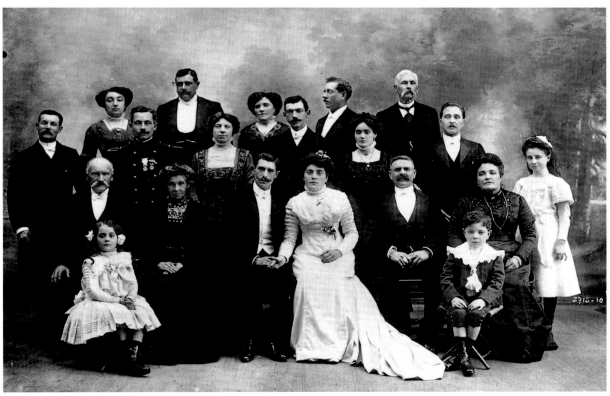

7

The scene "seemed disgusting" to Robert, who controlled his feelings so much that he appeared indifferent:

> I was in the front row of the funeral procession, and my father held my hand. There were the big wheels of the hearse rolling over the cobbles, and the droppings of the horses that pulled it. The droppings seemed strange to me so I kicked them. Memories are like that for me, when they are too moving. I always give the impression of not being too affected, it's my way of showing off.[6]

> I have so many terrible memories of her death. I made up lots of stories for myself about it—on the burial, on the route that the cortège took to get to the graveyard, the gravestone. My aunt let out a shriek that I found obscene. . . . My youth was very gray. I was not a very healthy child, and it was awful to have to go past the cemetery every day on my way to school.

> I always felt the lack of a mother, of a female personality . . . so I had a great urge to grow up; to have a wife, a lover, a sweetheart . . . it was the chase after a feminine perfume.

In 1922, Gaston Doisneau remarried, wedding a Madame Lucie Larmé (née Lang), a woman whose husband had been killed in the Great War and who had a son—Lucien—of about the same age as Robert. The new ménage moved to another part of Gentilly, an apartment on the third floor of 7, rue de la Poste (pl. 36), in a building of the type known as an *immeuble de rapport* (investment property), increasingly common in the banlieue during this period, as the area expanded in the postwar boom. The era was one of rapid development in the *banlieue parisienne* as new industries located in areas of lower cost: factories making machinery and tools on the poor land in the *boucle* (belt) of the Seine, from Asnières to Gennevilliers; car manufacturers by the docks of the Seine in the west—Boulogne (Renault) and between Grenelle and Issy (Citroën); and pharmaceutical companies in the north and the southeast, including Gentilly. While the population of Paris fell in the first twenty-five years of Doisneau's life (1912–37), the area in which he lived—the old *département* of Seine—gained 800,000 inhabitants. The housing problem dominated the post-Great War period as it was to do again after 1945. Nowhere was this more evident than in the banlieue, where the urban hinterland was crisscrossed by a checkerboard of small market gardens (around Gentilly at certain times of the year, Doisneau recalled, there was always the smell of fresh celery), areas of scrubland dotted with shacks and caravans, the remnants of the fortifications, and small plots with their lovingly cherished *pavillons* (small homes) and villas.

Doisneau's playground as a child was the streets and *terrains vagues* (wasteland) of the banlieue between Gentilly and Paris, that is, the *zone*. Even in the 1920s it was still semirural: goats roamed over the old fortifications. At the time Robert was growing up, the *zone* was still populated by a shifting and cosmopolitan population seeking work in the new factories and workshops developing around Paris—gypsies, beggars, casual day-laborers, and *chiffoniers* (rag-and-bone men), and emigrants from other parts of France and Europe (particularly Italy, Spain, Poland, and Russia). The *zone* at this time contained many shacks and slums, but also here and there the little workers'

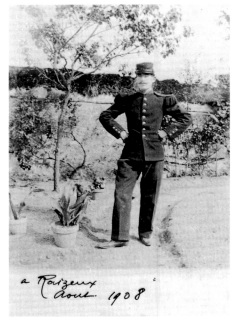

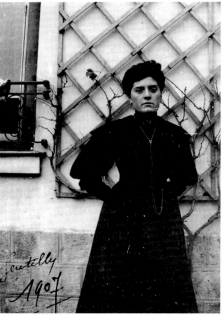

8. *Gaston Doisneau in his uniform during his military service, 1908.*

9. *Robert's mother, Sylvie, in the garden at the Duval home at rue de Raspail, Gentilly, in 1907, at about the time that she first met Gaston Doisneau.*

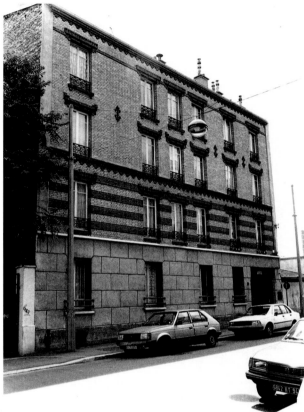

10

12

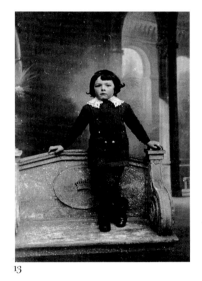

13

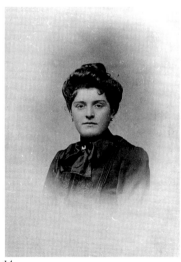

14

11

10. *Doisneau's birthplace and his home until 1922: 21 (now 37), rue de Raspail, Gentilly. The building served both as the Duval home and as workplace and warehouse for the family's plumbing and roofing business. The Doisneau family lived on the second floor. The building is still used as the offices and workshops of a local plumbing and central heating business.*

11. *Menu for baptism of Robert Doisneau, June 2, 1912.*

12. *Robert Doisneau at thirty-three months, January 1915.*

13. *Robert Doisneau at age five, 1917.*

14. *A photograph of Sylvie Doisneau, carried by her husband Gaston while he was away at the front during the 1914–18 war. It is one of the last photographs made of Sylvie.*

and petit-bourgeois *pavillons* with their neatly fenced gardens, known as *pavillons Mimiles* after a popular song of the period about a character called Emile—the quintessential French worker. (Mimile is an affectionate version of Emile.)

Nevertheless, it was a lawless place. In 1919, the fortifications were officially abandoned: the jurisdiction of the Paris police force extended as far as the limits of the city, while that of the rural gendarmerie only began in the banlieue proper. Doisneau recalled the tale of the *appariteur* (municipal bailiff) sent to deliver a summons in the *zone,* who was forced to return to the town hall stark naked and still clutching his order, his impressive uniform having been distributed among the urchins.

The *zone* and its *fortifs* now belonged to the gangs of children who played there: it was the landscape of the happiest times of Doisneau's childhood, a transitory and marginal wasteland where, as he said, "You went either to play, to make love, or to commit suicide." It fascinated him, and from an early age he felt it to be a fragile and fleeting place of which he must *"inscrire les décors"* (record the surroundings). Near his home was the thirteenth-century Château de la Reine Blanche, also known as the Château Victor Hugo, after the writer who lived there briefly in the 1820s. Robert had a friend who lived nearby and with whom he would play in the vaults beneath the derelict and haunting castle. The streets provided a whole series of entertainments: there were few cars on the road, and many merchants and tradespeople still plied their wares in the street, rag-and-bone men alongside the stands where fish and birdseed were sold. Doisneau recalled that until the 1920s it was still possible to hear the cries of the dog-turd collector on his route around Gentilly, who sold his wares to the local tanneries! The sounds, smells, and sights of the streets fascinated Doisneau, and gave him a lifelong urge to use the street as his "studio."

Gradually the *fortifs* began to be dismantled, the *zones non-constructibles* divided up into housing plots to feed the dream of a *paradis pavillonaire* (bungalow heaven) among the *classe populaire:* the little house and garden to which every Mimile had the right to aspire. But the pressure on the banlieue was so great that many—particularly those with few resources but large families—could not afford their own *pavillon,* and it was on their behalf that new theories of urbanism were put into action, designed to improve workers' housing and thus avert the threat of social unrest. They unleashed a veritable flood of social housing: from 1928 the construction of 200,000 apartments was undertaken by the municipalities in the *couronne* ("crown") of Paris. The most notable were the *Habitations à bon marché* (HBM), blocks of low-rent workers' apartments that began to ring the city with their concrete and brick towers. Those in Gentilly were put up in the late 1920s and figure as a constant motif throughout Doisneau's documentation of the landscape of his banlieue (pl. 7, one of Doisneau's first photographs of Gentilly).

The street was Doisneau's real school, although Gentilly's Ecole Communale was the one he was obliged to attend. He was not, as he recalled, a good student, preferring to entertain the class with all manner of pranks. He was, however, gifted at painting and drawing, as some pictures from this time attest (see pls. 19–20), and a voracious reader from an early age. Given the petit-bourgeois milieu in which he was raised, it is not surprising that there were few books in the home and that the literary events of the period would

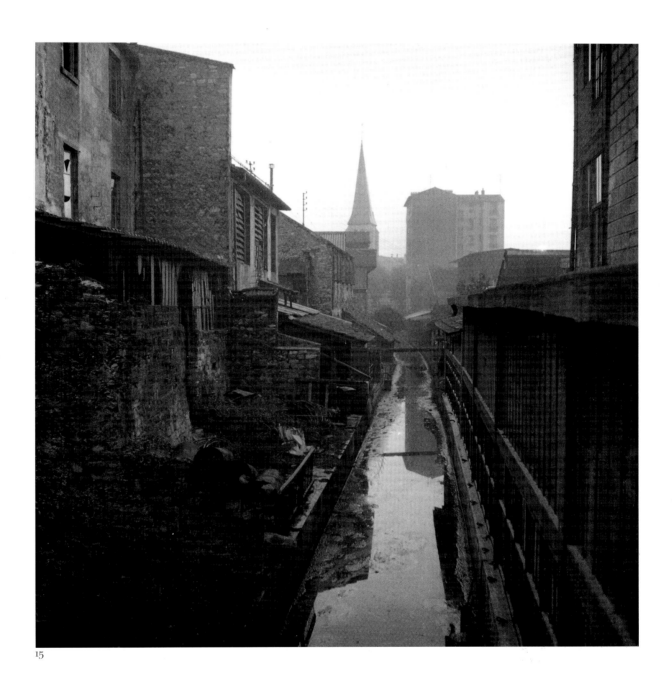

15

15. *The Bièvre at Gentilly, photographed by Doisneau in 1945. The church in the distance, St. Saturnin, was close to the Duval home in rue de Raspail. The river has since been covered over.*

probably have held little interest for his parents. Yet Gaston Doisneau had acquired great respect for "classic" literature.

> There was a bookcase that wasn't very big, but in it were four volumes considered to be its precious stones because they were bound and because they were a recent acquisition. One day a door-to-door salesman had come to the house and said, "I've got a bargain here that you can pay for over three months—*Les Misérables* by Victor Hugo."
>
> Now there wasn't a lot of space in the bookcase, it had a whole series of theater programs from 1900 to 1910. That's how I know all about the *théâtre de boulevard,* because I read them all. But then towering in the middle of all that was *Les Misérables* by Victor Hugo. My father said to me: "That, you can't read like any other book. It has to be read slowly, you have to savor it." So every night before going to sleep I read six or eight pages of *Misérables* with so much care that there are still some sentences, pages even, that I know by heart.

The tragic hero of Hugo's novel, Jean Valjean, made a great impression on Robert at the age of ten or eleven, about the same time that he was having to come to terms with the new family in which he lived. Although not disposed to dwell on the matter, Robert never hid the fact that he was not close to his stepmother or stepbrother:

> I lived with my father and my stepmother, and you know it's not very nice to have a stepmother because it must be difficult to have a stepson, the smell of other people's children isn't very nice, and it's just the same with sheep: when the ewe has lost her lamb, she won't give milk. I had everything I wanted materially. As for everything else, I didn't get what she couldn't give me.[7]

In such a context, reading is an avenue of escape into worlds more exciting, absorbing, and warm, where if you can identify with the protagonists you can live the whole gamut of human emotions vicariously. Robert read a lot of Victor Hugo for pleasure, but detested the "boring poets that they made us read at school," such as Lamartine, whose *La Chute d'un ange* he found impossible to complete. He was allowed some comics at home, including *Le Petit Inventeur,* and a morally improving periodical called *Mon Journal.* He recalled that it contained stories about the good and bad pupil, the latter always getting into trouble while the former "was the pride of his parents." Robert felt himself to be the *mauvais élève* (bad student) of the family, while his stepbrother Lucien was the *bon élève* (good student). The two boys were not too distant as children—they enjoyed going together, Robert remembered, to the velodrome at the Bois de Vincennes. But as adolescence progressed both found increasingly less to say to each other.

If he was a *mauvais élève* it is remarkable that Robert's school certificate, awarded at the age of eleven, contains the grade *très bien*—probably unmerited, as he suggested that it was in the award of this high mark that he began to appreciate the importance of having well-placed friends; his maternal uncle was at that time a *député.*

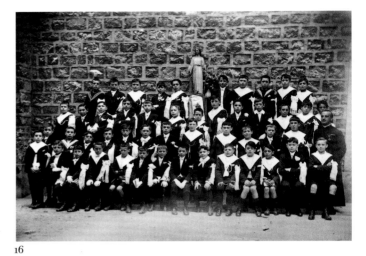

16

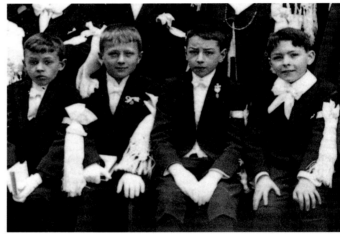

17

16. *Robert Doisneau and his stepbrother Lucien Larmé at their first communion, 1923. Afterward Lucien's grandfather took the two boys to the Folies Bergères in Paris! Robert, sixth from right, front row; Lucien, sixth from left, second row.*

17. *Detail of plate 16; Robert, far right.*

18. *Children leaving the Ecole Communale, Fourteenth Arrondissement, Paris, c. 1934–35. Posted by the entrance is a notice of examination for the Ecoles Professionales (including the Ecole Estienne, which Doisneau attended).*

19–20. *Paintings and drawings by Robert Doisneau, age eleven.*

19. *Pencil-and-watercolor sketch of peasant woman, dated Friday, June 23, 1923.*

20. *Pencil-and-watercolor sketch of children playing and swimming in an imaginary moat in the trenches of the fortifications at Gentilly.*

18

19

20

School proved a somewhat sad experience for Robert and no doubt a disappointment for his parents (his father had wanted him to be an engineer), but at the age of thirteen he passed the entrance examination to a craft school for the book trade, the Ecole Estienne, located in the Fourteenth Arrondissement of Paris, near Gentilly. His family must have thought that at least the children would be able to learn a skilled craft and get some sort of reasonably secure job (his stepbrother Lucien followed the same route, studying photolithography).

His *cahiers* (workbooks) from the Estienne show that Robert was gifted at graphic design, and in particular at lettering (pls. 22–30). The shape and form of letters and words had always fascinated him, and were to have a practical relevance to his photography, for one of his compositional approaches was to try to construct an image in the form of a letter of the alphabet.[8] His love of lettering had a strong emotive link to his mother, who drew and wrote beautifully. When she and the six-year-old Robert stayed in the château at Mialaret in Corrèze, they spent some time on his writing:

> There on the table was my exercise book, and the inkwell with violet ink. My mother wrote a superb capital letter, indeed she drew the letters, she wrote marvelously. She drew in a calligraphic hand a beautiful capital "D" like that, and she said to me, "Go on, do a page of capital letters." It began not too badly, and I did some other capital letters, and slowly but surely it got worse, because I saw my cousin going off fishing. I wanted to go fishing with him as well. And she said, "Go on, another line." And I started to cry, to cry like a baby! There was nothing sadder, nothing at all: for me the symbol of holiday homework, it's the violet ink diluted with tears, and it's horrible.

As his *cahiers* and other work (pls. 27–31) show, Doisneau's eye for line, form, and tone was highly developed, and artistically he had some promise, although the educational regime of the Estienne seems to have lagged well behind contemporary trends in the graphic arts:

> It was a good school for the book trade. All the *profs* were specialists—in typography, bookbinding, in engraving. The *prof* himself had to pass an exam to become a teacher. He had a workshop with about twenty boys for whom he was responsible for four years, training them in manual skills.
>
> There were seventeen or twenty-two studios, I can't be sure how many, but for the first seventeen or twenty-two days when I first entered the Estienne, we spent a day in each one. It was what they called the *circulus*. At the end of this we had to choose one. Without really knowing why, I chose lithographic engraving.
>
> Outside of the school, techniques evolved. But the *prof* was in a form of semiretirement. Each day he taught us something that became ever more outdated. At the end of the four years the kids who had managed to stay the course found themselves with a diploma—in my case for a lithographic engraver. We were asked to go to a number of employers, and they would all say, "It's been a long time since we needed anybody who could do that!"
>
> I was very bitter. It was a farce. The *profs* lived OK, but what they put into the teaching was completely wasted. . . . I'd been launched into the

21

21. *Robert Doisneau on his bicycle, age 15-16, in 1927–28.*

22–23. *Samples of work made by Doisneau during his studies at the Ecole Estienne, between 1925 and 1929.*

24. *Robert Doisneau, age fourteen, in a classroom at the Ecole Estienne, 1926.*

world of printing and publishing with very few usable skills. I could do a wine label showing the medals won at the Concours agricole of 1900, but nothing useful in 1929!

The Estienne's art teachers also imposed their outdated tastes and attitudes: these were men who disapproved of any modern art, from the Impressionists onward. The Ecole Estienne was frustrating to a young man like Robert, who had begun to acquire certain artistic skills and was obliged to devote them to the engraving craft of the 1890s. Yet the school experience failed to alienate him completely from creative work in the graphic arts. He still found himself wanting to graphically reproduce the forms and shapes that he discovered in the banlieue and on the streets of Paris. He told how, as a young child, he had wanted to draw the dead tree that he could see from his bedroom window in Gentilly, but that his attention soon shifted to the gaslight also in view. It is not clear whether this desire to "fix" his environment in a graphic form came from his growing realization while a student at the Ecole Estienne that modernism both existed and offered strong ideas about what should be done in the banlieue; within its framework, the banlieue that Doisneau both loved and hated was entirely *provisoire* (temporary). He first came across the ideas of Le Corbusier at about this time, and he saw them as the salvation of the area in which he lived. "I wanted my completely stupid banlieue to become functional." Yet at the same time he was aware of the appeal of the *terrains vagues,* especially to children, and he knew that there the imagination could transform the wreck of an old car into a golden coach with six white horses.

The adolescent Robert Doisneau felt that the banlieue was a gray, miserable, suffocating place to live. Was this more than anything else a personal reaction to his home environment? Like many adolescents, he was confused about what he really wanted. Nearing the end of his time at the Estienne, when he was sixteen or seventeen, Doisneau began to read the work of Jean Giono, whose first novel, *Colline,* was published in 1928. Giono's work is an almost blanket rejection of the urban, modern, industrial world. In his first three novels, and the semiautobiographical *Jean le Bleu* of 1932, Giono described a sort of romantic rural paradise set in Provence, in which strong peasants create an existence in fragile balance with the forces of nature. This writing, which at the time had a subversive character, perhaps served to further arouse feelings of antipathy toward the unplanned and apparently dehumanizing aspects of life on the edge of Paris. As with Victor Hugo, Robert committed sections of Giono to memory, and could repeat them until the end of his life. Later he would read Giono while he was supposed to be working in the darkroom at Renault, named his canoe *Jean le Bleu,* carried a small tract with a pacifist text by the writer in his knapsack when he was mobilized in 1939 (pl. 98), and toward the end of the 1950s carried out a self-financed project on Provençal shepherds which, however, failed to find a publisher.

His education at the Ecole Estienne had many defects, but the training Doisneau received there made him a highly skilled draftsman. His first job—from July to September 1929—was in the very traditional engraving atelier of Xavier Vincent, at rue des Arquebusiers in the Marais, where he earned about

25

26

25. *Gaston Doisneau, Robert's father, at work in his garden. Sepia wash painting, about 1926–27.*

26. *Sample of work made by Doisneau during his studies at the Ecole Estienne, between 1925 and 1929.*

27

27–30. *Samples of work made by Doisneau during his studies at the Ecole Estienne, between 1925 and 1929. The cigar box and Renault Vivastella designs are lithographic engravings.*

29

28

30

one hundred francs a week. Though he got on well with his fellow workers and the patron, the work of meticulous hand engraving in a style already considered outmoded in 1900 was something he detested, and when the opportunity arose in the autumn of 1929 to take a job as a lettering artist in a Parisian graphic art studio, the Atelier Ullmann at 82, rue Lecourbe (Fifteenth Arrondissement), Robert jumped at the chance.

The years that had been spent in the laborious activity of engraving, working on a tiny area of stone with a magnifying glass, had given him a powerful urge to go out on the streets of Paris and through the banlieue, to capture the reflections of the water flowing in the gutters, to show the vibrancy of life in the streets, of people moving through the metropolis. To continue with the one aspect of art he had enjoyed at the Estienne—drawing—he enrolled for evening classes in life drawing and still life in Montparnasse:

> I wasn't too bad at drawing. But at the Estienne they made us draw Roman emperors, plaster things with nasty faces. . . . When I went out I could see very clearly. I saw the newspaper-vendors who had interesting faces, the woman selling vegetables who had an interesting face, but I couldn't ask them "*Bonjour,* madame, can I draw you, can I make a portrait of you?" I would never have dared to do that. So I went to the corner with a sketchbook, and I did some sketches of houses. . . . I looked like a child. I must say I wasn't very big, I looked quite naive, and then some guys took my sketchbook, saying, "Let's have a look at what you're doing, kid." They looked at it and said, "Ha, ha, ha, that's funny, that is, go on kid, that's OK!" I was ashamed, and it wasn't really what I wanted to show—I wanted to show the texture of things, the paving stones, the walls, the expressions of the people.[9]

Disappointed, he began to wonder if he could capture what he saw in the streets better through photography. At the Estienne, it had been necessary to learn something about photolithography, so he was already aware of some of the processes involved. While still at the school in 1928–9, Robert borrowed a camera belonging to his stepbrother Lucien. Not a particularly convenient instrument, this English "folding" bellows camera that had belonged to Lucien's father used nine-by-twelve-centimeter glass plates. Robert recalled his stepbrother being very worried that he would lose it somewhere in the *zone,* get it damaged or have it stolen, for he wanted to make pictures in interesting places. But things went well, and Robert made his first series of photographs. Some have survived in the form of original prints dated either 1929 or 1930, the negatives being lost during the war. There are as yet no people in these pictures, for Doisneau was still at this stage too shy to approach them. Instead, the photographs show such subjects as a pile of cobblestones (pl. 32), peeling posters on the palisades (pl. 33), a broken bicycle wheel (pl. 34). One photograph (pl. 36) was made in his bedroom at 7, rue de la Poste, Gentilly. It is possible to see a desk, the window looking out on the roofs of the buildings across the road, lace curtains, the foot of Robert's bed: "I wanted to show the really oppressive side of this house. There was a seedy order to everything, even in the cushions and the curtains. I hate petit-bourgeois style: it's suffocating."

31. Le Coq (The Cock), *pen-and-wash sketch,*
1923 or 1924.

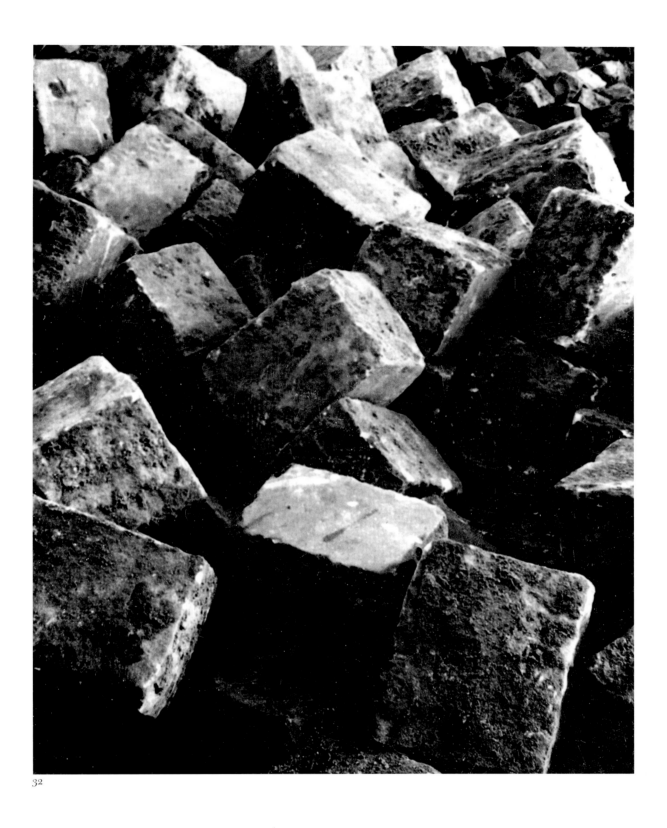

32

32. Tas de pavés (Pile of Cobblestones), *1929. Made with a nine-by-twelve-centimeter camera, this is one of Doisneau's first personal photographs— objects found in the zone near Gentilly, 1929-30.*

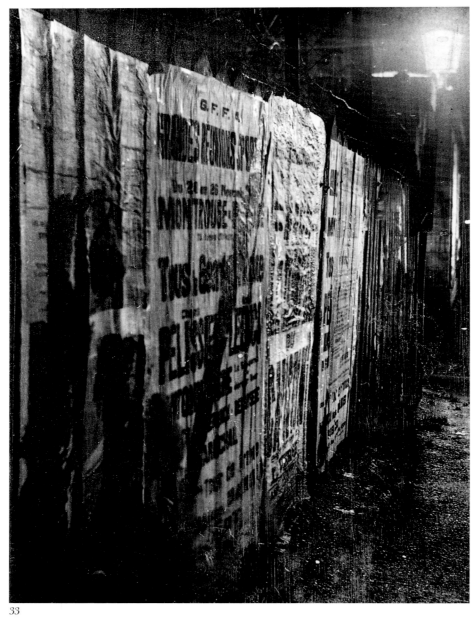

33

33. *Posters on fence, Gentilly, 1929.*

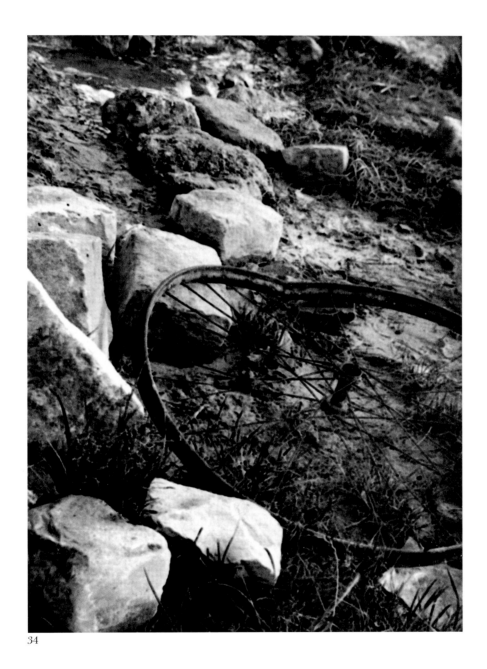

34

34. *Broken bicycle wheel in the zone, 1929.*

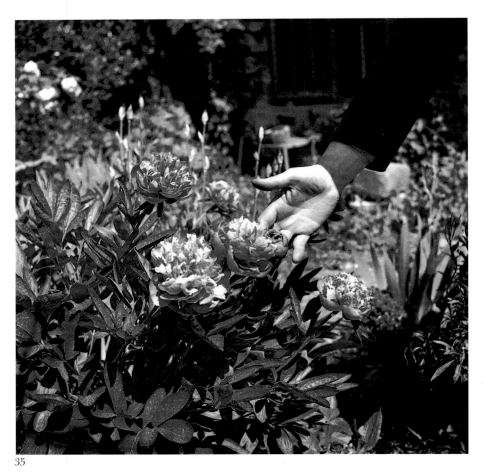

35

35. *Hand and flower, garden of a Gobelins tapes-*
try worker. Many of the workers lived in Gentilly.
One of the first six-by-six-centimeter Rolleiflex pho-
tographs made by Doisneau with the camera he
borrowed as part of his assignment for the munici-
pality of Gentilly. (See caption for plate 1.)

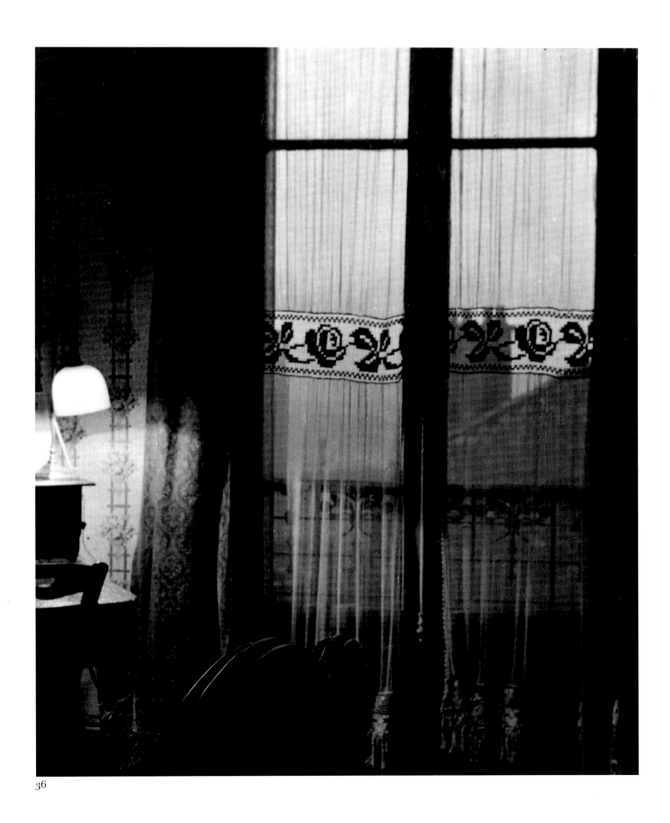

36

36. *Doisneau's room in 7, rue de la Poste, Gentilly, where he lived with his father, stepmother, and stepbrother. "I wanted to show the really oppressive side of this house. There was a seedy order to everything, even in the cushions and the curtains. I hate petit-bourgeois style: it's suffocating."*

In 1929, Robert wrote the following lines in his journal:

I am seventeen.

I am skinny and badly dressed.

I am learning a craft that has no future.

The scenery that surrounds me is absurd.

When I show my photos to those around me, they all agree it's a waste of film.

So what, I'll continue anyway.

Some day, perhaps, there will be someone for whom they will raise a rebellious snigger.

Alfred Sauvigny, his engraving teacher at the Estienne, had tried to discourage Robert when he showed him some of his early pictures: "You know what I call photographers? Crap-ographers!" On the other hand his uncle, Auguste Gratien, by now the mayor of Gentilly, had encouraged him—perhaps urged on by Aunt Zoë for whom *le petit* Robert was a special case—to take on a commission for the municipality, for which he was able to borrow one of the new Rolleiflex six-by-six-centimeter format twin lens reflex cameras then just appearing in France, easy to use and equipped with a sharp Zeiss Tessar lens. Its accuracy made a great impression on him (pl. 47, Rolleiflex camera c. 1930). Robert had the prints carefully bound in an album and took them to the official responsible for the municipal archives, who asked him "How much do we owe?" Robert hesitated, then stuttered out the price—"Twelve hundred francs." A lot of money, perhaps three months' wages for a worker or *petit-employé,* yet it was paid without demur to the mayor's nephew! It was the price of a new Rolleiflex. One of the first pictures made with the new acquisition is a self-portrait: Doisneau gazing intently into the viewfinder (pl. 37).

APPRENTICESHIP

1929-1939

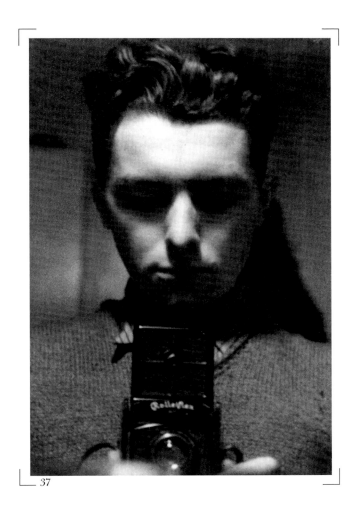

"Let's begin with diffuse light, which comes in large amounts. It's like rosé wine that they say goes with everything. It's often true that thanks to this smooth ambience shapes fill out to become a delight to the eye."

"It was essential to see Vigneau, with his air of a Hindu prince and those weary gestures of his, turn an object in his hands, any old thing, work of art or functional utensil. He took a visible physical pleasure in finding the right angle, then in choosing a form of lighting that would suit it so well that the cigarette pinched absentmindedly between his fingers would burn them before the moment of inspiration struck."

[R]OBERT DOISNEAU JOINED the Atelier Ullmann in September 1929. The firm, with premises at 82, rue Lecourbe, deep in the southwestern Fifteenth Arrondissement, specialized in advertising artwork for the pharmaceutical industry. Robert worked initially as a lettering artist, producing slogans in italics (his specialty) such as "Bloggs Tablets stop your headache." Pharmaceutical companies wanted to project themselves and their products as thoroughly modern: a number of them sponsored luxuriously produced magazines such as *Art et médecine*. Under the impact of modernist trends in graphic design, photography was becoming increasingly used in advertising, and Ullmann decided to install a darkroom and acquired a wood-and-leather bellows-stand camera, some brass-bound lenses, and lights. A young man called Lucien Chauffard (see pl. 79) was given the responsibility for using them, but soon had an unofficial assistant in Robert Doisneau, fascinated by the possibilities of this new medium:

> This boy showed me what to do before going to another job. The boss had seen me hanging around the darkroom, and he asked me, "Doisneau, can you photograph these granules, syrups, tablets, etc.?" I tried—it wasn't too bad, so they put me on this work for a while.

Thus it was by chance that Robert Doisneau became an advertising photographer, but it was a profession still regarded with suspicion: "At that time, a photographer was somebody whom you might offer a glass of wine in the kitchen, but you'd never invite them into the house."[1]

When in the 1890s the widespread availability of the Kodak box-camera had brought the new art of photography to the masses, the social status of the photographer declined. By the 1920s and 1930s photographers in France were widely thought of as akin to the *forain ou camelot* (fairground barker or flea-market dealer). This was certainly true of Eugène Atget (1857–1927), spiritual predecessor of Doisneau, a failed actor who from the 1890s to the 1920s devoted his life to a minute exploration of "le vieux Paris." Atget led a marginal existence, hawking his views of the city—its denizens, architecture, and surroundings—to the private and public buyers of such photographs, who would use them as documents in historical research or for artistic and decorative inspiration.[2] His photography, despite its belated appreciation by Surrealists such as Man Ray and André Breton, was little known. On his visiting card, as on his prints, the subordinate role of photography was acknowledged: *Documents pour artistes*. But when he died in 1927, this idea was already under attack from a number of directions.

Pictorialism—the fashion for photography that imitated painting, which had been dominant among the "art photography" movements of the late nineteenth and early twentieth centuries—was still influential but widely perceived by modernist artists and photographers to be an aesthetic dead-end. Pictorialist photographers sought out and emphasized aspects of the photographic process that imitated painting. Special lenses were used to render an overall soft-focus image, often further textured by brushstrokes in the print's emulsion, while preparations such as gum bichromate disguised the photographic source of the image, its subject usually idealized and symbolic: nudes bathing in pools, sailboats in the sunset, children dressed as wood nymphs.

37. *Page 33: Robert Doisneau, self-portrait with first Rolleiflex camera, 1932. "Like a fortune-teller with her crystal ball."*

Even the best pictorialist work created between 1890 and 1920 by photographers such as Edward Steichen, Alvin Langdon Coburn, or Robert Demachy, has a contrived, romantic, and intentionally painterly look that avoids naturalistic presentation of its subject matter. Pictorialism was in part an attempt to force practitioners of the conventionally defined plastic arts to accept that photography had artistic pretensions and was more than a purely documentary or scientific technique of image making.

In 1908, Alfred Steiglitz, editor of the avant-garde magazine *Camera Work*, which had featured the work of the leading pictorialists, asked a number of prominent French artists and critics whether they thought photography capable of producing works of art and whether they approved of the pictorialist emphasis on interpretation and symbolism. The response was overwhelmingly negative. Matisse, perhaps the most liberal of those surveyed, was especially critical:

> Photography can provide the most precious documents existing and no one can contest its value from that point of view. If it is practiced by a man of taste, the photograph will have an appearance of art. But I believe that it is not of any importance in what style they have been produced; photographs will always be impressive because they show us nature, and all artists will find in them a world of sensations. The photographer must therefore intervene as little as possible, so as not to cause photography to lose the objective charm which it naturally possesses, notwithstanding its defects. By trying to add to it he may give the result the appearance of an echo of a different process. Photography should register and give us documents.[3]

The mounting dissatisfaction with the pictorialist conventions dominating French photography was fed by a debate started by Florent Fels in his avant-garde journal *L'Art vivant* during 1927. For Fels the pictorialism that dominated the main French photographic exhibition, the Salon de la Photographie, was retrogressive, and in an article on the first modernist Salon Indépendant de la Photographie (see below) he damned "all that aesthetic that finds its proper outlet in painting but that has nothing to do with the strict laws of photography dedicated to two tones, white and black."[4]

Atget's practice, which emphasizes the exclusively documentary role of his images, seems to follow the prescriptions of Matisse (who was, moreover, one of his clients). Despite the fact that Atget's photography was beginning to be seen in a new light, that of Surrealism, he was still working within an aesthetic in which photography was considered a craft skill. Notwithstanding similarities in both perspective and subject matter, Doisneau was then unaware of Atget's photography and of the worthy attempts at promoting his work in the period 1927–30 by Berenice Abbott, Man Ray, André Breton, and the writer Pierre Mac Orlan.

Mac Orlan contributed to the debate begun by Fels, and in his remarks prefacing the publication of Atget's photographs in 1930, he put forward the idea that they were especially effective at transmitting *le fantastique social de la rue* (the social fantastic of the street).[5] Later in the 1930s, writing about André Kertész's photographs of Paris, Mac Orlan declared that "photography is the great expressionist art of our time." The ideal activity for both photographer and writer as visualized by Mac Orlan was thus to be a *flâneur,*

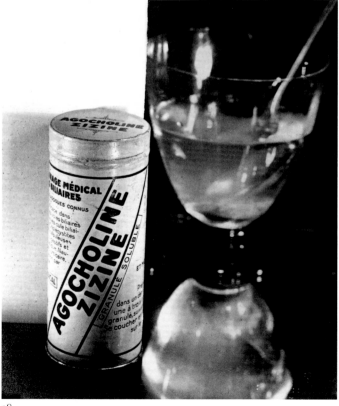

38

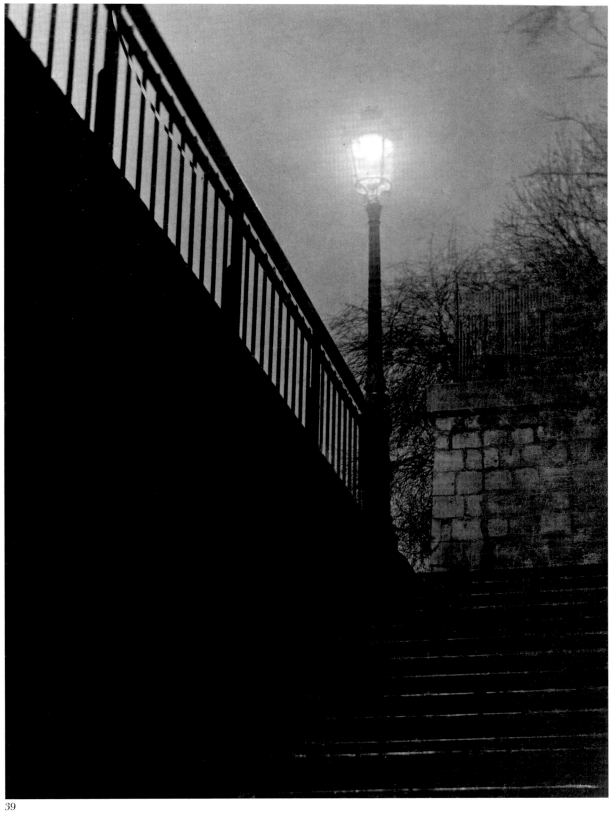

39

39. *An image of Paris at night with steps and street-light, 1930–31. An early nine-by-twelve-centimeter photograph, reminiscent of Brassaï, showing the influence of modernism.*

a casual spectator who observers the *fantastique social* of the street by taking part in it.

By the mid-1920s, two distinct strands of modernism were combining to push photography to the forefront of avant-garde art. The 1914–18 war changed ideas about art, and many artists, designers, and photographers in Germany and central Europe wanted to create wholly new approaches that owed nothing to the art traditions they associated with the societies destroyed in the Great War. The revolutions of 1917–18 also brought new political ideas to the forefront, and activists in groups as diverse and opposed as Communism and Fascism all grasped the idea that photography and film could be used to carry political ideas to the masses and to project images of the new societies that they sought to create.

In Germany, artists such as the expatriate Hungarian László Moholy-Nagy developed ideas originated within the radical artistic movement of Dadaism, a forerunner of Surrealism, proposing a "new vision" in which photography played a progressive, emancipatory role. Artistic creativity, in this approach, is no longer concerned merely with representation but becomes an instrument or tool with which to train and condition the new vision. Thus for Moholy-Nagy as well as for a number of other photographer-theorists—Albert Renger-Patzsch, Karl Blossfeldt, and the Russian Constructivists El Lissitzky and Alexander Rodchenko in particular—photography was about finding a new form of perception.

Such ideas coincided with a widespread feeling in postwar Germany that technology—whose destructive powers had recently been displayed to ferocious effect—should now be directed toward the creation of a new and better society. German industry was redirected toward the modernization of urban society, and there was a renaissance in industrial and architectural design, of which Walter Gropius's Bauhaus at Weimar is only one example. Photography played an important part in this process, for as early as 1922 it was being widely used in advertising, marketing, and the popular press, in ways that were entirely novel. Machines and materials, cities and industries, became important subject matter, not merely for the avant-garde artists and photographers but also for industrial and commercial photographers and graphic designers, and for a new breed: the photojournalists, who served the needs of industry and the press.

Photography's role as a visual language was being developed, and in great contrast to pictorialism, it advanced through an emphasis on the distinctively photographic qualities of the medium. New and sharper lenses rendered physical forms more accurately; prints were made on glossy white paper so as to transfer all of the tonal information and resolution of the negative to the print; better cameras and emulsions recorded images more precisely or allowed the photographer to grasp movement and to be in the middle of it, while radically new viewpoints and compositional approaches gave the "new vision" an exciting panoply of images entirely in keeping with the vibrant, optimistic postwar world. New angles—shooting directly up or down, tilting the frame to generate a dynamic diagonal—created exciting, unsettling perspectives on a real world, in strong contrast to the make-believe mist of pictorialism.

In 1929 the great exhibition held at Stuttgart under the direction of Moholy-Nagy and his colleagues at the Bauhaus—*Film und Foto*—showed the new uses of photographs in art, advertising, and journalism. The effect of this

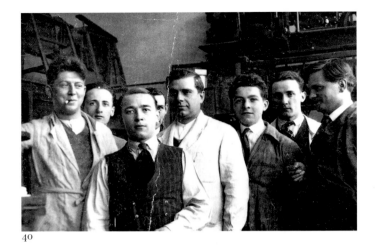

40

40. *Robert Doisneau, lettering artist and trainee-photographer (third from left) at Atelier Ullmann, Paris, 1929.*

41. *Page 39: Nicolas de Staël (background) and Nadia Khodasavietch (standing right) with students at Fernand Léger's painting school, Montrouge, 1938.*

42. *Page 39: Fernand Léger and his painting school, 1938. Léger was a neighbor in Montrouge for whom Doisneau carried out occasional assignments photographing the painting school and the students' work. Nadia Khodasavietch, seated to the right of Léger, was later to become his wife. Léger had given lectures at the Renault plant in Boulogne-Billancourt where Doisneau worked, and he encouraged the workers to join his art classes. It is possible that this is how they met.*

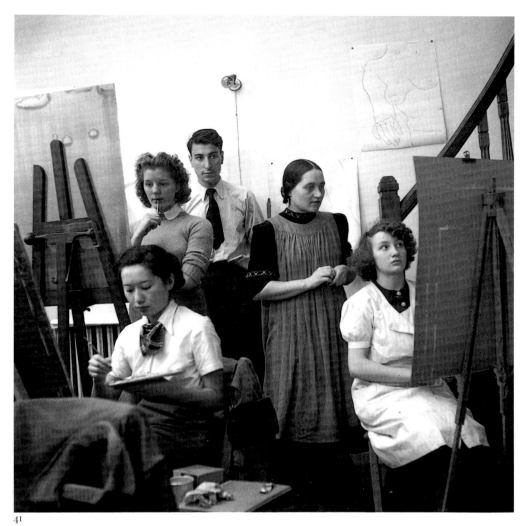

41

42

exhibition on avant-garde circles in France, and the growing diffusion of "new vision" ideas into French photographic culture, cannot be underestimated, these influences indelibly marked Robert Doisneau's own photographic perspective.

Young artists and photographers flowed into Berlin, Munich, or Cologne to be part of the exciting new experiments in the visual arts. In western Europe and North America, the tenets of pictorialism became rapidly outmoded. In France, the modernist trend was reinforced by those who came from the east: André Kertész, Germaine Krull, and Gyorgy Brassaï being only the best known of those who arrived in the 1920s and early 1930s after the rise of fascism in Germany.

The impact of the new photography in France was thus felt relatively soon after it first appeared in Germany. The first event to mark the emergence of the "new vision" was the Salon Indépendant de la Photographie, also known as the Salon de l'Escalier because it was held on the staircase of the Comédie des Champs-Elysées theater in 1928. The emphasis was on "realist" photography: the prints exhibited came from Nadar, Atget, Man Ray, Krull, Kertész, d'Ora,[6] Berenice Abbott, Laure Albin-Guillot, and George Hoynighen-Huene. Among those still alive at the time of the exhibition, only Albin-Guillot was French—a strange choice, since her work was marked by pictorialist tendencies.

Modernist photography was also shown in a number of small Parisian galleries—La Pléiade, La Plume d'Or, the exhibition space of the Tiranty photographic company. However, the wider public consecration of modernism came about through the publication in 1930 of *Photographie,* the first special number of the prestigious graphic arts journal *Arts et métiers graphiques* devoted to photography and edited by Emmanuel Sougez. The latter was the chief French proponent of *la photographie pure* and director of the photographic department of the magazine *L'Illustration.* In the first edition of what was to become an annual publication during the 1930s—and in which Doisneau himself would be published in 1947—Sougez laid out a vast panorama of modernist photography, superbly printed by rotogravure, and supported it with an authoritative essay by the respected critic and writer Waldemar George. The work, according to Daniel Masclet, "was like a bomb going off in the artistic world of the time. It destroyed in a brief period the old photography, moribund since 1914."[7] Most of those photographers exhibited in the Salon de l'Escalier were also featured in the first edition of *Photographie,* and it came to be seen as the bible of the new photography in France. Other reviews—notably the previously mentioned *Art et médecine,* published by Laboratoires du Docteur Debat and sent free to doctors—also took up the modernist approach and used photography in novel ways as an illustrative medium. Such publications credited the photographer, a new practice that confirmed the rising status of the medium and its practitioners.

As the impact of modernist ideas was felt in the graphic arts, in advertising, and in the rapidly emerging illustrated press, a network of small agencies and studios grew up to supply the images these industries consumed. They were often run by emigrants from eastern and central Europe; the photographic agency, though not invented in Germany, had been given a new and interesting form there through its symbiotic link with the mass-circulation illustrated magazines. During the 1920s companies such as the Ullstein Press had been

43

43. *Children at a puppet show, Parc des Buttes Chaumont, Paris, 1932. A typical subject for Doisneau at this time.*

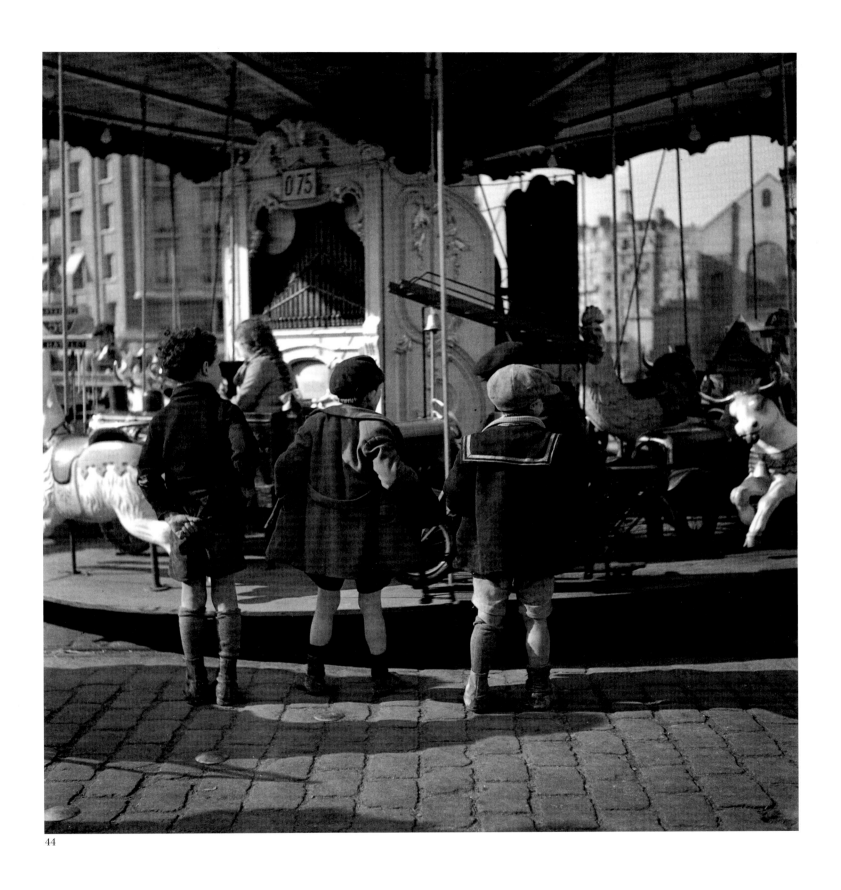

44

44. *Children at a merry-go-round, Paris, Twentieth Arrondissement, 1933–34.*

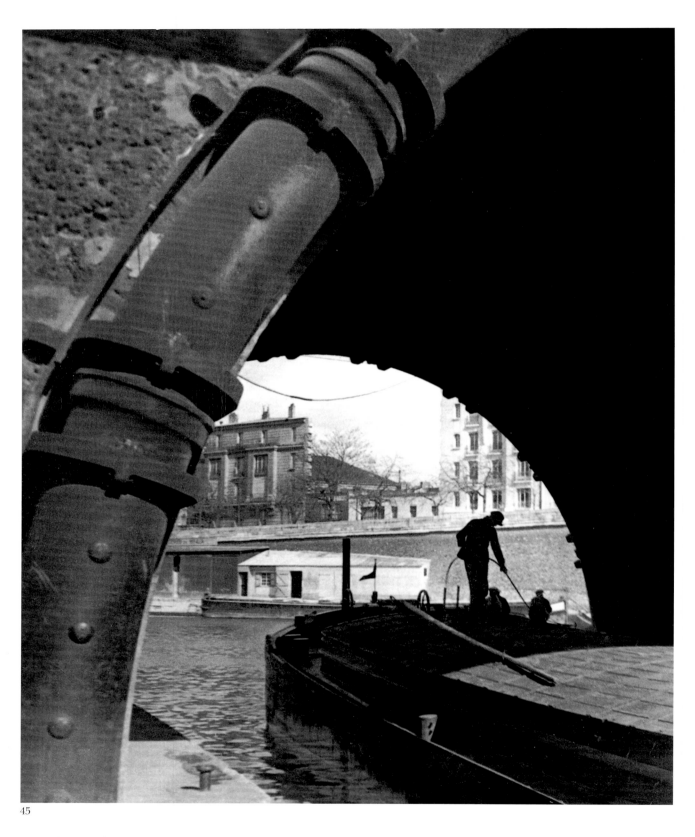

45

45. Péniche sous les ponts (Bridge and Barge), *quai de Seine, Paris, Thirteenth Arrondissement, 1932–33.*

46. *Page 43:* L'Accordéoniste du Kremlin Bicetre, *Paris, 1932. One of the earliest photographs made by Doisneau with his newly purchased Rolleiflex camera. As is typical of his photographs at this time, adults are presented from the back or in the middle distance, a function of his timidity in approaching them directly to make a photograph.*

successful in producing magazines that combined popular appeal with the dynamic and innovative use of photographs. One of these, the *Berliner illustrierte Zeitung* (*BIZ*), regularly sold two million copies in its heyday. The success of such magazines encouraged the press in France and other countries to develop mass-circulation illustrated magazines such as *Vu, Picture Post,* and *LIFE*—plus a host of now mainly forgotten imitators.

BIZ is generally credited with inventing both the "slice of life" photograph and the picture story with its sequence of interrelated images. Both were to influence the style of photography practiced by Robert Doisneau. "Slice of life" or "candid" photography drew its inspiration from the new ability of the photographer to make pictures where the subjects were unaware of or unconcerned about his or her presence, but came to characterize a wider aesthetic, evolving into what has since come to be known as "humanism." Early "candid" pictures of important political figures such as Hitler, Mussolini, Aristide Briand, and Lloyd George, made for *BIZ* by photographers such as Erich Salomon, Felix Man, Ti Gidal, Kurt Hubschmann (better known as Kurt Hutton when he worked for *Picture Post*), and Alfred Eisenstaedt showed that those who were in positions of great power or influence were really no more remarkable than anybody else.

Candid photography also opened up everyday life to the public gaze in a way that had not been possible before, for these photographers exploited new films and new cameras—the Ermanox, the Leica, the Rolleiflex—which meant that pictures could be made without tripods, as well as without flash or other artificial illumination, thus revealing the world in a relatively naturalistic way. They confirmed that everyone is an individual, and that the most mundane people can be capable of interesting and exotic things. The new cameras, because they could be hand held, also offered the possibility of finding angles of view that were altogether unexpected, thus encouraging the use of the new visual perspectives of modernism in the illustrated press. They rendered images that were more vivid and lifelike, encouraging the viewer to regard them as if he or she were a participant-observer.

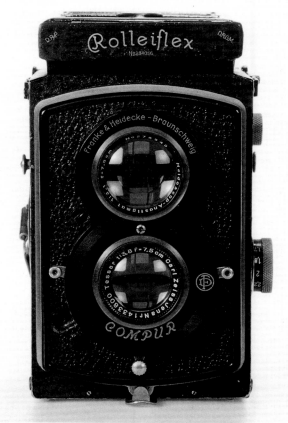

47. *Original model of Rolleiflex camera as used by Robert Doisneau in 1930–31.*

Hitherto, press photographers had been primarily concerned with providing documentary images of events—they were news reporters. Now a second, alternative role appeared: that of the photographer as illustrator. The French even developed a term to describe it: *photographe-illustrateur.* As Pierre Mac Orlan had argued, photography was now the illustrative medium par excellence.

Lucien Vogel's *Vu* magazine was an imitator of *BIZ* but soon developed a distinctive style of its own, heavily influenced by "new vision" photography . Published from 1928–1939 (although Vogel's ownership ceased in 1936), *Vu* was in its heyday the best produced of all the popular illustrated magazines of the 1930s. Before the 1914–18 war Vogel had directed the French fashion magazine *La Gazette du bon ton,* a luxurious review of contemporary arts and manners owned by Condé Nast, publishers of *Vogue.* Later, Vogel founded *Le jardin des modes,* but by 1928 Vogel had tired of fashion and set out to make a leftist, liberal magazine of high quality that would appeal to the common man.

His training in the visual arts led Vogel to design a magazine allying the populist editorial appeal of the German periodicals with the high design and photographic standards of *La Gazette du bon ton* and *Le jardin des modes.*

48

48. *Reflections in a gutter, Paris, Fourteenth Arrondissement, 1932–34. A photograph that perfectly captures Doisneau's fascination with the quality and unpredictability of light in the streets. He was tempted to take up photography because of his inability to capture such scenes through drawing or painting.*

49

Cassandre, arguably France's leading graphic designer of the 1920s, designed the magazine's logo, and it was printed in sepia neogravure to a very high standard. But it was in photography that *Vu* proved most innovative, for Vogel employed many of the émigré photographers who were bringing "new vision" photography to France; Kertész, Germaine Krull, and James Abbé were extensively featured in the first issues. Later, photographers such as Brassaï, Cartier-Bresson, and Robert Capa would be used. *Vu* treated photography with a new seriousness: many images published in the magazine were exhibited in galleries or reprinted in other prestigious publications. During its first year of publication 3,324 photographs had been used in *Vu.* No other magazine of the time even approached this figure.

As the 1930s progressed and the political situation in France deteriorated, Vogel took the magazine further toward the left. Alexander Liberman, then art director of *Vu,* employed politically inspired photomontage and collage techniques—pioneered in Soviet Russia by Rodchenko and El Lissitzky—to make some very striking covers and to illustrate articles on such themes as the emerging threat from Germany, and strikes and poverty in France. Through the use of modernist graphics and photography, *Vu* and certain of its imitators (such as *Regards,* funded by the CGT [Confédération Général du Travail]), established a connection between modernist-humanist photography and leftist politics. It may also be argued that the magazine made a significant contribution to the mounting desire for change in France, which reached its apogee in the Popular Front and strikes of 1936.

Vu had sales of 300,000 issues a week at its peak, but its influence on young French photographers such as Doisneau was out of all proportion to its sales. Vogel also edited the *supplément photographique* of Charles Peignot's *Arts et métiers graphiques,* evidence of the close link between popular and more esoteric uses of the new photography. The sort of images widely employed in *Vu* reflected many of the ideas enunciated by writers such as Mac Orlan and certain of the Surrealists, such as André Breton and Louis Aragon, about the values of popular culture. For example, in an early edition of *Vu* (April 1928), Germaine Krull's photographs of fairs are used to illustrate an article on *fêtes foraines* (street festivals), a classic locus for the *fantastique social.*[8] Later, in 1932, Brassaï has a double spread of eight photographs of a scene that at first sight seems entirely banal, for they show a man who has collapsed in the street.[9] Seen through an apartment window, a crowd forms, an ambulance arrives, the body is taken away, the crowd disperses. In these eight images, Brassaï encapsulates the *fantastique social de la rue.* The street is ordinary—the view is one typically available to the modern city-dweller from his apartment window. The streets are wet, and the angle of view of the frame is slightly tilted, so that the composition is interesting. This is more than a document, it is an interpretation of the alienation inherent in modern urban life, which supplies a wider meaning for a scene then increasingly common in Paris, where the poor and indigent were to be seen on the streets as economic depression deepened.

In many of the photographs by Kertész, Krull, Brassaï, and by the younger French photographers, such as Jean Moral, Pierre Boucher, René Zuber, Cartier-Bresson, Pierre Jahan, and René-Jacques,[10] there is clear evidence of an increasing fascination with the life of the street. These images reflect an emergent idea of modernism—the city visualized as a vast organism pulsating

49. *Street football game, rue Auguste Comte, Paris, Sixth Arrondissement, 1932.*

50. *Anglers on quai de Seine, near Pont-Mirabeau, Paris, Fifteenth Arrondissement, 1932.*

50

51. Deux Femmes sur un diable (Two Women on a Market-Porter's handcart), *near St. Eustache church, Les Halles market, Paris, Fourth Arrondissement, 1932.*

with the lives of its inhabitants. In part, the semi-marginal existence of certain of the émigré photographers (and their young French counterparts) led them directly to this new subject matter. Many lived in hotel rooms, without the capital or regular income necessary for permanent lodgings. (A marvelous 1931 self-portrait by Brassaï shows him by his improvised darkroom in his room at the Hôtel des Terrasses, rue de la Glacière, sheets pinned up over the window to black it out.) They could not afford studios and darkrooms and therefore the street served as backdrop, while their bathrooms were used for developing and printing, or they borrowed such facilities from friends. Willy Ronis, for example, whose father ran a commercial photography studio in the Eleventh Arrondissement, met Brassaï, Chim,[11] and Robert Capa in the 1930s when they came to use the darkroom and photofinishing equipment. Their photography, concerned above all with the street and the life coursing through it—fairs, cafés, markets, street-vendors, sideshows, traffic, *clochards* (vagrants)—was built around an aesthetic and a mode of working that grasped the immediacy of the city and translated it into strong images that attracted the attention of a magazine-reading public.

Doisneau was increasingly drawn to this type of photography, although in his case the route to it took a slightly different path. His fascination with such an approach was intimately connected with a developing sense of *désobeissance*—the desire to break with convention, to make images that had an even closer connection with everyday reality.

◆

Robert Doisneau's decisive move into photography as a profession began against the backdrop of the modernist trends outlined above. In 1931 came the confirmation of his new role, and a turning point in Doisneau's life: he went to work as an *opérateur* (assistant) to André Vigneau (1892–1968).

> One day I saw Lucien Chauffard, the guy who'd taught me the rudiments of photography [at the Atelier Ullmann], and he said, "Vigneau is looking for an *opérateur*—why not try him? I had already heard a bit about him. I thought I was completely useless for this role. I took some of my photos—pictures taken in the street, at the *marché aux puces* (flea market), et cetera—and Vigneau was kind. He looked at the pictures and said, "OK: it's November first—could you start on the first of December?"

Vigneau had made his name as a painter, designer, and sculptor, and was highly successful as a maker of fashion mannequins: Man Ray, Hoynighen-Huene, and Paul Outerbridge photographed those he created for Siégel at the Exposition des Arts Décoratifs in 1925, and they became symbols of modern elegance. He ran an advertising photography studio for the Lecram Press from 1930 until late 1932, and at the time Doisneau was working with him was engaged in establishing his own studio—Caméra—to specialize in photography, film, and cartoon production.

Vigneau's establishment at 22, rue Monsieur le Prince in the Sixth Arrondissement was a meeting place for many figures from the visual and literary arts. The nineteen-year-old Doisneau would often meet people such as Georges

52

53

52. Marché aux oiseaux (Caged-Bird Market), *Châtelet, Paris, 1932. This photograph was part of Doisneau's second published reportage, in* Excelsior.

53. Marché aux puces (Flea Market), *St. Ouen, Paris, 1932. Doisneau's first published reportage, for* Excelsior.

"The proprietor of Excelsior, M. de Wendel, was watching a session with the pretty models in their dresses that Vigneau was photographing for the supplement Modes. Vigneau said to him, 'Here's my assistant. Doisneau, show us what you did last Sunday.' De Wendel looked at them and said, 'That's very interesting. How many have you got?' A dozen, perhaps more. 'Good. That'll make a page.' It was my first publication."

54

56

54. Marché aux oiseaux, *Châtelet, Paris, 1932.*

55. *Page from* Excelsior *newspaper, Doisneau's first reportage.* Excelsior, *September 25, 1932, p. 5.*

56. Marché aux puces, *St. Ouen, Paris, 1932. A variant of the photograph used in* Excelsior, *and described as "an old artisan—virtually a painter—looking for a picture frame." In nearly all these photographs, adults are shown in profile or from the back: Doisneau had not yet conquered his timidity.*

LE MARCHÉ AUX PUCES

DES CROQUENOTS DE CHOIX, C'EST DU COUSU MAIN, DU SOLIDE !

LE "CHIFFORTIN", UN BÉBÉ QUI TAPE, SIMPLEMENT, DANS LE TAS...

LA MÉNAGÈRE ÉCONOME A L'AFFUT DE L' "OCCASE RARE "

CE VIEIL ARTISAN - PRESQUE ARTISTE - EST EN QUÊTE D'UN CADRE PATINÉ

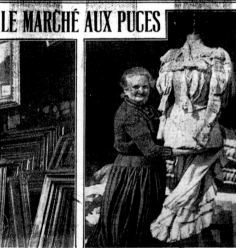

CHEZ LA MARCHANDE A LA TOILETTE, LA ROBE "CHIC" POUR CÉRÉMONIE, MODÈLE 1900

DES PIÈCES "UNIQUES", DES CHAPSKAS A GALONS, DES CASQUES A CRINIÈRE...

LE VIEUX VENDEUR, DÉSABUSÉ, RÉFUGIÉ DANS "SON" FEUILLETON

DES ACHETEURS DÉFIANTS A QUI ON NE SAURAIT LA FAIRE

Au delà de la porte de Clignancourt, rue Paul-Bert, rue Jules-Vallès, avenue Michelet, avenue de la Porte-de-Clignancourt et dans les petites rues adjacentes, le célèbre Marché aux Puces s'étend un peu plus chaque année.

Ce ne sont qu'éventaires en plein vent se touchant des deux côtés, tout au long des trottoirs, sur trois kilomètres au moins. Les samedi, dimanche et lundi de chaque semaine, c'est le plus invraisemblable déballage de « décrochez-moi ça » qui puisse se concevoir, dans une atmosphère de liesse populaire, chargée du relent de fritures débitées à foison dans les guin-

guettes avoisinantes. Des objets fantastiques — dont on ignore quelquefois le nom et l'usage — se rencontrent, là, sur le bord du trottoir.

Il y a de tout : des icones ébréchées et de poussiéreuses idoles nègres, d'inutilisables yo-yos — déjà ! — et des cro-quenots pour pieds-bots — des chambres à air moisies et des pièces démonétisées — la glorieuse pouillerie, semble-t-il, de tous les pays et de tous les siècles.

Et parmi tout cela, une foule grouillante et bariolée aux visages ingénus, aux visages de proie...

L'AMATEUR ÉCLAIRÉ PLONGEANT DANS LE FLEUVE DES LIVRES

55

Simenon, then coming to prominence as a novelist, the Prévert brothers, Man Ray, the modernist architect Szivashi, the writer Louis Cheronnet, the painter Raoul Dufy, and the musician Cliquet Pleyel. Sometimes he would come to work in the morning to find the studio filled with Vigneau and his friends, arguing among themselves and challenging the established values and attitudes of his petit-bourgeois world. It was music to Doisneau's ears: "They expressed loud and clear what I hadn't dared say to my teachers." The life of Vigneau's studio was part of a world far removed from the suffocating climate at home in Gentilly:

> There was a Picasso engraving on the wall, a camera and special animation table, and on the loggia of the first floor a life-size statue by Vigneau of a golfer. It was all very functional and futurist. On my first day I arrived all apprehensive, in my gray work-coat and with my retouching equipment under my arm. I climbed the stairs at rue Monsieur le Prince and knocked on the door. After some time I was let in by Mme Vigneau.[12] I said "I'm the new *opérateur*." I went into the darkroom to find out where everything was, check out the developing tanks, and so forth. There was a door at the end of the darkroom, and I thought I'd better check what's in this cupboard, so I opened it and who should I find but Vigneau, completely nude under the shower! Very calmly and continuing to soap himself, he said, "Now you will be able to say that you know me very well." It was a sign of my destiny.

Vigneau's photography was as modernist as his decor, and his approach was as much influenced by the ideas of the Hungarian and German photographers as by the Surrealists. In one fell swoop, Doisneau was introduced to a visual universe in which all of the new techniques, principles, and approaches of modernism were part of *l'air du temps* that he breathed.

Robert's family was not entirely pleased with his new profession. His aunt Zoë continued to introduce him as "my nephew the engraver" for many years rather than admit that a person with the vulgar occupation of photographer was part of her family. When Robert took his job with Vigneau, Gaston Doisneau was so concerned about his son's future that he went to see his new employer. "He saw this rather serious, bearded gentleman. He asked, 'How much are you going to pay him?' And he concluded that Vigneau was dependable [*sérieux*]. He was rather reassured by that. But Vigneau wasn't at all dependable! My father had absolutely no idea!"

Up until the time that he entered Vigneau's employ, Doisneau continued to nourish the hope that he might become an artist or painter. If he had met, say, Fernand Léger at the same age he might easily have ended up "painting imitation Légers." Although it is not easy to detect the influence of Vigneau's work in Doisneau's pictures made around this time, it was a formative experience:

> For the first time I heard people talking about Surrealism, about Le Corbusier's "living machines," about Moholy-Nagy, about the Siégel mannequins, about Soviet films and the first novel of someone called Céline. It's hard to imagine nowadays what an exciting mix of ideas this was.[13]

57

58

59

57. Cover of Brassaï, Paris de nuit, *1933, a highly influential publication for modernist "new vision" photography.*

58. André Vigneau, for whom Doisneau worked as assistant, 1931–33.

59. André Vigneau, La Route mouillé *(The Slick Road), 1929–30. Advertising photograph for Dunlop.*

60. Page 51: Les Petits Enfants au lait *(Two Children Going for Milk), Gentilly, 1932.*

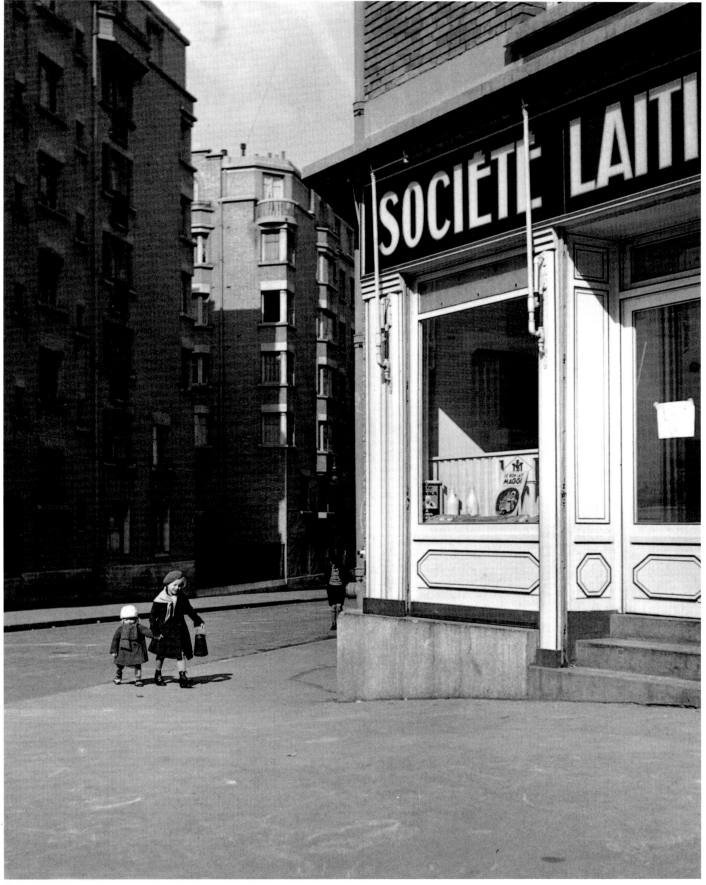

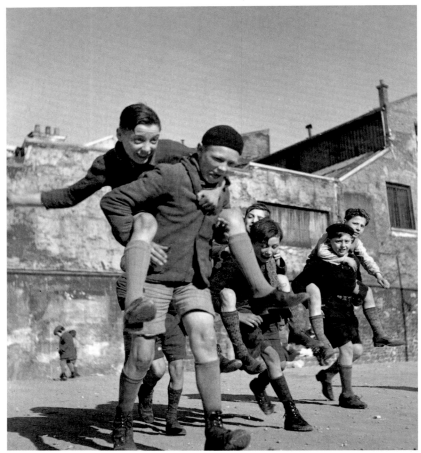

61

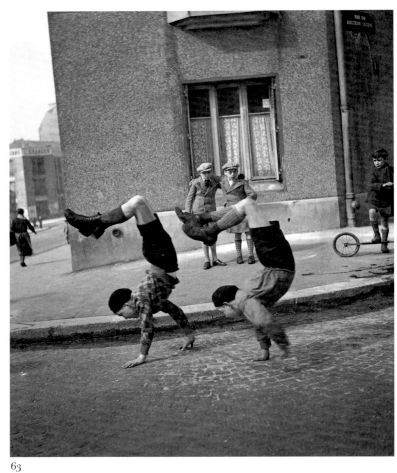

63

61. *Boys playing, Ménilmontant, Paris, Twentieth Arrondissement, 1935.*

62. *Line of children waiting to enter the Ecole Municipal, Gentilly, 1931–32. Part of a reportage for the municipality of Gentilly, made with a borrowed Rolleiflex camera.*

63. Les Deux Frères (The Two Brothers), *Avenue du Docteur Lécène, Paris, Thirteenth Arrondissement, 1934.*

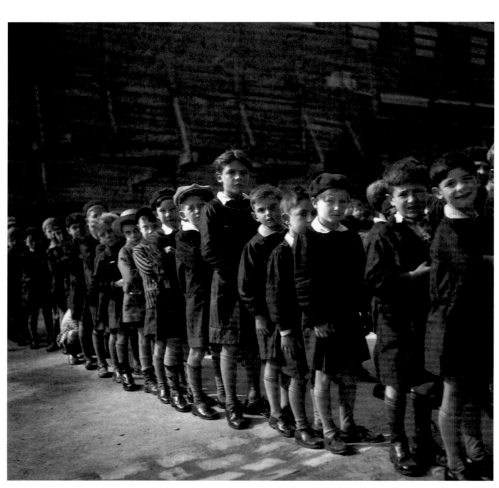

62

64

64. Les Jeux de la rue (Street Games), *Ménilmon-tant, Paris, Twentieth Arrondissement, 1935.*

65

Vigneau encouraged Doisneau to bring in his own photographs and to discuss the new work appearing in magazines and in books. One publication that made a great impression on Doisneau, as it did on the modernist milieu generally, was Brassaï's *Paris de nuit* (see pl. 57), published with an introduction by Paul Morand in 1933 to great critical acclaim. Doisneau tried to make some similar pictures (see pl. 34). Brassaï had given some indications as to the technical aspects of night photography in an article in a magazine. However, he did not provide the critically important information regarding specific exposure times, only stating that they should be "as long as it takes to smoke a Gauloise, or if it is particularly dark, as long as it takes to smoke a Boyard."[14]

By this point, Robert had acquired a distaste for the style of postcard photography common at the time. Influenced by pictorialism, the sky was always dark, the clouds were always fluffy "cauliflowers,"[15] the trees replete with leaves, the whole beautifully composed but emotionally dead. In contrast, one of Vigneau's pictures, *La Route mouillé* (pl. 59), used in a Dunlop advertising campaign in 1932, made a lasting impression on Doisneau. Here was the "new" photography—an impression, a feeling, a subjective reaction of the person viewing the scene, and all translated via the apparently scientific and mechanical process of photography into something that others could see and feel. For Robert, Vigneau's picture "was a sort of photographic *désobéissance.*"

In addition to responding to Vigneau's vision, Robert learned much from him of a technical nature. He began to acquire his consummate mastery of the use of artificial light by observing how Vigneau used the spotlights and floodlights in the studio, together with reflectors and diffusers, to "caress the form":

> I drank in like a vampire all I could to understand the characteristics of different light sources in order to create harmonies between the subjects that chance wanted to send me, without making stupid mistakes. As a result of watching him, I learned some elementary principles that have stood the test of time.
>
> Let's begin with diffuse light, which comes in large amounts. It's like rosé wine that they say goes with everything. It's often true that thanks to this smooth ambience shapes fill out to become a delight to the eye. By contrast, the sharp beam of a spotlight placed far away is good for picking out the finest detail. Methodical, like a detective in a crime novel, it is not really aggressive. And when it brings a lot of attention to detailing the surface of things, it can be wonderful.
>
> Finally, there is the light placed behind the object, which simplifies shapes and silhouettes, leaving within their outlines a welcoming shadow, giving everyone the freedom to bring their own dreams to it.[16]

By now Robert was making photographs in his spare time around Gentilly and in Paris. Inspiration from Vigneau combined with his continuing desire to *inscrire les décors* eventually drove Robert to become a little bolder with people, but to begin with many of his subjects were children, at play in the streets or in the *zone.* The famous picture that he later titled *Les petits Enfants au lait,* two tiny children going for milk (pl. 60), can be read as an illustration of his frustrations with the banlieue as an environment, the massive scale of the buildings contrasting starkly with the children's minute proportions.

65. La Poterne des Peupliers, *Paris, Fourteenth Arrondissement, 1934.*

66. *Montage: street-person and luxury car, 1932–33.*

66

67

67. Les Jeux de la rue (Street Games), *Ménilmontant, Paris, Twentieth Arrondissement, 1935.*

Robert spent much of his spare time from 1931–33 walking around the banlieue and some of the *quartiers populaires* of Paris with his Rolleiflex. Some of these promenades were close to home, around the Portes d'Italie, d'Orléans, de Gentilly, and to Kremlin-Bicêtre. But from there he went farther into Paris, up toward the Latin Quarter and the Luxembourg Garden. There were trips across the Seine into the area around the Tuileries; to Ménilmontant and Belleville up on the northeast of Paris; to the *marché aux puces* (flea market) at St. Ouen, and the *marché aux oiseaux* (caged-bird market) at Châtelet. He also wandered westward toward the vast Renault factory at Boulogne-Billancourt to take photographs of men being taken on and later at their *casse-croute* (workbreak). But the itineraries of Doisneau's promenades in the 1930s are not simply random; they also evince his personal response to the salient themes of popular culture of the early 1930s, his attempt to capture the texture of everyday life at the margins of Paris, that life bemoaned in popular songs of the 1930s such as those of Edith Piaf or Fréhel, with titles like "Ou sont-ils donc?" ("Where are They Now?") and "Entre Saint-Ouen et Clignancourt."

Contemporary sentiments of nostalgia for the *zone* lie behind the series of photographs Doisneau made at the St. Ouen flea market. These were his first publications, appearing in the newspaper *Excelsior* in 1932 (pls. 53, 55).

Later the same year, Doisneau sold more photographs to *Excelsior*—this time a series on the caged-bird market at Châtelet (pls. 52, 54). But the experience was not to be repeated, for *Excelsior* ceased to be a client of Vigneau at about this time, and the studio was increasingly affected by the mounting economic crisis in France. The signs of impending doom were all too evident to Robert, adding to the sense of disenchantment he already felt, for although the studio had never been exclusively concerned with photography, Vigneau's interests had increasingly been turning toward other media. In 1932 he set up a company called Caméra-Films to make animated films and documentaries. As Doisneau recounted:

> He tried to develop a hand-colored animated film, based on a scenario by Jacques Prévert, *Baladar*. All his energy went into this and documentaries. He did photography on the side, only because it allowed him to make ends meet.

Baladar was a disaster. Vigneau expended much of his wealth on the project, but no distributor or producer could be found. To make matters worse, Vigneau and his wife parted, shortly before Doisneau left the studio to begin his military service in the spring of 1933, in the First Regiment of the *chasseurs à pied* (infantry), stationed in the Vosges mountains of eastern France. "I was bored to death by the army," he recalled. He detested military music, military cuisine, and military justice. They were a powerful goad to the antiauthoritarian, anarchic streak in his character.

After a painful year of military service, he returned to Vigneau. But the work had changed and was now concerned with book and documentary film projects. There was no place for him in the studio.

◆

Cinema was an important influence on Doisneau's photography. His period at Vigneau's studio had provided further reinforcement, initiating him into the

68

68. *Hélène Boucher, aviatrix, 1934. One of Doisneau's first photographs for Renault. She had just set a world speed record (620 miles at 253.7 mph). Boucher was tragically killed in an airplane crash later the same year.*

69. *Coupe Deutsch air-race, Etampes, double exposure, 1934. The early Rolleiflex cameras had separate shutter-cocking and film-advance levers. Effects like this could be readily produced by accident.*

70. *Marcel Riffard and Caudron-Renault airplane, Coupe Deutsch, Etampes, 1934. When he left Renault in July 1939, Doisneau carried out some freelance photography for Louis Caudron's company.*

71. *Left to right: Maurice Arnoux, Marcel Riffard, Louis Caudron, Coupe Deutsch, Etampes, 1934.*

69

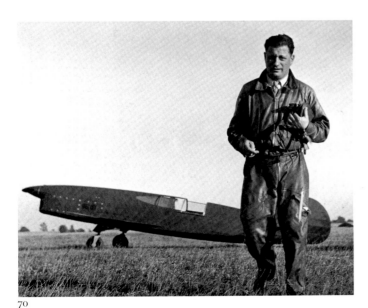

70

71

new and radical filmmaking coming out of Soviet Russia. Eisenstein was greatly interested in "new vision" photography, and used its ideas and viewpoints in such classics as *Battleship Potemkin*. Viewing such films contributed to the sharpening of Robert's vision, finding a counterpart in the composition and symbolism of his photographs. It confirmed to Doisneau that his own approach, modernist and social-realist, was the path to follow. It was a route that French cinema was also to develop through the 1930s, in the hands of Jean Renoir, Jean Vigo, and Marcel Carné (one of the instigators of the Salon Indépendant de la Photographie in 1928).

The economic situation in France had by now become a crisis. There were 13,000 people out of work in 1930, but some 345,000 by 1934, and these figures seriously understated the real level of unemployment. It was with a sense of relief that in early April 1934, Robert received a call from the providential Lucien Chauffard:

My dear Robert—have you found a job?
No, I don't know what to do.
Then come and work with me at Renault. I'm head of the photographic department.

Robert was taken on. In fact the department did not yet exist; there was only the old technical photography section, which had no studios or darkrooms. He started his new job on April 12, 1934, as a salaried employee, closer in status to the clerks and technicians of the company than to the manual workers of the factory. At first there was nothing to do, so he spent the first couple of months in the mailroom, hiding behind a pile of paper while he read books or chatted with the young female employees.

Fortunately Robert had his Rolleiflex, and he was asked to use it to record the participation of Renault's aircraft company, Caudron, in a famous air-race: the Coupe Deutsch. It was an exciting project for Robert. It involved a trip out to the airfield at Etampes, where he was to take photographs for press and public relations use. But there was a more sinister side to the commission: he was also told to photograph the other competitors in the air-race, and was given particular directions about getting shots of their technical features. It was a sort of industrial espionage.[17]

The Renault factory at Boulogne-Billancourt in 1934 was Europe's largest industrial plant. Louis Renault loved to say that it was larger than the city of Chartres—a claim used widely in the firm's advertising (see pl. 77). There were 30,000 employees in the 165-acre site, which was to expand to over 200 acres before the end of the decade. The disciplinary regime in the factory was severe. Louis Renault was an industrialist in the manner of Henry Ford or John D. Rockefeller: a self-made man who built an industrial empire around him, which he ruled with almost tyrannical authority. Like Ford, Renault believed that to be successful you had to control every aspect of the production process and to rule the factory with an iron hand. He hated all bureaucracy: in his opinion a desk and a chair were a temptation to be lazy, to have a nap after lunch, or a chat. The slightest hint of comfort would tempt the staff to have a rest, to read the paper or smoke instead of working. Robert recalled a foreman in the pressing plant who had such an

72

72. *Man launching model aircraft, airshow at Polygone de Vincennes, Paris, 1936.*

73. *Man Launching Model Glider, airshow at Polygone de Vincennes, Paris, 1936.*

73

74

74. L'aéroplane de Papa, *Choisy-le-Roi, 1934.*

acute sense of responsibility that "he would never take the train to work, preferring to travel the thirteen miles each day from his home on his own little motorcycle, to which he had fitted crude pedals, so that if the engine failed he'd be able to pedal like a lunatic and get there on time." Robert's attitudes to authority were molded in this setting and remained with him to the end of his life: "Renault—for me it was the true beginning of my career as a photographer and the end of my youth."

◆

Other influences outside of work at Renault were also pushing Doisneau toward adulthood. On holiday in the Doisneau family village of Raizeux in the late 1920s he had met a lively and attractive girl named Pierrette Chaumaison. They bicycled everywhere together: Robert photographed Pierrette. This continued for a number of years, and as time went by it became an ever more natural assumption that they would eventually marry. Robert remembered a seaside holiday in Normandy in 1930 or 1931 marked by two experiences: intense feelings of boredom with his father and stepmother, and long hours spent writing love letters to Pierrette in a little bistro that he used as a poste restante to receive her replies, since his parents did not know that they were writing to each other. "We were so young. I wrote a lot and I was so bored, the beach was a real purgatory for me. The days were so long."

Pierrette Chaumaison lived at Choisy-le-Roi, in the southern banlieue, perhaps a half-hour's tramride southeast of Gentilly. Robert's dark wavy hair and winning smile appealed to her. Pierrette came from a Protestant family, and one of her sisters would marry another photographer, Marc Foucault.[18] Many of the photographs Doisneau made during his Sunday outings are of places he and Pierrette visited together—the parks of Paris, the banks of the Marne, the quays of the Seine, local events in the banlieue. He made some snapshots at the *fête des gondoles* (parade of floats) at Choisy held in the summer of 1934: Yvonne, one of Pierrette's two sisters-in-law, had been chosen as the queen, and was paraded through the streets on the back of a lorry decorated for the occasion. It was during this festival that Robert made one of his most telling portraits of the *banlieusard*, now known as *L'Aéroplane de Papa* (see pl. 74). Robert said of the photograph that he was attracted to the man with his child in the airplane because of his growing fascination with *"l'absurde quotidien"* (the absurdity of everyday life), in this instance a man who had, like so many others in the banlieue, labored for hours in his spare time to construct this fantasy of an airplane. Robert followed him and the procession around the streets of Choisy, concentrating on a number of themes—the children gathered around or holding on to the *gondoles,* the musicians on trucks, the marching band, and Papa with his son and his airplane. The circular darkening (vignetting) on several of these photographs, as on many others from the same era, came about because Doisneau had limited resources: "It was because I didn't have enough money to buy a lens-hood, so I'd made one out of an aspirin container. It vignetted completely on the edges, didn't it? I used it for a long time. I had very poor equipment, which I mostly made myself."

For his personal or private photography there was no question of using Renault's darkrooms, and Robert had to make do as best he could at home. He

75

76

75. *Pierrette Chaumaison and Robert Doisneau on their wedding day, November 28, 1934.*

76. *Pierrette Doisneau, double-exposure photograph with flames, 1937.*

77

77. *Aerial photograph of Renault factory, Boulogne-Billancourt, 1934–35.*

modified an old magic lantern as an enlarger, adding an electric light to it and placing the whole affair on a table. The windows of the kitchen or bathroom were blacked out, and the printing paper tacked to a board on the wall. To focus the enlarger, it was slid backward and forward. Perhaps this explains Doisneau's extraordinary ability to construct the image *sur place,* to find in the moment of clicking the shutter the ideal disposition of elements—light, figures, background—that make the photograph. For Doisneau, the photograph either works or it does not: no printing technique or subsequent manipulation of the image will bring it from the realm of the unsuccessful to the successful. This does not mean that he avoided "playing" with the image, however, for throughout his photographic career he made collages, photomontages, or simply degraded the image and distorted it to obtain special effects that he wanted to use to a particular aesthetic end.

78

◆

Robert and Pierrette were married on November 28, 1934, when Robert was twenty-two. After a short honeymoon in Olivet in the Loiret, they made their first home in a newly built apartment building in rue Telle de La Potérie in Issy-les-Moulineaux. The small apartment was not far from the Renault factory where Robert reported each morning: "I had a real problem with getting up. I didn't really like the work. . . . I took the bus to get home quickly so I could have lunch at home, to spend half-an-hour with my wife. One day I got back, she was still sleeping, that was great! The apartment was completely silent, she didn't move—and I'd already spent half a day at work! We laughed so much about it."

While he was processing film and plates in the darkrooms at the factory, Robert would read the works of Jean Giono. (His friends Jacques and Nicole Chaboureau, whom he'd met at Renault, recalled that "we were all 'Gionistes' then.") Inspired by the romanticism of Giono's vision of a Provençal idyll, Robert said to his wife, "Why don't we pack a few things and rush off down to Manosque. We can sleep out of doors and join the people trying to make a new life with Giono." Pierrette, who shared Robert's love of Giono's romanticism but had her practical side, replied, "Yes, that sounds wonderful, but let's get the apartment sorted out first."

The apartment was comfortable and convenient, and Robert could have stayed there all his life but for a chance encounter in 1936. He came across a painter who wanted his paintings photographed. One Sunday Robert went to his studio, in place Jules Ferry, Montrouge, by the main road to Orléans. The buildings there, next to a little park and not far from the marketplace, had been recently constructed as studio-apartments for artists, architects, etc. Later, the painter Fernand Léger would live in one of them; the whole area had a somewhat bohemian air:

> I thought that was great, these studios with their balconies. This is where I want to live! I found the concierge, I said to him "Do you think I could get an apartment?" "Of course, they are always vacant, people are regularly leaving." In great excitement I wrote to the owner of my apartment at Issy-les-Moulineaux, to give notice. I came back to Montrouge only for the concierge to say, "Oh no, there's nothing available at the moment." It was terrible.

78. *Doisneau at work in the studio at Renault, mid-1930s.*

79. Dejeuner sur l'herbe, *1934. Advertising photograph for Renault (à la Manet), made on thirteen-by-eighteen-centimeter large-format camera. The models are all Renault employees or their families. On the left foreground, back to camera, is Lucien Chauffard, who was instrumental in advancing Doisneau's career during the 1930s.*

80. *Pages 64–65: Industrial photograph of presses in the Renault factory, Boulogne-Billancourt, made on eighteen-by-twenty-four-centimeter large format camera, 1936. "The equipment, property of Renault, was heavy and cumbersome: a wooden camera, a 'Union' cast-iron tripod, three or four brass lenses, a dozen plate holders, each with two heavy glass plates, magnesium powder, a spotlight, and about thirty yards of electric cable. More than twenty kilos in all, to be dragged around the different parts of the factory. There was no such thing as a shutter . . . you used a Basque beret. You held the beret in front of the lens with your left hand, opened the plateholder, focused under the black cloth, held the magnesium flare in your other hand, took away the beret more or less in time with the flash, and there you were . . . in a great bonfire of flash."*

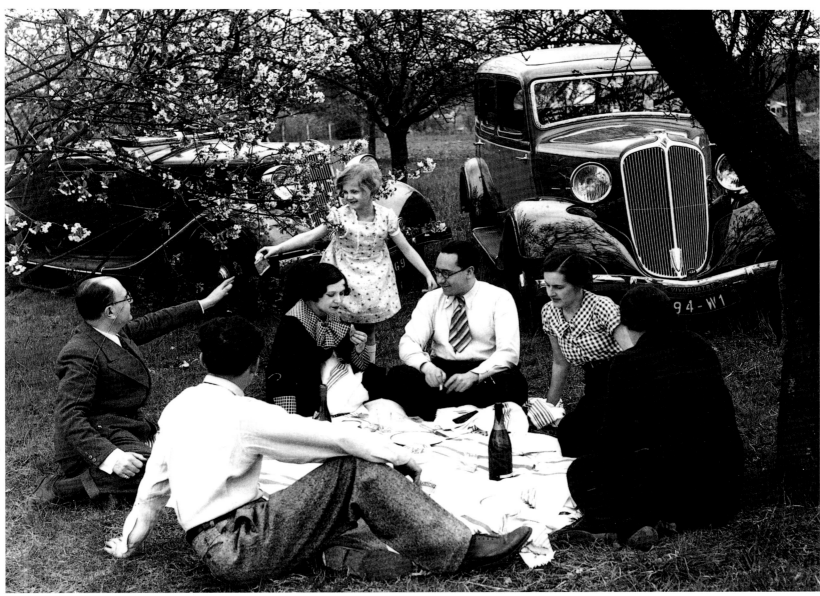

79

81

81. La Cantine Renault (Factory Cafeteria), *Boulogne-Billancourt, 1951. A photograph made post-war for a book on Renault, by then a nationalized firm.*

82

84

82. *Assembly-line worker, Renault factory, 1937.*

83. *Renault factory, Boulogne-Billancourt, 1938–39.*

84. *Renault workers on their break, Boulogne-Billancourt, 1934.*

83

The apartment at Issy had now been rented to another tenant, and the young couple had to put their furniture in storage with friends and look for somewhere else to live. Doisneau looked everywhere, finally locating a small apartment on the first floor of a run-down building in rue François Mouthon, near rue Lecourbe:

> It was really dark, with bugs . . . three months later Pierrette fell ill. I had to send her to the country to stay with the family of a friend in the Beauce. Not much fun . . .

After nine months of this, with constant visits to Montrouge to see if there was an apartment free, Doisneau discovered that a family of Austrians was just about to move out of an apartment on the first floor of a building just next to that for which the concierge had provided such misleading information. The Doisneaus moved in during 1937, to a small one-bedroom apartment that included a studio with a high ceiling. They were very happy to move there, staying a lifetime and eventually buying the apartment next door to increase their living and working space.

◆

The work that Robert carried out at Renault gave him a solid grounding in photography, for it involved lugging around a heavy eighteen-by-twenty-four-centimeter plate camera. He took many photographs of the interior of the factory, which tell us much about the life at Billancourt. The experience of working closely with such people began to break down Robert's natural shyness. He felt an increasing affinity with the workers in the foundries and on the assembly lines, despite the fact that his working conditions and his contract of employment were different, as a salaried employee with the right to paid holidays. In addition he had the regular tasks of photographing parts for catalogues and providing illustrations for sales brochures and press advertising (pls. 87–88). At Renault all photography for any purpose had to be carried out with the resources of the factory, so instead of using professional models for the brochures, Robert and his colleagues had to select people from the offices and factory to be their extras (see pls. 79, 89).

The advent of a left-wing Popular Front government, led by Léon Blum in May–June 1936, set off a wave of strikes and occupations in French factories. Workers believed that the new government would improve working conditions and hand over control of the means of production to the proletariat: it was not surprising, given Louis Renault's harsh disciplinary regime, that Renault was one of the first factories to be affected.

The occupation at Boulogne-Billancourt began on May 28, 1936. The strikers' demands included collective bargaining and regular worker representation—both of which were anathema to Louis Renault. The CGT (Confédération Général du Travail) union that was bargaining with the Renault management continued the occupation for three weeks. By all accounts, the occupation took place in a carnival atmosphere. Robert had initially seen the occupation as an excuse for some additional vacation time at his employer's expense. But just as he was about to set off on a canoe trip on the

85

85. Homme devant pointeuse—Usine Renault (Man at Time-Card Machine), *1937. This image contains an unconscious irony, for Doisneau was fired by Renault in July 1939 for repeatedly falsifying his time card.*

86

86. *Bridge over the Seine, Renault factory, Boulogne-Billancourt, 1951. After the war Doisneau returned briefly to photograph at Renault. In this case it was to provide photographs for a book on the nationalized car firm, a project that united a number of prominent French photographers (among them Nora Dumas, René-Jacques, Pierre Jahan, Roger Schall, René Zuber). It was published as L'Automobile de France.*

Marne, a CGT representative came to the apartment. Robert was persuaded to attend an important meeting at a cinema in Billancourt, where the strikers were presenting their demands to the rest of the workforce.

> I was ashamed to be so unaware of social events. I was so happy to take my canoe and go with my wife and a friend to paddle along the Marne. The union representative said, "You have no right to go off." It was true. It was a bit of a cold shower, but necessary all the same. He was older than me by a few years. He understood very clearly that we were going through an important period; he helped me discover a world where people gave up their free time to study the leaflets—*Wages, Prices, and Profits* by Marx for example—rather than take a trip on the Marne.
>
> I spent my life with people who got up early. So I understood their concerns. I knew their way of life, their generosity as well, for when these guys were generous they would give you everything!

Robert soon joined the CGT, whereas salaried employees were being encouraged to join the employers' union: "During a meeting we were being invited to play the role of the bosses' courtesans. I said 'No. I am in favor of the CGT.' It had an extraordinary effect!" The CGT is the union closest to the French Communist party and in the period shortly before the Popular Front in 1936 was the primary means by which the PCF (Parti Communiste Français) could organize workers who wanted a change in government. Membership in the CGT combined with his ever more apparent *désobéissance* probably ensured that Robert had little future at Renault. In any case, he grew increasingly restless. Every Sunday morning, he would go on a long walk with his camera. He began to conceive of another career—that of a photojournalist. His pictures of Paris, the banlieue and their inhabitants of this period (1934–39), indicate that he was constructing an archive that could be sold as illustrative material to the press. The thematic principles of negative numbering in use at Renault seem to have been taken over by Doisneau, who was then using a system based on initial letters to indicate subject matter (B for example is Paris, G work or industry). Unfortunately this system, which he finally abandoned in 1945 in favor of a simple numerical system, does not easily permit the reconstruction of dates from his early negatives (see Appendices: "Doisneau's Systems of Classification").

From 1937, Doisneau began to experiment with the Carbro colorprinting process. Late nights spent trying to perfect the process in the kitchen at Montrouge led to many late arrivals at the factory. The strikes were long over, and discipline was strict under the head of the advertising department. Here is the beginning of an office memo on discipline at Renault:

> I think it necessary to take the opportunity offered by the holiday period to remind everyone of certain operating standards for the department, which should be even more rigorously respected as the number present is reduced.
>
> 1. To begin with, PUNCTUALITY. I remind you that any absence without prior agreement may lead to serious consequences, and that agreement will only be given for pressing personal or family reasons.

87

87. *"Le Printemps est plus beau . . . avec une Renault" (Spring is finer . . . with a Renault), 1937. Large-format thirteen-by-eighteen-centimeter advertising photograph made at Parc de St. Cloud, Paris.*

88. Concours d'Elegance, *Renault Vivasport, Bois de Boulogne, Paris, 1937. It was "the highlight of the year for us. All at once you were let out of a world of slavery and into one of frivolity. Elegant women with their little dogs . . . accompanied by chauffeurs. All this was miles away from the sooty world of the forge. And yet the two places were not so far apart: the factory was only a few hundred yards away. . . ."*

88

89

89. *Advertising photograph, Renault, Boulogne-Billancourt, 1935–37.* "Casting was on the make-shift side, including friends, typists from the office, waitresses from the cafeteria. For a woman, being picked out from her friends in the office meant she had made her mark. In fact the main reason for the choice was that they were fairly slim, which meant we could put three on a seat!"

2. TIDINESS IN THE DEPARTMENT: all the equipment and other objects must be kept rigorously tidy: papers, photographs, pencils, paints, etc. In particular I ask the camera operators and persons working in the studio to keep all the equipment, tools, and products they use as neat as possible. Studio lights in particular should be put away every evening in their proper place. The big sheets of paper used as reflectors must be put away after use and not left hanging for several days like rags.

3. DISCIPLINE: The quality of work is always a function of the care given to its execution, in other words of the discipline and attitudes of those who carry it out. One can be sure that someone who has a slapdash attitude, hands in pockets, or who slouches, will not work as effectively as someone who wastes neither time nor energy.

The document goes on to remind employees of bans on smoking, and to advise them against chatting, singing, whistling, and even daydreaming, particularly "during the holiday period, in view of the reduced numbers of personnel present," and is signed "R. GIRAUD (Head of the Advertising Department, Automobiles Renault)."[19]

•

In early 1939 Robert went to see his friend Chauffard, who had left Renault two years earlier to found his own studio. Chauffard was working with the émigré Hungarian photographer Ergy Landau, who was successfully selling her photographs (principally of children) through an agency set up by another Hungarian, Charles Rado. Rado, who had been trained in the Ullstein publishing group as a picture editor before the advent of the Nazi regime, called his agency RAdo-PHoto, or RAPHO for short.[20] The agency distributed the work of other Hungarian photographers active in Paris, including Ylla, Nora Dumas, and Brassaï. The illustrated press was continuing to expand in France, creating a demand for illustrative photography. Since the early 1930s an increasing number of weekly and monthly magazines had appeared, each of which gave an important place to photographs in their layout and editorial policy. The most important were the Communist weekly *Regards,* launched in 1932, *Marianne* in 1933, and *Match,* which was launched with a record-breaking first issue of 1,400,000 copies in 1937. In addition Denoël published a regular series of photographic albums entitled *Documents,* in competition with Lucien Vogel's *Témoignages de nôtre temps,* running from 1934 to 1936.

Through Chauffard's good offices, Doisneau met Charles Rado sometime early in 1939. The meeting, however, did not turn out quite as Doisneau had hoped: "I confided in him that I was going to leave Renault. 'Oh that's awful. Don't do that—you've got a job, hang on to it!' That really came at a good time! I had been trying to get kicked out for five years." But fate was preparing its solution for Robert, who was finding it harder and harder to get to work on time. He had to clock in and had already received warnings about the consequences of arriving late. In May 1939 he began to systematically forge his time cards: he had found what he thought was a perfect method. But in mid-July he received a letter from his boss:

90

90. *Canoe holiday, Dordogne, 1939. Doisneau's first reportage for Charles Rado's agency, RAPHO. Pierrette Doisneau is in canoe at right.*

91. *Noëllie Pomarel, attendant at the Eyzies caves, Dordogne, 1939. It was she who first told Doisneau of the outbreak of the Second World War.*

91

92

92. Lavoir Municipal (Village Washtub), *Dor-dogne, 1937.*

My dear DOISNEAU

 We were surprised not to see you today, without having received any warning on your part.

 This is not the first time you have done this, without thinking it necessary to warn us other than by your late arrival.

 You should be perfectly well aware that the department in which you work cannot permit irregularities of this nature, and that it is indispensable that you let us know, in a definite manner, if you wish to leave the factory, or to work normally like everyone else.

Yours, etc. . . .

R. GIRAUD

Luckily, as a result of the employment legislation brought in by the Popular Front government of 1936–37, Doisneau was entitled to some severance pay, since he had worked for nearly five-and-a-half years for Renault. With the money Robert bought himself a new Rolleiflex Automat camera, a *"chambre en bois"* (wooden bellows-camera of thirteen-by-eighteen-centimeter format), a new upright Lorient enlarger to replace the converted magic lantern, a tripod, and three processing tanks. His dream had come true: he was now obliged to earn his living as a *photographe-illustrateur indépendant.*

◆

Robert contacted Charles Rado again, told him of his changed circumstances, and arranged his first commissions: first, a travel piece on a canoe trip down the Haute Dordogne River, which Robert and Pierrette were about to make with a group of friends; and, second, a series of pictures to be made of the prehistoric caves of Les Eyzies in the Dordogne (pl. 91).

 This vacation assignment was funded from what was left of his severance pay. But, sadly, there was a canoe accident. Pierrette was injured and a canoe smashed: the new Rolleiflex was thrown into the water. Although dismantled and dried out by Doisneau, the camera must have retained a small amount of moisture, for a number of the pictures made with it were slightly blurred. The party went on to the caves at Eyzies in late August:

> Every day I was the first to get up to fetch the milk. One morning I met the attendant of the caves, Noëllie Pomarel, stunned by what was in the newspaper: "My poor children, with these modern weapons, you will all soon be killed!" It was a catastrophe. She showed me the newspaper with the mobilization numbers on the front page. It was the war. Sadly, we packed up all our stuff, the tent, et cetera, and we left for Montrouge.

The war had come to shatter Doisneau's hopes, as it had for those of a whole generation.

THE WAR

1939-1944

"Two days later I went to the gare de Reuilly to take the train to the Eastern Front. I knew already that it was a sort of trick that would take my youth away from me. I was not mistaken."

ERMANY INVADED POLAND on September 1, 1939, and the French army was mobilized. Doisneau, his wife, and their entourage of fifteen friends had to return to Paris from their trip down the Haute Dordogne as quickly as possible.[1] France was in disarray, and on the left, in particular, there was chaos. The Nazi-Soviet pact signed on August 23, 1939, had led to the CGT parting company with the PCF, whose leaders refused to renounce Soviet policy. Worse still, in September 1939 the Parti Communiste Français was declared illegal, and its *députés* expelled from parliament four months later.

There was little enthusiasm for war among the French. The bloody conflict of 1914–18 had decimated the population of able-bodied men and contributed to the *société bloqué* (dead-end society) of the 1920s and 1930s: an aging population and a low reproductive rate, with most positions of power and authority in the hands of elderly men. While parties of the extreme right and extreme left were united in their recognition of the need to defend France, in both cases there was fundamental criticism of the conduct of the state in having allowed the situation to develop. For unlike in 1914 there had been little sense that *la Patrie* was in immediate danger: until the German offensive of May–June 1940, the French, with their allies, maintained the belief that their best strategy was to prepare for a defensive war, relying on the strength of the Maginot Line along the Franco-German frontier to protect them.

For the Doisneaus, it all happened so quickly:

I took Pierrette, her sister, and her mother to a little patch of the country in Normandy called Berchères-sur-Vègre, where they were lodging in a very uncomfortable house. It was really terrible to leave them in such a state. I was furious. Two days later I went to the gare de Reuilly to take the train to the Eastern Front. I knew already that it was a sort of trick that would take my youth away from me. I was not mistaken. I'd had to come back to Paris and then leave again to make war, and I didn't like the idea at all. I left to catch my train with a little cardboard suitcase, I was so disgusted. They had caught me, I was like a rat in a trap. I was ready to revolt. When I got to the metro, I said to the poor ticket clerk, "I'm not going to pay!" I was absolutely fuming, eh? "I'm not going to pay to go to war." The clerk began to cry, saying "My poor chap, my husband has had to go as well."

I got to the station, it was full of people crying, leaving each other. Not much fun, eh?[2] There was a guy there, very well informed about the latest shockwave bombs—"They drop it seven miles away, it blows up your lungs, there's no way out!" Ah, I said, thanks for the information.

This was one of the few periods in his life when Doisneau made no photographs. In his regiment, the Eighty-first Battalion of the *chasseurs à pied*, (infantry) soldiers were forbidden cameras, in case the pictures they might take were to fall into enemy hands and betray some military secret.

The weather toward the end of 1939 was severe. The Germans were forced to delay the blitzkrieg offensive against France planned for November. Doisneau's health, which had never been strong (he suffered from asthma as a child), began to deteriorate in the damp and cold Vosges forest where he was stationed. He fell ill, was evacuated to a military hospital, and was then given a brief leave:

93. *Page 75: Children at the plateau Beaubourg, Paris, Third Arrondissement, with "camouflaged" baby carriages in imitation of German tanks then retreating from Paris, August 1944.*

94

At the end of December I went to get my wife, and we came back to Montrouge for Christmas. I wanted to give her something. We didn't have a *sou* [penny], it was so sad. In the end I went into Montrouge and I got a little wool knit scarf for her, really nothing at all. And then I had to leave. My regiment had changed position, to northern Alsace. It was really cold there, around Gunstett, almost directly in front of the Maginot Line. To celebrate my return they had cooked two rabbits, but the saucepans were too small—the legs were still raw, while the bodies were burnt. The fine French army? We were done for . . .

This was the *drôle de guerre* (phoney war), the occasional probing attack or skirmish, designed to test the defenses of the enemy. It involved a good deal of aerial reconnaissance and occasional bombing of troop concentrations. The German armies were preparing for a lightning push through the heavily wooded Ardennes—the one spot where the Allies had judged the terrain impervious to attack. The French army waited in its defensive positions, complacent in the belief that with the British they had virtual parity in heavy weapons and aircraft.

His captain assigned Robert to observation duties: "Doisneau, I believe you have made aerial photographs?" Robert replied that he had, but only in civilian aircraft. Despite his unfamiliarity with military planes, he was ordered to go with two other soldiers to the top of the church tower at Gunstett to act as observers for the regiment. Few aircraft put in an appearance:

> One day I saw these planes—twin engine, V-shaped tails. I said to my mates "Potez!" [French bombers] and suddenly there were these things floating in the air, and with no hesitation I identified them as mail bags. Two or three minutes later we heard the bomb explosions! I'd made a mistake: they were Dorniers [German bombers]. Nobody was killed, but they made a real mess. We were scared stiff. It wasn't too glorious, my war.

He remained in Alsace with his regiment until the end of January 1940. His health deteriorated: "I caught a terrible cold, and was so sick of everything that I would have just let myself die." The military doctor decided there was a risk of tuberculosis and evacuated Robert to a military hospital. At the station where all the sick and wounded military personnel were concentrated before dispersal to the appropriate medical facility, Doisneau came across another young man, who from his appearance—heavily bandaged arms, a coat laid across his shoulders—had been badly wounded.

> He dropped his book, and I picked it up and put it in his pocket. It was a novel by Colette. I said, "Hey, that's a good book," and we sat down together on a bench in the snow. A train was standing in the station, its smoke went straight up in the freezing winter air. He said, "Look at that!" and I replied, "Well, that's pretty." He started to laugh: "You know the right word for any situation!" He wasn't at all like the others.

This new friend was Pierre Lorquet. They traveled by train together to Annonay, near Lyons. Robert asked him: "Your injuries. . . . Did you step on a

94. Robert Doisneau with his wife Pierrette and his brother-in-law Marc Foucault, after being temporarily discharged from the army following an illness, March or April 1940.

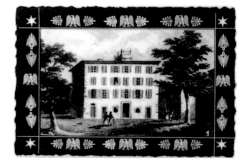

95

95. See page 79.

95. *On his return to Montrouge after a brief period in Poitou during the* Grande Débâcle *of 1940, Doisneau had to try to make a living. At one stage he was reduced to making cheap jewelry, but he was eventually able to get the agreement of the* Musée de l'Armée *at Les Invalides permitting him to make and sell sets of photographic postcards of the life of Napoleon. This set, though incomplete, is the only one remaining.*

mine?": "No," replied Pierre, "I've only been able to eat canned food and I developed an enormous boil!"

At the gare de Annonay, they said goodbye to each other, Lorquet taken by ambulance in one direction, Doisneau in the other. Yet only a few hours later they found themselves in adjoining beds at a seminary in Lyons that had been converted into a military hospital. They became fast friends, linked by a passion for literature. Lorquet was an aspiring writer; he would later draft a preface for a book of photographs that Doisneau put together shortly after the war.

In his depressed and malnourished state, being in a hospital was a godsend for Doisneau, and he began to recover:

> It was nice and warm there. Young bourgeois girls from Lyons gave us board games. I stayed over a week, and then the doctor—named Florence—came to see me: "Ah, you're getting better. In eight to ten days you'll be able to go back to your unit." I stopped eating—it wasn't hard—and Lorquet managed to get himself operated on for a bogus appendicitis. They decided I had a "dangerous weight-loss"—in other words I might be getting tuberculosis. If you caught it in the army, you might get a pension. They would prefer you went home before it was diagnosed, so they didn't have to pay! Florence was a nice guy and suggested I be given a medical leave. That wasn't a bad idea. I was given temporary sick leave for three months, and I came back to Paris. I had gotten very weak. My wife came back from Berchères-sur-Vègre. Now the thing was to survive . . . we had almost nothing to live on.

Robert did not have tuberculosis, but his lungs had always been weak, and his physical condition had not been improved by the cold and army food. Money was very short. The Doisneaus' savings were minimal, and his pay as a private in the army had been only 1.20 francs a day, not enough even to feed a couple. In any case, as soon as he was given sick leave in February 1940, the army pay ceased. Like it or not, he had to live from his work as a freelance photographer, yet magazine and book illustration work was virtually nonexistent.

In the hospital at Lyons, Robert had been cheered one day to receive a package from Charles Rado: inside it he found a Swedish camping and canoeing magazine illustrated with the photographs from his first freelance assignment of August 1939. It was a small victory, but any chances of building on his relationship with RAPHO were dashed as the war dragged on into 1940 and magazines and newspapers closed down. The agency had to close when Charles Rado bravely volunteered in 1940 for military service in the Foreign Legion. After the *Grande Débâcle* he somehow managed to get on a ship for the USA and was able to start another agency in New York. But that was of little consolation to Doisneau, for whom contacts and opportunities that had begun to appear in 1939 had now vanished:

> Some people came to me for copies of photographs of men sent away to war, for passports, things like that. We lived for three months on that, and then there was the *Grande Débâcle*. My father came here, saying, "You are the only one who knows how to drive your stepbrother's car—we must leave Paris." So we left by car. It was the great exodus of June 1940. There

96. Cour du ferme (Farmyard) *of the Motillon family, near St. Sauvant in Poitou, where Robert Doisneau and his wife Pierrette took refuge after the* Grande Débâcle *of June 1940. This photograph was made during one of their wartime visits to the Motillon farm, where they probably helped with the harvest.*

96

97

97. *Pont Notre-Dame, Ile de la Cité, Paris, Fourth Arrondissement, 1941. For seventy days during the winter of 1940–41, the most severe of the war, the temperature in Paris never rose above freezing.*

was my father, Pierrette, her sister, and a cousin with her baby. On the road we were machine-gunned and bombed. It was the defeat: the dissolution of France. Soldiers, civilians, and peasants formed a terrified herd on the roads of France. We went down to Poitou where one of Pierrette's sisters was staying.

The German offensive that began in the Ardennes on May 10, 1940, carried their armies through to Paris by June 14. The capital had been declared an open city by the French high command three days earlier. If the speed of the German advance ensured that military casualties were low compared to the first war, the impact on civilian life was striking. Six or seven million French people took to the roads to escape. Organization of the exodus was minimal. Chaos and panic reigned. The state literally collapsed, at both the local and national levels. In Versailles, for example, a few miles from Montrouge, posters appeared that read "Evacuation Order: the *Mairie* asks that everyone leave at once." In some cities and towns, virtually the entire population fled. Only eight hundred of Chartres's twenty-three thousand inhabitants stayed behind, and fewer than thirty of Troyes's fifty-eight thousand. In many parts of France people could not go home until well into the autumn: and in the areas bordering Belgium and France the Germans forbade them to return.

The government decamped to Bordeaux, and between late May and June 10, three-quarters of the population of Paris abandoned the city. Robert and Pierrette were swept along in the current, aboard their old Renault. They took their tent with them. A few days later the "savior of Verdun," Maréchal Pétain, took over the leadership of the government and sued for peace. Most of France probably agreed with him that an armistice was the only viable option.

Doisneau made no photographs during the flight to Poitou, nor during his stay there. "I had no heart for it." The Motillon family on whose land they were camping were Protestants, like Pierrette and her sister. After a few days under canvas the Motillons invited them to come into the farmhouse: "You can't go on sleeping outside like gypsies, come sleep in the bedroom." They stayed there at St. Sauvant for about three months, returning to Montrouge at the end of August. They would later return to stay with the Motillons on many occasions, attending various marriages and other celebrations. These occasions would provide Doisneau with the material for a number of his best-known photographs, including *La Ruban de la mariée* (1951) (pl. 169).

Back in Montrouge, life was extremely hard. Like much of the population, the Doisneaus had to get used to a completely different way of life, in which the people and government of France were now the spectators, if not the active accomplices, of Nazi policies. Pétain's government had virtually autocratic powers, legitimized by the widespread belief that it was a purely provisional arrangement. Paris and all of the northern and western parts of France were made part of the Occupied Zone, while the southeastern third of France became the Unoccupied Zone. Pétain's government was located near the border between the two zones in the spa town of Vichy. In theory it governed both zones, but in the Occupied Zone the reality was that Germany ruled, running the French economy with the aid of its collaborators in Vichy, with about half of the French production going to Nazi Germany. Exchange rates between the deutsche mark and the franc were fixed at over twice the market rate, while

LE CLUB DE BOULOGNE-BILLANCOURT DES USAGERS DES
AUBERGES DE JEUNESSE DU CENTRE LAIQUE TE RAPPELLE

LES SEULES VÉRITÉS :

Il n'y a pas de héros : les morts sont tout de suite oubliés.
Les veuves de héros se marient avec des hommes vivants, simplement parce qu'ils sont vivants et qu'être vivant est une plus grande qualité qu'être héros mort.
Il ne reste plus de héros après la guerre : il ne reste que des boiteux, des culs-de-jatte, des visages affreux dont les femmes se détournent ; il ne reste plus que des sots.
Après la guerre, celui qui vit c'est celui qui n'a pas fait la guerre.
Après la guerre, tout le monde oublie la guerre et ceux qui ont fait la guerre.
Et c'est justice. Car la guerre est inutile et il ne faut rendre aucun culte à ceux qui se consacrent à l'inutile.
JEAN GIONO (29 septembre 1938).

98

98. Les Seules Verités: *leaflet with pacifist text by Jean Giono distributed to conscripts at the call-up in September 1939. Doisneau carried this and a book by Giono in his knapsack when he was drafted. The text reads:*

THE BOULOGNE-BILLANCOURT CLUB FOR
THE USERS OF THE YOUTH HOSTELS OF
THE LAY CENTER REMINDS YOU OF:

THE ONLY TRUTHS:

There are no heroes: the dead are quickly forgotten. Widows of heroes marry living men, simply because they are alive and because being alive is a greater quality than being a dead hero. There are no heroes after the war: there are only cripples, deformed faces, so frightening that women turn away from them; there are only idiots. After the war those who are alive are those who did not go to war. After the war, everybody forgets the war and those who fought in it. And that is just. Because war is useless and we must not serve a cult for those who devote themselves to the useless.

JEAN GIONO (September 29, 1938)

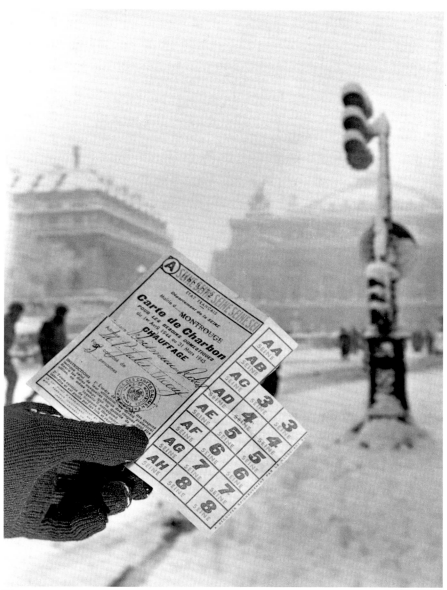

99

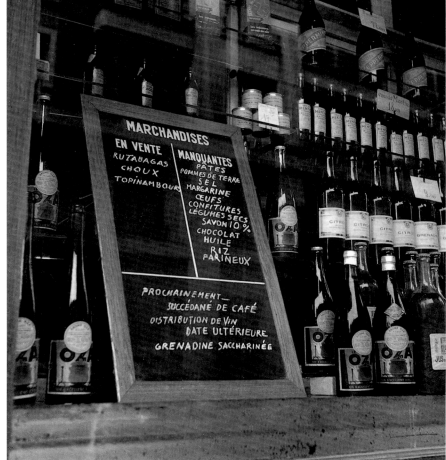

99. Carte de Charbon (Coal-ration Card), *Paris 1944. Doisneau's desire to document the impact of the Occupation on everyday life led to photographs like this, which deal with the contemporary obsessions with the lack of fuel and food—his precious coal-ration card against the snowy backdrop of the Opéra.*

100. *From the first days of the Occupation, Parisians discovered long lines and empty shelves. By the time the rationing system was put into operation in September 1940, some goods had already disappeared from the shops altogether. Pure coffee, for example, was replaced by a mixture in which roasted barley seemed to be the main ingredient.*

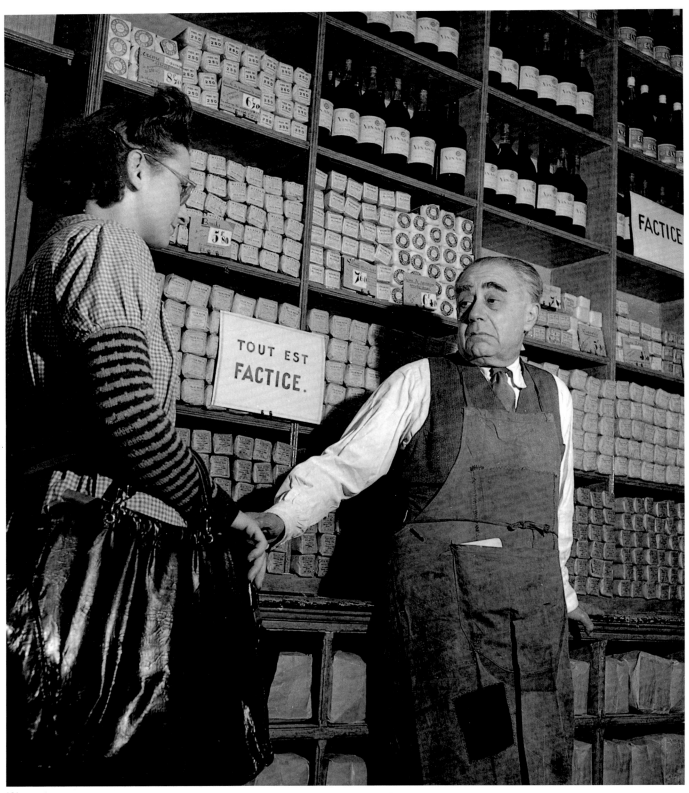

101

101. Tout est factice (Everything is Artificial), *1941–42. Photograph of a Parisian shop selling synthetic products made to resemble the real thing, with artificial wine, food, and toiletries on the shelves. Part of Doisneau's documentation of the* Ticket d'Alimentation.

102. *Empty store windows were a common sight as the Occupation progressed. The exchange rate between franc and deutsche mark was set so much in the Germans' favor that French goods were cheap to buy and to export back to the Fatherland.*

103. *The winters of Occupation, 1940-44, were far more severe than those that had preceded them, and the heat in the big department stores of Paris was turned off. This photograph, made for the magazine* Vrai, *for which Doisneau carried out a number of assignments in 1941, shows both customer and saleswoman in thick coats.*

French prices were held at unrealistically low levels in order to give the Germans even greater purchasing power. Soon over a third of the French labor force was effectively working for Germany. Bread was rationed from as early as September 1940, and the general standard of living of the population declined progressively throughout the war. Rationing covered most aspects of the normal diet, and those obliged to subsist on the official ration were on only twelve hundred calories per day by 1943, rather than the seventeen hundred necessary to maintain health. For the average French person, surviving meant, as Doisneau put it, *"vivre avec des combines"*—to figure out ways of getting around the rules and regulations.

The winters of the Occupation years were the worst in living memory. Robert remembered that in 1941–43, when fuel was very short, the inhabitants of Montrouge would organize nocturnal expeditions to the Stade Buffalo, near place Jules Ferry, to rip out the wooden seats of the stadium for firewood. The plane trees in the square were regularly trimmed by the inhabitants for kindling, a scene recorded by Robert from his apartment window. Those with friends in the countryside were well placed to get a little extra in the way of food, for France was still, as Pétain had declared, "at base an agricultural nation." The Motillons would occasionally send some food to Robert and Pierrette, but even this was not easy to arrange, for money was very short. At first Robert eked out a living by selling what he could of their few possessions, making copies of photographs of prisoners of war and engraving a jewelry catalogue, until he hit upon the idea of producing postcards. He met a general at the Musée de l'Armée at Les Invalides who was in charge of the sales of postcards, books, and other memorabilia for visitors, for German soldiers touring Paris came there to visit the tomb of Napoleon, whom they much admired. Doisneau did a deal with the general to produce and sell a series of postcards in an envelope—a *mignonette*—on the life of Napoleon. He made a fine large-format image on a thirteen-by-eighteen-centimeter glass plate of Napoleon's tomb, and took the other scenes from books (without permission), including an image of Napoleon's home in Ajaccio, which was simply copied from an old volume found at a bookstall along the Seine. He engraved an Imperial-style frame for each image and printed all twenty negatives at once on large sheets of paper. He and Pierrette would cut them up, and as soon as they had a hundred or so together, Robert would bicycle off to the Invalides to sell them (pl. 95). A battered notebook dating from this period survives in Robert's archives, containing a few pages of accounts for these sales, the first being dated September 1940. Robert seems to have sold them for six francs a set: costs are neatly laid out, including plates and film coming to 621.10 francs, leaving Robert with a gross profit of about 1300 francs. Postcard sales continued into 1942 but tailed off quite markedly after 1940.[3]

As the Occupation progressed, a small amount of illustration work began to come in, as new magazines and newspapers appeared. Robert also made photographs of what living conditions were like for ordinary people: "It was my way of recording what was happening." We see the food ration cards, and the *vélo-taxis* that people made to replace motorized taxis. There are a number of fascinating pictures of the ways in which people supplemented their meager rations—digging up the Tuileries to plant vegetables, or grazing their rabbits on the Champ de Mars. Germans figure among these images; soldiers at the

104

104. *Vélo-taxi near the Opéra, 1940–41. The introduction of gasoline rationing in 1940 virtually cleared the streets of civilian cars and trucks. All manner of conveyances appeared to replace them, including the bicycle-based vélo-taxi. Such photographs were part of Doisneau's documentation of everyday life under the Occupation.*

105. *Page 87:* Le Cheval tombé (The Fallen Horse), *Paris, Sixth Arrondissement, 1942.*

106. *Pages 88–89: German soldiers marching along the rue de Rivoli, Paris, 1943. Doisneau wanted to photograph this symbol of Germany hegemony, which took place every day. The military headquarters of the occupying power was situated in the Hotel Meurice, facing the place Vendôme (a Napoleonic symbol of the French state). "I was there with my Rollei on the steps at the Tuileries garden. It was somewhat of a risk."*

105

Trocadero, under the Eiffel Tower, or by Notre-Dame. In some cases the image provides a wider and more charged interpretation of the spirit of the times, such as *Le Cheval tombé* (pl. 105). As a photograph made in 1942, it is heavily symbolic. Would the country, the horse, ever rise again? The image was made in winter, while Doisneau was carrying out his assignments for the Vox project *Nouveaux Destins de l'intelligence français* (discussed below). He came across a horse that had slipped on the icy roads and could not get up. So strong an image did this seem to him that he made two negatives of the scene, rare for him in a period when film was in short supply. But as an image it powerfully epitomizes the plight of Paris under the Nazi boot:

107

Paris during the Occupation: it was humiliating. You had to get off the sidewalk to let the superb German officer pass by, to show your identity card or open your briefcase no matter where. You switched on the radio, there were no more programs. Silence. A great sadness. A brooding atmosphere; yet despite everything a few sunny spots: young girls on their bikes, with short skirts flying up in the wind, like a little flower. I found that pretty. And then the black-marketeers—"Interested in some butter?"

The French suffered, and tried to get out of it. A lot were *Pétainistes*. I remember the crowds who acclaimed Pétain, often the same people who, sometime later, went to applaud de Gaulle on the Champs-Élysées. Here at Montrouge, the building contained studios occupied at that time by painters from central Europe, too poor to live in Montparnasse. Among them, a lot of Jews, all with difficulties. We experienced scenes that were tragic and vaudevillian at the same time. We could go up to the seventh floor by an outside ladder, and come down through the building next door to escape from the Germans. There was real solidarity, even if it was a little bit crazy!

A friend who felt threatened one day asked me to take under my name the studio of our neighbor Fernand Léger, who'd gone to the United States. So for two years, I was the proud owner of fifty Léger paintings!

The photographs that depict the Germans in Paris (see pl. 106), or show the French police in their collaborationist role, contain more subversive messages—although they could not be used at the time. Though Robert would reject any suggestion that this was a brave thing to do, it must have taken some courage to photograph the German troops on their daily march by the rue de Rivoli and on to place de la Concorde—although help might come from the most unlikely of quarters:

I still remember wanting to photograph the Germans who marched each day up the rue de Rivoli. I was there with my Rollei on the steps at the Tuileries garden. It was somewhat of a risk. There was a guy looking at me. A plainclothes policeman. He said, "Get behind me," and put his coat up to hide me. Not long ago this guy reminded me of this event. But I don't want to be thought of as somebody heroic. In fact, I was scared.

Officially, every professional photographer providing material to the press was supposed to register with the association formed for that purpose by the

107. *Robert Doisneau:* Photographe-illustrateur independant *(freelance reportage photographer), with Rolleiflex and flashgun, 1944.*

108. Imprimeries clandestines *(Clandestine Presses). Issue of* Le Point *magazine with photographs by Doisneau, 1945.*

108

109. *Page 91: A clandestine press of the Parisian Resistance. Doisneau's friend, the painter Enrico Pontremoli (code name "Monsieur Philippe") at center, his wife at right, another painter (Philibert) at left. Reportage for* Le Point, *1945.*

109

Germans, popularly known as the Propaganda Staffel and located in the rue de Clichy. Photographers were supposed to carry a card granting rights to buy film, paper, chemicals, etc. Many thought it wiser not to be registered with the authorities, but well-known photographers could not avoid it, because Lieutenant Dietrich, who ran the Propaganda Staffel, had been the Paris representative of one of the German photographic companies before the war, and knew the photographic milieu. Fortunately, Robert remained unknown, for as a photographer and engraver his skills were of some importance to the Resistance. Following the German invasion of Russia in June 1941, the resistance movement—which until then had been confined mainly to various tiny right-wing groups, and to alliances of Socialist and Catholic trade-unionists— was reinforced by the Communists, hitherto restrained by the Nazi-Soviet pact from active involvement in hostile action against the German forces. In the autumn Communists began a notorious series of actions against the Germans in Paris. In savage reprisals, fifty to one hundred French prisoners were executed for each German soldier killed. The Vichy régime—perhaps even more afraid of the "red menace" than its German bosses—also engaged in the active pursuit of resisters, especially after the formation in January 1943 of the hated Milice Française, which worked directly with the German authorities in order to combat the Resistance and to pursue Jews, Communists, and Freemasons.

One day in June 1941 Robert Doisneau received a visit from a certain Monsieur Philippe. It was not until the Liberation that he discovered this was the code name of the Jewish painter Enrico Pontremoli, a member of the Mouvement pour la Libération Nationale, of which Pierre Mendès-France was the political leader.

He asked me to make a copy of a police inspector's card. He said: "It's simple. The inspector is in the square. He's waiting for you to finish this job." He sat down on a chair and didn't move. I acted as if I didn't understand what he wanted. But I felt intuitively that he was honest, that he wasn't a traitor. I understood that he worked for the Resistance, so I did it. He offered to pay me but I refused the money. Then he told me that the organization was rich, and that he would need to use me again. It was a matter of making photographic copies of documents, which were then carefully modified: bleaching the print with potassium ferricyanide, after you had laboriously inked over the typed or printed sections with india ink, which remained on the paper after you had washed away the photographic emulsion. From then on I would get all sorts of jobs—identity cards to make up, Ausweisse, passports, false papers for Jews. We even put up a guy who had been chased by the police all the way from the porte d'Orléans. A cyclist who hid in our apartment even left a suitcase full of guns.

Doisneau acted from conviction, retaining close links with socialist and communist groups. But he was always modest about these activities, which took up much of the night. "I was only helping my friends," he would say, forgetting the constant fear of denunciation and of sudden searches. If caught he would have been executed or deported to Germany, yet Pierrette, pregnant with their first daughter, seemed to take it all in stride. Furthermore, Robert's work for the

110

111

110. *Cover of* Foyers de France, *a nativity scene with Robert and Pierrette's first daughter Annette as the model for the infant Jesus, 1942.*

111. *Pierrette Doisneau and her daughter Annette, 1942. This photograph is one of many that Doisneau made of his wife and first child; the group formed part of his picture library.*

112. *Page 93:* L'Amour sous l'occupation (Love During the Occupation), *jardin des Tuileries, Paris, 1943–44.*

Resistance was time-consuming, making it even more difficult to feed the family. The price of false papers was fixed at 220 francs, which barely covered materials.

French police raided the apartment three times without finding anything, despite the crudeness of Robert's precautions: false documents were rolled up in the blinds over the high windows of his atelier. Although he was obsessive about destroying the negatives and prints made during the forgeries, one thirteen-by-eighteen-centimeter glass plate somehow survived—a photograph of a letter from a German organization regulating the publishing industry.

One morning in 1942, three Citroëns pulled up in place Jules Ferry; their hubcaps painted yellow, the "Tractions" were instantly recognizable. The Gestapo. The men in long leather coats and felt hats had come to search the apartments. Opening all doors and drawers, pulling books off their shelves, placing seals on unoccupied apartments. Lunchtime came and nothing had been found. "We'll be back soon. Don't touch anything," they said to the concierge, Paul Barabé, who had only recently taken the job. Barabé was a burly veteran of the 1914–18 war, a bookbinder by trade, a CGT union organizer in the printing trade; he had been blacklisted since 1936. He and his wife Lucie had just moved into the concierge's *loge* at 46, place Jules Ferry, left vacant by the previous occupant, a Communist who disappeared suddenly one day in 1941 when the party was outlawed. Barabé knew that the cellar hid a secret printing press and a register containing the names and addresses of about fifty people, all members of the Communist party cell in Montrouge. Barabé broke the locks on the doors of the cellar, smashed the press to pieces with a hammer, and tore up the register, throwing everything down the drain, the last load going in moments before the Gestapo men returned. They continued their search into the evening, but nothing was found.

Robert and Pierrette's first daughter, Annette, was born on March 31, 1942. Although this was a time when the future looked uncertain, the Doisneaus were acting like many of their compatriots, for in the Occupation years the birthrate actually rose, despite the fact that 1,800,000 French men and women were held as prisoners of war.

Robert photographed Pierrette and Annette as much as he could: Pierrette in the hospital, Annette in her bassinette, all the little procedures that go with having a baby—diaper-changing, bathing, playing. Most of these pictures were for his personal archive, but the line between the personal and the commercial was a thin one; many of Doisneau's best photographs are of his own life. Annette's first assignment was to model in a nativity scene for a magazine cover (pl. 110); Robert also began to receive advertising commissions. Once he devised a bedroom set in his Montrouge apartment as the set for a sleeping pills advertisement with the assistance of a young man taken on as a favor to a friend who was afraid his son would get into trouble. It was a relatively important assignment; a couple of days were spent building the set, with a bed made up from boards, a wallpapered backdrop to represent the walls, a bedside table and lamp, and the product neatly displayed on a little tray. Robert hired a professional model to play the part of the pretty girl in her nightgown. When she arrived, Robert and his assistant tactfully withdrew while she changed. As they waited in the kitchen for the girl to get ready, they heard a scream and a crash: as soon as the girl had climbed into the "bed" the whole rickety construction collapsed under her weight!

113

113. *Cover of* La Vie Catholique Illustrée, *August 1945, with Doisneau's photograph of conditions in wartime Paris just before the liberation of the city, when air raids and fuel shortages made blackouts a common feature of everyday life.*

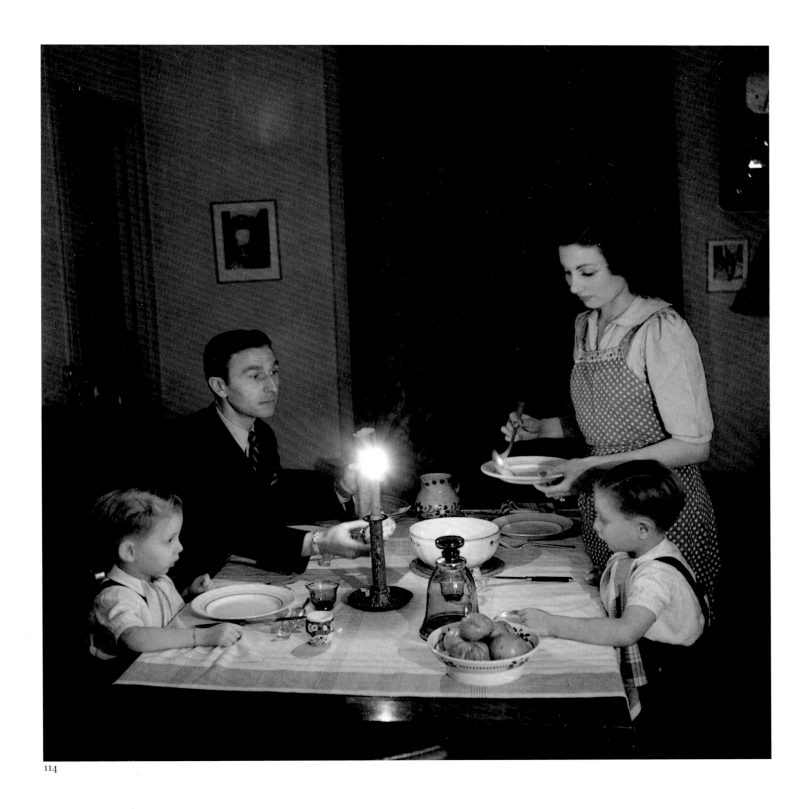

114

114. *Dinner by candlelight, wartime Paris, 1944.*
A variant of the photograph used to illustrate the
cover of La Vie Catholique Illustrée.

Obtaining photographic materials during the Occupation was not easy. Before the war Kodak Panatomic and XX were the films Robert had primarily favored for the Rolleiflex. These were now difficult to obtain, and all manner of *combines* (tricks and schemes) were needed to ensure a reasonable supply. It was relatively simple to get hold of film made by the French firm Bauchet, but it was of very poor quality. German products such as Agfa films and papers, and even some Kodak materials could be obtained, but as the war continued supply became ever more problematic. Silver, the base product for photographic emulsions, was scarce. As Robert said, "You had to be ingenious to survive. To live by your wits. I knew what that meant. You couldn't just buy film or paper, you had to trade some silver." One method of obtaining it was by electrolytically recovering the silver deposited in the processing of films and papers from the solutions. A simpler expedient was to offer a silver item such as cutlery or jewelry in exchange for a few rolls of film or a box of printing paper. Doisneau had to do both in the two stores where he could buy materials—Alea, by the Denfert-Rochereau metro station (Fourteenth Arrondissement), and Michaud in avenue de Wagram (Seventeenth).

Because materials were scarce, a certain visual economy was imposed on Doisneau. Film in particular could not be wasted, and Robert "constructed" more shots during the war as a result. But this also sharpened his already formidable visual skills, pushing him to frame the image in attractive and interesting ways. Each image of a breadline, of empty grocery shops, of the miseries of life under the Occupation was made at high cost, but Doisneau's determination to *inscrire les décors,* to show what was happening to people like himself, allowed him to continue on in spite of the hardships that had become mundane. Robert recalled opening the kitchen cupboards to discover nothing whatsoever to eat in them. On one pathetically memorable occasion, Pierrette lost a twenty-franc note in the wintry streets of Montrouge. They had no other money at all and no food, and Robert went out to the street where she had lost it, returning several hours later gleefully clutching the note, miraculously found in the snow.

When Robert needed a new Rolleiflex, he had to resort to the black market:

> I bought it from a dealer in a bistro near the parc Monceau. You went into the back room. The guy said, "I have the object. Do you have some money?" "How much?" "What I told you." It was funny, you couldn't say the price or the name of the camera. He passed the package under the table—what a business! He must have worked for the railroad, traveling between France and Germany as a train-inspector.

The limited amount of commercial work he did obtain kept the wolf from the door, but the majority of assignments Doisneau was able to obtain during the Occupation seem to have been illustrative. Perhaps through contacts at the Musée de l'Armée, he received some assignments from the Secours National, an organization set up under the patronage of Pétain to help the families of prisoners of war and which published a women's magazine containing advice and general articles on life in France. In early 1941 he was introduced to Madame Delmas, a rich woman involved with Secours who wanted to produce a high-quality magazine. It was to be called *Vrai* (True). Doisneau illustrated various articles for the magazine: on *"les artisans des faubourgs";* the Bibliothèque

115

116

115. *Maximilien Vox, 1944. Doisneau met the publisher and book designer in 1941, when he was working on the magazine* Vrai. *Vox commissioned a number of assignments for the magazine, and in 1942 asked Doisneau to provide photographs of leading French scientists to illustrate* Les Nouveaux Destins de l'intelligence française, *a book designed to show that despite wartime difficulties French science and culture was still active. Vox was later to be editor of the* Album du Figaro, *and in October 1945 sent Doisneau to Aix-en-Provence to photograph Blaise Cendrars, a meeting that was to change the course of Doisneau's career and lead directly to his first book,* La Banlieue de Paris *(see Chapter 5).*

116. *Reader at the Bibliothèque Nationale, rue Vivienne, Paris, Eighth Arrondissement, 1941. An assignment on the great national library of France, for* Vrai.

117. *Page 97:* Les Ères de Charles Jacob, professeur à la Sorbonne *(The Eras of Charles Jacob, Professor at the Sorbonne), 1942. In the series of portraits that he made for the book* Les Nouveaux Destins de l'intelligence française, *Doisneau began to stamp his own style more clearly on the settings and presentation of his subjects. In this photograph he creates an intriguing portrait of a subject that could appear extremely dull.*

118

119

119. Un Physicien dans le Vent (Physicist in the Wind/A Fashionable Physicist), *1942. Portrait of a meteorologist for* Les Nouveux Destins de l'intelligence française.

120. *Professor Henri Vallois examining a skull, Musée de l'homme, Paris, 1942. Photograph for* Les Nouveaux Destins de l'intelligence française.

118. *Page 98:* Le Tableau noir de Louis de Broglie (Louis de Broglie's Blackboard), *1942. Portrait of the Nobel-prize-winning physicist for* Les Nouveaux Destins de l'intelligence française.

120

Nationale; printers; science and scientists; the problems of heating apartments; artists and sculptors; and on the wives of prisoners running farms while their husbands were away. In one important sense these short assignments on "human interest" stories prefigured what Doisneau would do after the war, and they helped him hone his style to the needs of illustrated magazines.

The art director of *Vrai* was a highly respected graphic designer and literary editor, Maximilien Vox.[4] It was he who sent Doisneau out on his various assignments for the magazine, until it folded at the end of 1941, after only a few issues. Robert, however, continued to work on a similar magazine for the Secours National. Despite setbacks such as the failure of *Vrai*, the publishing industry was not entirely moribund, and well-produced, "luxury" illustrated books were selling well:

> After *Vrai* folded, Maximilien Vox asked me to work on a book that would show that France was still the shining light of the world, that our intellectuals and scientists, our writers, in short our entire scientific and cultural community, was part of a universal elite. So I accepted this assignment for a book that had very limited success [*Les Nouveaux Destins de l'intelligence française*].

This was the first book he had done, and Doisneau spent the latter part of 1941 and the beginning of 1942 photographing in all the leading scientific establishments of Paris and the banlieue. He made a large number of portraits, including those of leading figures such as the Joliot-Curies and the Prince de Broglie. It was an important job for Robert because it allowed him the time and the resources to investigate and photograph a subject in some depth; and because he was able to stamp many of the images with his own approach to portraiture, in ways suggesting the context of a person's work and personality. In many of these photographs we see Doisneau marrying his inimitable sense of fun with an acute eye for character. *Un Physicien dans le vent* (pl. 119) is representative of this work.

The assignment also provided one of the few occasions on which Doisneau was obliged to request an authorization to photograph after the curfew, for the assignment involved some *prises de vues* (shooting) at the Observatoire in boulevard Arago. Doisneau cycled everywhere during the war, his camera case fixed to the *porte-bagage* of the bike, and with the tripod in a bag across the handlebars. The only cyclist on the dark streets after the curfew, he was stopped one night by the German *Abwehr*, who thought he was carrying a machine gun instead of a tripod—they suspected he was a *terroriste* but let him go when they realized they had only caught a humble photographer.

The publication of *Les Nouveaux Destins de l'intelligence française* was a disappointment in more than one sense. The fact that it appeared in the middle of the Occupation, with a preface by Pétain, meant that the book, although beautifully produced, sank without trace. Perhaps worse than this was the fact that so few of Doisneau's photographs were used to illustrate the chapters on science, despite their undeniable quality.[5]

In 1943 Doisneau acquired another client: the Vichy government's youth and sport ministry (Ministère de la Jeunesse et du Sport). In January 1944 Pétain expressed the spirit of education involved in its youth program: "What

121

121. *Rabbit feeding on the grass on the Champ de Mars, Paris, 1941. The great shortage of food led to attempts to use all resources available, carefully documented by Doisneau. Rabbits and chickens were encouraged to eat whatever was available in the public spaces of Paris, and even the jardin des Tuileries was used for vegetable gardens.*

122. *Page 101:* Notre Photographe a fait le même reportage . . . (Our Photographer Has Carried Out the Same Reportage), *a magazine spread from* Point de Vue, *comparing Doisneau's photographs made during the Liberation of Paris with those made at the same locations three years later.*

123. *Page 101:* Monsieur Mouchonnet, sertisseur et meilleur ouvrier de France (Monsieur Mouchonnet, jewel-setter and Best Craftsman in France), *rue de Mail, Paris, Second Arrondissement, 1941. An article on "Les Artisans des faubourgs," for* Vrai.

124. *Page 101: Manufacture of clarinets, Paris, 1941. Photograph made on assignment for* Vrai *magazine, article on "Les Artisans des faubourgs."*

125. *Page 102: "There's nothing finer than to see a crowd roll up a street." Doisneau photographed the creation of a barricade in the Latin Quarter, corner of rue de la Huchette and boulevard St. Michel, during the insurrection of August 1944.*

126. *Page 103: Barricade at the corner of rue de la Huchette and place du Petit Pont, opposite the Préfecture de Police on the Ile de la Cité, Liberation of Paris, August 1944.*

NOTRE PHOTOGRAPHE A FAIT LE MÊME REPORTAGE..

122

123

124

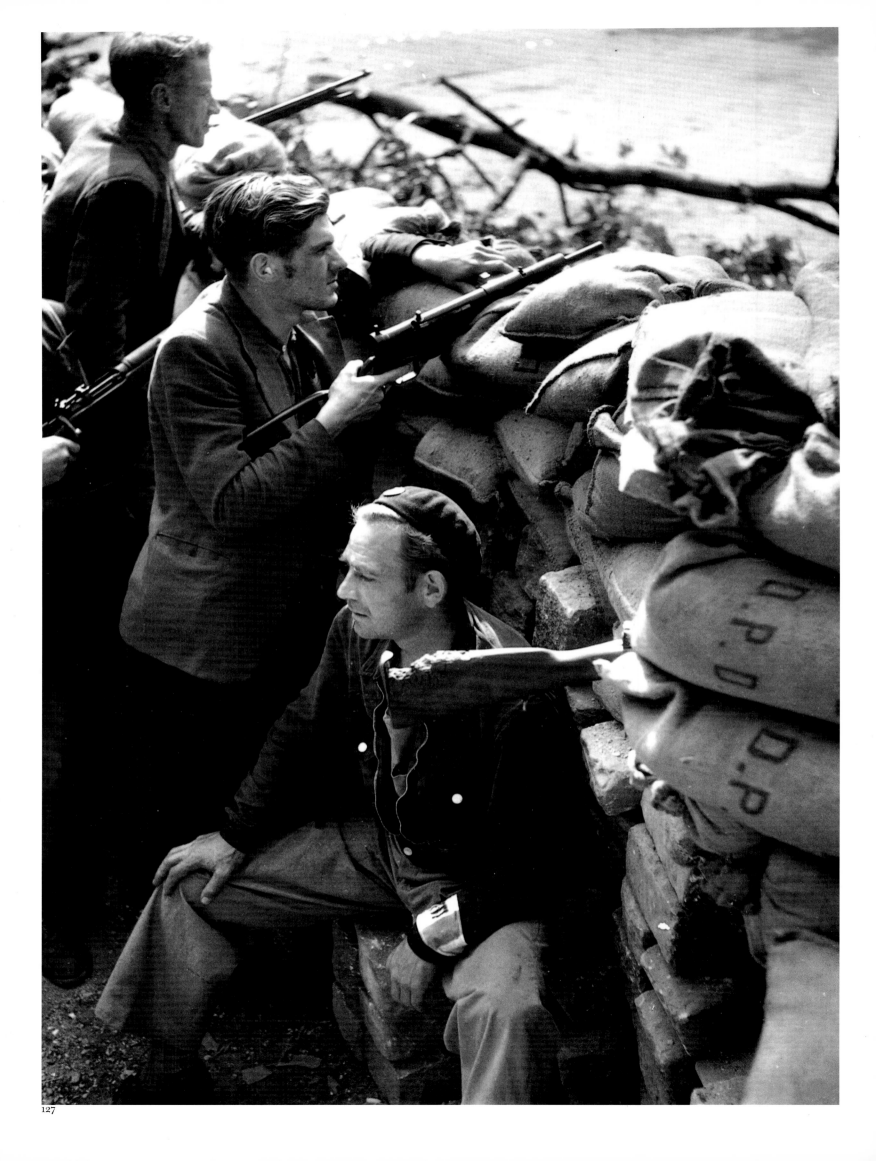

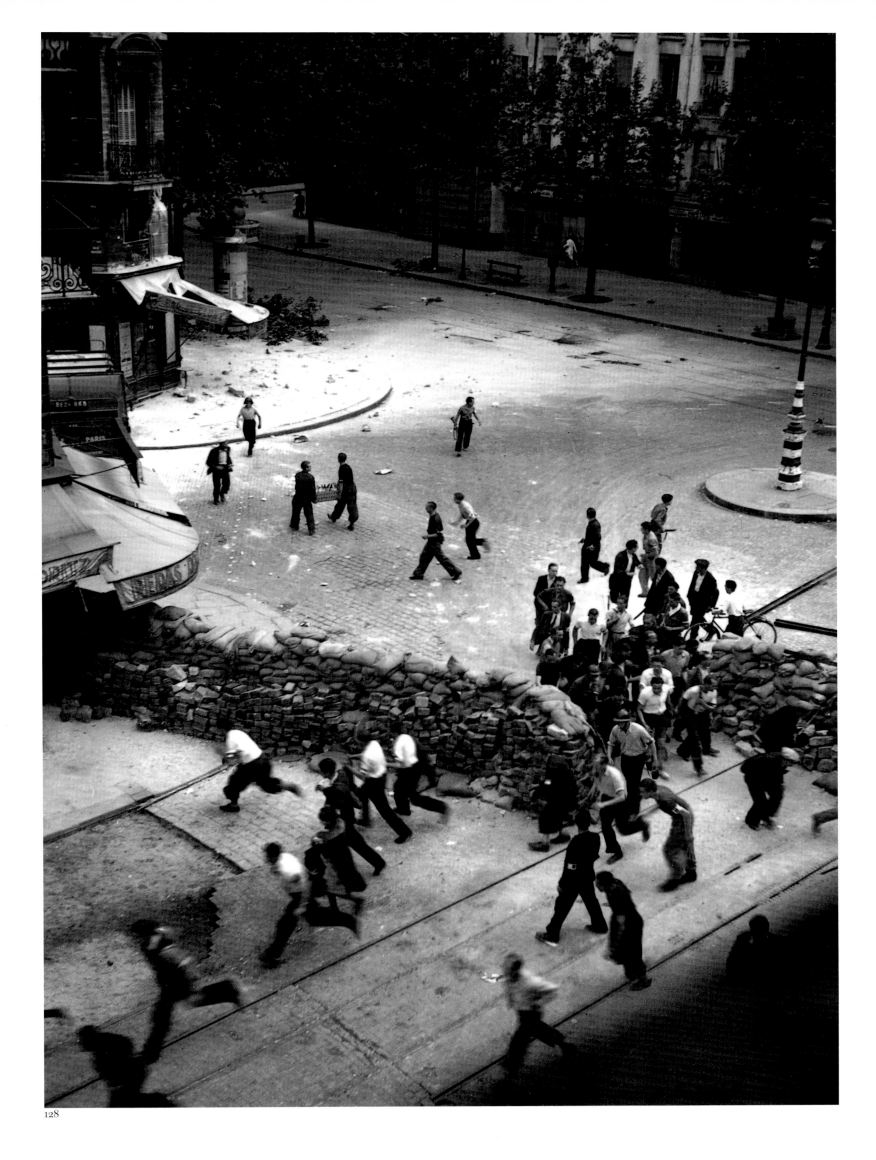

our dear France needs are not minds but characters." School curricula and the youth programs developed by Georges Lamirand's youth department and Jean Borotra's sports section were designed to equip young French people with self-discipline, public spirit, and national loyalty. Doisneau traveled around, making photographs of schools and other institutions involved in education, vocational training, and sport. The results were, as he put it, "images of bare-chested young men singing patriotic anthems."

By the end of 1943 the tide of war had turned definitively against Germany. The Resistance was becoming more obviously the basis for an alternative government, with its allies in London under Charles de Gaulle's leadership, once France was liberated from occupation. After June 6, 1944, the only questions remaining were when de Gaulle would arrive in Paris and whether the withdrawing Germans would wreak havoc on the city before they left. The armed wing of the Resistance—uniting most individual groups such as the Communist Francs-Tireurs, the Forces Françaises de l'Intérieur (FFI)—had declared a general insurrection as early as June 6; but fighting only broke out on a grand scale when it was clear that the Allies, including General Leclerc's French division, were within striking distance of Paris. Following a mounting campaign of strikes, Henri-Rol-Tanguy and other Communist resistance leaders launched an insurrection in Paris on August 19, quickly occupying the Hôtel de Ville and other key buildings such as the Préfecture de Police on the Ile de la Cité. De Gaulle and other more conservative elements in the Free French hierarchy were worried that the Communists wanted to unleash a left-wing takeover of the capital reminiscent of the Paris Commune of 1871. A brief August 20 truce with the German garrison commander General von Choltitz, negotiated by the Gaullist resistance (who feared massive reprisals against the population), was swiftly followed by a general resumption of fighting. Doisneau had already decided that he must try to record what was going on when he received an order from his resistance group to go to Ménilmontant in northeastern Paris:

I left Montrouge on my bicycle, with my camera bag on the shopping basket, my Rolleiflex, one film, and a second backup film. I had two films [24 negatives] to photograph something as important as the liberation of Paris! I arrived at Ménilmontant, where I was supposed to photograph a derailed train in a tunnel: it was of course dark and I had no flash!

I was with a representative of the FFI post at Ménilmontant. We cycled down to the rue des Couronnes. Arriving at rue de Ménilmontant we came across a gang of FFI—guys dressed half in military outfits, half in street clothes, with some very odd weapons—a belt of grenades, a 6.35 mm handgun, a little pistol with a mother-of-pearl handle—guys like that. They said, "Ah, you're a photographer? You must do a group picture." Well, you understand, for me to make a group picture seemed like a waste of film! I'd taken two or three shots of the barricades already. So against my better judgment I had to photograph these guys. Now it just happens that this photo is one of the most important ones I made that day, the most charged with information, clothes, weapons. . . . Sometimes having very little is useful.

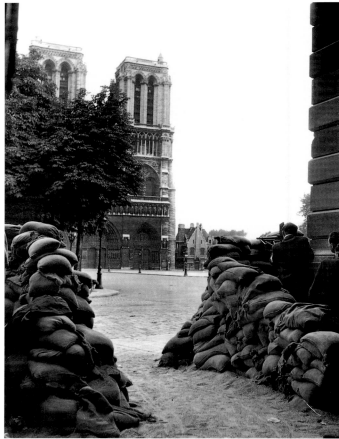

129

127. *Page 104: On the barricades, Liberation of Paris, August 1944.*

128. *Page 105: Barricades and insurgents, Latin Quarter, August 1944.*

129. *Battle for the Préfecture de Police (Notre-Dame in background), Liberation of Paris, August 1944.*

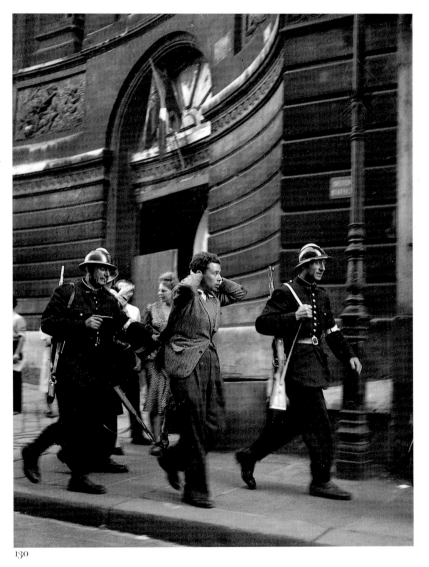

130

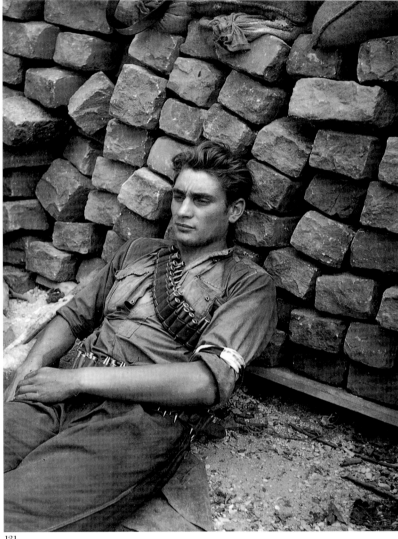

131

130. *Two policemen arrest a suspected* franc-tireur *(collaborationist sniper) in the Latin Quarter, Paris, August 23, 1944.*

131. Le Repos du FFI (A Resistance Fighter of the Forces Françaises de l'Interieur at Rest), *Paris, August 1944.*

After the disappointments of Ménilmontant Doisneau decided to ignore the instructions of his resistance group. He spent most of the next few days of the insurrection in the Quartier Latin, near Notre-Dame, or in the Préfecture de Police. His photographs show the popular nature of the struggle to liberate Paris—the young men manning the barricades, with women, children, and the elderly building them. There are some images of tanks burning, German staff cars overturned, people running across streets to avoid fire, young men with guns, crouched on a street corner, or firing from a window. There are few if any dead bodies, few photographs that dwell on the violence. But Robert made sure to photograph near the Kommandantur, at place de la Concorde. He took pictures of camouflaged German tanks and lorries covered in camouflage netting pulling out of the city, but characteristically devoted four or five frames of his precious film to their imitators—Parisian children pushing an old carriage strewn with leaves to camouflage its form, mocking in play the departing representatives of the master race (pl. 93).

132

The only thing I refused to photograph was the ugliness of popular demonstrations, the women who'd been shaved, the women led around naked in the streets, I refused to do that. People said to me: "Go on, photograph that!" But it's a shame, terrible, the beastliness. A woman alone facing a band of sadists. The crowd is an awful thing.

Later, when the Leclerc division entered Paris with its American allies and von Choltitz surrendered, de Gaulle took the opportunity to consolidate his position as leader of the Free French—and thus head of the putative government that would form around him—by marching down the Champs-Elysées during the last throes of the insurrection and the battle for Paris. Doisneau was there to record the scene, de Gaulle at the head of the column striding down the road to announce that Paris had been "libéré par son peuple." Perhaps as he photographed Doisneau may have overheard him tell Georges Bidault, the leader of the Catholic resistance movement, to keep firmly behind him. De Gaulle wanted above all for this popular liberation of Paris to remain an insurrection, rather than a revolution in which the largely left-wing resistance took over the state.

But in looking at all of Doisneau's photographs of the Liberation of Paris, the viewer is struck by their essential humanism. A few images tell of the darker side of the time: collaborators being taken to their fate—execution—by FFI or gendarmes. Yet the overwhelming impression is of the record of a moment when the French *class populaire* played a heroic role.

132. *American military news photographer and comrades, Champs-Elysées, Paris, Eighth Arrondissement, August 1944.*

133. *De Gaulle's triumphant arrival in Paris, August 26, 1944.*

133

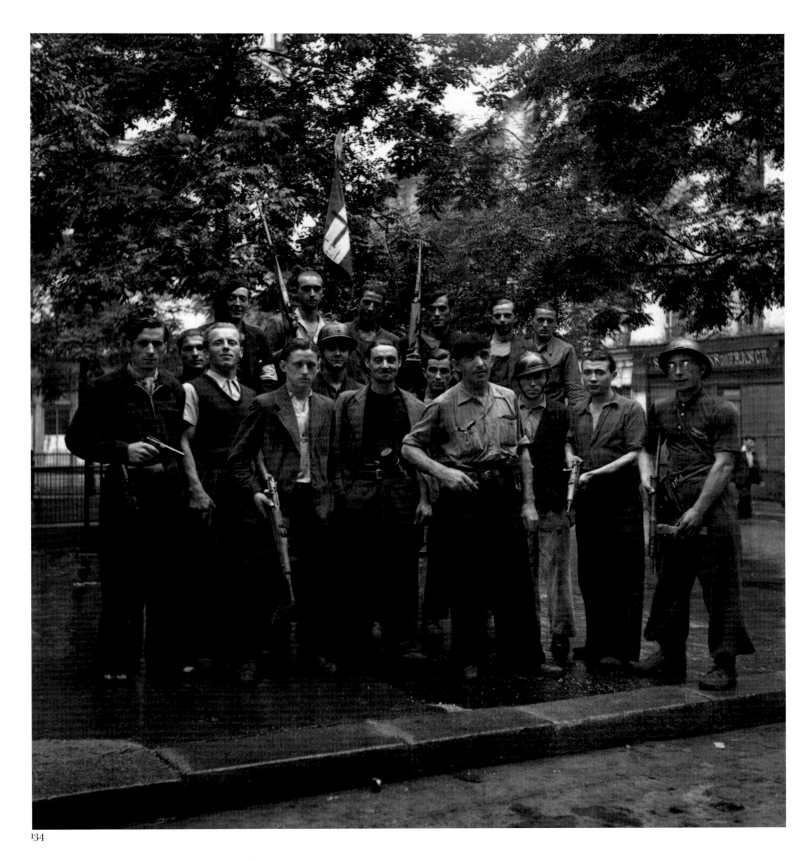

134

134. Les FFI de Ménilmontant (The Forces Françaises de l'Interieur at Ménilmontant), *Paris, August 22, 1944. "Arriving at rue de Menilmontant we came across a gang of FFI. They said, "Ah, you're a photographer? You must do a group picture." For me to make a group picture seemed like a waste of film! I'd taken two or three shots of the barricades already. So against my better judgment I had to photograph these guys. Now it just happens that this photo is one of the most important ones I made that day, the most charged with information, clothes, weapons, identity. . . . Sometimes having very little is useful."*

AFTER THE WAR

1945–1955

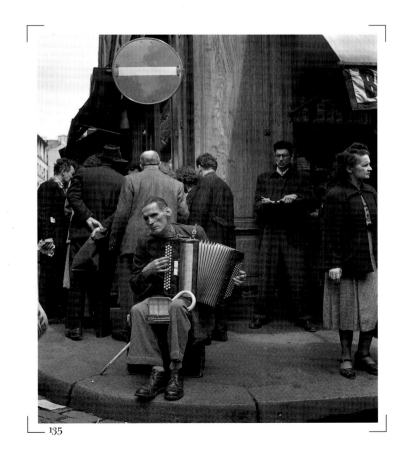

"It was in an extraordinary frenzy that, with the Liberation, I resumed the only métier I enjoyed. . . . It seemed to take a hopelessly long time. Just think: five years at Renault, where I couldn't make the sort of photos I wanted to, then the Occupation."

"You've got to struggle against the pollution of intelligence in order to become an animal with very sharp instincts—a sort of intuitive medium—so that to photograph becomes a magical act, and slowly other more suggestive images begin to appear behind the visible image, for which the photographer cannot be held responsible."

[I]N 1992 DOISNEAU WAS ASKED by Eamon McCabe, the picture editor for the *Guardian* whose sports photography and photojournalism had earned him wide renown, "Have you ever done any sports photography?" Robert replied with a chuckle, "J'ai fait *tout!*" ("I've done *everything!*"). And indeed he had done everything, from the most ordinary of local weddings to portraits of heads of state; from a drunk asleep on a subway grate to the count of Bestegui's masked ball in a Venetian palace; from a local cycling race in Gentilly to the internationally famous race at Le Mans.

In 1979, interviewed by Sophie Ristelhueber, Doisneau hinted that his photography concealed a more ambitious project, recognizably similar to that of Surrealism: "My little universe, photographed by scarcely anyone, has taken on an aspect so exotic as to have become the reserve of an amazing fauna. But I don't laugh at these images at all . . . even though, personally, the desire to amuse myself was great; indeed throughout my life I have amused myself, I've constructed my own little theater."

This "little theater" of personalities and places was assembled from the raw material of thousands of articles or commercial assignments, complemented by the occasions when he could stroll through the streets *"sans but précis"* ("aimlessly"), seeking only to amuse himself with what he might discover. Yet the "theater" was not a solitary affair; it depended to a large extent upon encounters and friendships with a whole cast of larger-than-life characters, among them the writer Blaise Cendrars; the cellist, skier, mountaineer, and actor Maurice Baquet; the journalist Robert Giraud; magazine editors Pierre Betz and Albert Plécy, and of course Jacques Prévert—Surrealist, poet, songwriter, screenwriter, and artist. "My life has been telescopic," Doisneau once said, "a series of fortunate or unfortunate encounters . . . a day-to-day improvisation. "

Doisneau was unwilling to see his photography explicitly aligned with any artistic movement. Yet his work does reflect important trends: for example, the "new vision" of modernism in the 1930s; humanist social realism in the 1940s and 1950s; montage and *art brut* in the 1960s. Almost from his first pictures of the banlieue in the early 1930s a guiding principle is evident: the opposition and tension between two elements of differing value, moral charge, or symbolic power. At its most clear-cut in pictures where statues form part of the composition, the simple opposition of the heroic (as exemplified by the statue) and the humble (often expressed by a person such as a child or perhaps a workman, or an animal such as a pigeon) is a visual device that delivers an immediately amusing image. He was not the only photographer to use the interplay of opposites in his work, but he certainly developed it to a high level during the period 1945 to 1960, conveying the intense spirit of *désobéissance* that underpins so much of his work. He discovered very early that placing or juxtaposing oppositional symbols in the same picture frame generated photographs that command attention. His photographs often give the lower-value element visual priority, subverting the established social and aesthetic orders.

As the range of his work developed in the 1940s and 1950s, Robert was able to play increasingly subtle tricks with the juxtaposition of opposites. A simple dichotomy such as good/evil could be almost indefinitely extended by overlaying it with others such as young/old, rich/poor, sacred/profane, erotic/virtuous, work/play, private/public, popular art/fine art, beautiful/

135. *Page 111:* L'Accordéoniste, *rue Mouffetard, Paris, Fifth Arrondissement, 1951.*

ugly, good taste/bad taste. The range of possible combinations is endless. Yet this was not simply a pictorial device. Perhaps reflecting the Cartesianism of French culture, Doisneau was fascinated throughout his life by the ways in which both culture and society tend to generate and maintain false oppositions, to construct means of exclusion through the imposition of simple dichotomies that define classes of things and of people: cultured versus popular taste; bourgeoisie versus proletariat, and so forth. These were the simple polarities of silent films, music halls, the *théâtre du boulevard,* popular songs, and the oral narrative tradition still widely practiced in the bistros and cafés of Paris. In drawing attention to such oppositions in a satirical or ironic fashion, he sought to undermine them by presenting them as faintly ridiculous, and in so doing tried to defuse their divisive charge.

Robert was able to use this approach to make photographs that attracted the attention of picture editors and viewers alike, and it became part of his stock-in-trade. It also begins to explain why he made so many photographs that feature statues as central compositional elements. Paris is a city in which official art is ever-present: symbolically charged monumental buildings signifying some event or other, statues, fountains, columns, even the organization of trees in public gardens. The geographical disposition of these elements over the city contains its own story of social, economic, and political divisions: for example, the bourgeois and conservative West vs. the republican and popular East.[1] The *désobéissance* of Doisneau's photography—itself rooted in the street, in public space—seeks then to deconstruct and defuse the hegemonic power of official art, to contrast it with the ephemeral but more vital representations of popular culture. The juxtaposition of a statue with lovers kissing, with children playing, with workmen eating, with Maurice Baquet playing a game, provides both an intriguing backdrop to the photograph and a reevaluation of the symbolic function of the statue. Generals have their authority undermined, political leaders their pomp deflated, famous artists their pretensions mocked.

Other forms of juxtaposition recur endlessly in Robert's photographs, making the image of almost any person or thing hint at deeper meanings. Late in life, when asked his views on what makes a good picture, Robert often referred to two principles to be used in the construction of an image that will command the viewer's attention and interest.

One was the graphic power of letterforms. Thus an image constructed in the form of a "V," for instance, is readily accepted by the viewer (see pl. 140). This is of course an example of a field-ground juxtaposition, where a strong graphic element on a visually confusing background pulls the image together.

The second principle is that photographs seeming to recall a parable, proverb, or symbolically charged story—particularly those encapsulated in a well-known image—acquire greater visual power. *The Last Supper,* for instance, or the *Mona Lisa* play the roles of visual-symbolic exemplars. Yet even here opposites come into play, for within these narratives there is typically a tension between good and evil, riches and poverty, beauty and the beast.

In France the period following the end of the war in May 1945 was marked by an intense urge for reconciliation and for reconstructive change. Much of France's industrial and communications infrastructure had been destroyed. Housing conditions were very poor, fuel was in short supply, and simply getting

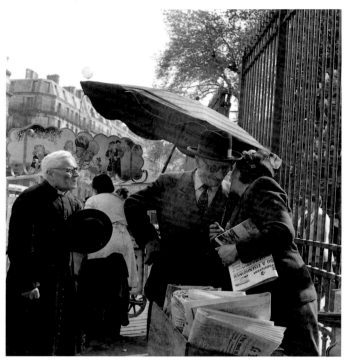

136

136. Aux Grilles de Luxembourg (By the Luxembourg Gardens Fence), *Paris, Sixth Arrondissement, 1953. A classic example of Doisneau's juxtaposition of opposing values (in this case the sacred and the profane) to give his images greater impact.*

137. *Page 115:* La Stricte Intimité (In the Strictest Intimacy), *rue Marcelin Berthelot, Montrouge, 1945. Like so many of Doisneau's great images, this one was made while he was photographing a local wedding for friends—the niece of his concierge, Monsieur Barabé.*

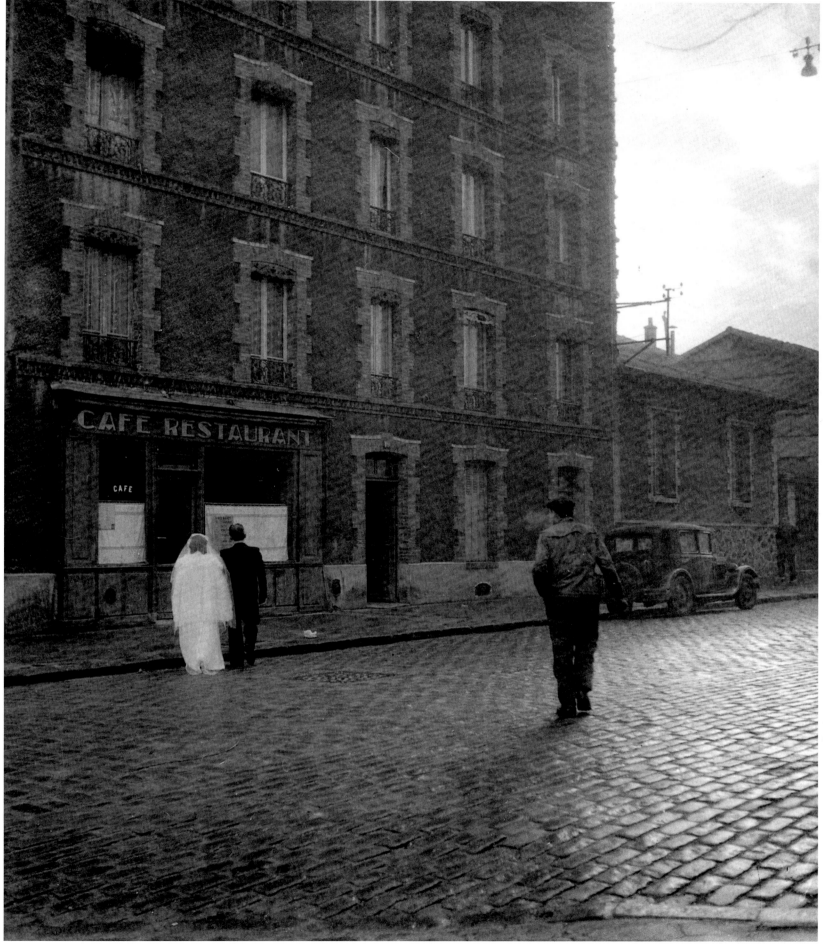

137

enough to eat was a major problem. Rationing continued, along with its inevitable counterpart, a powerful black market. Materially, then, conditions for the majority of the population became even worse in the immediate postwar period than they had been before the Liberation. By the winter of 1945–46, the food ration was lower than in the depths of the Occupation. To make matters worse, the *épuration* (purge) following Liberation made the wounds of political and social division harder to heal. But despite these problems, the younger generation, essentially those under thirty-five, found a renewed vitality, an appetite for life, which had been suppressed by the years of war and occupation.

The Liberation at last allowed Doisneau the freedom to make the kind of photographs he had always wanted to create. He seized the opportunities it provided, even the poorest paid: "It was in an extraordinary frenzy that, with the Liberation, I resumed the only métier I enjoyed. . . . It seemed to take a hopelessly long time. Just think: five years at Renault, where I couldn't make the sort of photos I wanted to, then the Occupation."

Most of Doisneau's photographs of the Liberation of Paris in 1944 were sold to American and British newspapers and magazines, as well as to the emergent French press. Later they would be used in several of the illustrated books on the insurrection that appeared between the autumn of 1944 and late 1945. In late 1944, largely due to this success, he was encouraged to join ADEP (Agence de Documentation et d'Edition Photographique)—a photographer's agency run on a "cooperative" basis. ADEP was in one sense the postwar rebirth of a celebrated agency of the 1930s, Alliance-Photo, and was constantly referred to as "Alliance" by those associated with it. Founded in Paris in 1934 by Maria Eisner, a Jewish refugee from Nazi Germany who had worked in the Berlin publishing industry, and the French photographers Pierre Boucher and René Zuber, it had steadily developed a wider membership of both French and emigré photographers. Eisner found that an increasing demand from the press for report and news photography (*actualité*) called for a different type of material, which was produced by freelance photographers. To meet this demand Eisner took on some new faces, and Alliance experienced a brief period of prewar fame as the agency that distributed the Spanish Civil War pictures of Robert Capa (Endré Friedmann) and those of his lover, Gerda Taro. Henri Cartier-Bresson and an emigré Pole, David Szymin (later known as Chim), were also associated with the agency. The outbreak of war brought the activities of *Alliance* to an end—and soon after the Occupation its archives were seized by the Gestapo, almost certainly because the agency was associated with a number of communist and anti-fascist photographers.[2]

After being interned at the Vélodrome d'Hiver in April 1940 as an "alien from Germany," Maria Eisner was fortunately set free during the *Grande Débâcle*, eventually arriving in New York in July 1940. Although she returned to Paris in 1946, what remained of Alliance-Photo had by then been reformed by Suzanne Laroche, a French photographer then married to René Zuber. Laroche and Pierre Boucher, whom she was later to marry in 1950, were the prime movers in the resuscitation of the agency as ADEP, and for a brief period the agency was able to attract many of the leading names of French photography. It was there that Doisneau came to know Henri Cartier-Bresson (although the latter recalled meeting Doisneau before the Liberation of Paris, probably shortly after Cartier returned from a prisoner-of-war camp in 1943)

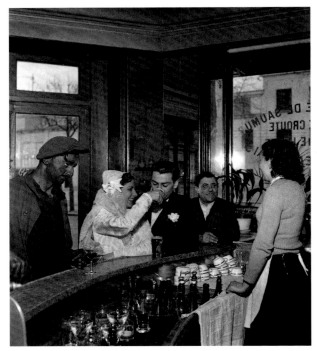

138

138. Café noir et blanc (Black-and-White Café), *Joinville-le-Pont, 1948. Photographed by Doisneau for a magazine story on the postwar marriage boom. "They aren't a real wedding couple, but models from the Joinville film studios. I asked them if they wouldn't mind me making a photo, yes, they agreed, and by chance in walked a* bougnat! *Of course it's a bit crude, the black and the white . . . in addition, he was very shy . . . you know, a guy completely black alongside all that whiteness, he is bound to be a bit awkward, and that creates a tension."*

139. Les Beaux Jeudis (Happy Thursdays): *the day French schoolchildren had as a holiday, rue Amelot, Paris, Eleventh Arrondissement, 1957.*

139

140

140. Les Gosses de la place Hébert (The Kids at the place Hébert), *Paris, Eighteenth Arrondissement,* 1957. *"I came across the boy and the young girl holding the tiny child by the hand. . . . It arranged itself like a bouquet: there's a V, the lines of the police box, the background, and the kids who come and put themselves in the center of this sort of angle."*

141

141. Danse à la fontaine (Dance at the Fountain),
Latin Quarter, Paris, Fifth Arrondissement, 1947.

142

142. La Descente à l'usine (Down to the Factory),
St.-Denis, 1946.

and a number of photographers who were to shape the humanistic photojournalism of the postwar era.

Alliance-Photo and ADEP have a place in the history of photography as early attempts to create the type of cooperative agency run for and by photographers that had so animated Robert Capa, and which led directly to the founding of Magnum in 1947. Yet ADEP was far from being the sort of organization that Capa had dreamed of. Doisneau recalled that although he consigned most of his Liberation photographs to the agency—and they apparently sold well—he found it very difficult to make any money from his association with ADEP, which continued into 1946. "The people were not very careful to make sure you got paid. I worked very hard for them. All day on assignment, all night in the darkroom. And I was very rarely paid! Alliance took all my liberation pictures, and I never received a *sou.*" Robert found it galling to be making do with an old camera while other members of the agency were proudly using new and expensive equipment.

This was occurring at a time when in Paris alone some thirty-four daily papers were being published in the harsh conditions of 1945, despite a lack of paper and other materials, as compared to thirty-two in 1939. Yet the demand for illustrative photography was extensive. New magazines continued to appear, and one, *Paris-Match,* would become a huge success, but many soon disappeared or merged with other titles. Although they supplied a constant flow of work, the pay was extremely poor. The social role of photojournalists was recognized and their status elevated, but none could survive simply on low-paid reporting work, and their typical range of activities included advertising, portraiture, industrial photography, public-relations work, and travel photography. Doisneau was not alone in assembling collections of images of Paris, photographs that could be used to illustrate travel books, brochures, postcards. Specialization did not yet exist.

Robert Doisneau first came across Raymond Grosset in January 1946 because he had heard that the RAPHO agency might be starting up again. Grosset, who had dabbled a little as an amateur photographer before the war, was on friendly terms with several of the Hungarians for whom Charles Rado ran an agency: Brassaï, Nora Dumas, Ylla,[3] and Ergy Landau. The latter had been associated with Doisneau's friend Lucien Chauffard in 1938–39 and had helped Doisneau make contact with Rado: they must have been good friends, for she had left some equipment for safekeeping with Doisneau during the Occupation.

Before the war, Grosset had worked in cinematic film processing, running a laboratory in Finland for a film-production company when hostilities had begun. After the *Débâcle* he went to England with de Gaulle, and following distinguished war service in the Free French forces returned to Paris in late 1945, unsure of what to do. His father had a place for him in the family metal-gilding business, but Raymond had no interest in such a job. "One day I came across an old friend, Ergy Landau. I confided my problem to her and she said, 'Why not start up the RAPHO agency again? You know us all, it would be very simple.'" Rado had decided to stay in New York, for he had begun a very successful collaboration with Black Star, and his own agency—now known as RAPHO-Guillumette—was thriving. Ergy Landau knew that Rado wouldn't come back to Paris, so she saw in Grosset someone in whom she and her colleagues (Brassaï, Nora Dumas, Ylla, Emile Savitry) could have confidence.

143

144

143. *Racing driver Jean Behra and engineer Amedée Gordini with Simca-Gordini Grand Prix car, 1952.*

144. *Spectators at the twenty-four-hour Le Mans, 1953.*

145. *Spectators at the twenty-four-hour Le Mans, 1953.*

145

With the current demand for images, it was a good time to start a photographic agency. Only the big American titles—such as *LIFE, LOOK, Collier's,* and *Harper's Bazaar,* which all maintained Paris offices from the mid-1940s onwards—could afford to pay the really big sums justified by their large readership and massive advertising revenues. As one of Robert's colleagues, Willy Ronis, pointed out in an article in 1948, the economy was in so poor a state in the latter half of the 1940s that the French weekly illustrated magazines were hard pressed to print a maximum of sixteen and occasionally twenty-four pages per issue, at a time when *Picture Post* in Britain was regularly printing forty pages and *LIFE* between seventy and one-hundred-forty pages.

Raymond Grosset recalled his first visit from Doisneau (January 1946?):

> He came to me with his photos when he learned from Ergy Landau that RAPHO was reopening. Then he gave notice at Alliance Photo in order to rejoin us.
>
> I began by sending his work abroad, because the French market was so poor, almost nonexistent. In February 1946 I went to Britain to try and sell some work by Brassaï and Doisneau (in particular his series on the Liberation of Paris and his photos made in the same places in August 1945).[4] Almost right away we began to work with *Point de vue*; Robert's assignment was to photograph the naturists who lived in the big trees at Meulan-sur-Seine [pl. 153].

Grosset was then operating out of a room in his parents' apartment in rue d'Alger, a narrow street between the rue St. Honoré and the rue de Rivoli, near the Tuileries gardens and within an easy bicycle ride of the editorial offices for the main illustrated magazines. He would even cycle over to Montrouge to see Doisneau: Robert remembered him coming to discuss terms for a commission that Grosset offered him while he was still formally with ADEP. "Grosset said, 'I'll take a certain percentage and pay you when I receive the money from the client.' I was a bit skeptical after the experience with *Alliance*. What about a test? O.K., he gave me a sort of *commande*, go and do some pictures at Meulan for a revue. He came next day before noon to collect the prints—on his bike! He went away and the next day he came back with 250 *balles* (francs)—it was incredible! He said, 'I've kept my commission, 50 francs.' I was amazed. He was so honest."

Later, in an interview published in 1974, Doisneau summed up why his collaboration with the *RAPHO* agency had lasted so long: "Raymond Grosset is organization personified, something of which I am incapable. If someone wants a photo for a particular date and comes to me, they risk not getting it, because I'm thinking about something else. That's when Grosset comes in, kindly but firmly, and everything is sorted out."

In joining RAPHO he was simply squaring the circle of a set of determining influences that located him as a quintessentially French photographer. It also ensured that his work—despite its visual power and charm—remained confined to a largely French audience, notwithstanding occasional forays into such magazines as *LIFE, Esquire, Collier's,* and *Picture Post.* As Raymond Grosset saw it, there was a constant problem in getting Doisneau's work accepted by the American picture editors who set the media agenda of the

146. *Advertising photograph for Nestlé, using Doisneau's daughter Francine as model, early 1950s.*

146

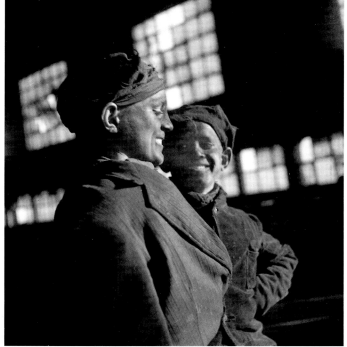

147

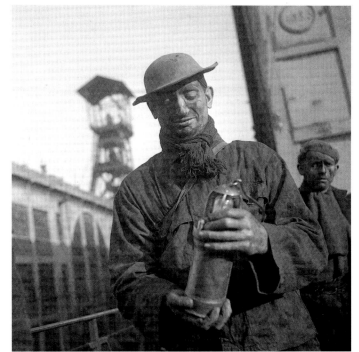

149

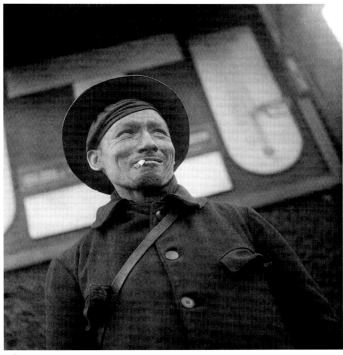

148

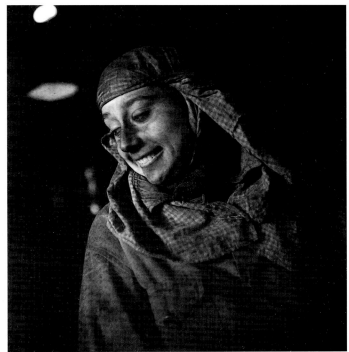

150

147–50. *Photographs made during Doisneau's reportage for* Regards *during the coal crisis of 1945, Lens, 1945.*

147. *"Galibots" (argot for boy-miners).*

148. *Miner.*

149. *Miner.*

150. *Woman Coal-Sorter.*

time. Speaking only French, Doisneau was unable to work with English-speaking journalists, and in being "polyvalent" he was immediately suspect to editors who always preferred a "specialist." Grosset was familiar with the practices of American editors, for he was a fluent English speaker; on his bookshelves can still be found a copy of the book *Words and Pictures* (1952), by the photo/editor at *LIFE,* Wilson Hicks. No comparable book, setting out empirically based rules and principles of photojournalism, existed in French. As Henri Cartier-Bresson later stated: "We were considered little different from minor tradesmen. And we, we thought of ourselves as a little world: people like Doisneau, Capa, Chim, and I felt that it was vulgar to talk about photography when we were together."

Robert recalled that his Liberation pictures brought him into contact with *LIFE* magazine while he was still involved with *Alliance.* "After those photographs were in the magazine, I was asked to do a couple of things: a report on the *chasse aux palombes* [pigeon hunt] in the Pyrénées, and then one on the vote for women (introduced for the referendum of October 1945).[5] I didn't ask for anything, but they said to me, 'Do you need an airplane, a car?' C'est fou, hein? They had incredible resources." This was at a time when Doisneau rarely had two films (twenty-four frames) available for a report for the French press. He had been forced on some occasions at the end of the Occupation to use sheets of fifty-by-sixty-centimeter film intended for photoengraving, and to cut them into six-centimeter-wide strips in the dark, winding them into used 120 bobbins with the old paper covering: "It made a thick film, so you only got six frames, instead of twelve." After the Liberation film became much more readily available on the black market, and the need to go to such complicated lengths diminished.

Thanks to the increasing numbers of his photographs appearing in French, British, and American magazines, Robert's quite distinctive approach was beginning to be noticed. His star was ascendant, and in late 1946–early 1947 Maria Eisner came to see him to talk about joining the cooperative agency she and Robert Capa were planning to start with George Rodger, William Vandivert, Chim, and of course Henri Cartier-Bresson, whom Doisneau had known since the Occupation period.

> Maria Eisner, perhaps at Cartier's suggestion, came to ask me to join Magnum. We met at the Cameron restaurant near the Opéra. . . . This was after Raymond Grosset had asked me to work with him. . . . I said, "Listen, it's a shame but I've just promised Raymond Grosset that I would work with him, and moreover he is starting up RAPHO again, he's a great guy, so I think I'm really obliged to stay." Chance played its hand well, because I would have been a bit overwhelmed at Magnum. They sent you on big assignments—India, China, etc. I don't like traveling, I only speak one language, and I photograph best people who are most like me. It's a sort of transposition of my personality into theirs.

Doisneau was loath to join a new agency that might not be able to pay him properly and might even want to assign him to work outside France; neither were congenial options to a man who only spoke French and had a family to raise (Francine, the second daughter of Pierrette and Robert, was born in

151

151. *Raymond Grosset at his desk, Agence RAPHO, Paris, 1967.*

152. Les Enfants des mineurs à la ferme (The Miner's Children on the Farm), Regards, *May 11, 1948. Cover photo by Doisneau, part of a reportage on the miners' children who were sent to foster parents during a long strike in northern France. Robert and Pierrette Doisneau looked after one of these children.*

152

153

153. *Naturists in the trees, Meulan, 1946. Doisneau's first assignment for Raymond Grosset's resuscitated RAPHO agency: an article on a naturist group who lived in the trees.*

1947). Henri Cartier-Bresson recalled that Robert told him he did not want to join Magnum because "If I were to leave Montrouge, I would be lost." It is worth noting that the offer came at a time when Doisneau was becoming ever more deeply immersed in his own study of Paris and Parisians. The RAPHO agency, then, was set up in early 1946, with Ergy Landau, Brassaï, Nora Dumas, Ylla, Emile Savitry, and Robert Doisneau on its books, to be followed soon after (in 1947) by Willy Ronis.

In 1947, Grosset took Robert to London. He was sure that it would be possible to sell Doisneau's work to the British magazines, such as *Picture Post*[6] and *Illustrated*. While in London, Grosset introduced Robert to Bill Brandt, who took great interest in his pictures of the Liberation of Paris. Robert took several photographs featuring well-known landmarks (the Houses of Parliament, Trafalgar Square, Tower Bridge), but there are also some of East End pubs and street markets, at the round pond in Kensington, in the London Underground, and outside a "surgical goods" store (a sex-aids and contraceptive shop!).

Certain of these images suggest that Doisneau saw London, in the grim postwar years of austerity, in similar ways to the American photographer Robert Frank, who three years later would visit the city to make some classic images. In 1950, Doisneau returned to make a more extensive and detailed set of photos, on commissions for the *Daily Mirror* and *Sunday Pictorial* newspapers and for *Esquire* magazine. The latter article, "Soho: London's Casbah," used an image of an alley reminiscent of those Doisneau was making during his nocturnal adventures in Paris with Giraud. Other photographs made on this second trip also echo themes already developed in Paris: for instance a series of *regards obliques* (sideways glances; pls. 165–66), in which Doisneau set himself alongside and inside a shop selling women's underwear and watched passersby for their reactions to the goods on display. Grosset suggested that the initial aim had been to photograph how the English looked at women: but "the assignment was a failure. According to Robert, they only looked at their reflections in shop windows!" Failure or not, these images connect with Robert's typical concern with puncturing authority. During the trip he also visited the English south coast, creating a marvelous image of a seaside theater (pl. 161). Other photos are simply humorous: elderly women bowling; dog-fanciers in Crufts Show in Olympia (pl. 164), a pair of construction workers taking tea on a building site. Yet the Chalkwell Beach Theatre image and a photograph of a bedraggled man on a path by a river (pl. 162) are much less easily "readable" at first glance. They attest to Doisneau's search for a genre of photography in which enigmatic and mysterious elements come into play, and which little by little he was discovering in his work where the image is less *construit* (set up) and more left to chance—for instance *Mademoiselle Anita* (see pl. 253).

The RAPHO agency under Grosset's leadership eventually took over the whole apartment in rue d'Alger. From being mainly a photographer's agency, RAPHO evolved into an image bank, for the archives were increasingly the source of its income. Doisneau was the "factotum" on the agency's books, the man who would try anything: within the agency's files of myriad photographs, stored in heavy cardboard boxes piled up against the walls, there were many by Doisneau. Until at least the early 1950s, life was extremely penurious for the *photographe-illustrateur indépendant*. RAPHO had only

154

154. *Robert Doisneau, self-portrait with thirteen-by-eighteen-centimeter wooden camera, Montrouge, 1946. This photograph was made at approximately the same time as the series on the Cyclocross à Gentilly (pls. 155–59).*

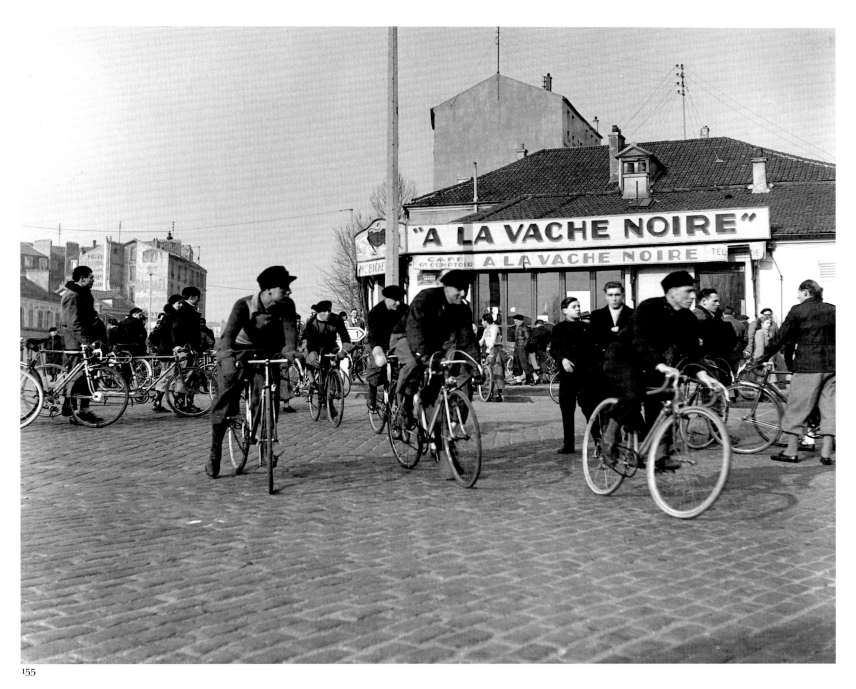

155

155–59. *Pages 127–129: From the series Cyclocross à Gentilly, 1946. This series showing a cycling race in the quarry at Gentilly was made soon after Doisneau had arranged to produce his book on the banlieue with Blaise Cendrars (see Chapter 5).*

155. *Cyclists at the Vache Noire, a famous meeting point on the main road between Montrouge and Gentilly, 1946, photographed just before the event began.*

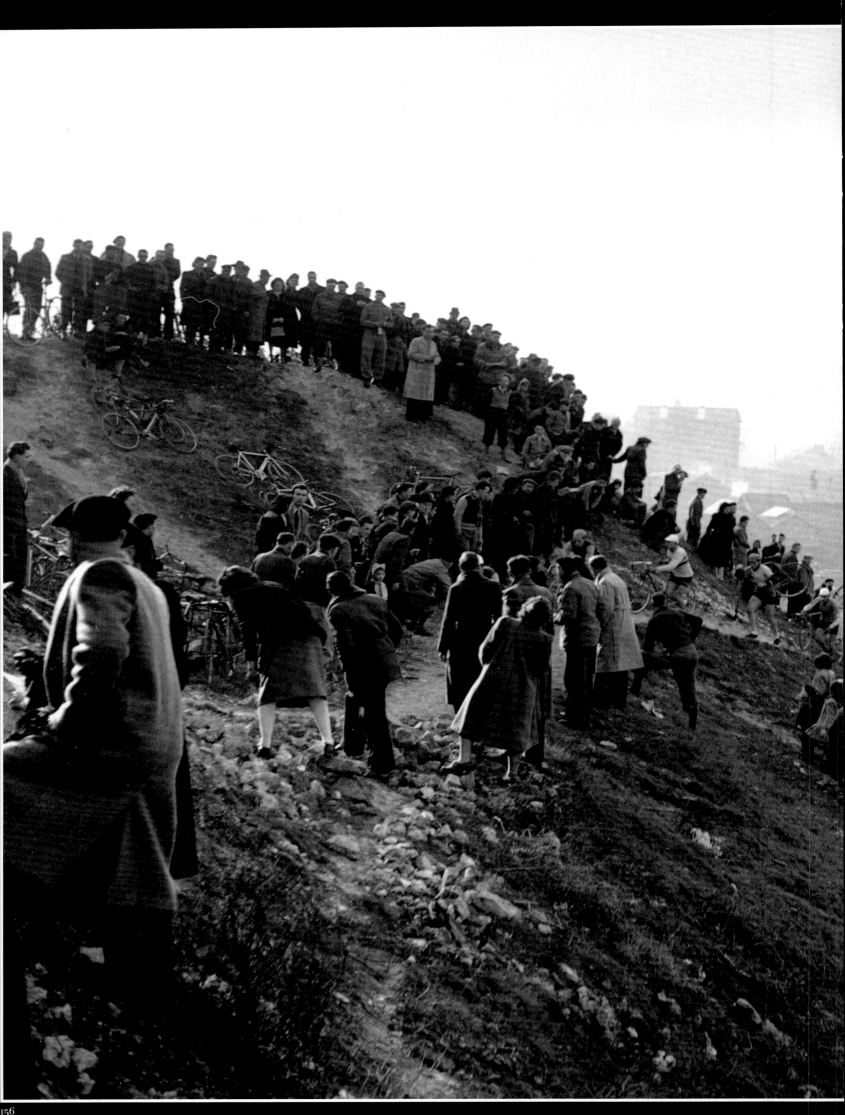

156–59. *From the series Cyclocross à Gentilly, 1946. Six-by-six-centimeter contact prints. Here Doisneau is clearly fascinated with the contrast between the stark architecture of the HBM buildings on the rim of the quarry and the crowd spread out to watch the event.*

one full-time freelancer on its books—Doisneau. The rest of the photographers represented by Grosset had other sources of income—a studio, a contract with a magazine or newspaper, or a regular commercial client.

Despite his importance to the agency Doisneau was not able to obtain support for his project on the banlieue, then still in gestation. Raymond Grosset was less than enthusiastic about the idea: in the late 1940s, he had seen the banlieue work as unimportant. "At the time Robert came by every three or four days to show me his photos of the banlieue. I said to him 'Listen, your banlieue is sad, how do you think I can sell sadness? Fortunately, he didn't follow my advice." When asked if RAPHO had influenced his work in one direction or another, Robert said:

> Not at all. I always resisted that. Raymond said to me, "Don't waste your time with this business on the banlieue, it's a shame to see you do things like that. I've got an assignment from *Plaisir de France* on the banks of the Marne, it's virtually an official one. . . ." But I knew that I wanted to do my project on the banlieue.

Doisneau often repeated his view that "time is a precious commodity," and it must have seemed to him that so much of what he was obliged to do during this period—though it paid the bills—wasted this *denrée de luxe*. In November 1948, in a letter to Pierre Betz, editor of *Le Point,* Doisneau indicates that things have become so bad that he might have to devote himself to other work:

> *Le Point* must not go under—*zut*—it's a bad time for business, but one shouldn't give up. All the publishers are having a hard time. I see it as well, no new commissions for interesting things—only the humdrum assignments for weekly magazines, so I've had a very poor October—although things are now going a bit better—I'll end up doing weddings and functions—they're more reliable and better paid than wandering about from this to that.

Thankfully, Robert Doisneau did not decide to specialize in *noces et banquets*, but he photographed many such functions, for friends, family, and clients. That he was usually able to find images of enduring fascination within them attests to his vision and his skills: some were used in *La Banlieue de Paris.* Years later while attempting to caption photographs he would note:

> You've got to struggle against the pollution of intelligence in order to become an animal with very sharp instincts—a sort of intuitive medium— so that to photograph becomes a magical act, and slowly other more suggestive images begin to appear behind the visible image, for which the photographer cannot be held responsible.[7]

This is why Doisneau would work on projects for which the pay was derisory, for they offered the prospect of creating images where the "magical" and the "real" fused. Indeed, a *Le Point* assignment paid so little that Doisneau and Grosset agreed that the photographer and Betz should deal directly with each other.

160. *Page 131: Street scene, London, 1947. Raymond Grosset took Doisneau to London in 1947 and again in 1950 to try to interest British magazines such as* Picture Post *and* Illustrated *in his distinctive approach. While in England Doisneau made several pictures that transcended banal travel imagery.*

161

161–62. *Pages 132–33: In 1950, Doisneau returned to England to make a more extensive detailed set of photographs, this time on commissions for the* Daily Mirror *and* Sunday Pictorial *newspapers and for* Esquire *magazine.*

161. *Chalkwell Beach Theater, England, 1950.*

162

162. *Thames Towpath, London, 1950.*

163

163. Pierre Betz, *Souillac, Lot, 1954.* "*It was he who opened Picasso's door to me, as he did those of Georges Braque, Jean Lurçat, Henri Laurens, Marcel Gromaire, and Colette. Pierre Betz could have borne the title of creator of the review* Le Point. *He was at the same time the literary director and art editor, head of the advertising department and the mailroom supervisor. To accomplish these varying functions, all he needed was a table in the Café de Paris at Souillac. That was his office, his command post. He only left it for brief trips to Mulhouse, to the printing press of his friend Pierre Braun, where he went to supervise the printing of an issue, and he returned quickly to his table to write the address labels for his loyal subscribers.*"

164–66. *Pages 134–35: These photographs were made by Doisneau on his 1950 trip to London. The sideways glances series (165–66) echoes themes he had already developed in Paris.*

164. *Crufts Dog Show, Olympia, London, 1950.*

164

165

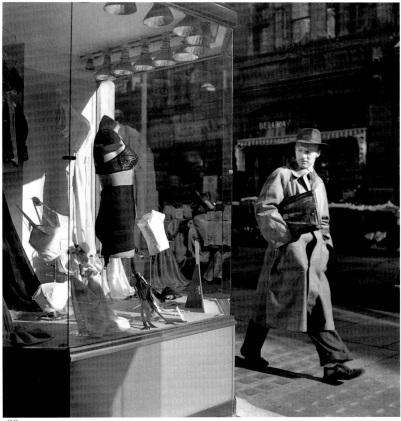

166

165. *Lingerie shop window, London, 1950.*

166. *Lingerie shop window, London, 1950.*

Through Pierre Betz I got to know lots of people—Lurçat, Vercors,[8] Picasso, Braque, Léautaud,[9] etc.—and with my friend Giraud I did something for him on *bistrots*. Betz was just about to bring out an edition of *Le Point* with my photos of Simenon when he died. I was really thought of as a friend, and by Braun, the printer of *Le Point,* as a good supplier.

In the same letter as that cited above, Doisneau refers to the fact that he will send Betz a list of potential subscribers to help the journal's finances.

During the war, Doisneau had photographed briefly in the Lot region of France, producing reportages on truffle growing and on the local folklore. It was a region he had fallen in love with before the war, camping and canoeing there. In 1945 Pierre Betz asked Robert to produce a series of photographs of Jean Lurçat's work for the Aubusson tapestry works, to be published in *Le Point.* Lurçat (1892–1966), a contemporary of Fernand Léger, had devoted himself to tapestry after a brief career as a Cubist painter, working from 1937 for both Aubusson and the Gobelins works. He lived in St. Céré, and while there Robert met Jean Cassagnade and his nephew Pierre Delbos, who were in the process of founding a dance-hall and exhibition site called the Casino (so named because when it was built in 1945 it was hoped a gambling license would be granted). Betz—who was based nearby at Souillac—evidently had good local contacts, for he found Doisneau some work producing photographs for postcards and leaflets used by the local tourist bureau. Thus began a close relationship with both St. Céré and the Casino, which lasted until Doisneau's death. Robert and Pierette developed a close friendship with Pierre and Andrée Delbos, visiting the area for holidays as often as possible. Robert would later help organize exhibitions at the Casino, including one of Picasso's engravings and ceramics.

One assignment that did pay well came in early 1950, from *LIFE* magazine via Charles Rado in New York. RAPHO in Paris was continually seeking assignments like this, at a time when the French magazines paid very little, even for a cover image. Doisneau was lucky if photographs for these French magazines brought in three hundred francs (figure adjusted to 1990 value, the equivalent of forty-five dollars), while a story sold to *LIFE* earned twenty or thirty times that figure! The idea behind this particular assignment was hardly original: romance in springtime Paris. It was designed for Doisneau, who had already begun to develop a series on *les amoureux*. As he had learned in creating a number of his contemporary photographs—a series on weddings in the banlieue included the photograph now known as *Café noir et blanc,* later used in *La Banlieue de Paris*—Doisneau knew that the only way to carry out such a task was to use *figurants* (models) and to place them in interesting situations using very "Parisian" settings as backdrops. Among the models were two young actors, Françoise Bournet and Jacques Cartaud. Doisneau paraded them around, photographing them in the rue de Rivoli, the gare St. Lazare, Palais d'Elysée, rue de Rivoli, Pont-Neuf, by a street market in the Latin Quarter, on a three-wheeled delivery cycle, on the quays of the Seine, by the square du Vert-Galant, and by the pont Henri-Quatre. At the metro at Opéra an interesting long-exposure shot (five seconds) was made, in which the lovers are isolated from the crowd, whose movement turns them into a blur. This was eventually used as the opening photograph for the *LIFE* article "Speaking of

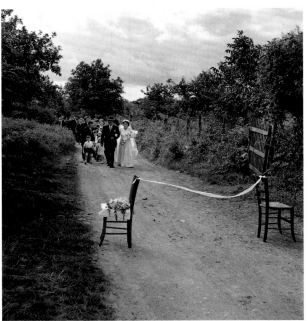

167

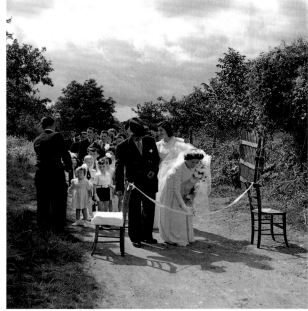

168

167–69. *Pages 136–37: The series Un Mariage à la campagne, Saint Sauvant, Poitou, 1951. Contemporary RAPHO captions: "During August Robert Doisneau had the good fortune to be invited to the center of France for the wedding of a farmer's daughter, with whom he and his little girl had stayed during the German occupation . . . in the Vienne, one of the regions where folk traditions have been best preserved. The bride, Anne Motillon, is eighteen and the young bridegroom Gilbert Macheteau is twenty-four. Both are from farming families, live in the same village, and have known each other since childhood.*

The whole marriage party is formed up as a cortege and walks the two-and-a-half miles that separate the Motillon's farm from the village. In front of each house along the route a ribbon is tied between two chairs."

168. *"The bride, led by her father, approaches the ribbon and cuts it with her scissors, while her father places some money on the chairs. It is a custom that probably derives from the ancient toll-right."*

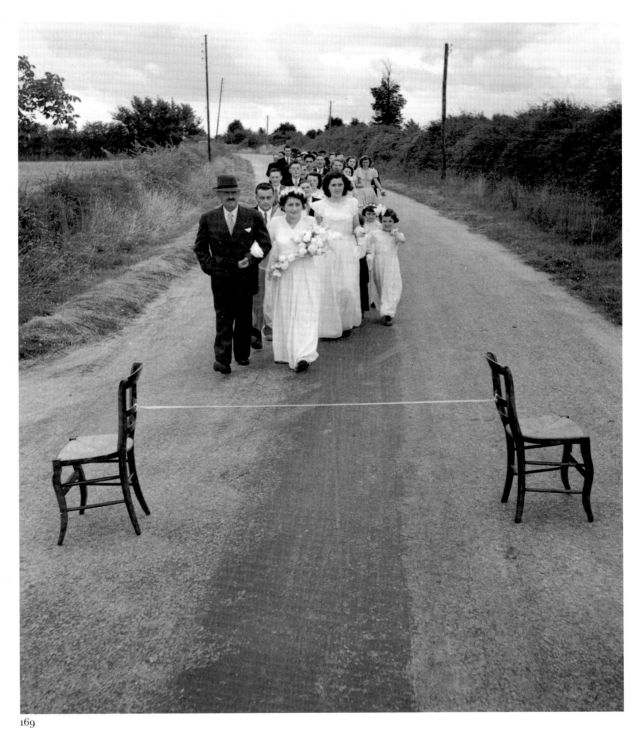

169

169. Le Ruban de la mariée (The Bride's Ribbon), *Saint Sauvant, Poitou, 1951.*

Pictures . . . In Paris Young Lovers Kiss Wherever They Want and Nobody Seems to Care" (see pls. 173–77). Several shots feature at least one other young couple. The pictures were naturalistic, for at least some of the models were in love at the time. Yet for Doisneau, the assignment was "a bit corny" and its images never figured in his personal list of favorites. However, the resulting article with its series of photographs was extremely popular in *LIFE*, attracting a good deal of correspondence. It was published later in a slightly modified form in the French paper *Ce Soir* as "the photo story that delighted Americans." The images were presented as being "unposed pictures" by *LIFE,* a journalistic sobriquet that was entirely in keeping with the vocabulary of such "human interest" stories at the time. Given its origins, it is remarkable that the pseudo-documentary form of the story would so many years later generate such controversy in the case of one image: *Le Baiser de l'Hôtel de Ville* (see discussion in Chapter 9). While this is an *image à la sauvette,* the record of a "decisive moment" (as Cartier-Bresson's phrase has come to be rendered in English), it has acquired a notoriety that goes far beyond its merits as a photograph per se.

RAPHO's modest initial success and subsequent development was connected to the French public's seemingly insatiable thirst for illustrated magazines (*Paris-Match, Réalités, Point de vue, Regards*). This *folle soif d'images* seems to have been in large part a response to the agonies and deprivations of the war years. Doisneau himself argued that the time was one in which there was a huge demand for photographs in *très mauvais goût* (very bad taste) and that he saw this as a very healthy sign and something to which he contributed (for example in such images as *Le Regard oblique* and *Fox-terrier sur le pont des Arts*). The central theme of much of this imagery is the search for ways of representing a quintessential Frenchness, a means of picturing France and the French that could help to heal the wounds of a society divided by war, defeat, occupation, collaboration, and resistance. The visual approach and social perspective of humanistic reportage produced the images demanded by such a market. Humanism, in this context, is the egalitarian representation of major issues and concerns through their impact on specific individuals—usually "ordinary people," although not exclusively from the *classe populaire*. This representation implies that both the viewers of such imagery and the people represented in it share a common humanity. Class, ethnic, or gender divisions are submerged in the idea that all are part of the "Family of Man." In the mid-1950s Edward Steichen's great photographic exhibition at the Museum of Modern Art in New York took this idea to its logical conclusion.

Photographers working in the humanistic style, particularly as it developed in Europe and America after 1945, tended to employ "straight" photography, moving away from the overt formalism of composition evident in the 1930s—for example, the use of the tilted frame to preserve a strong diagonal—in favor of movement, emotion, and a sense of "being there." The contrived painterly effects of pictorialism had by now been long consigned to the parochial reaches of the most backward salons of amateur photography. Humanism (known under several rubrics in other settings, such as *subjektive Fotografie* in Germany, *neo-realismo* in Italy,[10] and "concerned photography" in the United States was the dominant visual mode in the reportage photography of this period, and characterized the visual style and content of the leading

170. *Page 139:* Les Vingt Ans de Josette (Josette's Twentieth Birthday), *Gentilly, 1946. This photograph was widely used by the chief clients of the RAPHO agency in the 1940s (by the Catholic and Communist presses) and also appears as a section head image for "Dimanches et Fêtes" ("Sundays and Festivals")* in La Banlieue de Paris. *Used in* Regards *magazine to illustrate an article on the class solidarity of French working-class youth, it also appeared in a Catholic magazine to illustrate an article about the Easter festivities with this caption: "As the farandole shown above makes the great austerity of these blocks of flats disappear, the resurrection of Christ and the new life that is given to us renews everything."*

171–72. *Pages 140–41:* Bal du 14 juillet, Environs de la rue des Canettes, *1949. Doisneau often photographed public holidays such as Bastille Day, but on this occasion he began before noon and continued right up until the small hours. The series provides a wonderful insight into the* fêtes populaires *of the 1940s.*

171. *Contact sheet.*

172. La Dernier Valse du 14 juillet (Last Waltz on Bastille Day), *1949. This picture is the very last of the series made on July 14, 1949. A charming, romantic image, it expresses as well the communal spirit of the postwar reconstruction period.*

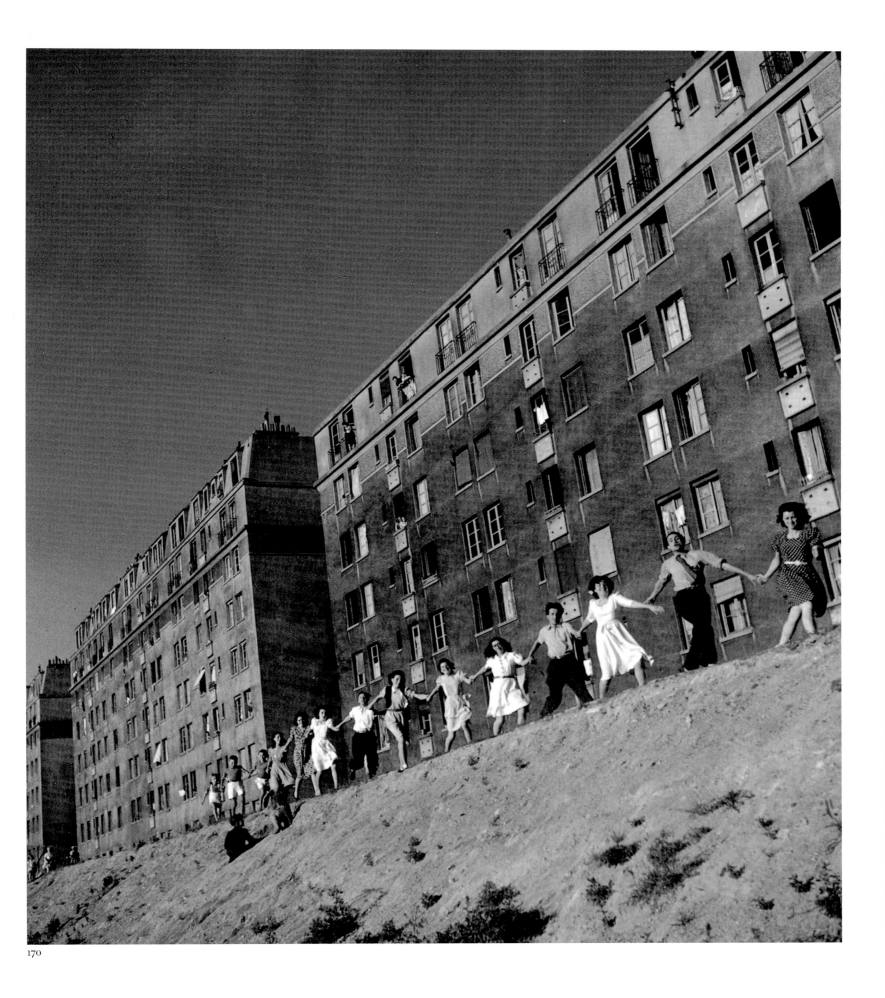

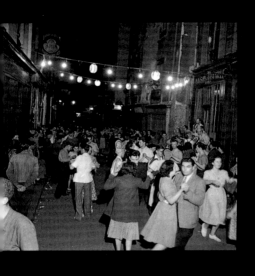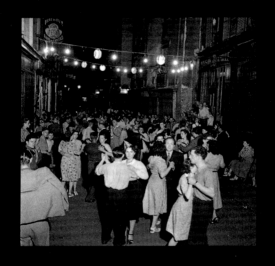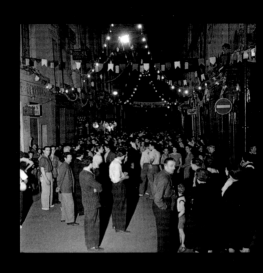
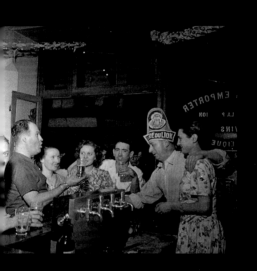
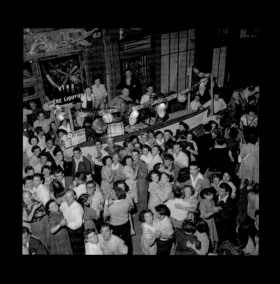
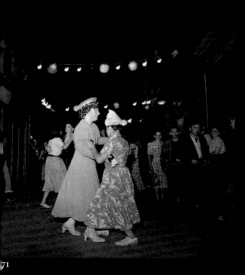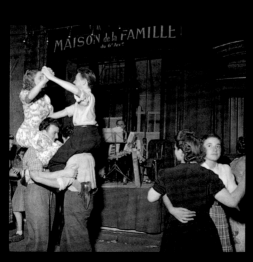

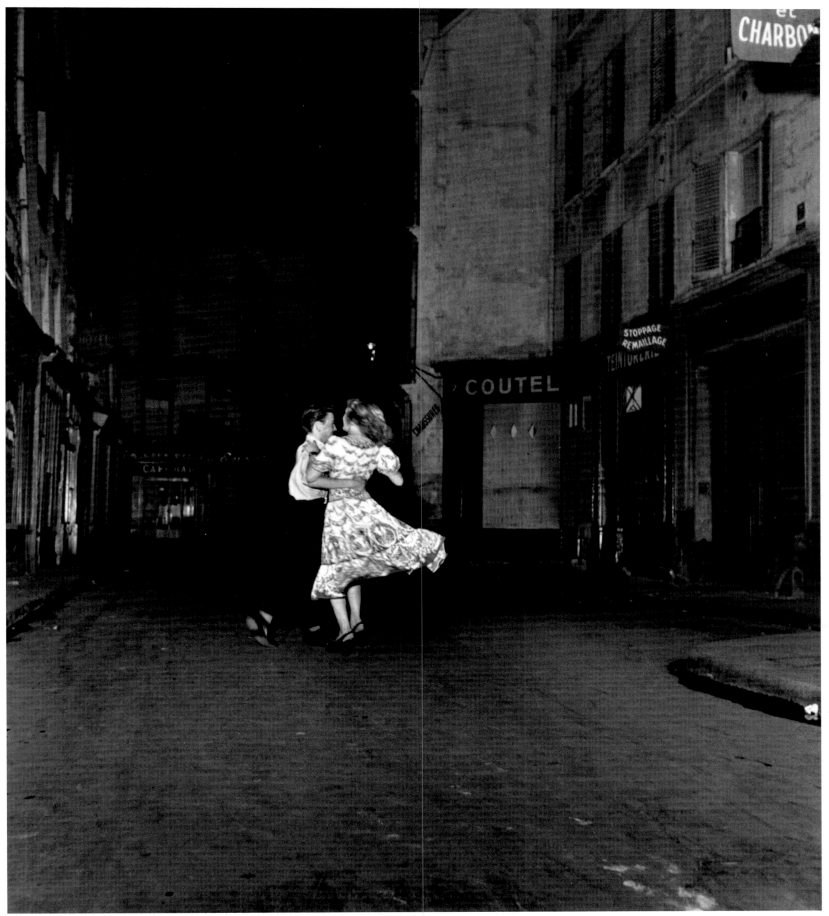

173

175

173–77. *Photographs from the* LIFE *assignment on young lovers in Paris, 1950. Doisneau did not risk using images of real couples kissing; he employed a number of models (mostly actors-in-training), placing them in interesting situations, with highly "Parisian" settings as backdrops. In each case he sought to reproduce the same gestural grace he had observed in other young lovers as they kissed. Only in the now famous* Le Baiser de l'Hôtel de Ville *did he capture an embrace that has the real feeling of authenticity, a quality that has made it an enormously popular photograph.*

173. Les Amoureux en triporteur (Lovers in a Three-Wheel Cart).

174. Le Baiser du quai (Kiss at the Quay), *Paris, 1950.*

175. Les Amants du Pont-Neuf (Lovers at Pont-Neuf). *This photograph, taken on the oldest bridge in Paris, inspired the film director Leos Carax to use a similar location for his film of the same title in 1992.*

176. Le Baiser aux poireaux (Kiss with Leeks).

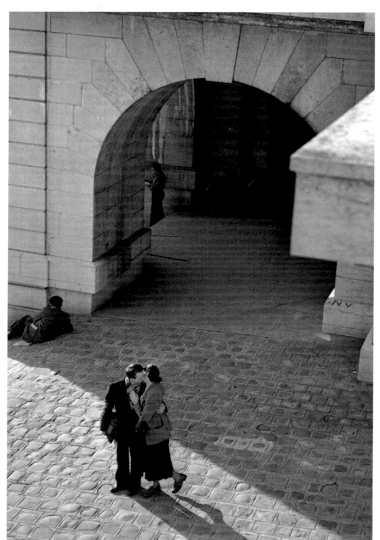

174

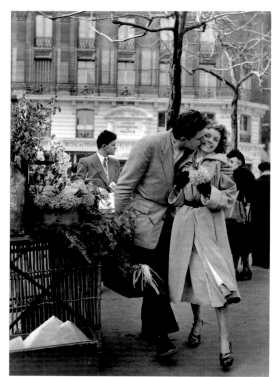

176

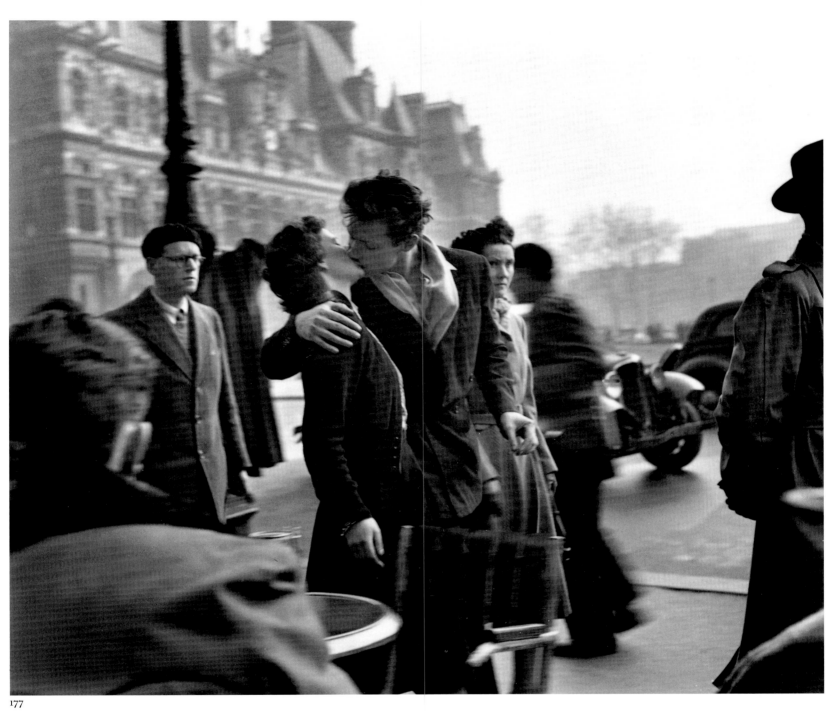

177

177. Le Baiser de l'Hôtel de Ville (Kiss at the Hôtel de Ville), *Paris, Fourth Arrondissement, 1950.*

illustrated magazines of the era, such as *LIFE, Picture Post, Regards, Stern,* and *Paris-Match.* Humanism was the common viewpoint of a group of internationally known photographers: Eugene Smith, George Rodger, Henri Cartier-Bresson, Dorothea Lange, Chim, Werner Bischof, Robert Capa, Bert Hardy, and, of course, Doisneau himself. The Magnum agency, in particular, articulated and developed humanism as a photojournalistic philosophy. In postwar France humanistic photography was quite closely linked to ideas about social realism that emanated from the cultural philosophy of the French Communist party (Parti Communiste Français, PCF), an expression of the populist cultural trends of the Reconstruction era, which exemplified the need to create a modern France that would not be riven by class divisions.

The RAPHO agency played a vital role in the propagation and diffusion of this approach, for its main clients were the Communist and the Catholic presses. Each developed ideological positions that were illustrated by their choice of subject matter and its treatment in the magazines they controlled. Catholic humanism, or "personalism," was in part a response to what the church saw as the dangers of the postwar intellectual craze—existentialism—which seemed to offer the possibility of action and behavior no longer informed by the moral authority of Catholicism. By contrast the Communist press was involved in a struggle to contest existentialism on different terrain. In each case, there was a demand for imagery that took as its theme the issues facing ordinary people in every sphere of their lives. Typically these magazines presented the ordinary Frenchman or Frenchwoman—perhaps a young woman typing her letters by the Seine on a hot day, a child playing in the streets, a pair of *cheminots* (railway workers) about to board their steam engine, a doctor going about his duties in the banlieue, an old lady or a curé in a small village somewhere in *la France profonde*—all themes tackled by Doisneau in assignments for *Regards.*

This approach—typical of the uses of French humanist photography—contrasts with that found in the American illustrated magazines of the same period, in which there was a marked tendency to focus visual attention on specific, named individuals who were held up as ideal types of a particular social role, or who could be represented as symbolizing a specific issue.[11]

In RAPHO's case, the anonymity of the subject was an asset: the photograph could more easily be sold to both Communist and Catholic clients to illustrate an article. A classic example of this is the Robert Doisneau photograph of 1947, *Les Vingt Ans de Josette* (pl. 170), which figures as the section head image for *Dimanches et fêtes* in *La Banlieue de Paris,* but was also employed in *Regards* magazine to illustrate an article on the class solidarity of French working-class youth, and in a Catholic magazine to illustrate an article about the Easter festivities: "As the farandole shown above makes the great austerity of these blocks of flats disappear, the resurrection of Christ and the new life which is given to us renews everything." The image is a good example of the Doisneausian juxtaposition referred to previously: young, attractive people against a grim, dirty old building; hope versus pessimism; solidarity versus socioeconomic oppression—the picture is resonant with themes to which contemporary viewers would have responded.

LA BANLIEUE
DE PARIS

1945–1950

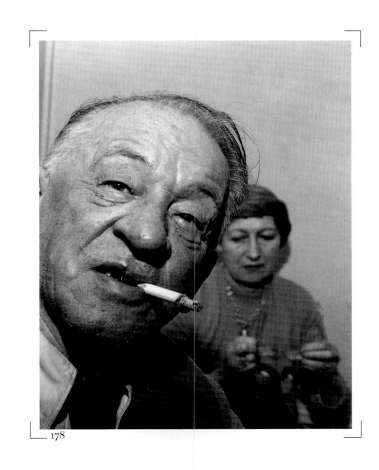

"La Banlieue *is my self-portrait.*"

"*Cendrars said that his vision was darker than mine—he explained, in his own way, that to make images you require some light, while he could work in the dark.*"

[I]N 1949, DOISNEAU'S FIRST BOOK—*La Banlieue de Paris*—was published in two simultaneous editions, one for sale in France under the imprint of Pierre Seghers, and the other in a book-club edition sold by the Guilde du Livre in Switzerland. Though the book sold poorly in France, its publication was a very important step in Robert's career, for it confirmed to him and to others that he was a creative artist with a distinct and personal vision. This would not have occurred but for the collaboration between Doisneau and the writer Blaise Cendrars, who was one of the first cultural figures to understand and value Doisneau's unique photographic perspective on the banlieue.

Doisneau's meeting with Blaise Cendrars in the autumn of 1945 proved to be one of the most significant of the several important encounters that form a turning point in both Doisneau's life and his career as a photographer toward the end of the war. Robert later frequently alluded to the fact that his life was a series of more or less accidental meetings, which proved of great importance to him. A sort of "elective affinity" is evident in Doisneau's relations with Cendrars, as it is with Baquet, with Giraud, with Prévert, and with Albert Plécy. Whether through timidity or fatalism, Doisneau's willingness to be carried along by the current of chance in these meetings has its counterpart in his increasing realization that his best work was done when he allowed chance to work its own magic.

Blaise Cendrars was born in Switzerland in 1887 as Frédéric Sauser. He later chose his pseudonym to evoke the idea of someone reborn from the ashes of a previous incarnation. His writings, well known and popular before the war, are a curious mixture of poetry, reportage, criticism, travel adventure, autobiography, and novel. He led a life of almost constant movement, between callings as well as between places: he visited Russia from 1904 to 1907 and two years later performed as a juggler on the same bill as Charlie Chaplin in a London music hall. By 1911 he was in New York, where he began to write modernist poetry. During the 1914–18 war he fought on the Marne for the Foreign Legion and from 1924 to 1936 spent several months each year in Brazil. He worked as a businessman, a film director, and a journalist. In his biography of Cendrars's close friend Fernand Léger, Peter de Francia describes the writer's life and work as "a continuous series of military operations, of *coups d'état* launched against flagging society, inertia, obstacles to Utopian freedom, and the masochism of cultural citadels."[1] Cendrars's novels and poetry, distilled from the whole range of his experience, are set within the context of his almost constant travel in a world he represents as a fascinating mix of reality and fantasy. He called it *"utopieland";* some critics have suggested that Cendrars traveled farther in his imagination than in reality, although he was certainly an inveterate globe-trotter. It was certainly a territory he shared with Robert Doisneau, whose spirit of imaginative or "magical" realism was increasingly evident in his best photographs. In a poem entitled "Contrasts," Cendrars declares:

> The windows of my poetry are wide open onto the boulevards
> and in its shop windows
> Shine
> The jewels of light . . .[2]

178. *Page 145: Blaise Cendrars and Raymone Duchâteau at their house in St. Segond, near Villefranche-sur-Mer on the Mediterranean coast of France, 1948.*

A resident of Paris from 1912 and a French citizen since 1916—the year after he lost his right arm in battle—Cendrars moved in the Parisian avant-garde circles of art and literature in the 1910s and 1920s. He was particularly closely linked with Apollinaire and the Cubists, with Jean Cocteau, and with Erik Satie and the group of musicians and composers called "Les Six," of whom François Poulenc is today the best known. In 1913, he wrote the first "simultaneist" work *Prose du Transsibérien et de la petite Jehanne de France.* In his writing he sought a verbal equivalent of the visual imagery of his painter friends Robert and Sonia Delaunay and Fernand Léger. His writing, like their painting, is concerned with movement and change, and with dissolving the notion of time as a continuous process.

Before an enforced exile in Aix-en-Provence began in July 1940, Cendrars had been a war reporter with the British Expeditionary Force in northern France. Sickened by the defeat of France, he refused to write for some time, but in late 1943 when the tide turned definitively in favor of the Allies he began to produce a notable series of semi-autobiographical works, of which *L'Homme foudroyé* (*The Astonished Man*) was the first to be published, in October 1945.

In October 1945 Doisneau was asked to go down to Aix and photograph Cendrars as part of the carefully managed publicity for *L'Homme foudroyé.* This invitation came from Vox, the editorial director of Editions Denoël who also wrote for journals and magazines and wanted to do a piece on Cendrars to appear in the fashion supplement of *Le Figaro,* illustrated by Doisneau's photographs. *L'Album du Figaro* was a luxuriously produced magazine that managed to maintain high production values despite the problems afflicting the postwar printing industry.

> Vox asked, "You've read some of Cendrars's work?" I knew *L'Or,* which had been a successful book [*Gold,* a fable based on the life of John Sutter], but that was just about all. Vox gave me a bottle of rum and Cendrars's address. The journey seemed interminable. It was a time when it was difficult to get around. I thought I wouldn't be hanging around too long in Aix. I said to myself that taking the portrait of a writer never takes very long.[3]

Doisneau arrived in Aix on the morning of October 17, 1945, with only the vaguest notion of the man he was going to photograph. He went straight to the house—12, rue Clemenceau—where Cendrars had an apartment on the third floor. An old woman, probably the concierge who lived on the ground floor, put her head out of the window and told him:

> "Between 10 and 11 in the morning he is generally at the Café des Deux Garçons." I looked for him in the café. The only thing I knew was that he had one arm. Not finding him among the customers, I asked the patron about him: "Cendrars? He's gone to Marseilles in a carriage with some friends. . . ."[4]

What could Doisneau do? There was no doubt he would have to wait for the writer's return. But might there be other picture-taking opportunities? Recalling that Cézanne had worked in the area, from his house near Mont St. Victoire, Robert decided to see what could be photographed.

179

180

179. *Cover of* L'Homme foudroyé (The Astonished Man), *by Blaise Cendrars, copy given to Robert Doisneau at the first meeting between the writer and the photographer, October 19, 1945.*

180. *Dedication of* L'Homme foudroyé *from Blaise Cendrars to Robert Doisneau.*

181

181. Blaise Cendrars au travail (Blaise Cendrars at Work), *Aix-en-Provence, 1945. Doisneau photographed the writer at his kitchen table in the camel-hair lining of the trenchcoat he acquired as a war correspondent with the British in 1939–40. The photograph appeared with the article in* L'Album du Figaro, *December 1945, by Maximilien Vox, editorial director of Editions Denoël.*

It was like going into a windmill. The postman lived there and all the objects were still there that he'd used in his still-lifes. It would have been possible to re-compose a Cézanne. I spent the whole day there, and the next day I wandered around the landscape that Cézanne had painted.

It is obvious from the contact prints of this self-assignment that Doisneau went so far as to play around with some of the props that belonged to the painter, making his own "still-lifes." In one of these he even reconstructs a well-known Cézanne composition, using a cloth, a knife, some pottery, and fruit (see pl. 186). He also visited a museum to photograph Roman relics, and a church to record its impressive Renaissance triptych. But time was beginning to hang a little heavy on his hands. The following day, having nothing to do, Doisneau decided to go to the barber:

> Next to me sat a big fat gentleman who was talking about the Talmud to the barber's assistant. I said to myself: that's strange, these people of the Midi are less superficial than they appear. And then the gentleman got up and I saw that he had only one arm. . . . All he said was, "When you've finished, we'll meet up again at Café des Deux Garçons . . .[5]

Doisneau started taking pictures of Cendrars almost immediately, following the poet around the streets of Aix:

> He had such a human presence that he could speak to anybody in the street: a gypsy, an American soldier, children. We happened to go past a shop selling harnesses. So Cendrars picked up a whip and he showed the harness-maker all the figures that one could make with it—the "rose of the winds," for instance, and lots of other moves.[6]

During their two days of working together, Cendrars seemed ready for any scene Doisneau devised. In some of them he used the available light of the room—a table or ceiling lamp; perhaps his stock of flash bulbs was limited. In the thirty six-by-six-centimeter Rolleiflex negatives resulting from this assignment, Doisneau's economy of means is evident. The last shots are of Cendrars on the *terrasse* of a café in evening light. Was it then that he began to talk about the banlieue? Earlier, when they first met, Cendrars had commented on his appearance and asked Doisneau where he came from:

> I said: "I'm from Gentilly."
> "No, no, surely not there . . . Your grandparents?"
> "Well . . . from the Beauce."
> "Ah. There you are, the cathedral of Chartres. Me, I've lived in the cathedral of Chartres."

And on the spur of the moment he went off into a story that he surely invented as he was telling it, into which Chartres entered when, as a young man, he had worked in the aircraft industry. At that time he had calculated mathematically the shape of propellers, and he added, "I lived in the cathedral of Chartres and before that I lived in a forest of chestnut trees, a wood that repels spiders."[7]

182

183

184

182–84. *Photographs made during Doisneau's assignment on Blaise Cendrars in Aix-en-Provence, October, 1945, commissioned by Maximilien Vox.*

182. *At the Café des Deux Garçons with a black American soldier.*

183. *"We happened to go past a shop selling harnesses. So Cendrars picked up a whip and he showed the harness-maker all the figures that one could make with it."*

184. *Cendrars writing at his kitchen table. Maximilien Vox's gift of a bottle of rum can be seen on the table.*

185

186

187

185–87. *While waiting for Cendrars to return to Aix, Doisneau made a visit to Cézanne's house near Mont St. Victoire. "All the objects were still there that he'd used in his still-lifes. It would have been possible to re-compose a Cézanne. I spent the whole day there. . . ."*

188–89. *Blaise Cendrars in the streets of Aix-en-Provence, 1945.*

190. *Page 152: Blaise Cendrars in his garden at St. Segond, July 1948. It was at about this time that he proposed to Doisneau that they should make an album together:* La Banlieue de Paris.

191. *Page 153: Blaise Cendrars at St. Segond, July 1948. This photograph was used to illustrate Cendrars's* Le Lotissement du ciel (Subdivided Sky), *1949.*

188

189

191

Cendrars certainly worked in Chartres for an *atelier de constructions aéronautiques* in 1913, a job to which his friend Robert Delaunay had introduced him. But how much else of the story he told Doisneau that day in Aix was invented we shall never know; it was Cendrars's lyrical ability to transcend "mere facts" which was so congenial to Doisneau. Their conversation ranged over their shared experiences of the *zone* and the *banlieue sud* that figures in a substantial section of *L'Homme foudroyé*. They touched on Léger, whose painting school Doisneau had photographed in 1937–38, and who had been a neighbor in Montrouge. At the time, Cendrars was still estranged from Léger, and it was not until 1955 that they would be reconciled, through the intervention of the publisher of *La Banlieue de Paris*, Pierre Seghers. It was shortly after this discussion that Doisneau photographed Léger again, for an article in *Regards* on the occasion of the painter's return to France in December 1945. From Doisneau's recollections it is clear that the affinity between the photographer and Cendrars became apparent at their first meeting.

192

Usually Aix-en-Provence is evoked when you're in Villejuif. With him it was the reverse. He told me about an entire and terrifying world, places where nobody could go, and when one day the painter Fernand Léger wanted to go back there on his own, he was beaten up. I knew this area really well, which hasn't changed much—it's the hill that goes from the valley of the Bièvre to the cancer hospital at Villejuif. I let him know I'd made some photos of the southern banlieue. Cendrars seemed surprised by this, even astonished, he had presented it to me as a kind of jungle. . . . After two days of wandering around, I promised to send him some of these photos, along with those we had just made. . . . Cendrars said, "Put in some images of Villejuif if you've got any. . . ." I'd hardly got back to Paris when I sent him a dozen portraits and some prints of Villejuif.

The writer gave him a copy of his new novel. On its flyleaf he wrote:

To my friend Doisneau
photographer
Zone-dweller
man of the Beauce
who will find his Kremlin-Bicêtre
and Notre-Dame of Chartres as he turns
some pages—and who
is the first to whom I write a
dedication in a copy of
L'Homme foudroyé
With my friendly hand

Blaise Cendrars
Oct. 1, 45
Aix en Prov.

192. *Pierre Courtade, editor of the newspaper* Action, *for whom Doisneau carried out many assignments in 1945–46. With Cendrars, he was one of the first to see in Doisneau's photographs of the banlieue a distinctive vision and outlook.*

193. *Page 155:* Les Baigneurs de la Varenne (Bathers at la Varenne), *Seine, Paris, 1945. One of Doisneau's collection of "banlieue et banlieusards" photographs that he showed to Cendrars, but which was not used in the book.*

193

Doisneau proudly carried the book home with him to Montrouge. Soon after his return, he wrote the following letter (dated October 24, 1945) to accompany the results of his work:

> Dear Monsieur Cendrars,
>
> I spent the journey from Marseilles to Paris in the corridor but with your book and now I am even prouder to have this dedication and I hope that the photos enclosed will please you and reward you a little for the patience you showed me. Your negro will be disappointed as his profile is lost in the two prints,[8] it's a shame since he seemed so happy with them already.
>
> In a little while I'll send you the photos of the 3 [quinces?] and the foot of the whip[9]—I'm beginning a series on the banlieue that I found in *L'Homme foudroyé,* some of it is still there—as soon as I have some things worth showing I'll send them to you. Au revoir, Monsieur Cendrars, I'm still quite overwhelmed by the kind welcome I received from you. . . .

Doisneau was so stimulated by the meeting and by his reading of *L'Homme foudroyé* that he began a new series of banlieue photographs. It may also be significant that about this time he began to classify his photographic archive within distinct themes, of which "banlieue" was an important subcategory.

With his customary zeal, Doisneau quickly processed and printed up the best photos from the assignment, which probably went first to Maximilien Vox—the client—who wrote to Cendrars from Paris on October 25th, 1945, full of enthusiasm: "*Le Petit* Doisneau has done a bloody fine series of photos." The package of photos from Montrouge arrived in Aix on October 26th, 1945, and Cendrars's letter in reply to Doisneau only seems to confirm the view that at this stage in their relationship neither writer nor photographer seriously envisaged collaborating on a book about the banlieue. Raymond Grosset confirmed that Doisneau had been working on the banlieue project well before Cendrars suggested writing a text: for it would have been impossible at the time to get a book of photographs published without having a "literary locomotive" to pull in a publisher. Cendrars refers approvingly to Doisneau's declared idea (in his letter of October 24, 1945) of doing "a series on the banlieue . . . found in *L'Homme foudroyé,*" and asks for "a set" to be reserved for him. This exchange of letters suggests that in fact Cendrars was only dimly aware that Doisneau had already created a series on the banlieue and its people, for his comment "and what a good idea to make some photos of the banlieue!" would be redundant if it was already common knowledge between them. These letters suggest that Robert saw in Cendrars a potential collaborator on a book project and was keen to engage his enthusiasm for such an enterprise, but felt the idea must come from Cendrars. Robert would have been too timid to have suggested it: as he said, most people who had seen his banlieue photographs had dismissed them as "*misérabiliste.*"

Maximilien Vox's article, entitled "Blaise Cendrars—Homme libre" appeared in *L'Album du Figaro* in late December 1945, with seven of Doisneau's photographs (pls. 181–184). One of the photographs showing Cendrars writing in his kitchen, wearing the camel-hair coat lining, is reproduced on almost two-thirds of the last page of the article. Two of the photographs also appeared early in 1946 in the weekly newspaper *Action,* from

194

195

194. Commèrage sous la pluie (Gossip in the Rain), *Meudon, 1945. As captioned by Cendrars, plate 41,* La Banlieue de Paris *(1949).*

195. St.-Denis, 1945. *Photograph made for a municipal architect for a project on the redevelopment of the town.*

196. Arcueil de nuit (Arcueil at night), *Arcueil, 1947. Cendrars captioned this photograph, plate 32 in* La Banlieue de Paris *(1949),* Pavillons des délaissées (Little Houses of the Abandoned).

which Doisneau was by now receiving regular assignments. Its editor, the Communist writer Pierre Courtade (see pl. 192) was, like Cendrars, one of the first to see in Doisneau's photographs of the banlieue a distinctive vision and outlook.

The two writers found these images interesting for different reasons: Courtade saw in them condemnation of the petite-bourgeoisie's attachment to the values of property, while Cendrars had a bleaker view of the poverty—material, cultural, intellectual—to which he felt they pointed.

There is no remaining correspondence between Doisneau and Cendrars from October 1945 until early 1946. While Robert may have wanted to follow up on his offer to show Cendrars the photographs without delay, tragedy had intervened. Shortly before the article appeared, Cendrars received news of the death of his fighter-pilot son Rémy in an aircrash in North Africa on November 26, 1945. Cendrars bought a flower to remind him of his son, put it in a glass of water on his table—and continued to write. By a curious coincidence, his daughter Miriam told him a few days later that she was expecting a baby.[10] When the Vox article appeared, Cendrars did his best to sound impressed, confiding to Raymone on December 31, 1945:

> Aren't these photos good! But what I find unusual is to be mixed up, all of a sudden, in these fabrics, gloves, hats, perfumes, etc.—and I wonder how and why? But it pleases me . . .

Doisneau did not write again to Blaise Cendrars until early January 1946, when he sent one of his New Year's cards. It seems that Cendrars had in the meantime requested a print (or prints), for Doisneau is apologizing for not having yet started the work. However, as the letter makes clear, he had sent a banlieue picture to Cendrars, "an image made at the Poterne des Peupliers," perhaps the 1932 photograph of a boy already in his portfolio collection?

This letter is fascinating in the sense that it shows Doisneau responding to what he found in *L'Homme foudroyé* with a photograph. There is a passage in the book describing a visit by Cendrars and Léger to the *banlieue sud* near Gentilly:

> And I took Léger on the path that goes around the cemetery at Gentilly, in the direction of the Poterne des Peupliers.
> The kid ran behind us along the ridge, leading her bear.[11]

Despite the fact that no correspondence remains to bear witness, Robert confirmed to the author that he had remained in regular contact with Cendrars—sending him photographs from time to time—from early 1946 until the next surviving exchange of letters, which occurred in July 1948. By this stage Maximilien Vox had dropped by the wayside, for Editions Denoël had been taken over by the heirs of Robert Denoël, its founder, who had died in late 1945. It would seem there followed certain problems in the publishing company. By early 1947 Vox had left the company, for its difficulties had enabled Mme Jean Voilier, Robert Denoël's widow, to take over.

In the early summer of 1948, Doisneau went to Yugoslavia. *Regards* had commissioned a reportage from him, which went badly wrong. During the

197

197. Marshall Tito, *Belgrade, Yugoslavia, 1948. An assignment for* Regards.

198. *Page 159:* Dimanche soir: on rentre (Sunday Evening: Going Home), *place de la Gare, Ivry-sur-Seine, 1949. As captioned by Cendrars, plate 33 in* La Banlieue de Paris *(1949)*.

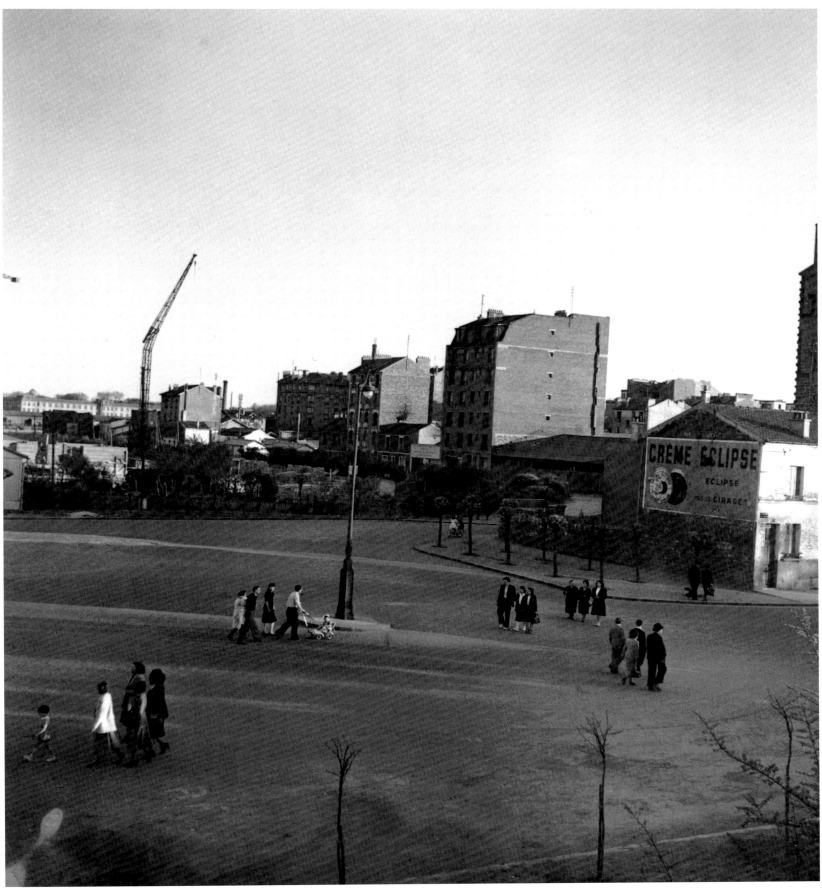

198

LA BANLIEUE DE PARIS | 159

stay Tito broke with Stalin, and because Doisneau's party had come from France, where the PCF was still aligned with the Russian Communist party, he and his colleagues were immediately suspect. Though he managed to photograph Tito the day after he severed relations with Stalin (see pl. 197), Doisneau and the journalist with him were arrested by the Yugoslav authorities and immediately sent packing.

A letter Doisneau received just after this episode (dated July 6, 1948) proves almost beyond doubt that the idea that led to *La Banlieue de Paris* occurred to Cendrars at about this time, for in it he states: "I had an idea about doing an album with you. We'll talk about how to get it together. I will do a little text to accompany the photos."

Doisneau did indeed go to see Cendrars and Raymone in their *paradis terrestre* of Saint-Segond in the second half of July 1948. Robert took with him his collection of prints, provisionally titled *Banlieue et banlieusards,* and of course the Rolleiflex. At Saint-Segond he photographed both Blaise and Raymone in the garden and made another series of Cendrars in his study, by his beloved typewriter. In these pictures, very different in tone from those made three years before in Aix-en-Provence, Doisneau seems both more inventive with his compositions and easier in his relationship with the writer. Several (see pls. 190–91) are fairly intimate close-ups, probably taken at or near the limit of the Rollei's focusing range—about ninety centimeters. They show that the relationship between writer and photographer was now much closer.

On September 30, 1948 Cendrars wrote again to Doisneau, including his compliments on the banlieue photographs:

> Concerning these photos, Tosi, the director of Denoël, has written to tell me that he's asked you to come and see him. I hope that it's done. Concerning the photos of the banlieue and its people, I just don't have enough compliments to send you. We'll talk about them later. I'm really enthusiastic. Tosi is waiting for the boss to come back to make a decision on the album that I will write the text for—and so happily! I will write to Mme Voilier when she gets back—and if despite my urgings she decides not to publish the album, we'll go elsewhere. I thought about Peignot, director of *Art et Métier graphiques* [sic].

Doisneau sent Cendrars the set of prints he had requested, but typically would not accept payment. The project, moving fairly slowly until that moment, had now begun to accelerate. The reference to Peignot in Cendrars's letter is significant: by this time the distinguished director of *Arts et métiers graphiques* would have been well aware of Doisneau's work, for two of his photographs (a portrait of Utrillo and a *mariage de banlieue* photograph) had been published in the 1947 edition[12] of the magazine's photographic supplement.

In a letter of October 3, 1948, Cendrars goes on to reassure Doisneau:

> Don't worry about getting the album published. When I showed your Parisian banlieue and banlieusards to some friends the other day, the opinion was unanimous. "This fellow's a genius," they exclaimed. I think so too.

199

199. *Villejuif, 1945.*

200

201

201. La rue du Fort: Manifestation pour la paix (Peace Demonstration), *Montrouge, 1949. This photograph was made as part of a reportage assignment for* Regards. *The CGT-organized rally took place at the stade Buffalo, not far from place Jules Ferry where Doisneau was living (trees of the place can be seen). It is an image that bears all the hallmarks of modernism, the tilted frame making a strong diagonal while emphasizing the solitary worker digging his vegetable plot. Cendrars was aware of the political construction of this image, which he captioned: "They Annoy Us with Their Politics," pointing out that the* décentrement *was used to that end.*

202. *Page 163:* Un Dimanche à la campagne (A Sunday in the Country), *1949.*

He again suggests Peignot, and further develops the project:

> Naturally we'll have to make a choice, a selection, a classification from what I have in front of me, and to complete certain series: Terminus, Travail, Sports, and I promise that I shall be proud to write a text for you. . . .
>
> If it proves necessary I'll come to Paris toward the end of the year in order to nab a publisher and get the business underway, for it really is something I believe in.

On December 12, 1948, Cendrars writes to tell Doisneau that he has finally pinned down the elusive Mme Voilier:

> Mme Jean Voilier has at last returned. I wrote immediately to her to ask her to get in touch with you right away so that you can show her your file on *Banlieue et banlieusards,* telling her it is quite simply wonderful and that if she publishes them as an album I will happily write a new text.
>
> We'll see what her reaction is to the photos and my proposition. If it doesn't lead anywhere don't get discouraged, we'll try something elsewhere. I've got another couple of places in mind. Then, there's a third. We'll get there. All roads lead to Rome!

> With my friendly hand
> Blaise Cendrars

Whether Mme Voilier and Doisneau ever met to discuss the banlieue project is not clear. However, in the first edition of *Le Lotissement du ciel* (published in July 1949) Denoël printed on the frontispiece one of Doisneau's portraits of Cendrars made the year before in the *parc exotique* at Saint-Segond, so Mme Voilier must have taken at least some of Cendrars's advice seriously.

The poet Pierre Seghers, who ran a small publishing house in Paris, had visited Blaise in Saint-Segond in late 1948 or early 1949, keen to publish some of his poetry.[13] In a subsequent letter, Blaise proposed that in addition to publishing a small volume of his poems, Seghers should consider producing the album that Cendrars and Doisneau were to collaborate on. Raymond Grosset recalled that Seghers needed some persuasion to accept the book[14] and suggested that "the book was done by Seghers as a result of his links with Jean Mermoud, director of the Guilde du Livre book club in Lausanne.[15] Without Mermoud's help, Pierre Seghers would never have dared publish the book, which sold well in Switzerland thanks to the Guild but very badly in France. Mermoud's page layout can be criticized, as well as his attitude toward Robert, for all his attention was on Cendrars. The page layout was not even shown to Robert![16] According to Miriam Cendrars, although Seghers thought that such a book would be a big risk for his small firm (publishing a large number of photographs is costly), he felt it would be an honor to publish something to which Cendrars was clearly ready to devote his considerable talents.[17]

Now the work began in earnest—at least for Cendrars. After a meeting between Doisneau and Seghers on February 24, 1949, which tied up the details, Robert forged ahead—making new photographs and gathering together

203

203. *Cover, first edition of* La Banlieue de Paris, *1949. The photograph was a montage of one of the pictures of the Cyclocross à Gentilly sandwiched with two other pictures: the Eiffel Tower, and clouds. Doisneau experimented with many versions of this image before finding the definitive one, and it attests to his lifelong fascination with what he called* bricolage et jeux photographiques.

204

204. Au bon coin, *St.-Denis, 1947.*

archival material to serve as the basis of the album section. One hundred thirty of Doisneau's photographs were used in *La Banlieue de Paris* (128 in the album section, plus a cover photograph of the Eiffel Tower and an aerial photograph of northwestern Paris for the endpapers).

At least seventy percent of the photographs used in the book were in fact made *before* Cendrars sent his historic proposal of July 1948.[18] In the *Table des illustrations,* Cendrars writes that "the photographs illustrating the present work were made in 1947–49,"—while it was almost certain that he knew a good third were in fact made earlier. This is important in confirming the fact that Doisneau had been working assiduously on this personal project for some considerable time.

A careful comparison of the volume's photographs with the commissions Doisneau was completing during the period 1945–49, in particular for *Regards,* shows that some of what made up *La Banlieue de Paris* emerged directly from the reportage work. Several pictures were from a long article on the Renault factory that ran in *Regards* in April 1947, while a number are from a three-part article on *Les Hommes du rail*[19] that appeared in the same magazine in March/April 1948. The gasworks at Gennevilliers and Aubervilliers were photographed by Doisneau for *Regards* in 1946–47, and one or two of the images made for this assignment (but not published by the magazine) found their way into the book. An article in *Regards* on *"Les Noces au bord de la Marne,"* which employs several of Doisneau's pictures of lovers and wedding parties at Chez Gégène, Joinville-le-Pont, contains images used again in the *Amours* section of *La Banlieue de Paris.* On the other hand, some photographs made expressly for *La Banlieue de Paris* moved in the other direction: a plunging panoramic shot of Arcueil—captioned by Cendrars as having been taken from the window of the house in which Erik Satie lived in the 1920s—appears in an article on *"Docteur X . . . de banlieue"* that appeared in the January 16, 1948, edition of *Regards.* This demonstrates the remarkably organic linkages between the production and diffusion of Doisneau's photographic work. Much of the social-documentary photography produced by him at this time—whether commissioned or personal—was used by magazines, newspapers, and other publications because it was so intimately in step with the spirit of the times. In part this was due to Doisneau's personal fascination with the subject matter, but it was also driven to a large degree by his political involvements.

If we underline Doisneau's then-current adhesion to the PCF and his role as a *militant de base,* it is not hard to imagine that his picture-making at this time was infused with a strong commitment to "inscrire" the social and economic conditions found around him in the banlieue, combined with a corresponding desire to represent the lives of those among whom he lived and worked in as positive a light as possible. That the social reportage aspect of his work came from deeply held convictions is evident in the great number of assignments he undertook for the communist and socialist press from 1945 until the 1990s. These included reportages on various industries, especially the coal miners and mining communities of the Nord. His photographs taken in 1945, when the government was inciting the workforce to produce coal for an energy-starved France at all costs, are deeply revealing of the hideous conditions in which men, women, and children worked. Several of his photos of this

205

205. Le Nez au carreau, (Nose to the Window),
rue Pajol, Paris, Twelfth Arrondissement, 1953.

206

207

206. Assurance contre le soif (Thirst-Insurance),
Gentilly, 1943.

207. *Café. Paris, Twelfth Arrondissement, 1953. A
"faubourg" project photograph.*

time were taken deep underground: I once asked him whether this was dangerous, for he had used an open flash—wasn't there a risk of a gas explosion from the *grisou* (firedamp) endemic to those pits? "Of course," Robert simply replied, "but I wanted to make my picture." Later, during a serious strike closed the pits in 1948, the government tried to starve the miners into submission. Robert carried out a reportage on the miners' children who had been welcomed all over France by other workers' and peasants' families, to help their beleaguered parents. Robert and his wife Pierrette even found space in their cramped apartment in Montrouge to take in one of these children.

By the early summer of 1949, Cendrars was well advanced on the project, which he seems to have directed as if it were one of his films. In particular, he began asking Doisneau to make certain photographs to give the book a better balance, evidently concerned that the majority of the photographs were taken in the environs of Gentilly-Montrouge. As Robert noted in *Pour saluer Cendrars*:

> Cendrars said that his vision was darker than mine—he explained, in his own way, that to make images you require some light, while he could work in the dark. He also spoke about his social convictions. He imagined me to be a militant communist. To him a factory was a place you got away from as soon as possible. I was very familiar with the banlieues beyond the portes de Gentilly or Orléans. The zones populated by Italians and gypsies. Of course, from time to time they could be frightening. It was a maze of little tracks, houses protected by old mattresses, bedsprings stretched tight, or even a headboard used to make a fence, reinforced with tar-paper coated with sand. And there were flowers everywhere![20]

It was a bit late to be getting worried that Doisneau's banlieue was composed of the areas where he grew up and then lived, but Cendrars insists in a letter of June 4, 1949, that

> . . . generally there are too many pictures of the *southern* banlieue. (It's true that you live in Montrouge.) I don't like cheating. But I will find myself having to give sometimes a bit of a nudge to the place-names on the contents page in order to present a more comprehensive sense of the banlieue. Do you think that poses a problem? I will do it with great discretion. Certain photos could have been taken anywhere.

By early July, Cendrars was hard at work on his text and on the organization of the album section of the book. Doisneau faithfully followed his directions, making large-format views of the railway line in the *ceinture vert* (greenbelt) and of the streets of St.-Denis. This work directly followed the suggestions made by the writer on July 21, 1949:

> Mon cher Doisneau
>
> For the last 15 days I've worked for you alone. I think that a photo taken of a train on the Montparnasse-Versailles line or of the electric Invalides-Versailles would go well in the album. In that area, between lower Meudon, Bellevue, Sèvres, an industrial-urban panorama, Paris, the

208

208. Dimanche en banlieue: Course à la valise (Sunday in the Banlieue: Suitcase Race), *Athis-Mons, Essonne, 1947.*

209. *Page 169:* Dimanche en banlieue: Les Cheveux de bois (Sunday in the Banlieue: Wooden Horses), *Montrouge, 1946.*

210. *Page 169:* Cinéma de banlieue (Suburban Cinema), *Gentilly, 1948.*

211. *Page 170:* Le 14 juillet, *Gentilly, 1947.*

212. *Page 171:* Street entertainment, HBM, *Gentilly, 1949. Probably one of the last photographs made for inclusion in* La Banlieue de Paris, *in the summer of 1949. Although only the side of the building can be seen, the photograph attests to Doisneau's lifelong fascination with this site and the life of its inhabitants.*

209

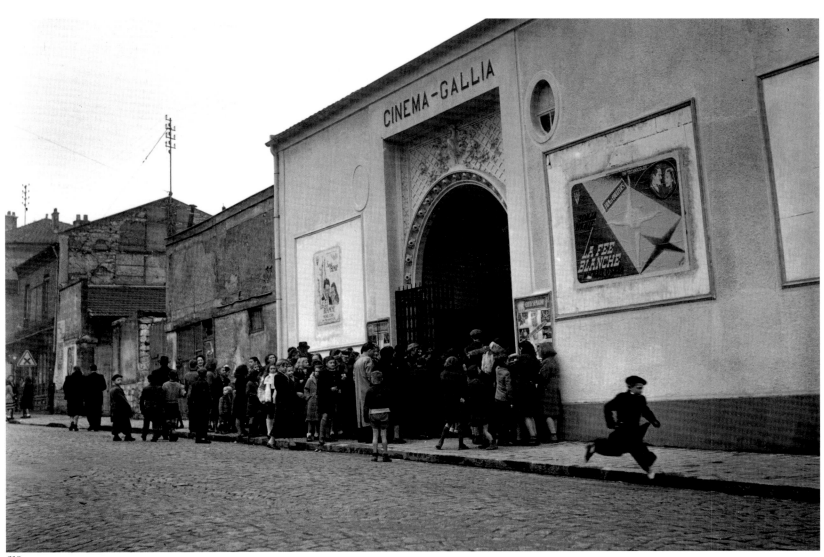

210

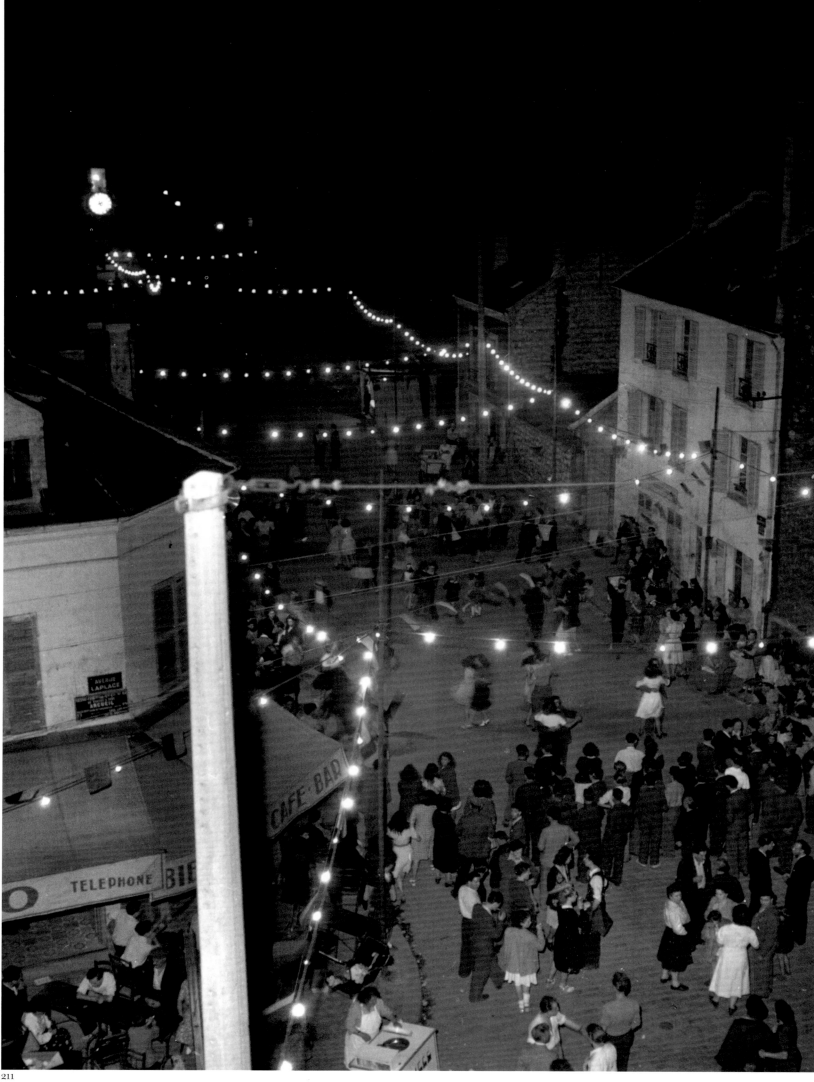

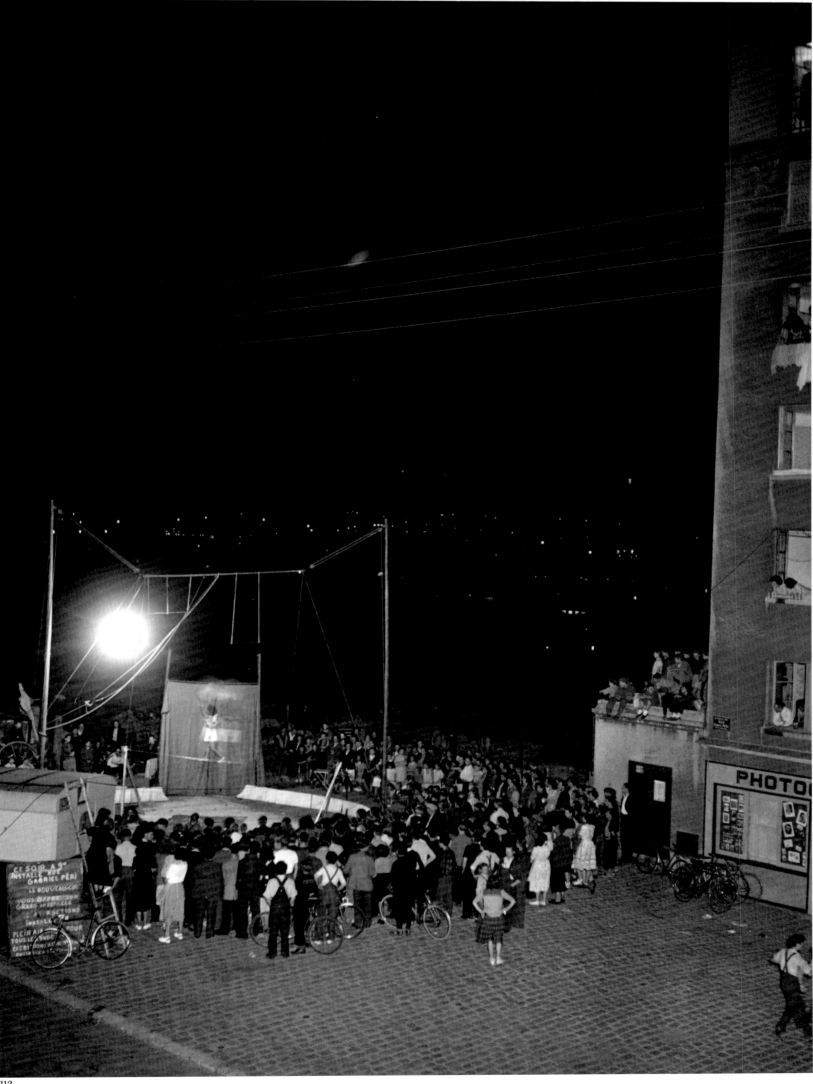

Eiffel Tower, the Seine, the Renaud (sic) factories, and the railway lines one on top of the other and the viaducts and the haze of Boulogne. You would do well to go and wander round there. It's up to you to find the angle of view and the best time of day.

To this view from the south I'd like a balancing one from the north, again a panorama, taken either from the top of Sacré-Coeur of the banlieue Aubervilliers—St.-Denis, or from the top of the bridge on boulevard de la Chapelle, the rails fanning out from the north and the west, all in smoke. One could go at the beginning and one at the end as endpapers. They would balance well with the Eiffel Tower on the cover!

The next day, Doisneau received more directions:

I need a double photo: the staircase at the gare St.-Lazare at rush hour: half of the picture in the morning, when the people are getting off their trains to go to work, seen from the front, descending the staircase; the other half, in the evening when the people are heading back to their distant banlieue, seen from the back, as they climb up the staircase.

It needs to be swarming like an anthill!

Doisneau remarked that Cendrars had asked him to photograph people in the early morning, going to work still half-asleep. Though this fragment of their correspondence has now sadly disappeared, Cendrars quotes directly from one of these lost letters in his text for *Banlieue de Paris*. Doisneau had written to him:

I've not been able to do the guys who go to the factory in the morning—at night the buses are like aquariums, the beans in oil that stain the lunch-bags and the backs of so many fine men. The lighting is difficult. We don't have any emulsions sufficiently fast to make snapshots in the mildewed light of the early morning. I need a light source. The "flash" destroys the ambiance when the grayness comes over everything and fits the banlieue where I live like a glove . . . the banlieue waking up is difficult to light. Up till now I've chickened out. But I'm going to start again with another mechanical system. . . .[21]

And Cendrars, who otherwise was not interested in the technical considerations, used this pretext to explain his method of working with Doisneau:

I owe the reader this avowal, that we have never wandered around the banlieue together, Robert Doisneau and I. Our association was established in fact by the present work, in the form of a congenial collaboration, with me making the first choice and my friend Pierre Seghers the second from the fifty thousand photos that Doisneau was able to make of the ban-lieue, of which I am far from able to guess the variety; and Doisneau, who would not have been able to follow my tracks around all the spots in the banlieue where I've been able to cool my heels for the last fifty years if he had known or if I had given him the slightest indication of where they were, for too many people have been there since and with so many of those grubby corners not existing any longer or not being worthy of the

213

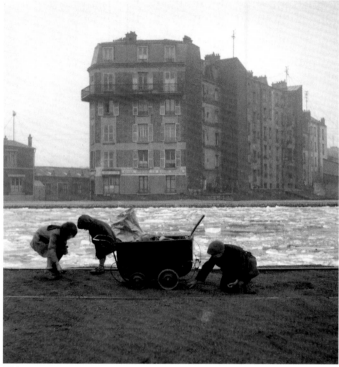

214

213. *Gentilly, 1943.*

214. Les Glaneurs de charbon (The Coal-Pickers), *Canal de St.-Denis, Aubervilliers, 1947. Cendrars captioned it:* Corvée de petit bois flottant (Fishing for Driftwood).

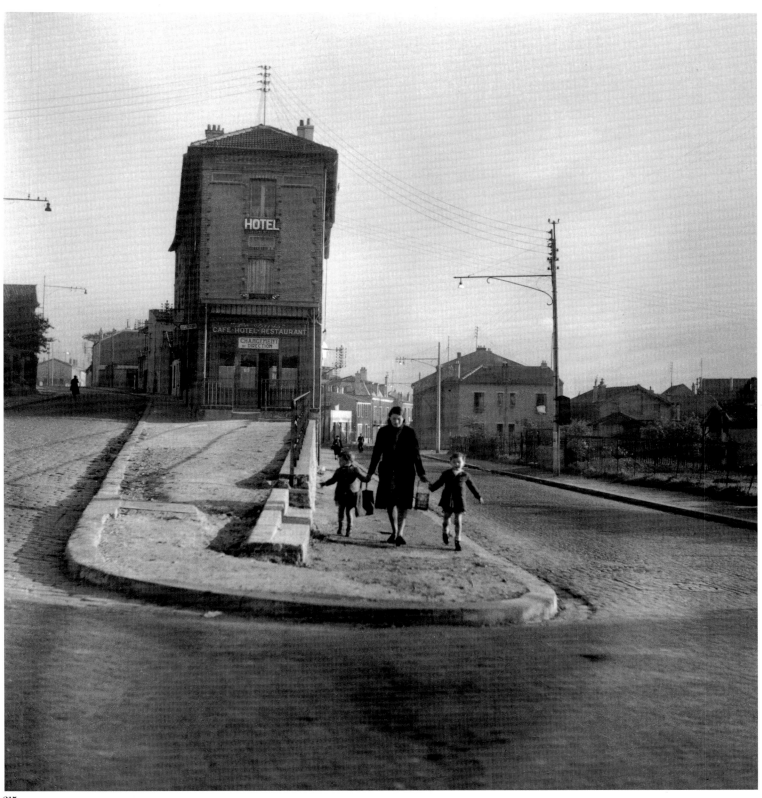

215

trouble nowadays he thus photographed what he wanted, taking his chances and benefiting from whatever he discovered.

What Doisneau said about light and the slowness of emulsions confirms what I said a little earlier about the shadow cast by my text, which overshadows his images. I am one of the déclassé, a transplant, and my professional conditioning, not to mention the fatigue of the writer who pursues an exhausting métier, pushes me toward the darkness if not toward a systematic pessimism.[22]

The work and the correspondence continued during the holidays of 1949, for we find Cendrars writing to Doisneau on August 23, 1949, poste restante at Giens, in the Var, where he was staying with his family.

For the cover: the best place from which to photograph the Eiffel Tower is the footbridge at Billy. That's for the first plate of the cover. For the second plate, it would be good to have some wide shots, some elements muddled up together, pell-mell.

It seems that Doisneau tried to respond to all of Cendrars's requests for new and different images for their book. However, regarding Cendrars's suggestion about the view from the "footbridge at Billy," Doisneau said that "his idea was completely crazy! You couldn't see anything interesting from the footbridge at Billy."

When Cendrars met Robert Delaunay in 1912, they explored together all the surroundings of the Eiffel Tower, which had been the subject of some of Delaunay's most important modernist paintings (*L'Equipe de Cardiff*, 1911; *Le Tour rouge*, 1911–12, etc.). Both Delaunay and Cendrars were fascinated by the problem of dealing with its perspective, and in particular with placing its height within the rectangular space of a painting. Among Doisneau's archives there are many examples of the way in which he played around with representations of the Eiffel Tower: the earliest of them date from the period 1945 to 1949.

Cendrars's ideas about film and photography proved equally unrealistic, although delivered in a suitably authoritative and enchanting manner.

He had neither the time nor the patience to study technical matters. He had a rather global view of all that. Another time, I said to him, "I've got to photograph ants and I can't find a lens for that. . . ." To which he replied, "You'll have to go to the beginning of the quai Saint-Michel, there's a small optician there who provided the lenses to film *La Roue*." Of course I went straight there, and of course the good fellow knew nothing about anything. Somewhere, in an essay, he explained his perception of lenses: "That one is sharp, it catches skin well, that one, etc." For me this was music to my ears![23]

For Doisneau, his association with the writer, his mythomanic elevation to the *photographe beaceron-zonier*, put him into a new and different class. No longer could he be seen as "*le petit* Doisneau," as Vox had fondly described him—a sort of artisan who had come to take a picture, much as a plumber comes to mend a burst pipe. He was now a creative artist in his own right. The fantasy woven about his work by Cendrars was confirmation that he was taking photographs

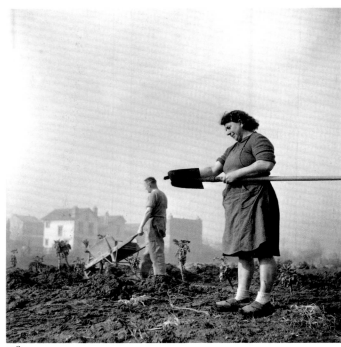

216

216. Femme à la bèche (Woman with Spade), *Fresnes, 1946.*

217. *Page 175:* Devant l'usine de produits chimiques Rhône-Poulenc, à Choisy-le-Roi (The Angelus Bell: Facing the Rhône-Poulenc Chemical Factory at Choisy-Le-Roi), *1946. Caption by Cendrars.*

218. *Page 175:* Cheminot retraité: Introspection (Retired Railwayman: Introspection), *Ville-neuve-Saint-Georges, 1947. The organization by Cendrars of photographs within themed sections in* La Banlieue de Paris *corresponded to Doisneau's emerging classification system for his work (see appendix). Some of the bleakest pictures are to be found in the section entitled "Terminus."*

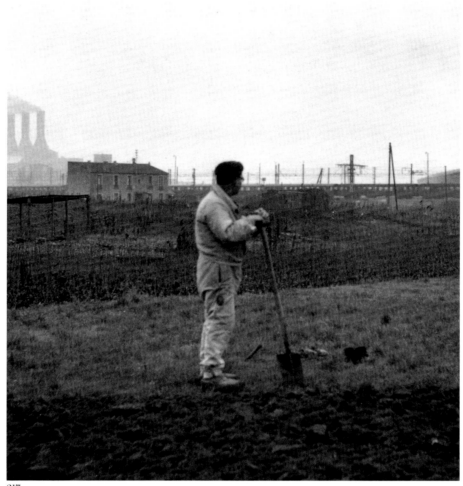

217

218

unlike those of other photographers, that he indeed possessed a special vision. It must have been a fortifying feeling. For Robert, Cendrars perhaps became a role model, proving that *désobéissance* was in fact a viable way of life:

> What really attracted me to Cendrars was that he had formulated his own set of rules, which were not necessarily those of others. He didn't worry about being in fashion, because fashion also follows its own rules. On the other hand, the rules of the thief or the killer interested him. People who were beyond the pale of the normal, who played another tune—as he did as a writer—they fascinated him. I like people who have given themselves the trouble to live first and write later. Examples: Cendrars, Prévert for his poetry, and Cavanna as well, who is a bad lad and who learned everything in the street. I far prefer this sort of writer, because they awake in me dormant harmonies that I collected during my childhood. What Cendrars liked about my photos of the banlieue was that they were antiacademic. In the same way he loved that big elephant Fernand Léger because he over-turned everything.
>
> The switch that turns on people like me is the same thing that drives painters and sculptors who make *art brut*. They are either insomniacs or mystics or even people who have things left over from childhood that come back up the throat and give them courage. Nothing to do with academicism! I was a poor student, I tried to disobey, to invent my own rules of the game, and it was perhaps that which Cendrars sensed from our first encounter.[24]

When *La Banlieue de Paris* book was published in November 1949, Cendrars was alongside Doisneau at the launch party (see pl. 160). Afterward they dined together, with their wives, at a small restaurant:

> A book-signing was organized at the Delatte bookshop, in rue de la Pompe, Paris. Cendrars's readers came in droves to have their earlier books signed by him. After a little while he got fed up and, borrowing some money from Delatte, we went off to dine with Raymone, to an *auberge* near the gare Saint-Lazare, with beams, a roasting spit, and hams hanging from the ceiling. It was clear he wanted a party. The book didn't sell well—nobody liked these banlieues. I was a little disappointed, but from the moment when I saw two or three copies in a bookstore window that was enough for me. Moreover, it was overwhelming for me that a man like him might have written such an essay. In fact I couldn't manage to read it, the sentences danced around. I needed at least a year until I could read it calmly and especially so that I could understand all that it contained.

A total of 2,500 copies were printed by Seghers for the first edition (following a larger "pre-edition" run for the Guilde du Livre), a small print run in view of Cendrars's reputation. In many ways the book was a model for the projects Doisneau has most enjoyed, where he worked with a writer who possessed a strong point of view and for whom his photographs could serve as creative stimulus. The fact that it made no money was certainly a disappointment, but Robert was content that the book—though he thought that the

219

219. La Pleine Lune du Bourget dépôt de locomotives (The Turntable of Le Bourget: Locomotive Sheds), *Paris, 1948, published in "Les Hommes du Rail,"* Regards, *March/April 1948.*

220. *Trains, Villeneuve-St.-Georges, 1945.*

220

221

221. Passerelle et fumée (Footbridge and Smoke),
Villeneuve-St.-Georges, 1946.

printing and layout could have been better—was a small *succès d'estime* (critical success). The success of *La Banlieue de Paris* for Doisneau was measured in terms far from commercial—in the fact that it was published and that it had attracted the collaboration of a heavyweight author, who had confirmed his perspective. As a result, Robert thought, why not try to do a similar book on the faubourgs of Paris—the outer arrondissements, essentially the more working-class and petit-bourgeois areas to the east and north of central Paris. Perhaps he had assumed that he could interest Cendrars in writing the text, for he began to show him some of the pictures.

> Encouraged by the publication of *La Banlieue,* I started a series on the faubourgs of Paris. In fact for me the photos of the banlieue were like self-portraits, the reflection of this absurd scenery I detested. So I showed Cendrars my prints of the faubourgs. He looked at them for a long time and then he said, "You have found your thing."
>
> To have found my thing! But he was right. What was normal for the banlieue had become a sort of system that I applied to life. It was the search for the grayest, most absurd, most stupid, most run-down of quarters, the places where workers were most centralized. So then I said to myself, "It's true I am in a system, I shouldn't do that," and I stopped working on the faubourgs. His judgment was correct. I was playing on the oppositions: big buildings/flea-ridden children; pretty, curly-haired young girl against a background of dank walls. I was exploiting a rich seam. His judgment was harsh but fair. All of sudden it put me back on course. Thanks Monsieur Cendrars! Without him I would have made 36,000 photos of my little kids. After that it was the worst of all, I was working for *Vogue.* For me, Cendrars was my older brother. He had been close to death, violence, fire, blood. . . . I remember his voice, he had a weighty diction—I'm sure he wouldn't have liked me to say this—but he was a little Germanic.[25]

From 1945 until 1947 (for much of the time when he was working on *La Banlieue de Paris*), Doisneau was a member of the PCF. This must have made an impression on those with whom he came into contact, as it did for Cendrars. Although it is clear that Doisneau was not happy as a *militant de base*—his *désobéissance* always got in the way of any attempt to involve him in disciplined political action—Doisneau felt a close affinity with the working class and petite-bourgeoisie. As he said once to the author, "I look like them, I speak their language, I share their conversation, I eat like them. I am completely integrated into that milieu. I have my own work that is a bit different from theirs, but perhaps I am a sort of representative of that class." Cendrars picked this up, for he referred to Doisneau quite often as an "artisan" in *La Banlieue de Paris.* Years after their work on *La Banlieue de Paris*, Doisneau went to photograph Cendrars again, when he was living in rue Jean-Dolent, near La Santé prison:

> To counterbalance his judgment on the faubourgs he once paid me a fine compliment. A publisher wanted me to photograph the things he had around him: a bottle of rum, a passport, his glasses, etc. . . . I started with the bottle of "Super" rum. To make a background I took off my jacket,

222

222. Les Croque-morts de Nanterre (Pallbearers of Nanterre), *Prison-Hospice de Nanterre, 1952.*

223. *Page 179: Hearse at the Prison-Hospice de Nanterre, 1952.*

224. *Page 179:* Un Pauvre roule à tombeau fermé vers Bagneux (A Poor Man is Driven Slowly Toward Bagneux), *Bagneux, 1947. Caption by Cendrars. There is a large municipal cemetery serving much of the southern banlieue at Bagneux, a short distance from Montrouge, where this photograph was made in early 1947.*

223

224

which had a satin lining. I arranged the folds and I placed the bottle on top. Cendrars then said to me: "That's great, you work like a *forain* (fairground stallholder). . . ." This improvisation with whatever was to hand really pleased him.

Certain photographs in *La Banlieue de Paris* were in effect mise-en-scènes rather than strictly documentary pictures, a technique Doisneau was developing during this period. It reveals his fascination with the *fantastique social.* He would frequently observe something happening but be unable to record it with his camera, later trying to restage what he had seen—as in *Le Baiser de l'Hôtel de Ville.* A classic example in *La Banlieue de Paris* is the photograph captioned by Cendrars as *Dans le train de Juvisy.* It depicts the "worker who has been to the quai aux Fleurs and has brought back a rosebush complete with its clod of earth," whom Doisneau will later "peer over a wall to surprise, at home, in the process of fondly planting his rosebush." The "worker" is in fact Monsieur Barabé, Doisneau's concierge and assistant (see Chapter 6). The case is instructive, for it shows us with what skill Doisneau sought to present his own perspective on the *classe populaire.* Through the intelligent use of models—who were mostly people that he knew—he was able to suggest deeper truths about ordinary life than would have been possible through a purely documentary approach. A perfect example is the series of photographs in which the *Café noir et blanc* photograph is to be found, for the young couple in their wedding attire were a couple of actors from the Joinville studios recruited specially for a magazine assignment.

What Doisneau wished to show in his pictures was the magical possibilities that existed within the apparently banal banlieue. Cendrars had the intelligence to see this, where others denigrated the work. Thus Doisneau's vision was powerfully confirmed:

> You know . . . Cendrars . . . was the first to be interested, which is to say that he looked more closely at the pictures I showed him . . . work scorned by others, people said to be "cultivated." They thought that it was only picturesque *misérabilisme.* And that was not my aim at all. I didn't want to show things that were the simply miserable or facile picturesque (like accidents or poverty)—that wasn't my thing at all. . . .
>
> It was more to say "Look, during a day there are loads of moments that might be considered banal. . . . And then I really enjoyed myself in the street. . . . I wanted to show that. Does that interest you? Do you want to share the joy it gave me, the jubilation, the gaiety I drew from it?" It was really just that, at the beginning and for a long time afterward.
>
> Now Cendrars took the bait immediately, finding that it represented a sort of popular dynamism. He thought it was good to do that, he liked the idea that creativity was generous, and he did not want to scorn it. By contrast a very celebrated man of letters like Aragon thought that it was merely "populist" and only of minor interest.

PÊCHEUR D'IMAGES

1945–1960

"He had the ability to spot things that would quickly disappear . . . There were people who thought Atget was an animal. But I'm also an animal. Because Atget was very raw. For me, in an Atget there is the smell of game, an animal that smells more like hare than tame rabbit, eh?"

"It doesn't matter where you look, there's always something going on. All you need to do is wait, and look for long enough until the curtain deigns to go up. So I wait and each time the same pompous formula trots through my head: Paris is a theater where you buy your seat by wasting time. And I'm still waiting."

WHILE THE LONG STORY of *La Banlieue de Paris* was unfolding, Doisneau had been more than active in other domains. From 1945 to the early 1950s, he was both involved in and an enthusiastic observer of the intellectual and cultural ferment of St.-Germain-des-Près, and his work at this time featured many of the locations and people who came to symbolize the excitement of Left Bank culture. In the markets of St. Germain des Près it was all too easy to bump into an existentialist or two, although you might more easily see them in a club or café. Robert photographed some of the key figures in the debate around existentialism—for example, Sartre, Camus, Merleau-Ponty, and Simone de Beauvoir (his picture of her writing in the café Flore (pl. 230) is perhaps the most telling portrait, capturing well her aloof attitude; Robert recalled feeling that "no possible contact" could be made with her).[1] He documented the life of such famous cellar-clubs as Tabou and the well-frequented cafés and restaurants, such as Le Flore, Les Deux Magots, Lipp, and Roger le Grenouille, as well as the Louisiane Hotel, where Juliette Gréco, Eddy Constantine, and innumerable now-forgotten starlets and performers lived.[2] He tracked those who made St.-Germaine -des-Près their world: Georges Brassens—whom he photographed in a memorable series with some *clochards* (vagrants), Christian Bérard, Gréco, Roger Vailland, Jean Cocteau, and the painter and poster artist Yves Corbassière, whose Renault painted with black and yellow squares was often to be seen on the streets.

It was a time when writers and artists formed close ties: Paulhan with Artaud, Ponge with Richier and Hélion, Beckett with Van de Velde, Fautrier, and Dubuffet. Evidence that a new and shared set of postwar values was emerging dates to 1945, when a number of artists—including Dubuffet and Giacometti—declared themselves "existentialists." Michel Tapié caught this new spirit of cultural cooperation in his "Un art autre" of 1952, a manifesto for a new art freed from formal aesthetic conventions, an *informe* art whose spirit was expressed by Michaux, Wols, Dubuffet, and Fautrier. (Tapié also cites Americans barely known at that time, such as Mark Tobey and Jackson Pollock.)

Robert was keenly aware of the interconnections between artists, writers, intellectuals, musicians, and filmmakers, for this was the world into which he was increasingly drawn. He was concerned as well with those who had been major figures of the last wave of avant-garde art, and he photographed the painters Utrillo and Léger, his architect-hero Le Corbusier, whose atelier was in the rue de Sèvres, and Picasso, both at the famous Salon de la Libération in October 1944 and later at his studio in the rue des Grands Augustins. In July 1948 Robert wrote to Pierre Betz at Souillac:

> I'm doing a reportage on St.-Germain-des-Près—the caves, the fauna, and the artists that together constitute the highest point of Western civilization. This new Montparnasse is very important for me, someone who believes in the maturing of his archives—but it takes a lot of my time . . .[3]

In 1946, probably as a result of the work he had begun to carry out on a regular basis for Albert Plécy of *Point de vue*, Robert had met a journalist based in the Rive Gauche who was known as "Romi" and whose real name was Robert Miquel. Together they frequented the bars and bistros of the *quartier*, especially Chez Fraysse in the rue de Seine. Romi owned a small antique

225. *Page 181: Tattooed man, Prison-Hospice de Nanterre, Nanterre, 1952.*

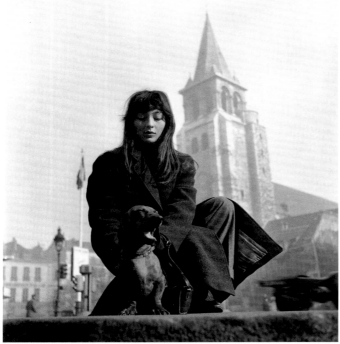

226

228

227

226–229. *"I'm doing a reportage on St.-Germain des-Prés—the caves, the fauna, and the artists that together constitute the highest point of western civilization. This new Montparnasse is very important for me, someone who believes in the maturing of his archives—but it takes a lot of my time . . ."*

226. *Juliet Greco, 1949.*

227. *Mouloudji, 1950.*

228. *Georges Brassens, 1953.*

229. *Le Tabou, St.-Germain-des-Près, Paris, 1947.*

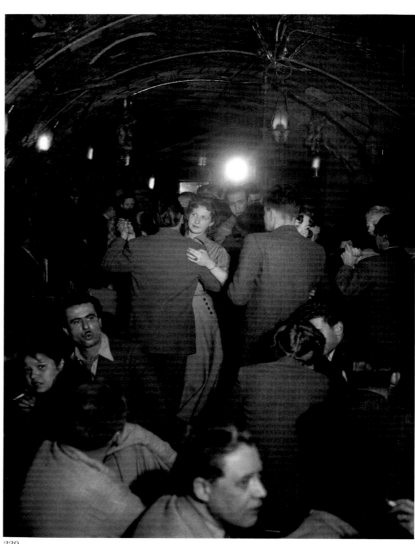

229

230

230. *Simone de Beauvoir at the café Flore, 1944.*

shop a few doors away, and together they would come up with story ideas to propose to the magazines for which they worked. It was in collaboration with Romi that Doisneau began to experiment with a new photographic genre—the picture series. There was a growing trend in illustrated magazines toward telling a short story or gag through the use of a number of interlinked photographs. This was in effect the beginning of Doisneau's long fascination with the narrative image, and he put it to good use in a number of notable series from this period: *La Joconde* (1946), which shows the reactions of visitors to Leonardo's *Mona Lisa* in the Louvre; the painter of the upside-down picture (1946) at the Institut de France; and the most celebrated of all, now known as *Le Regard oblique* (pls. 232–33). The latter was made in Romi's antique shop in 1949, appearing first in *Point de vue* and then in many other magazines throughout the world.

Through Romi, Doisneau met another journalist who worked occasionally in the antique shop, Robert Giraud—perhaps one of the most intriguing of his friends from this period (see pl. 231: Romi and Giraud in front of the antique shop):

> Inside the shop was Robert Giraud, who had no job and looked after it for Romi during the day. Giraud and I began to talk, then we went to drink a glass of wine together in the bistro next door, Chez Fraysse, 21, rue de Seine. Giraud asked me: "Do you know Les Halles?" "Yes, but not very well." "Well, I know everybody there. Would it amuse you to take a trip around there?"
>
> So we began to wander around Les Halles together.

The role played by Robert Giraud in the development of Doisneau's photographic vision was decisive. He opened the doors to a world that Doisneau had glimpsed, but of which he had little knowledge; Giraud was fascinated by the "worlds of *la cloche* (the vagrant) and the night." He spent his nights and much of his days exploring this exotic universe of the underclass, shuttling between Mouffetard and Les Halles, between the *puces* ("fleas") at Kremlin-Bicêtre and the *tzigans* (gyspsies) of the porte de Clignancourt, collection experiences he could sell as stories for the flock of magazines that printed his work.

A native of Limoges, Giraud had come to Paris in 1945 to work on the journal of the MLN (Mouvement de la Libération Nationale), the main Communist resistance group. A student of law until the outbreak of war, he had evaded conscription in the Vichy Ateliers de Jeunesse, joined the Resistance and fought in the Limousin *maquis* (underground). Betrayed in 1943, he was imprisoned, where he was tortured by the collaborationist Milice before being sentenced to death for armed resistance, only escaping execution through the timely arrival of the Allied forces. In prison, where he had been kept in the cell for the condemned with his brother, Giraud had begun to compose poetry. Not allowed paper, he memorized it, and when he was finally released he transcribed everything from memory to create the book of poems called *La Cage aux lions,* published in 1946. Afterward, he gave up all idea of resuming his studies, for the experience of war, occupation, resistance, and imprisonment had completely changed his outlook on life. In 1945 the MLN sent Giraud to Paris as editor-in-chief of their magazine, *Unir,* which by a neat irony was sit-

231

231. *Romi (Robert Miguel) and Giraud in front of Romi's gallery, 15, rue de Seine, Sixth Arrondissement, Paris, 1947.*

232–33. *Pages 187–89:* Le Regard oblique (The Sideways Glance), *Paris, Sixth Arrondissement, 1949. A series of photographs made in Romi's antique-shop. He sold objets d'art of the nineteenth century, and also worked occasionally as a journalist with Doisneau, employing "Bob" Giraud as part-time assistant. At the time this series was made, Doisneau had been successful in selling a number of "photo-novels" that magazines such as* LIFE, Lilliput, Picture Post, *or* Point de vue *would publish as amusing anecdotes on everyday life. Romi had recently bought a nude by the nineteenth-century painter Wagner, and both Giraud and Doisneau had noticed that it attracted quite a lot of attention. "It was a little provocative in those days to put such a picture in the window. I went to see Giraud in the gallery one day, and I saw that a lot of people glanced at the painting in the window, and their reactions were quite amusing. I thought it would make a good photo-series . . . I arranged with Romi to sit in the shop, holding the Rolleiflex on my knee, to see if I could get some good pictures. Because there was a reflection in the window, passers-by couldn't see what I was doing. All but the picture of the policeman were made in the space of two to three hours." He characterized this scene as* comique terrestre—"down to earth humor." *The series is wrongly attributed in* Point de vue *to Doisneau and Willy Ronis!*

(REPORTAGE PAR RON

12

uated in the same offices as those previously occupied by the collaborationist PPF (Parti Patriotique Français) of Jacques Doriot.

Giraud has described himself as being *très communiste* when he met Robert Doisneau, and their shared political values probably drew them even closer together: "I had been in the Resistance like Robert—that brought us together. Then there was the fact that Robert really understood street life." Yet Giraud's fascination with the *bas-fonds* (low life) was not initially something for which Doisneau had a great deal of sympathy, for these people were a world away from the petite-bourgeoisie and honest working class of the banlieue.

In the immediate postwar period there was a population of perhaps five thousand or more *clochards* in the Maubert and Mouffetard districts alone (out of the total of ten thousand or so in Paris), living in the derelict *hôtels particuliers* and ancient apartment buildings. There and across the Seine around Les Halles there existed a whole network of restaurants, bistros, and even small hotels catering to the *clochards*. They formed a shifting and precarious society and economy—but most interestingly of all for Giraud a subculture—which functioned at the heart of the great city. As Giraud wrote, the *clochard*

> . . . doesn't work, but he does carry out useful tasks. Each one has his own fiddle, his defense—a way of sorting things out that he tells no one about, the secret of which he jealously guards. The *clochard* looks after himself at night and often sleeps during the day when fatigue strikes, on a bench, a hot-air grate, even on the pavement or the banks of the Seine.[4]

These were the people who begged outside the churches of the Latin Quarter, collected cigarette butts in the streets and bistros to peddle in the place Maubert, were engaged as casual *aides-renforts* in the markets, and foraged in the detritus of the "stomach of Paris" at Les Halles. Others worked as *biffins* (ragmen) during the night, ensuring that the trash cans were placed out in the street for collection, first sifting through the garbage for anything worth selling that could be carried away in an old cart. Many slept out on the quays and under the bridges of Paris, and plied a miserable trade as freaks in cafés and bars, displaying their tattoos and deformities for a few *sous*. Those who worked the markets also stole some of what they handled, an amount traditionally allowed for by the traders and known as *la redresse*.[5]

In addition to plying his trade as itinerant journalist, Giraud had a number of other activities that paid for his *gros rouge*. "Bob" Giraud was a friend—and for a time the secretary—of the painter Jean Dubuffet, worked for both the Galerie Drouin and Lydia Conti, was intimately involved in the *art brut* movement, and if money was particularly short he was not above occasional burglaries—for which he owned the appropriate equipment! (see pl. 234)

In retrospect, it is easy to understand Robert's fascination for his promenades with Bob Giraud: if nothing else, they offered the possibility of striking another vein of juxtaposition, of playing with the opposition of the world of the *cloche* with that of the *normal*, the world of the night against that of the day, the poor against the rich. It is also obvious that Doisneau and Giraud made a good team, for they could come up with a well-illustrated and well-written article from their explorations of both St.-Germain-des-Près and *le monde de*

234

234. *Robert Giraud, "thief of cats," 1954. "Bob" Giraud with cat-catching equipment on the rooftop of the Hôtel de Ville, Paris, Fourth Arrondissement. "It was not long after the Occupation. The scarcity of furs and coal gave birth to a new industry—the exploitation of cat fur. The pelts of this carnivore were, it seems, charged with electricity, possessing the power to keep you warm at relatively modest cost, to cure rheumatism. Advertising slogans confirmed it (Robert Giraud, Le Vin des rues, 1955)."*

235

235. *Monsieur and Madame Garofino, by the quai de la Rapée, Paris, Twelfth Arrondissement, 1951. A couple of* clochards *photographed during Doisneau and Giraud's nocturnal trips among the* monde de la cloche (world of the homeless), *whose customs, economy, and society they documented. Giraud's fascination with* art brut *brought Doisneau the opportunity to photograph marginal artists like Duval (pl. 237) and Savary (pl. 238), who perfectly encapsulated his friend Jean Dubuffet's theories about the importance of the art produced by those living on the edge of society. Duval made ephemeral paintings that he washed away each night, while Savary constructed his sculptures using objects that he had fished out of the Seine, from a boat made from crates found at Les Halles market. Dubuffet wanted to create new art forms that had a closer relationship to everyday life and culture; he saw in the work of such "primitives" a purer and more elemental art that went closer to the roots of mental activity, "where thought is close to its birth."*

236

236. *Monsieur Georges, "L'Archiduc," and Riton,*
rue Watt, Paris, Thirteenth Arrondissement, 1952.

237

237. *Maurice Duval, "the artist-tramp, who by day paints a watercolor on a waxed canvas that he washes each evening in the Seine," Paris, 1949.*

238

238. *Jean Savary, the sculptor-tramp of the Seine,*
pont des Arts, Paris, 1955.

239

239. L'Amiral, roi des clochards, sa reine, Germaine et leur bouffon, l'ancien clown Spinelly (The Admiral, King of the Tramps, his Queen Germaine, and their Jester, the Former Clown Spinelly), *Paris, 1953.*

la cloche (world of the homeless). But they also investigated the eccentrics who inhabited the marginal fringes of respectable society, those who had not yet sunk into the underclass but lived a curious existence through the pursuit of their enthusiasms; many of Doisneau's great portraits come from this aspect of their work, such as the fine large-format picture of Monsieur Nollan, the collector of reproduction furniture largely bought second-hand (pl. 242).

Together they would devise an article or series of pieces on this or that subject, take the photographs, write the text and captions, and then hawk it around to the magazines accustomed to their work: *Paris presse, L'Intransigeant, Point de vue, Combat, Cavalcade, Regards, Libération, Le Soir,* etc. The rewards were minimal, but probably kept them in the *pots de beaujolais* that fueled the pieces. Occasionally Doisneau would make a series of photographs with Giraud that would also be used by other journalists—for example, his pictures of Armand Fèvre, the Bonapartist of St.-Germaine-des-Près, whom Doisneau photographed for articles in *Regards, Le Soir,* and *Paris presse.* Living in the rue Bonaparte, dressed in clothes from the era, Fèvre had never been in a car, a bus, or the metro. His apartment was lit only with candles, and he made a modest living from buying and selling rare books of the Napoleonic era. When Doisneau photographed him it was on the condition that he not be shown alongside anything modern. On one occasion in 1950, Fèvre even fought a duel with a journalist, Pierre Merindol, which Doisneau captured on film (pl. 243).

The explorations of the *monde de la cloche*—or *"Les Etoiles de la nuit,"* ("the stars of the night") as Giraud baptized them for a series in *Paris Presse* during 1950—provided Doisneau with a counterbalance to his commitments at *Vogue* (see below). He confided that "it was a job that really irritated me by the end. And it was one of the main reasons why I went boozing with Giraud." They would meet in Chez Fraysse in rue de Seine, or in a *café-bougnat* called Chez Constans (with "the *Auvergnat* who was the worst accordion player in the world"⁶) after Doisneau had completed his work at *Vogue,* and then spend much of the night together exploring all the bars, brothels, clubs, and assorted dives that Giraud was in the process of "researching." Robert would return home to Montrouge by 2 or even 3 A.M., with Giraud continuing on until dawn.

It was not simply the need to seek solace in the easy confraternity of the bistro that drove Doisneau to make these sojourns, for the trusty Rolleiflex and a flashgun always went with him. Raymond Grosset recalled that Robert had such a developed sense of economy—no doubt acquired during the Occupation—that a roll of his film begun during a *Vogue* assignment would contain images of several *clochards* on its last few frames! In the contract negotiated with *Vogue,* Doisneau was free to carry out other work on a freelance basis, for it guaranteed that he would be paid for a certain number of pages per month—whether the magazine used them or not. Thus the adventures with Giraud had a dual function: firstly, they were the necessary counterbalance to the snobby world of *Vogue,* and secondly, they offered a photographic enterprise of great interest—a wholly new and intriguing set of *décors* and *personnages* for Doisneau to "inscrire." Yet Doisneau admitted to a sense of unease about the world into which he was drawn by Giraud:

Through him I met the marginal people. A world of people who were completely out of step with the law. It was his world. I was never very

240. Les Mégots (Cigarette Butts), *Paris, 1956. One of the traditional pursuits of the* clochard *was the collection in bistros and on the streets of discarded cigarette butts which were then sorted and re-sold as tobacco on the black market.*

241. *Armand Fèvre, the Bonapartist of St.-Germain-des-Près, Paris, 1950. Then living in the rue Bonaparte, dressed in clothes from the era, Fèvre had never been in a car, a bus, or the metro. He is typical of the* marginaux savants *(marginal intelllectuals) that Doisneau so enjoyed photographing, but he only allowed his portrait to be made if he was not shown alongside anything modern.*

242. *Page 197:* Monsieur Nollan, "L'Amiral," chez lui (Monsieur Nollan, "The Admiral," at Home), *surrounded by his possessions, mostly copies or things picked up in flea markets, Paris, Fifth Arrondissement, 1950. A large-format (four-by-five-inch) portrait made for a series of articles produced by Doisneau and Giraud on "Les Etoiles de la nuit" ("The Stars of the Night") for the newspaper* L'Intransigeant.

happy to be with the prostitutes, the pimps, but they interested him a lot. It was a world that seemed, in the end, fairly stupid. Girls telling dirty stories about their clients, that was never my thing.

Though the *personnages de la nuit* whom he photographed led to a fascinating set of images, the visual ethnography of a now-vanished world, it is clear that Doisneau had to use much of his famous capacity for complicity to obtain such pictures, and that at bottom they did not really interest him as much as did other people on the fringes of society with whom he came into contact. As he told the author, "Oddly enough, it's the marginal intellectuals who interest me most."

Discussing his photographs of the now-vanished life of the bistro, of which the vast majority were made with Giraud between about 1948 and 1955, Doisneau pointed out that "to take such pictures, you can't remain on the fringes of the crowd. You have to drink as much beaujolais as they do to feel part of what is going on, and so that they are no longer aware of you as a photographer." It is this participatory complicity that yielded such wonderful pictures for Doisneau, in which no artifice or mise-en-scène was necessary: in the pictures he made of the "evening of culture" at the run-down Aux Quatres Sergents de la Rochelle in the rue Mouffetard, for instance, where the patron Olivier Boucharain had organized a soirée to rival those in St.-Germain-des-Près. Giraud, the journalist Pierre Mérindol, and Doisneau himself probably took part in the entertainment: it included Claude the docker, whose specialty was the piercing of his ears and cheeks with needles, followed by a display of tattoos.

Giraud was fascinated by tattooing: with his cellmate from Resistance days, the Inspector Jacques Delarue, he gathered together as many people as he could for Doisneau to photograph, aiming for a book and exhibition on *le tatouage*. The book never appeared, but Giraud published a series of articles on the subject between 1947 and 1962 and devoted a chapter to it in his intriguing book *Le Royaume d'argot* (1965). Doisneau was fascinated by this project and devoted considerable energy to it, searching with Giraud for people with interesting tattoos to photograph. He kept a jerry-can of water, some rags, and a bottle of rubbing alcohol in the car in case they had to clean down a *clochard*'s arm or back to take a picture of a particularly interesting tattoo. They would do the rounds of the bistros around Les Halles or in the Mouffetard and Maubert areas of the Left Bank, calling out, "Is there anyone tattooed here who wants to earn two hundred francs?" In some of these bistros "they served the *gros rouge* in half-liter glasses. You couldn't take your eyes off your glass without the risk that it would be empty when you looked again. It didn't matter because the wine was not good; personally, I prefer it to less resemble paint thinner."[7] Doisneau recalls that it was in one of these seedy bistros (Aux Cloches de Notre-Dame) that they encountered one of the most fascinating subjects for this project: Richardo. As Giraud recounted in his book on the argot of Paris:

The years after the Liberation witnessed the appearance of "Richardo, the world's most tattooed man." It was the official title of his profession. Tattooed all over, Richardo exhibited himself in fairs and bistros at happy hour. Albert Londres, who knew him in prison, called him the "Living Gobelins" because his body, covered entirely in drawings, looked so like a tapestry.

243

243. *Duel between Bonapartist Armand Fèvre and journalist Pierre Mérindol, Paris, 1950. "One day one of our colleagues, Pierre Mérindol, called him 'washed-up' in an article. Fèvre took offence and demanded a duel. The chosen arms were cutlasses. They met in the forest of Senart. The Bonapartist, after a few ordinary-looking thrusts, injured his opponent on the hand. Blood was spilt. Honor was saved. But the press immediately got hold of the story, and Fèvre became famous. (Robert Giraud,* L'Intransigeant)."

244

245

244. *Entertainment at Aux Quatre Sergents de la Rochelle, 34, rue Mouffetard, Paris, 1950. As Doisneau recalled, "Olivier Boucharain, the owner, once confided in us his weariness with the daily grind: 'Ah! There are some days when I couldn't give a damn about this den of greedy, grimacing monkeys!' In sum, a moment of depression. And, as Mérindol and Giraud liked him a lot, they proposed a way out. 'Olivier, don't you see, St.-Germain-des-Près is packed with clubs, there are some nights when they're so full that people line up in the street. Rue Mouffetard is empty. So why not put on a typically Mouffetardian show? Guaranteed success.' 'You've got carte blanche,' said Olivier."*

245. Jeux de société au café rue Lacépède (Parlor Games at the rue Lacépède Café), *Paris, 1954.*

246

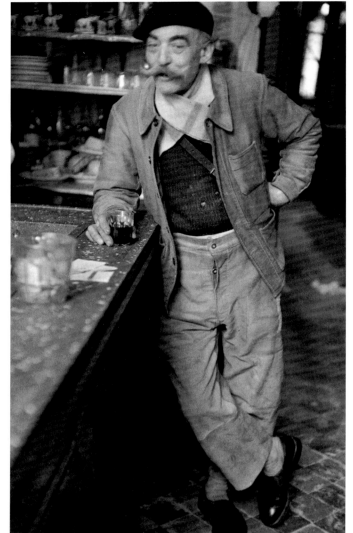

248

247

246. La Mimosa du comptoir (Mimosa on the Counter), *bistro rue Maître-Albert, Paris, Fifth Arrondissement, 1952. "The rue Maître-Albert bistro was not the kind of place you would expect to find potted plants or flowers. The clientele of sales-people from the flea markets were happy with the functional, run-down décor. How had the bunch of mimosa found its way to the bar . . . who had slipped its gentle perfume into the ever-present smell of cigarette smoke and the more acrid smell of the wine cloths? It was all that was needed for the stout Mado to regain her youthful heart."*

247. "Coco," Paris, 1952. *Also known as "Cloclo": according to Giraud, his specialty consisted of begging from those with official decorations, passing himself off as a hard-up legionnaire.*

248. Vieux consommateur (Old Consumer), *Chez Alain, 25, rue de Seine, Paris, 1953. An early thirty-five-millimeter image, made with the Leica IIIF camera that Doisneau acquired for low-light photography.*

249. Page 201: *Olivier Boucharain, Aux Quatre Sergents de la Rochelle, 34, rue Mouffetard, 1950. Large-format (four-by-five-inch) photograph.*

250

251

Extremely violent, Richardo had stabbed two men in the course of a fight. Given a heavy sentence, it was in prison that he dreamed of making a career out of skin engraving.

He played at *la belle* (escaping from prison) and succeeded with another convict called "La Souris" (The Mouse). They wandered all over the place, and finally after a long journey their status as hunted men led them to the Indies. It was there that they undertook to be tattooed together.

It took them five years, five years of insane and monstrous suffering. Their aim had been to exhibit themselves across the hemispheres as "the best and most tattooed twin brothers in the world." But misfortune fell upon this curious association. Poisoned, literally, by India ink, the two men had to be rushed to the hospital one fine day. La Souris soon died. Richardo had better luck and took eighteen months to recover, eighteen months of unspeakable torture treating the eighty boils that had grown over his whole body.

When he was finally cured, the illness had not changed his vocation. The scars that covered him had destroyed some of his tattoos, but as soon as he got out of the hospital he had them retouched, and without his twin, who had been killed by the procedure, began a profitable adventure.

"There you are, straight up, ten thousand francs on the table to anyone of you assembled here who can find on my body any plain space bigger than a one-hundred-*sou* coin," he was in the habit of saying during his work. Nobody ever took up the challenge of Richardo, who in 1930 had sold his skin to a doctor for the sum of fifty thousand francs.[8]

The problem with Richardo was that as he had to strip to show his tattoos, he could not easily be photographed in the bistro: the only possible solution was to take him back to place Jules Ferry. When they entered Doisneau's apartment, Annette and Francine were playing in the atelier with Pierrette. Richardo was brought in and politely, but in a deep and rough voice, bellowed out, "Bonjour mesdames!" The girls ran away in terror to hide under their parents' bed. Robert made a number of five-by-four-inch portraits of Richardo, against a dark backdrop in the atelier.[9] Robert reported that "Richardo came to a bad end":

He was exhibiting himself in the bistros—"A few coins and I'll open my dressing gown." A guy had laughed, the mark of disrespect. Richardo would not stand for that. "Outside if you're a man." The ignorant fellow went out first, a technical error. Richardo died in prison. On his identity card, in the box "distinguishing marks," a civil servant had written: "none."[10]

Nonetheless, there were certain things that Doisneau would never photograph. When Giraud took him to a club near the gare de Lyon, frequented by the gay community of Paris, Doisneau would not get his Rollei out of its case. It was a club (long since closed down) where notable professional men, such as lawyers, would meet their boyfriends for the evening, many of them *bagagistes* from the nearby train station.[11]

250. Le Barbier de Nanterre (The Barber of Nanterre), *Prison-Hospice de Nanterre, 1952.* "*Caught flagrantly committing the crime of begging, the beggar was immediately sent before the tribunal. There he was condemned to a prison sentence, depending on his previous record, and always accompanied by a complimentary and obligatory spell of thirty to forty-five days at the Nanterre departmental hospice. . . . The cursed of Nanterre had their hair cut to double zero, and they received a uniform and a prison number (Robert Giraud, "Ceux de la cloche, ceux de la zone," 1961).*

251. *Richardo, "the most tattooed man in the world," Montrouge, 1950.*

252. *Page 203: Richardo (back view), Montrouge, 1950. This is the full-frame of the four-by-five-inch negative, never reproduced before, but showing that every inch of Richardo was tattooed.*

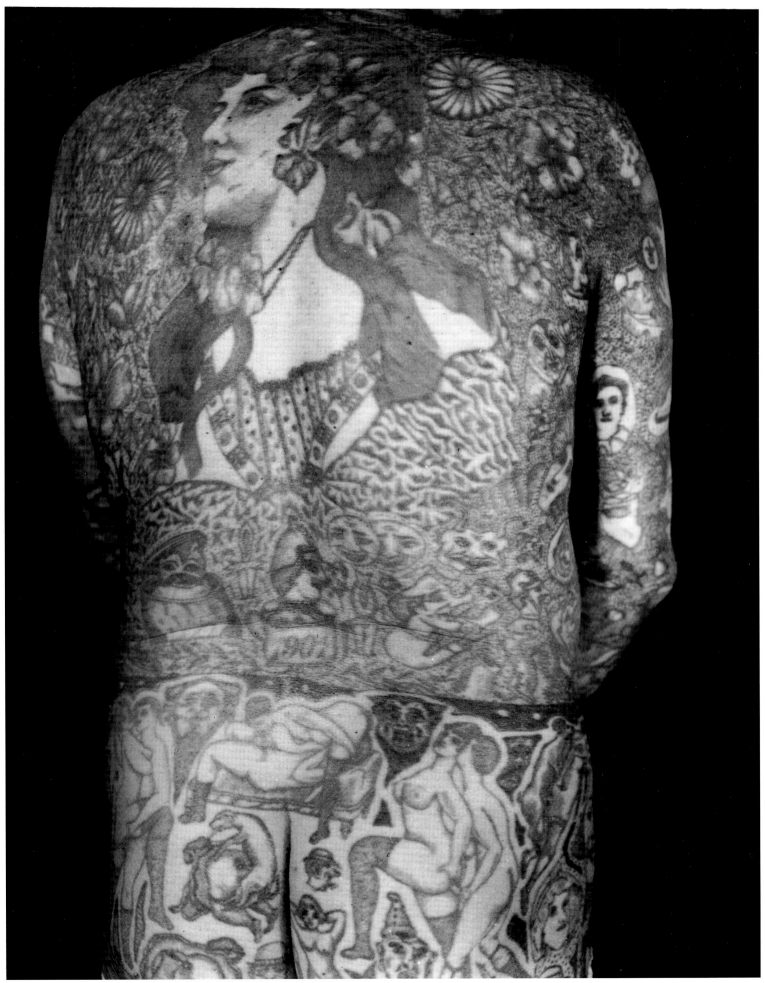

Giraud also introduced Doisneau to interesting figures in the *art brut* movement, such as the artist Gaston Chaissac, to Dubuffet, and was involved in the reportage assignments that led to certain important pictures of the period, such as *Mademoiselle Anita à la Boule Rouge* (1950; pl. 253), and *Les Bouchers mélomanes* (1953; pl. 257). With Jacques Prévert and others, Giraud and Doisneau enjoyed the life of the bistro. It was Prévert, for instance, who titled Giraud's book on his experiences with the *"personnages de la nuit" Le Vin des rues* (1955), although it was Doisneau who had cajoled and sobered up Giraud enough to get it written.[11] Albert Fraysse, proprietor of the bistro that was their favorite haunt in the rue de Seine, provided his house in Brittany for Giraud to get the writing done, but it is to Robert Doisneau that Giraud dedicated the book and to whom he gave the manuscript copy.

Later Doisneau would repay the compliment, for in the early 1960s he helped to design and install an exhibition of Giraud's postcard collection of the era 1900–25 at the Casino of Pierre and Andrée Delbos in St. Céré, Lot. From letters of the time it is clear that Doisneau went so far as to design the poster and even the panels on which the cards were displayed.

◆

The value of Giraud's friendship with Doisneau really came to the fore between 1949 and 1952, the period when he was under contract to Vogue magazine. Doisneau, by his own admission, could not summon up any interest in learning the language of fashion photography. Since so many of the most interesting pictures of the period 1949–52 were made elsewhere—on his own time or on other assignments—it is tempting to conclude that *Vogue* offered an incomplete creative impetus to Doisneau. He admitted to the author in 1991 that "nowadays I'm ashamed when I look at the fashion photographs." Yet certain aspects of his work for the magazine have lasted the test of time: his photographs of balls and society weddings, his portraits of artists, writers, and entertainers, and his pieces on French cities, which produced some of his finest work.

In 1948 the editor of *Vogue*, Michel de Brunhoff (brother of the inventor of the *Babar* stories for children) had commissioned Doisneau to carry out a reportage on Lurçat's work for the renowned tapestry works at Aubusson. The photographs were published, and shortly thereafter de Brunhoff asked Doisneau to come and see him. At the time, de Brunhoff would reserve a day a week to look at the work of photographers—neophytes and masters alike. It was a period when the great style magazines of the era were engaged in a search for new photographic talent, to create images more in keeping with the spirit of the age. Right out of the blue, as it seemed to Doisneau, de Brunhoff asked whether he would consider joining the magazine on a permanent basis:

> He'd asked me to bring in my pictures. He looked at them and said, "How do you live?" I replied, "I work for an agency." Brunhoff's son had been shot by the Germans—perhaps I seemed a little bit like his son—and he asked me to come to work for *Vogue*. I said, "What do you think I could do, Mr. Brunhoff? I know nothing about fashion." He said, "That's OK, we want to change things a bit." They wanted to introduce a "popular"

253. Mademoiselle Anita à la Boule Rouge, *Paris, Eleventh Arrondissement, 1950. This photograph was made as part of a reportage on accordion music and the singers who made their living in the cabarets and cafés of the* quartiers populaires *of Paris. Doisneau was working with Robert Giraud on an article featuring a well-known singer of the time, Jeanne Chacun, performing that evening at a cabaret in the rue de Lappe, a narrow street near the Bastille. While he was waiting for Chacun to begin her performance, Doisneau began to photograph the Boule Rouge's customers. This picture of Anita, who can be seen in a number of the frames of the series of exposures made by Doisneau that evening, is quite unlike any of the others, helped by the fact that the photograph was taken with the available light in the dance hall rather than with the flash used for other pictures in the series. Doisneau was obliged to use a very slow shutter speed on his Rolleiflex—about one-tenth of a second—and with the Tessar lens set at its maximum aperture of f3.5, there is a softness and slight blurring to the picture that only adds to its enigmatic quality. "This photograph . . . I call it Anita, that's all I know about her. We call an aura the sort of neon tube that lights up around certain people and isolates them for a brief moment. You have to work quickly to catch it because the aura is so fragile. I said to her, 'Please, don't change anything, don't move, I'll explain afterwards.' She must have been conscious of the effect produced, because without even lifting her eyes, she had kept up this attitude of stubborn modesty that suited her so well. There is a second picture of her before, where she is wearing the little jacket, and it's nothing at all. It's just an insignificant young girl. But if the jacket comes off, if we open the pod, we have this flower shining in the light of the place . . . but it only lasted a moment. I did well to wait and have the nerve to ask her 'Do you mind if . . ?' 'Yes.' And then she herself took off her little jacket, and with that the chrysalis opened and the butterfly appeared." Doisneau can be seen taking the photograph, his reflection appearing twice in the mirrors to the right of Anita.*

In his 1954 book, Instantanés de Paris, *another photograph of the* Mademoiselle Anita at the Boule Rouge *was published. But this was a more straightforward 'charm' photograph, and in his caption Doisneau wrote: "While waiting for Jeanne Chacun to sing, I put the Rolleiflex on the floor to record the memory of the prettiest legs in the Boule Rouge" (see pl. 255: Anita is at the extreme right).*

253

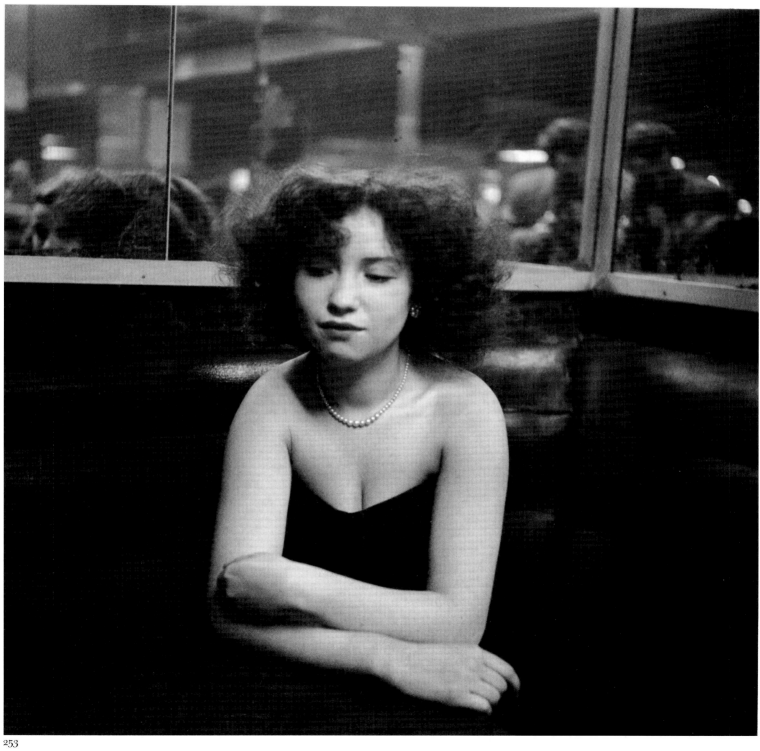

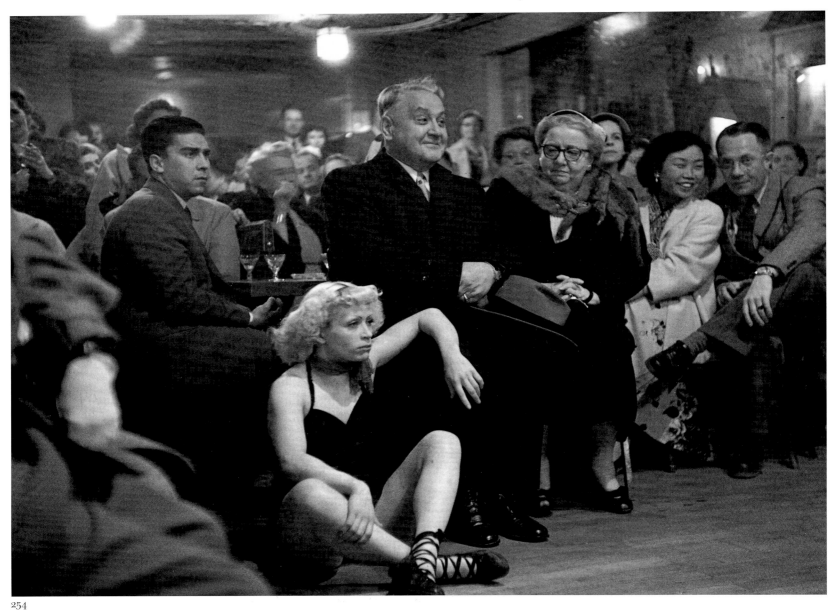

254

254. Le Petit Balcon, *rue de Lappe, Paris, Eleventh Arrondissement, 1953. A reportage on the "Paris by Night" bus tour, an early thirty-five millimeter photograph.*

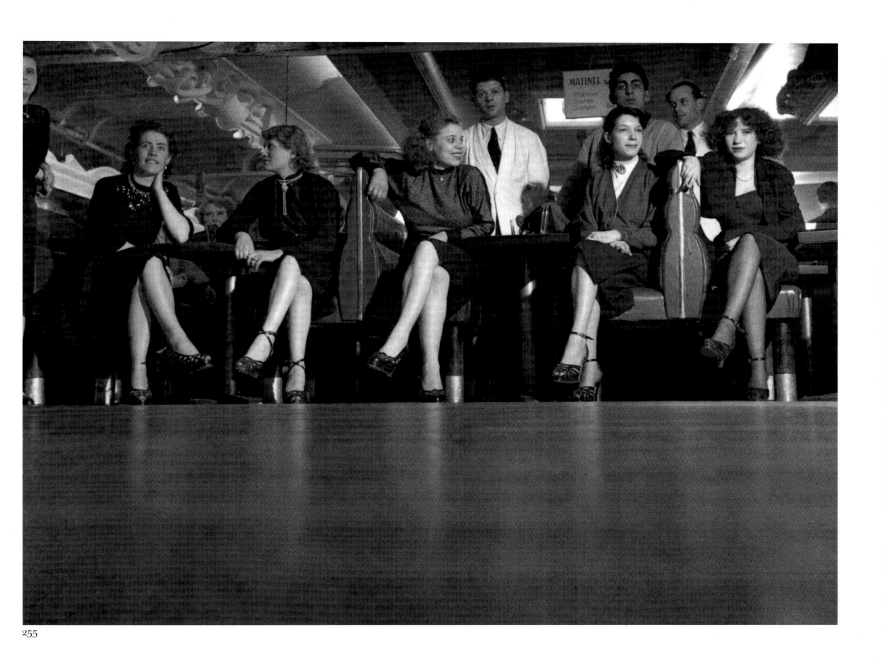

255. *La Boule-Rouge, Paris, Eleventh Arrondisse-
ment, 1951.*

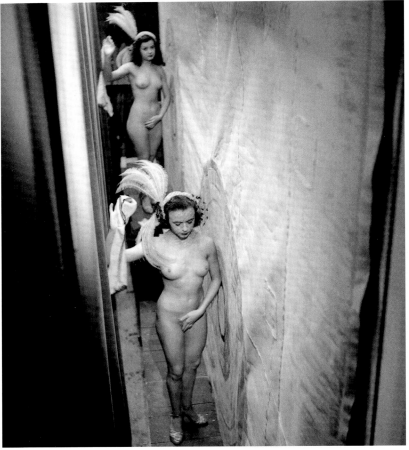

256

257

258

256–58. *Concert Mayol, 1952. RAPHO's picture-story explains: "The concert Mayol, located not far from the Folies Bergères, does not have the world-wide reputation of the latter, nor of the Casino de Paris. It has no ambition to rival the extravagance of their productions; in any case, its auditorium is small and can only accommodate an audience of four hundred. But the concert Mayol has a reputation well established over several decades as a music hall where the shows have dancers at least as naked as at the Folies Bergères. The audience is made up of, for the most part, non-Parisians who have come to Paris on business and who are looking for a night's entertainment before returning home. They are people looking for value, so the manager had the brilliant idea of offering a seat at each show at 5,000 francs (10 times the average price) to the fortunate spectator who wanted to help in the show backstage. The idea was successful, so at just about every show you could see a provincial, looking blissful despite his hard seat, happy that he had taken part in the show at the concert Mayol!"*

257. *Concert Mayol, 1952.*

258. *Hommages respecteux (Respectful Homage), concert Mayol, 1952. Here we see the "provincial" who has paid 5,000 francs for his stool: "The great advantage is that during intermission he can go backstage, a sacrosanct place where pleasant surprises are not missing."*

259

259. Examen d'entrée au concert Mayol (Audition at the Concert Mayol), *1953. Doisneau also photographed a story about the life of a Mayol dancer (see pl. 261).*

element into their magazine, a bit like the snobs who sometimes take up the language or clothes of ordinary people. They could see that things were changing.

I said, "I've got to talk to Monsieur Grosset, let me think about it for a week." When I told Raymond, I said, "You know, there's a loony at *Vogue* who wants me to come and work for them." Raymond said, "Listen, you can't refuse, they will give you a good contract with lots of money." I told him that I couldn't negotiate a contract like that, and he said, "I'll do it for you." At the time I was really useful to RAPHO. I was a bit of a *débrouillard*, I could do a lot of things for them—a cycle race, a restaurant interior, anything. He was so kind to negotiate such an advantageous contract.

Doisneau accepted because the pay, after so many years of penury, was welcome. He had a wife and two children to feed and wanted to get a bigger apartment, for the youngest daughter, Francine, still slept with her parents. All the darkroom work was done in the bathroom, the enlarger and the developing dishes sitting on a board over the tub. Once a week all would be removed so the children could take a bath. For the rest of the time, the darkroom work was carried on in an atmosphere lightly impregnated with the perfume of soap. Monsieur Barabé would occasionally do archival work or record prints to help out, and of course he could mix chemicals and wash and dry prints, but Robert himself had to do most of the developing and printing.

260

> *Vogue* took a lot of my time, four days a week. . . . It was a complete disaster. I couldn't put anything personal into the pictures. . . . I was good enough at my trade to do a ball with beautiful women. But when one is in a studio and obliged to make a good photo with a woman and a dress, I couldn't care less! I would rather do a fine photo of Sabine [Azéma] in a beautiful dress, in a hotel room—I can do that because she's a woman I really like, and we can play at being the photographer and the model in a nice dress! Fashion is not my thing, all that false world bores me. I couldn't care less, the dresses don't excite me. I don't understand a thing about collections, and during the runway shows I would look at my watch. I knew that the next day a model would arrive in the studio. What would I do with this dress and this model, who to make matters worse was Swedish, and couldn't speak French! I was more at ease in the bistro on the corner.

The *Vogue* contract, which in theory promised so much, was in many ways a great disappointment. Brunhoff was almost certainly influenced in his choice of Doisneau by the experience of Condé Nast's American art director, Alexander Liberman. Raymond Grosset suggests that the contract was in fact negotiated directly with Condé Nast in New York, by Charles Rado. This fits in with what we know of Liberman's policy during the postwar period of aiming to refresh the look of his magazines by introducing the new "small-camera" humanist-influenced approach to fashion and what would now be termed "style" photography.

Liberman had encouraged photojournalism-inspired imagery in the American *Vogue,* which employed a good deal of "outdoor naturalism" from the early 1940s until the mid-1950s. He had worked on *Vu* in Paris as art director

260. *Self-portrait with telephoto lens, Paris, 1956. From the mid-1950s on, Doisneau began to exploit the potential of the telephoto lens.*

261. *Page 211:* Mme Vivin, danseuse au concert Mayol (Mme Vivin, Dancer at the Concert Mayol), *Faubourg St.-Martin, Paris, Tenth Arrondissement, 1953.*

262

262. Mariage au Château de Gerbeviller (Marriage at the Chateau de Gerbeviller), *Meurthe-et-Moselle, 1949. Doisneau's first reportage for* Vogue.

263

263. Drapé de Grès (Gown by Grés), *Paris, 1955.*
Four-by-five-inch studio shot for Vogue.

264

265

266

267

264. *Page 214:* Les Imperméables (The Raincoats), *Pont-Neuf, Paris, 1951. "Outdoor fashion" photograph for* Vogue.

265. *Page 214:* Femme-paon (The Lady Peacock), *1947. "Round eyes peeking over a newspaper, a lighter's flame poised near a cigarette, three blue-rinsed ladies suddenly become silent when the woman in the velvet coat crosses the hall of the grand hotel, her train imperceptibly brushing the carpet; probably inspired by her movie-star looks, she passes by with the grace of a peacock. The man with the golden keys, even he who normally looks down on everyone, cannot keep his eyes off her."*

266. L'Art de la table, *editorial photograph for* Vogue, *1951.*

267. Baiser valsé (The Waltz Kiss), *Paris, 1950. The baron Cabrol, ball at the Hôtel Lambert (residence of the princes Czartorski). Reportage for* Vogue.

and managing editor from 1933 to 1936 and was convinced that "the immediacy of the unposed news photograph could be grafted on to fashion photographs to give them wider appeal, greater realism."[12] He reacted against the mannered prewar styles of a Beaton or a Horst, which did not reflect the new roles that women were taking on through the war years and after. Yet the world of fashion photography in postwar France remained quite backward-looking, still largely dominated by the photographic conventions laid down by Horst, Hoynigene-Huene, and Beaton. They took a close interest in fashion and all its gossip, not merely as a result of their profession, but because they also identified themselves closely with the *beau-monde*. Their contacts, their cultural universe, and their discourse were wholly elitist. Though by this stage Doisneau was no longer a member of the PCF, his political views had not substantially changed, and he viewed the world of which *Vogue* was a part with considerable distaste.

With only two of the *Vogue* journalists did he feel any complicity. Firstly, Henriette Pierrot, "a very nice old lady," as Doisneau described her, and with whom he carried out a number of interesting assignments, including a wonderful story on the concierges of Paris, and a marvelous series on *devins* (fortune-tellers; see pl. 277). Edmonde Charles-Roux, who later replaced de Brunhoff as editor-in-chief of *Vogue*, got on extremely well with Doisneau, both as journalist and as editor—despite their very different social origins. She was *haute bourgeoise,* the daughter of a French ambassador, yet her political sympathies were not dissimilar to those of Doisneau,[13] and she recalls that it was a joy to work with Robert. "When we worked together on reportages, we were in fits of laughter all the time."

Edmonde Charles-Roux suggested that "it's been said, here and there, that Robert Doisneau was brought into *Vogue* to do fashion photography. Nothing could be more false. Brunhoff was too well-informed to want to launch his protégé on the wrong path, to make him do something that bored him."[14] Yet Robert himself always regarded his work for the magazine as including a significant share of fashion assignments, and this view is borne out by the number of such pages that carry his byline from 1949 to 1953. Mme Charles-Roux emphasizes that in addition to the fashion work, she and Doisneau carried out a more intensive program of reportage assignments together:

> What *Vogue* expected of Doisneau was not a few portraits at the rate of one or two a month, but long assignments that included an incredible number of photos, which appeared over six, eight, or ten pages every month. He was the sole reporter on Parisian life. I wrote and he illustrated. We scoured the town for *café-théâtres,* stage sets, dance studios, dressing rooms, the studios of illustrious painters, the country houses of great writers. Nothing stood in our way.[15]

According to Edmonde Charles-Roux, Robert was given some studio tests by de Brunhoff that demonstrated that he was not really at ease in such a setting. There is no doubt that Doisneau was never a studio photographer: his genius lay elsewhere, in using what appeared around him to make an interesting image. However, this fails to explain why he never made any good fashion photos for *Vogue,* for the trend toward outdoor, apparently improvised fashion

268

268. Vernissage à la gallerie Charpentier (Private view at the Charpentier Gallery) *or* Trois Grandes Dames, *Paris, 1949. An early assignment for* Vogue.

269–274. *Photographs used in an article on Parisian concierges for* Vogue, *September 1949. As Henriette Pierrot remarked in her article: "Real concierges only exist in Paris. Real Paris is unimaginable without its concierges. From time to time there's talk of doing away with them; at the moment it's because of the new law on rents. But Parisians are very attached to their traditions, both good and bad. They want to keep their concierges, even if they curse them after ten o'clock at night. All the buildings of Paris conceal, at ground level, in a corner without light or air, a loge. In it lives a concierge, sometimes single, sometimes blessed with a husband, with children, dogs, cats, canaries. . . ."*

269. *Page 217:* La Concièrge aux lunettes (The Concierge in Glasses), *rue Jacob, Paris, 1946.*

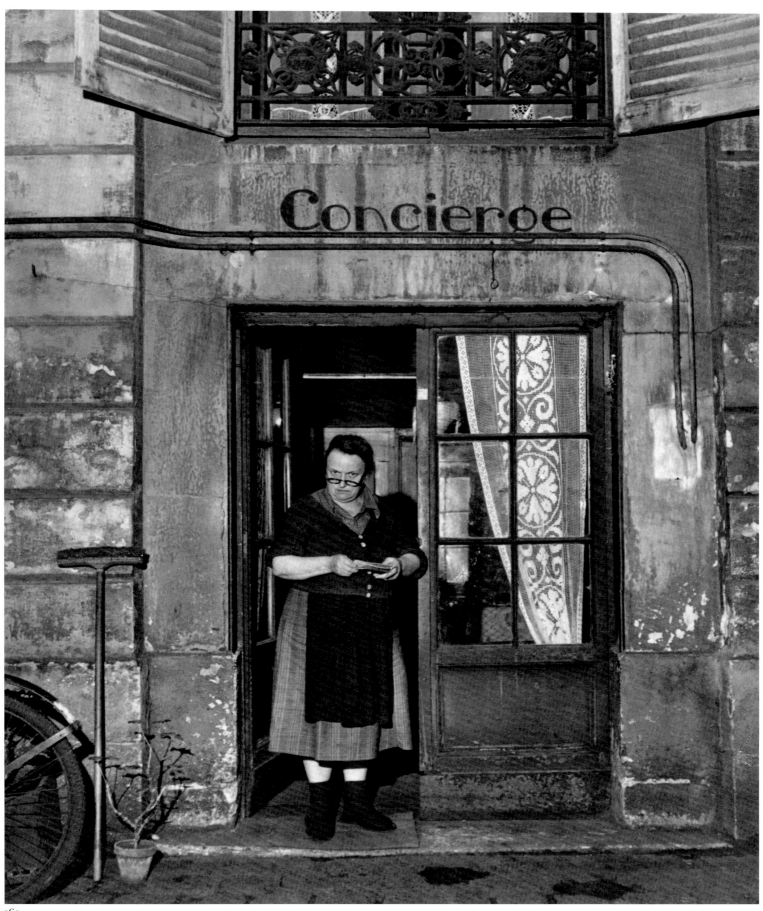

269

270. *Concierge, 1946.*

271. *Concierge, 1946.*

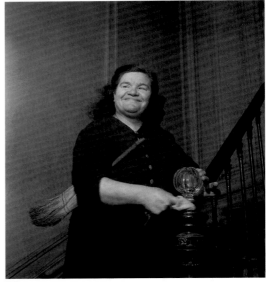

271

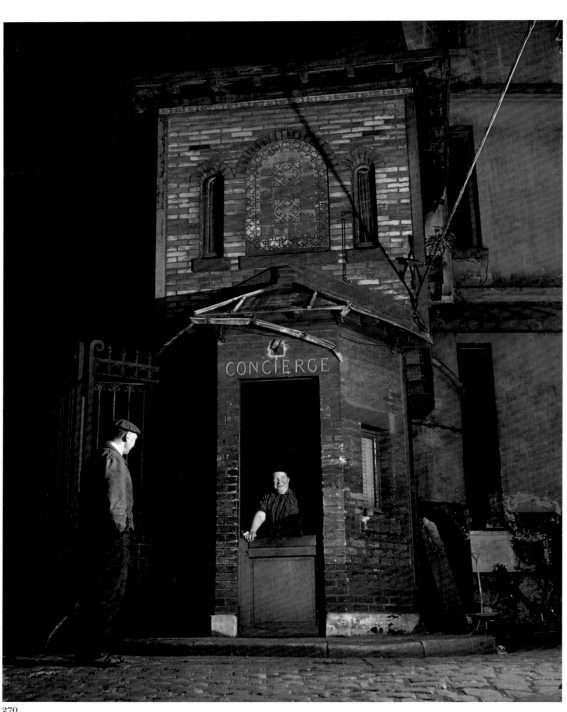

270

272. *Madame Augustin, concierge, rue Vilin, Paris, Twentieth Arrondissement, 1953. Some pictures were made with a four-by-five-inch camera, a format chosen because of the detail it records.*

272

273

273. *Concierges, rue du Dragon, Paris, 1945.*
"Every time I went to see Pouchol the ceramacist, I
wanted to take this picture. Grandmother herself
suggested that she water the geranium."

274. *Page 221:* Concièrge parisienne, *washing her*
cat, Paris, 1945.

shots was by then strong. It is more likely that Doisneau never wanted to take the opportunity to make the sort of fashion photographs of which he was capable. It would have been a very simple matter for him to exploit the image-making device with which he was by now very familiar—the juxtaposition of discordant values—to create striking fashion pictures. All he needed to do—as he once told the author—was to take a pretty girl in a costly dress to the faubourgs or banlieue, and find the most *pittoresque* backdrop available. He could quite simply have taken the models with him on his trips around the *monde de la cloche* with Giraud. The results would have been impressive (similar ideas were used by both Penn and Avedon among others, and Robert's would perhaps have been more interesting precisely because he would have found better *décors*). Yet he obstinately refused to exploit this approach.

Roland Barthes perhaps identified why Doisneau's creative drive could not be mobilized for fashion photography—though in other contexts it was so evident. The now-famous *Le Baiser de l'Hotel de Ville,* made in April 1950 when Doisneau was less than a year into his contract at *Vogue,* could so easily in other circumstances have become one of the classic fashion pictures of the postwar period. In his *Fashion System,* written a decade later (1959), Barthes argued that "the Fashion Photograph is not just any photograph, it bears little relationship to the news photograph or the snapshot, for example; it has its own units and rules; within photographic communication, it forms a specific language which no doubt has its own lexicon and syntax, its own banned or approved 'turns of phrase.'"[16] But Robert had no wish to learn or speak the "language" of fashion photography. He continued, however, to develop other ideas for the magazine, even after the contract ended. Great pictures such as *Les Animaux superieurs* of 1954 appeared there for the first time. His series of images of statues, in which pigeons sit on the genitalia of heroic figures or stain with their droppings great leaders of France—a series made when Robert was beginning to experiment with a very long telephoto lens of five hundred millimeters on a twenty-four-by-thirty-six-millimeter format camera—was made for *Vogue* magazine. Raymond Grosset recalls that it elicited a great peal of laughter from Michel de Brunhoff when he first saw the photo of the pigeon on the penis of the statue from the Arc de Triomphe (*Le Départ des volontiers*)—although he was of two minds as to whether the magazine could dare publish it (pl. 284).

The type of work in which Doisneau really excelled for *Vogue* was that in which he was already highly experienced: reportage assignments, for example, a series on the *grandes villes* of France: Lille, Marseilles, Bordeaux, Lyons, etc.; a study of the Palais Royal and its inhabitants (including Colette, see pl. 280, and "*casse croute* in the gardens") in Paris; articles about people such as concierges and mediums; and his numerous portraits of artists, celebrities, writers, and musicians. Soon after he joined *Vogue,* de Brunhoff paid Doisneau the compliment of publishing a long feature article of several pages on *La Banlieue de Paris.*[17]

Doisneau's dislike of *Vogue* also led him to give up the opportunity of carrying out a major assignment for the magazine, which has ended up as an important footnote in the history of photography. He was asked in 1950 if he would like to do a series of studio portraits on *les petits métiers* (minor crafts and trades)[18] but decided it was not for him, preferring to carry out such an

275. Madame Rayda cartomancienne, 45 rue Vilin (Madame Rayda the Fortune-teller, 45, rue Vilin), *Paris, Twentieth Arrondissement, 1953. An example of Doisneau's use of a four-by-five-inch camera to record as much detail as possible in such portraits.*

276. *Page 223:* Seance, 1944.

277. *Page 223:* Tireuse de cartes (Fortune-Teller), *Paris, 1951. Madame Oscar was a fortune-teller and tarot- reader who plied her trade in a bistro at Les Halles. Most of her clients were prostitutes. Her amulets contained photographs of de Gaulle, Georges Bidault, and François Mitterand.*

275

276

277

assignment in the streets, shops, and ateliers where they were practiced. The assignment went to Irving Penn, then active in Paris, who rented a daylight studio at the Société Française de la Photographie in rue de Vaugirard and, on Robert's recommendation, employed Giraud ("a young poet," as Penn described him[19]), to drive around Paris finding people in their work clothes and persuade them to come and be photographed. The assignment enabled Irving Penn to create a style of portraiture that came to mark his style. The project was so successful that it was continued in London and New York and brought Penn considerable renown.

The reportage projects for *Vogue* occasionally took Doisneau and Edmonde Charles-Roux to places they would rather not have visited: while working in Marseilles in the area known as La Vieille Charité—a slum inhabited by squatters—they were chased by a group of young men who did not like the idea of being photographed. Doisneau lost a camera, smashed by the pursuers, whom they only escaped by running as hard as they could. But this, like a number of the assignments for *Vogue*, produced good images. By this stage Doisneau had mastered a place-defining photograph that he used often in such reportages to set the scene for the article: a plunging panorama of the city from a high viewpoint. Often made with a large-format camera (thirteen-by-eighteen-centimeters or five-by-four-inches) Doisneau took delight in making such well-composed and finely detailed pictures throughout his career.

In Lille, Doisneau made one of his most striking portraits, of Monsieur Monnart, municipal employee in charge of the heads of the *"géants du nord"*—Lydéric and Phinaert—huge figures paraded throughout the streets of the city twice a year (pl. 278). Other assignments offered the opportunity to develop his skills: in particular a set of photographs of a ballet troupe, remarkable for their elegance. Later, in the mid-1960s, he would work on producing a book of photographs about the life of the dancer. The occasional portrait made in *Vogue's* studio also provided excellent material for Doisneau's approach, broadening the range of people whom he photographed and enriching his archive with famous and notable faces. Perhaps the best image of this type is that made in 1949 of Jacques Tati with dismantled bicycle recreating the role of the *facteur* (postman) in his highly successful film, *Jour de fête* (see pl. 282). Baquet and his troupe Les Rigodons also make an appearance in a Doisneau photograph in the pages of *Vogue,* as do Orson Welles, the sculptor César, Saul Steinberg, Fernand Léger, and a host of others: even Giraud is there, with Inspector Delarue against the backdrop of Doisneau's pictures of *tatoués* at the opening of their Paris exhibition on that theme in 1949.

Despite the satisfactions that certain of his assignments offered, his colleague Edmonde Charles-Roux watched Doisneau's discomfort with his role at *Vogue* become increasingly evident. During the reportage on Lille, Charles-Roux and Doisneau were invited to photograph a certain gentleman, owner of a major textile works, who had assembled the finest collection of art in the city. Edmonde Charles-Roux recalled:

He showed us his factory; next to it were houses for his workers. He was very keen that Doisneau should photograph this "magnificent social achievement" to put it in the magazine. But Doisneau really didn't want to, absolutely not. You could feel the atmosphere getting tense, it was

278

278. Les Géants du Nord et Monsieur Monnad (The Giants of the Nord and Monsieur Monnad), *reportage on Lille for* Vogue, *1951. The giants, Lydéric and Phinaert, are paraded through the streets of the city once a year for the Foire de Lille.*

279. *Orson Welles at the Les Chasseurs Café, Paris, 1949. A portrait typical of the work Doisneau carried out for* Vogue *with Edmonde Charles-Roux for a monthly section entitled "La Vie à Paris."*

279

280

280. Colette aux Sulfures, *at home, Palais Royal,
1950. Reportage on the Palais Royal, where the
writer Colette had an apartment, for* Vogue, *also
used in an issue of* Le Point *on Colette.*

going to explode! He would have caused a scandal. Doisneau did not want to do the photo because it would have symbolized the power of the master over his workers, obliged to work all their lives without being able to buy their homes. He was very controlled, but furious. One would never have imagined that he could be like that. Usually he was quite playful, never bitter, we never had a disagreement. It was very interesting to see his political development, but he was very discreet. On his eightieth birthday, all the party (PCF) was there! He was sympathetic to the Communists in France right to the end.

As Edmonde Charles-Roux's comments indicate, Doisneau's political position underpinned his work at *Vogue* but was never overtly stated or expressed in photographs in which the ideological function is foregrounded. Perhaps Doisneau's most pithy comment on the *Vogue* period and his detestation of the milieu may be found in some photographs made not long after he had given up his contract, which show the American fashion editor, Carmel Snow, at work with her assistants (pl. 281). Snow—fashion editor of *Harper's Bazaar*—was famous for being drunk most of the time, for dictating her orders to her two assistants while in the bathroom, seated at the toilet. Doisneau's pictures of her happily do not go this far, but show her in bed during a visit to Paris for the spring collections, with her assistants taking orders.

The decision not to renew the *Vogue* contract in 1953 liberated Doisneau from work he did not enjoy, but it also demanded that he seek a wider range of commercial assignments to supplement his meager income from reportage assignments. Almost none of the book contracts brought in anything resembling a decent income and it was not until the early 1980s—when the *Photopoche* volume published by the Centre Nationale de la Photographie was issued—that any of his books enjoyed much more than critical success, except for a little book to help small children learn to count—*1,2,3,4, compter en s'amusant*—issued in 1956, which sold about seventy thousand copies. It shows how his process of telling a story through pictures was developing. In each case the picture provides cues to the child—a certain number of objects which can be counted on the page. The book is well printed (by Braun) and beautifully laid out, the images made with all of Doisneau's customary care, using his daughters as models (pl. 283).

The sheer diversity of his output in this period is summed up by a series of contact sheets from 1952 to 1959, representing a huge range of commissions: *oblats* (missionaries) training in the Massif Central, a dormitory in the Salvation Army hostel barge on the Seine (pl. 285), an industrial reportage on the SNCASO aircraft factory, and a sumptuous ball for *Vogue*.

◆

As a professional photographer, and moreover someone who was deeply interested in the development of both his art and his technical expertise, it may not be too surprising that Doisneau was active in the main French photographic movement of the postwar years, the Groupe des XV—often simply known as les XV. This period in French photography is marked by the enthusiasm of its practitioners for the formation of groups and associations.

281

281. *Carmel Snow and her assistants, 1952. Snow was the fashion editor of* Harpers Bazaar *and worked closely with its art director, Alexei Brodovitch, to give the magazine its leading role in fashion photography.*

282. *Page 227:* Le Vélo de Tati (Tati's Bicycle), *Paris, 1949. A portrait made in the Vogue studio, showing Jacques Tati in the role he made famous in the film* Jour de fête. *For this picture, Doisneau asked Tati to dismantle the bicycle in the studio, photographing each stage of the process on a large format (four-by-five-inch) camera.*

283

There had been some important precursors before the war: the Association des Artistes et Ecrivains Revolutionnaires, of which both Willy Ronis and Cartier-Bresson were members; the Groupe du Rectangle (1936–39), which took some of its inspiration from Neue Sachlichkeit in Germany; and other "pure photography" movements, such as the short-lived but well-publicized Group F.64 in California in which Ansel Adams and Edward Weston were central participants. A leading light of the Rectangle before the war was Emmanuel Sougez, who played an important role in the development of French photography through his editorial direction of the *supplément photographique* of *Arts et métiers graphiques*; he briefly reorganized the Rectangle in 1942 as a cooperative to help fellow photographers cope with the difficult conditions of the Occupation. It is clear that by this time he knew Doisneau and his growing reputation as an illustrative photographer, and in December 1944 Sougez had attempted to involved him in what proved to be an abortive attempt to create an enlarged Groupe du Rectangle. Later in the 1940s, Sougez was influential in de Brunhoff's invitation to Doisneau to join *Vogue* magazine.

Les XV were brought together by a small group of ex-Rectangle members led by André Garban, a portrait photographer with a studio in rue Bourdalou (in the Seventeenth Arrondissement), a few doors away from Sougez's residence. Those invited to the first meeting were for the most part prewar members of the Rectangle. Formed in March 1946, les XV came together under a simple manifesto: "Proud above all of their craft, inspired by the same faith and wishing to contribute works of quality to the art of photography, they have decided to found a fraternity of photographic artists, which takes the name of the Groupe des XV.[20] The inclusion of Robert Doisneau and later Ronis among their number may have rehabilitated a group that was almost moribund, the majority of its members being studio photographers, most from the generation born in the 1890s or 1900s. It has been said that at the time (1945-55), the Groupe des XV was considered rather "old hat" by the photographic world, a sort of extension of the Société Française de la Photographie and thus totally outmoded.

The group—which hardly ever numbered exactly fifteen—had objectives more fraternal and organizational than aesthetic, for it did not seek to impose the "purist" rigor of an F.64 style on its members: according to Garban, writing about it a few years later, "Each member undertakes to respect the spirit of loyalty, of frankness and mutual aid, which is the very basis of the group."[21] But it would be misleading to imply that the group had no artistic goals, for it set out to "promote, through frequent exhibitions, French photography. Each member, according to his temperament . . . should seek in his practice to produce only works compositionally and technically perfect, and of real artistic value."[22] The fact that members agreed to certain technical standards in their work attests to mounting concerns that professional standards were under attack from amateurs who might become competitors for the limited resources available. But what is most clear from the list of both original and subsequent members is the common denominator of their "polyvalence" as professionals—they undertook reportage, advertising, industrial work, etc. Though several of the Groupe des XV were proprietors of portrait and advertising studios, others were, like Doisneau himself, taking whatever assignments they

283. *Annette and Francine Doisneau at Buthiers, 1954. Photograph made for* 1,2,3,4, compter en s'amusant, *Doisneau's most successful book for children (1956).*

284. Le Départ des volontiers (The Departure of the Volontiers), 1952. *Intending to exhibit this photograph at the Salon Nationale of the Confédération Française de la Photographie, Doisneau received this letter from his colleague André Garban: "Do you want me to get sent to prison? The fourth picture of the man and the bird, the one where the bird is perched on you-know-what, will have to be replaced." This is one of the earliest photographs Doisneau made with a long telephoto lens, used to create a series on how pigeons and other birds defaced historic monuments, in this case on the Arch of Triumph. It displays Doisneau's fascination with* désobéissant *imagery that deflated symbols of authority.*

284

285

286

285. La Péniche de l'Armée du Salut (Salvation Army Barge), *Paris, 1952. A photograph made with Robert Giraud as part of their documentation of the* monde de la cloche; *the barge was one of the shelters for clochards.*

286. *Fish sellers, Vieux Port, Marseilles, 1951. Made during Doisneau's reportage on the city for* Vogue.

could obtain and operating from their homes. Robert joined les XV in late 1946 and exhibited with it for the first time at the Galerie Pascaud, at 167, boulevard Haussmann, in April 1947. The theme—*Le Nu*—was particularly uncongenial to Doisneau, who contributed a baby picture, but the press reception for the show was enthusiastic. Robert continued to exhibit work at the annual exhibitions of les XV right up until its demise in 1958.

It is difficult to assess the real importance of the Groupe des XV in the postwar development of French photography, but its role as a forum for debate and for the discovery of certain relatively unknown photographers may well have been important. For Doisneau, it was the occasion to discover Atget for the first time, via the exhibition mounted by Berenice Abbot in 1948 and subsequent debates within the group, which was quite divided about the relevance of his photography. Doisneau said that he immediately felt a fellow-feeling with Atget's pictures, but his view was not universal in the XV:

> There were some—Lucien Lorelle, Pierre Jahan—who didn't like it [Atget's work]. I really liked it because he dared to show things thought to be of low value or of little interest. He had the ability to spot things that would quickly disappear. . . .
>
> There were people who thought Atget was an animal. But I'm also an animal. Because Atget was very raw. For me, in an Atget there is the smell of game, an animal that smells more like hare than tame rabbit, eh?
>
> Atget, even if I didn't know him, was my godfather. Atget became a reference for me—yes, that's the word for it. It reassured me. He was an old fool, and I was a young fool. I hung about the same spots. The do-it-yourself aspect, that's me, the obstinacy also of Atget to make photos rejected by everybody, the work I had to do to show my photos of the banlieue and the banlieusards . . . It needed a Cendrars to interest himself in that, to find in my images a sort of dynamism . . . the young guys who've lived in a working-class neighborhood, the ones in popular songs, sung on street corners, those girls I saw who were beautiful, those buildings that you could show in a good light. It's like the flower that grows between the railway tracks, infinitely more interesting than flowers in vases. It's the contrast. Colors are never more beautiful than when it rains.

For Robert, the main thing that he got from the Groupe des XV was the sentiment that his work had begun to be respected by his peers, that he had at least acquired recognition, that his vision was not entirely banal. Robert's first major award, the Prix Kodak, given in 1947, came not long after his invitation to join les XV and was probably linked to his membership in the group, for Kodak was somewhat involved as a sponsor of the 1947 exhibition. Doisneau's work also began to appear in international exhibitions—the Salon Nationale de la Photographie, at which he exhibited in Paris, went to London in 1947, and in 1951 his work was included in the important *Four French Photographers* show at the Museum of Modern Art in New York, along with that of Brassaï, Izis, and Ronis. When Edward Steichen prepared his massive touring exhibition (the hugely successful *Family of Man*) in 1952–55, he found space for no less than five photographs by Doisneau. This may have been helped by the fact that RAPHO-Guillumette in New York had a considerable stock of

287

287. *Cover of* Vogue, *1951 (original in color).*

288. Les Deux Couronnes (The Two Wreaths), *Marseilles, 1951. Made during reportage assignment for* Vogue *magazine.*

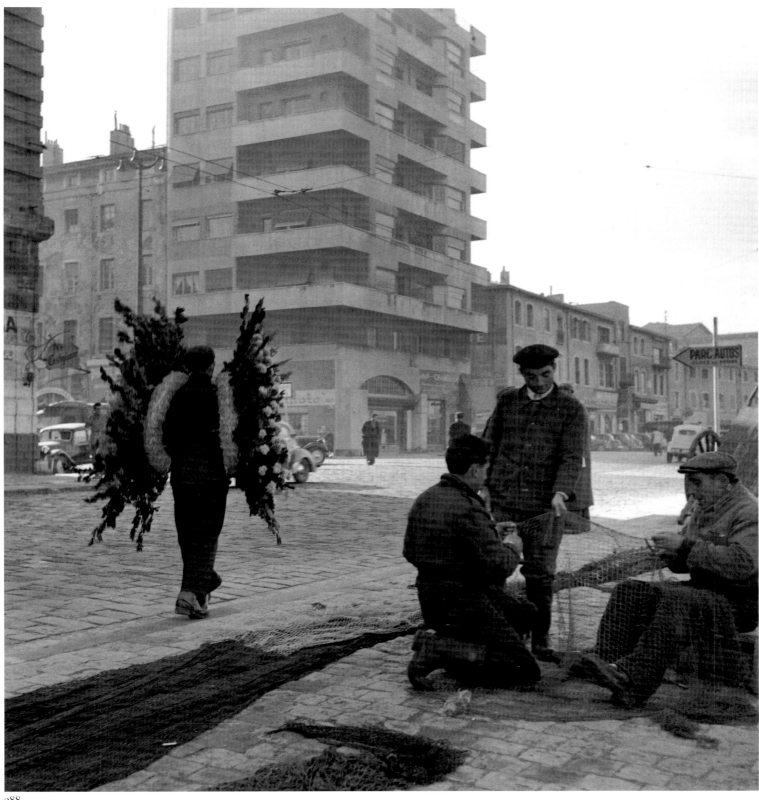

288

Robert's photographs; all of the photographs in Steichen's exhibition were drawn from picture libraries and similar sources, and Steichen did much of his research at RAPHO-Guillumette.

In 1956 the association Gens d'Images awarded Robert the Prix Niepce, an annual prize for the best photography publication. It was given for his exploration of the workings of the great city—*Pour que Paris soit,* with text by Elsa Triolet. By this stage of his career his work was also appearing fairly regularly in the pages of certain American magazines, such as *LIFE* and the American edition of *Vogue.* By the late 1950s, however, the Groupe des XV was on its last leg—probably under the pressures toward specialization that Doisneau so assiduously resisted: there was simply no place for such a "polyvalent" or generalist group, and especially one whose membership was no longer composed of *jeunes loups* ("young wolves"). Attempts to bring in younger members like Edouard Boubat and Jean Dieuzaide had begun, but most members of the group were much older than Doisneau himself, who by the final demise of les XV in 1958 was forty-six. He had come a long way from the "petit Doisneau" whom Vox had sent to Aix-en-Provence in October 1945.

The award of the Prix Niepce was gratifying to Doisneau, but it would not change the fundamental trajectory of his work, which by now was firmly established. Gens d'Images was far more representative of trends in photography by this point than the by now completely moribund Groupe des XV. It included among its members certain key figures in Robert's own career, such as Albert Plécy and Raymond Grosset. But it is interesting to find confirmation, in a contemporary article, of just how much of Robert's philosophy of life and of his photographic work had become very clearly delineated by this time.

The article, by A. Forest, situates Doisneau in the accepted genre of the reportage photographer—*chasseur d'images*—and was entitled: "Robert Doisneau (Prix Niepce of Photography) is Always Engaged in the *chasse aux images.*" Forest describes meeting him "in a little *café-tabac* in the rue de Seine."

His grog fumed on the burner, while he listened patiently to an unstoppable bore. His lean face with gray eyes was attentive.

He welcomed me like an old friend whom he'd seen the night before. . . .

— *Are you increasingly attracted by social events?*

— I'm not looking for the sensational. I prefer witnessing everyday life, the poetry in our daily surroundings. What is most important is the element of truth. Even if it's troubling, it cannot be suppressed. There are different ideas about photography. I don't like anything static. For me, it's the desire to crystallize a fugitive moment, to fix an instant of joy, or a gesture.

— *Do you work with a particular aim in mind?*

— No, it's a matter of luck in whom I meet.

— *Does traveling provide you with inspiration?*

— I don't need to go away. I find my subject-matter everywhere. When I do go away on vacation it's with the aim of relaxing by trout fishing. But I often come across something that gets me going. So then the relaxation is over! Since I've never had a darkroom and I work with my concierge as assistant in my bathroom, I am not too bothered about being able to develop the "treasures" of the day's work.

289. *Page 233: Monsieur Perrot, fishing instructor in his fishing-gear store, Au Tireur de Vers de Vase, Paris, 1951. This store was frequented by Doisneau, for whom fishing was a passion. One of his friends, the painter Dignimot, remarked of Perrot, "He just about condescended to sell you a spinner."*

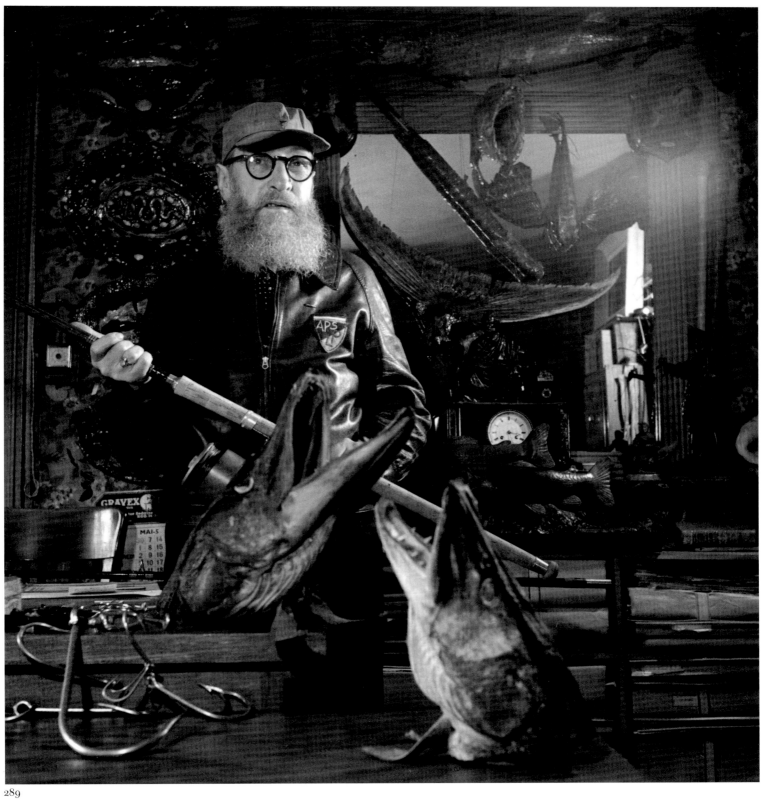

289

290

The practices—even the philosophies—of angling and photography came to be inextricably linked in Doisneau's mind, so that he took increasing pride in the professional description he coined for himself of *pêcheur d'images.* He evolved a method for his work that required capacities very similar to those of the angler: patience, a profound knowledge of the species, careful baiting of the lure, an intuitive feel for the best moment to strike, and an affection for the prey. Like fishing, his photography demanded enormous amounts of time and patience: "Time is a luxury commodity," he once said. In order to make "my" pictures, Robert once remarked to the author, "I had to get wet, to immerse myself in the life of the people whom I was photographing." In his introduction to *Trois Secondes d'éternité,* he describes this approach:

> It doesn't matter where you look, there's always something going on. All you need to do is wait, and look for long enough until the curtain deigns to go up. So I wait and each time the same pompous formula trots through my head: Paris is a theater where you buy your seat by wasting time. And I'm still waiting.
>
> To stand still in the middle of people who are going in all directions is a rather equivocal attitude; as I understood one day when I was planted somewhere. A passerby whispered in my ear, "You are in on it then. I'm also from the department!"[23]

Among his archives is a large dossier entitled "Pêche," and it shows that not only did he make a very large number of photographs of anglers, angling, and fish, but also that it was a sport he practiced very seriously, for occasionally in this file one comes across an outdated angling permit, or a page torn from an old fishing equipment catalogue, tucked in among the prints. Robert's fascination with the sport produced several series of photographs that attest to the popular nature of angling and demonstrate how the Seine and the canals crisscrossing Paris offered the worker in his brief moments of leisure the opportunity for some relaxation. "There were some," as Doisneau said, "who spent a whole day just to trouble one fish." (see pl. 290). These photographs are also a chapter in the social history of Paris, about a time when such communal social activities still took place, when the anglers of the *classe populaire* could still be seen fishing in large numbers on the quays of the Seine, or on the bridges and towpaths of the Canal St.-Martin, the Canal St.-Denis, or the Bassin de l'Arsenal (see, for example, the photograph of the *Angler and Sparrow,* pl. 297). In many of these images there is a poetic element, but in a series on an *école de lancer* (fishing school) on the quays opposite Notre-Dame, Doisneau wants to mock the seriousness that sometimes invades such activities (see pl. 291). In 1948, through his association with Pierre Betz and Pierre Braun of *Le Point,* Doisneau was able to turn his love of angling into a book project. In November 1948, we find him writing to Pierre Betz:

> For Braun's book on trout fishing I had the pleasure of being welcomed by Mermillon. We drank with dignity along the banks of the Ain—I narrowly avoided cirrhosis—this Mermillon is an artist in his pleasures, the first Lyonnais I've been close to. Now I will go through Lyons with respect, I who cursed this town where I took the wrong bridge each time I went across it.

290. *Tench caught in the Seine, Pont-Neuf, Paris, 1951.* "There were some who spent a whole day just to trouble one fish."

291. *Page 235:* Pecheur à la mouche sèche (Flycasting), *fishing lessons on the pont de la Tournelle, Paris, Fifth Arrondissement, 1951.*

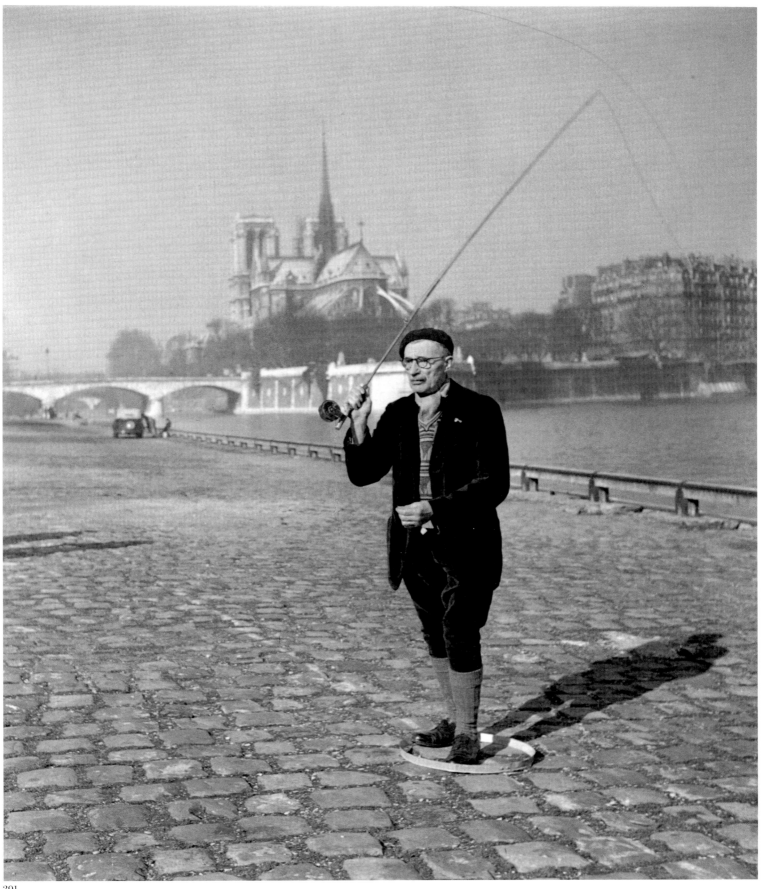

291

Marius Mermillon (pl. 296) was a wine wholesaler, a part-time art critic, and a passionate angler. A friend of Pierre Braun and an occasional contributor to *Le Point,* he had developed with Braun the notion of a book on trout fishing and had decided that the natural choice of photographer was Doisneau. Robert went down to Lyons to meet Mermillon in the autumn of 1948, and they immediately went fishing:

> Mermillon said, "We'll go fishing tomorrow, so we'll need to prepare properly." First he went to his wine cellar. He took a long time deciding which six bottles we would take with us, a bottle for each hour of the day! "A light red, a white wine . . . etc." Then we went off to the *charcuterie,* where he bought some sausages.
>
> At that time there was a butcher's paper, yellow, coarse-fibered. When he got to the riverside he started a wood fire. As soon as there was a pile of logs burning, he made the paper into a pointed cornet, filled it up with red wine, put the sausages in as well, and planted the cornet in the burning cinders. The paper doesn't burn because it's full of liquid, of wine. Then we went off to fish. When we came back there was no wine left in the cornet, for the wine had gone into the sausages—they were delicious and fairly strong as well!

The little book (see pl. 295, cover of *La Pêche à la truite*) was hardly an overnight success, but as with a companion volume Doisneau photographed on *boules,* it was, like much of his work with Braun and Betz, "friendlier" than a strictly commercial activity.

Later in the early 1960s and again in 1968, Doisneau worked on other projects about fishing: in one of these for a children's book he would return to the rivers and lakes of Corrèze where as a small child his passion for angling had first begun. The book was to be for the publisher Laffont, whose son would play the role of the young angler. But they had hardly begun to take pictures when tragedy struck. As Doisneau said, I'd just about had time to buy a rod for the kid, when all of a sudden came the news that my father had died. We had to return straight away."

The sudden death of his father, Gaston Doisneau, in the summer of 1962, brought this particular project to an end. Later in the 1960s the failure of a friend to produce the necessary texts for a couple of children's books on river and beach angling, for which he had made yet another series of photographs, proved a further disappointment to Robert. He was never to publish another book on his great passion.

The imagery of angling was so central to Doisneau's photographic perspective that it transmitted itself, through his pictures, into the perceptions of others. Jacques Prévert, for instance, writing about Doisneau and playing on the *chasseur d'images* metaphor, sees the ambiguities of his role thus:

> In the Sologne[24] they say that the game, which regards the hunter more with scorn than dread, has a sneaking regard for the *braconnier* (poacher), who it considers to be like a brother, and if given the choice would rather be taken by him to end its brief existence.
>
> That is why, when the sleeper awakened but still half-immersed in his thousand-and-one-nights meets Robert Doisneau, who smiles at him in

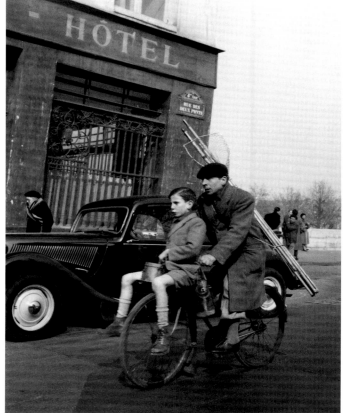

292

292. Le Vélo des deux ponts *(The Bicycle of Deux Ponts), rue des Deux Ponts, Paris, 1953.*

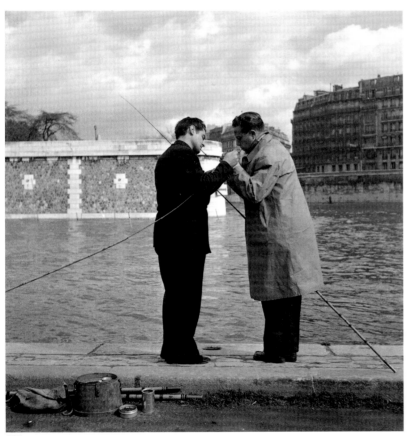

293

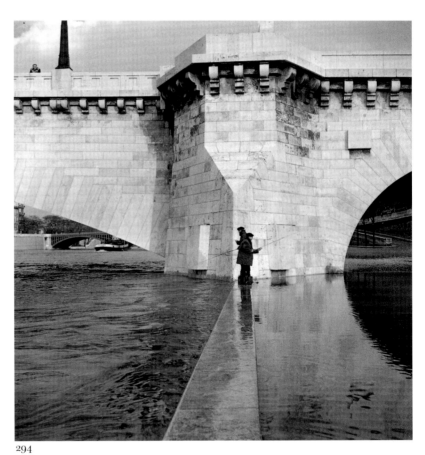

294

293. *Fishing on the banks of the Seine, Paris, 1951.*

294. *Anglers on the pont de Tournelle, Paris, Fifth Arrondissement, 1951. "The flood brought about a change in the Parisian angler; like an elephant in the song, he seemed to have a tail in front as well as at the back. This new device enabled him to pursue his crazed prey in every corner."*

the poor light of the outskirts, he smiles as well or simply looks at him with amused indifference and allows his portrait to be taken. . . .

When he works as a street-peddler, it is with brotherly humor and without any sense of superiority that he lays out his mirror to catch skylarks, his poacher's trapping kit, and it's always with the imperfect of the objective that he conjugates the verb to photograph.[25]

The *braconnier* metaphor resonates with other aspects of Doisneau's life; his paternal grandfather was a noted *braconnier* in his Beauceron village of Raizeux, the sort of man who never came back empty-handed from a trip into the woods.

But the *braconnier-pêcheur* is also another sort of *flâneur* or *badaud,* a saunterer without fixed purpose. Doisneau's photographs are the result of patience, reflection, complicity, involvement. Yet in their largely urban subject-matter they also encapsulate a key element of modernity—a modernity first expressed by Charles Baudelaire as a world of the contingent, the transitory, the fleeting, whose quintessential expression is the modern city. And no city is more modern than Paris. Doisneau reflected on his long and solitary promenades through the *décors* of the City of Light and described himself as the vulgar version of the *flâneur,* the *badaud:*

Outdated or not, if there's one *badaud* left, it's me. Nothing stops me going on the pont Alexandre III where the bronzes blow bubbles, with its farandole of busty women and chubby children, a pretty fantasy in the style of 1900, and over there the geometric pride of the Hôtel des Invalides emphasized by a line of rusty cannons and crowned by the Dôme under which Napoléon was finally immobilized beneath tons of red marble.

From there I will go, out of habit, to lean on the parapet, quai du Louvre, in front of the Wyers shop that sells fishing gear where on a great panoramic screen Paris is laid out horizontally—on the left pont-Neuf, in its center the two houses from the epoch of Louis XIII, which Henri IV regards on horseback with legitimate pride in the architectural talents of his son. In front, floating at water-level, the jardin du Vert-Galant with its team of bearded-hairy-guitar scratchers—a look to the right and it's the pont des Arts, ex-museum of chalk-drawing; in the distance, a tiny Eiffel Tower allows you to remember a souvenir of its existence.

Time to smoke a cigarette and then I'll wander to the lock of the quai de la Rapée to take a barge going up to La Villette to check whether the air vents in the tunnel are letting through columns of sunlight. Stopping off at the Hôtel du Nord—atmosphere, atmosphere—I'll dither between the boulangerie of the rue St.-Marthe and the staircase of the passage Julien Lacroix before finally choosing Ménilmontant. Alas! the tower of the rue Vilin has disappeared, along with the house of Madame Rayda the card-reader and the angled gaslight carrying the number 3593.[26]

295

295. *Cover of* La Pêche à la truite, *1948, showing Marius Mermillon fishing: "We boozed with dignity along the banks of the Ain."*

296. *Marius Mermillon assembling his equipment for the fishing trip along the Ain, which included a careful selection of wines from his cellar, 1948.*

296

297

297. Les Moineaux du canal Saint-Martin (The Sparrows of the Saint-Martin Canal), *Paris, 1953. A gentle stroll with no set goal or time limit. There are some days when everything works beautifully. Images appear everywhere. The show is continuous. Doisneau wrote in 1954, "One happy day like this I found the angler on the canal Saint-Martin. 'They're going to scoff up my forty francs worth of maggots, no, just look at them.'"*

THE COMPLICITIES

1945–1960

"Prévert would call up and say, 'Do you know the street where they unroll the big lengths of plywood near the Faubourg St. Antoine?' I would say 'Yes,' and he would say 'No you don't, come and get me and we'll go there.' So we would go and look at this, there would be whole logs of this stuff, we'd take in the sound of the work, the color of the wood, the smell of the sap and the look of it as it came out. . . . Prévert taught me to have confidence in the discovery of everyday objects that people didn't see anymore, because they were contemptuous of them, too used to them. He found ordinary words, used every day, and presented them to people as if they were precious jewels. And he loved to play, to discover new things, the names of streets for example: 'Why do the worst streets have the prettiest names?' he would say, and I would begin to hear the music of their names—la rue des Cinq-Diamants, la rue du Dessous-des-Berges, la rue du Pont-aux-Biches, le passage de la Main d'Or. . . ."

[A]lthough rarely cited among the important contacts that Doisneau established in the period immediately following the war, his friendship and working relationship with Paul Barabé is nevertheless full of significance. In 1945, Doisneau asked his concierge to become his photographic assistant and messenger:

> To begin with he would come in from time to time to glaze my prints, and then one day I asked him if he'd like to work with me. He wouldn't decide immediately, saying, "Perhaps I'm too old to change my profession?" But he was sent by the Almighty. We never had a cross word—it wasn't possible. It was his habit to go out for three hours every afternoon, so I had to give him things to deliver. He took my photos everywhere. He had once been a football player, so he would never take the bus to porte d'Orléans, since he preferred to walk the one-and-a-half miles from here.

Mme Barabé worked for Pierrette, washing and cleaning, helping with all the housework, baby-sitting Francine and Annette. The latter remembers Paul Barabé very well:

> He did everything, including answering the telephone. It was so funny. He would pick up the phone, tell the person to wait, then shout very loudly to my father, shut in the darkroom, "Monsieur Doisneau, are you here for Monsieur X?" Obviously Monsieur X heard everything, and if my father said *Non!* the other person understood that he didn't want to talk to them.

Barabé loved to buy small gadgets for the home, and in a letter to Pierre Betz in July 1947, Doisneau says that "the gentleman who works with me adores wandering around the BHV."[1] As Doisneau's illustrative and commercial work expanded, Barabé took on a more important role in the work and from time to time modeled for various mise-en-scènes (see pl. 299).

Annette Doisneau remembers Paul Barabé with great affection. "On Christmas Eve he left Montrouge to go to Les Halles, bringing back a Christmas tree that touched the ceiling, and in our apartment the ceiling was sixteen feet high! He carried it on his back, and in the evening his wife and he would prepare the piles of little gifts that they had been buying throughout the year. My parents would go to the movies. When they came back, they would eat oysters with the Barabés—while we, the little girls, would go to sleep thinking that he was Father Christmas."

Later, the Barabés would even take the children for holidays to the Doisneau's country house at Buthiers in the forêt de Fontainebleau.

◆

At the Liberation of Paris in the autumn of 1944, Robert Doisneau met a young cellist, actor, skier, and comedian named Maurice Baquet. He was appearing in a revue organized by Gilles Margaritis at L'Olympia in Paris with Fred Astaire and the Glenn Miller orchestra, to thank the Americans for their part in the Liberation. Doisneau was there to photograph the spectacle. It was as if, Maurice Baquet told the author, "they had always known each other."

298. *Page 241: Jacques Prévert, avenue du Général-Leclerc, Paris, 1955.*

Indeed the paths of Robert and Maurice Baquet might easily have crossed on a number of occasions before the war, for the Préverts and their circle were regular visitors to André Vigneau's studio in rue Monsieur le Prince, and Baquet had performed at Renault with Prévert's Groupe Octobre during the 1936 factory occupation. Around this time, when Doisneau was working for Renault, Baquet appeared as a newspaper deliveryman in Jean Renoir's classic film of the Front Populaire era, *Le Crime de Monsieur Lange.* The scenario and dialogues were written by Prévert, and several members of the Groupe Octobre (see below) had roles. Baquet was always ready to "play" with Doisneau, and through this became a close collaborator in a wholly new genre of photographic portraiture that Doisneau was now creating.

A naturally gifted musician, Maurice Baquet trained as a cellist at the Conservatoire de Paris in the early 1930s, where he won first prize in Gérard Hekking's class. Baquet had an individual style of playing the instrument, which led him to take his place very quickly alongside the virtuosi of his epoch: Paul Tortelier, Maurice Gendron, André Navarra, and more recently Miroslav Rostropovitch, who accompanied him on the piano at the Salle Gaveau in Paris, in an "irresistible comic number."

Baquet developed at least two other careers before the war, one as an accomplished skier and mountaineer—he was Champion de France in 1936 and later achieved, with Gaston Rebuffat, the first ascent of the south face of the Aiguille du Midi in 1957. The other career, which he has pursued until the time of this writing, has been that of an actor in innumerable theatrical productions and films. He was a member of "*la bande à* Jacques Prévert," the circle that formed around the Prévert brothers, Jacques and Pierre, in the early 1930s, and was involved with them in the radical leftist agitprop company Groupe Octobre from 1933 to the outbreak of war in 1939. Jacques Prévert defined the Groupe in the following terms:

> People of all sorts who were not required to meet, but who came together,
> without apparent resemblance to laugh at the big sacred cows
> And their laugh was a laugh aggressively healthy, undeniably contagious
> They liked the same things
> detested the same things
> They loved life[2]

The title—Groupe Octobre—was inspired by the Russian Revolution of October 1917. Like a number of his fellow Surrealists (Louis Aragon, André Breton, Pierre Naville), Prévert had gravitated toward Marxism in the early 1930s. During the Front Populaire period in 1936, the Groupe played an active role in the strikes affecting the mines in the North, the factories, and even the big department stores. It had the support of Paul Vaillant Couturier, one of the main figures in the PCF. Jacques Prévert wrote texts for the *choeurs parlés* (political chants)that were performed in the street, in the occupied factories (including Renault), and even in the section of the Samaritaine department store that sold articles for those attending their religious confirmations! Maurice Baquet played the cello at these events. Robert had followed the activities of the Groupe Octobre with discreet but enthusiastic interest.

299

299. *Paul Barabé as model for an advertising photograph, in Robert Doisneau's apartment, Montrouge, 1946. Concierge of the building where Doisneau lived, Barabé also acted as assistant, messenger, set-builder, child-minder, and model, as here.*

"A magazine called Bref said to me one day, in 1946 I think, 'Doisneau, we need a picture for the fourteenth of July.' That wasn't easy, a week before the event! I thought immediately of the fall of the Bastille. I knew that at the Musée Carnavalet they had a model of the Bastille carved out of stone. The director of the museum was named M. Bouchet. I told him, 'What I need is this: a photo of one of your attendants holding the carving.' He turned me down flat. What could I do? I photographed the model, and it's M. Barabé who is holding it in his arms. I rented an outfit for him—he loved dressing up. I needed an old-fashioned civil-servant uniform for that—Basque beret, gray jacket, with sleeves of polished cotton."

On Barabé's fingernails can be seen the tell-tale signs of the photographer's assistant: dark stains from developing solutions!

300. *Page 245:* Monsieur Barabé avec un rosier dans le train de Juvisy, ligne de Sceaux (*Monsieur Barabé with a Rose Tree on the Juvisy Train, Sceaux Line*), *1946. Cendrars captioned this photograph:* Dans le train de Juvisy, *and in the text of* La Banlieue de Paris *recounts that Doisneau followed the "worker with his rose tree" back to his home from the flower market, even climbing over a wall to photograph him planting it in his garden! Doisneau remarked that it was a "story invented by Cendrars, which claimed that I had been born in Chartres. . . . The idea of me as an intrepid reporter is nice, but it's not true."*

When he returned to Paris after the Liberation, Baquet renewed his association with the Préverts. At that point he lived in rue Lepic, not far from Prévert, who was also a resident of Montmartre, in the Cité Veron. Baquet was well placed to introduce Doisneau to a new cultural universe, that of St.-Germain-des-Prés. But as Baquet emphasized in conversations with the author, Robert had already come to know him through his role in films.

The thing that brought us closer was the period when I was making films . . . I had played a small character role as a sportsman in *Altitude 3200* [1938]. This captured the imagination of Robert, who would never forget "this young skier traversing the houses, skis on his feet, so light, so airy. . . ." Robert was attracted by my role, and little by little we became part of the same gang.

301.

301. *Maurice Baquet à Chamonix, 1957. Photograph made for Doisneau and Baquet's* Violoncelle slalom.

302. *Un Ingénieur sur un gazomètre (Engineer on a Gasometer), St.-Denis, 1949. The "engineer" is Maurice Baquet.*

303. *Page 247: Maurice Baquet by the steps at rue Vilin, Paris, Twentieth Arrondissement, 1957.*

304. *Page 247:* Maurice Baquet et M. Vermandel, l'Homme orchestre (Maurice Baquet and the One-Man-Band, M. Vermandel), *Paris, Eighteenth Arrondissement, 1957.*

305. *Page 247:* L'Archet (The Bow), *Maurice Baquet, studio portrait, Paris, 1956.*

Robert's friendship with Baquet soon turned into a collaborative relationship, for they decided to work on a book together—tentatively titled *On dirait de veau*[3]—which would combine their fascination with pushing their respective métiers to the limit. The idea for the book had come originally from Baquet, who had wanted to recount "little personal stories with the cello as a constant accompaniment. These stories amused Robert, who decided to make them into mise-en-scènes." So they began a project, or rather a game, that would last more than thirty years. The first working title was *Violoncelle slalom,* and one of the first photos was taken at Chamonix, where Baquet was shown with the cello on his back and skis on his feet, the Aiguille du Midi in the background.

By the time they first met, Maurice had already begun to put together some ideas for an illustrated autobiography: "I put scraps of writing in colored envelopes. I had the idea that these things might interest Robert, more for the images than for the words. Robert told me that they inspired him." Baquet was sufficiently radical in his views to want to subvert the conventional notion of the classical musician. In certain of his performances he had begun to introduce a comic note—going onstage and preparing to play, but without the instrument, for example.[4] His physique in itself seemed the antithesis of that of the classical musician, and was sufficient to provoke an audience to laugh before he had played a note. But Baquet was, and remains, a very fine musician: the desire to play, to amuse, and to subvert established conventions rested on a solid foundation of skill and a highly artistic temperament. This did not prevent him from attempting certain daunting exploits, such as skiing down the stairs of the Eiffel Tower on live television.

Baquet regularly took Doisneau to the mountains and initiated him into the delights of skiing: these settings gave Doisneau the chance to photograph Maurice with his cello in highly unlikely locations. Robert, for his part, took Maurice with him as companion or even assistant on many assignments, and in some cases even asked his friend to play the role of professional model. On one occasion, Robert was commissioned by *Vogue* to make a portrait of the comtesse Marie-Laure de Noailles, a well-known socialite who wrote regularly as a food critic for the style magazines of the era. She lived on a large estate in the Midi. At that moment (1962), Maurice was performing in Lyons, and Robert stopped off en route to his assignment to see his friend. By chance,

302

303

305

304

Baquet had a day off and delightedly suggested that he drive Robert down in his gleaming new American car, which he'd just brought back from the USA. When they arrived at the grand residence of the comtesse de Noailles, Maurice acted the role of Robert's chauffeur before the grand lady. Raymond Grosset recalled the story, as recounted to him by Robert: "Less than photogenic, she worried Maurice. Juggling with the lamps and wiring in the beautifully furnished room, he asked Robert, 'Boss, do we do her in at ninety?' 'Thanks Maurice, for the moment we're all right,' said Robert, trying to suppress his hilarity. 'You will let me know when,' insisted Maurice, 'I'll have the six-by-thirty-five ready.'" During the photo session held in the grand salon, Maurice terrified Marie-Laure de Noailles by acting the role of the clumsy assistant as he set up the lights and helped Robert with his shots, knocking into valuable vases which he then saved from being smashed to bits by catching them at the last moment. Throughout all of this, Maurice recalled, the grand lady kept shooting him a look, as if she half-recognized him but could not put a name or identity to the face. Robert was invited to lunch with her, while Baquet was sent to take his with the domestic staff. While Robert and Marie-Laure lunched, gales of laughter could be heard from time to time issuing through the door to the kitchen. When it was time to load up the car, the comtesse came out to wish Robert and his disquieting assistant bon voyage. Among the photographic equipment in the back of the car was Maurice's cello case, with his name clearly marked on it.

On Dirait du veau required some thirty-six years and a number of versions before it found a publisher and metamorphosed into *Ballade pour violoncelle et chambre noire* in 1981.[5] The initial title was used by Baquet for his amusing and highly anecdotal autobiography, published in 1979. In an early draft of the text for one of the versions of the project, Robert describes the album as "a photographic game," and it is clear that is an attempt to subvert the artistic pretensions of photography. Part and parcel of this was an increasing willingness to deform and denature the photographic image. The games that Baquet and Robert had enjoyed with the cello as prop had both intrigued and delighted Baquet's fellow cellists. The idea of an instrument that could swim alongside its owner in a lake, have its spiked foot stuck halfway up a tree, be played in an ornamental pond complete with swans, and have medals pinned to its front, is a subversive one. The images that Doisneau produced with Baquet explore many forms of photographic expression, including photomontage, collage, deformation, multiple imaging, and even semiabstract devices. Both Baquet's desire to play with the conventions of classical musicianship and Doisneau's urge to subvert the conventions of photographic portraiture were born from a fundamental sentiment of *désobéissance*.

Alongside these "games and technical tricks," part of the great complicity between Doisneau and Baquet derived from their joint embrace of left-wing values and a shared *désobéissance* that drove each to create new forms within their respective métiers. At the same time, both seemed to accept that their characters were different but complementary. Maurice Baquet confirmed that "Robert is often quite pessimistic in his thoughts, while in life he is not. I am the opposite. Once you know that, you can't fool each other." Raymond Grosset averred that Robert envied Maurice his carefree ability to enjoy life. Robert once said that Baquet was his "professor of happiness." This friendship

306

306. Marie-Laure de Noailles dans sa cuisine, (Marie-Laure de Noailles in the Kitchen), *Paris, 1962. Maurice Baquet played the role of Doisneau's assistant during this assignment.*

307. *Page 249:* Violoncelle de mer (Cello of the Sea), *Maurice Baquet, Paris, 1961. The collaboration with Baquet inspired Doisneau to be highly inventive with his use of photography to recount episodes (real or imagined) in Baquet's life. Many photographs were made in the late 1950s and 1960s, when Doisneau was exploring means of deconstructing the photographic image through montage, multiple exposure, distortions, and other* jeux photographique. *The project thus became a sort of extended game.*

307

had a liberating effect on Robert's imagination and explains in part the freedom of his inventions.

Like Paul Barabé and several other of Doisneau's friends of the postwar era, Maurice Baquet also played a role as model in certain photographs used for documentary, commercial, or advertising purposes. Photographs of Maurice Baquet appear, for example, in brochures for Simca cars. They were commissioned by Simca's advertising manager, Paul Baumgartner, with whom Doisneau had worked during his time at Renault. The layouts and final artwork for these brochures were the work of yet another old friend, Jacques Chaboureau (see pl. 308). We also see Maurice Baquet as a model in some of Robert's fashion photographs, but the role in which Baquet could best indulge his own spirit of *désobéissance* was that of occasional assistant to Doisneau at the *bals et soirées mondaines* that he photographed between 1949 and 1952 for *Vogue*. He and Robert would borrow or rent evening clothes and accompany Edmonde Charles Roux to some of the most elegant and sumptuous occasions of the postwar years, a period when the beau monde sought to forget the privations of the war and frittered their money away as quickly as possible in a vain attempt to erase the memory of defeat, occupation, collaboration, and death.

◆

Within the little community that established itself in the Paris of the 1950s, particularly around Jacques Prévert, Doisneau found that his role as photographer—because its status was still ill-defined—mixed easily with other forms of expression. The community brought together writers, poets, painters, filmmakers, even humorists such as Saul Steinberg and the poster designer Savignac. Within this context Doisneau's genius flowered. He contributed his ration of stories and anecdotes to animate the *vie de bistro* that all shared: "My great enjoyment was to show my pictures to my friends." Creations such as *Fox-terrier sur le pont des Arts* (pl. 310) are the result of a joke thought up in a nearby café by Doisneau, his painter friend Daniel Pipard, Jacques Prévert, and others. The monsieur with his fox terrier came along by chance to complete the picture. It is in this sense that we can describe Robert Doisneau as a photographer whose work provides a visual equivalent of the Parisian oral narrative tradition, a cultural form that has sadly now almost completely disappeared. Although he only began to write detailed captions for his photographs in the mid-1950s, for *Instantanés de Paris* (1955) he was already writing prose poems in a small notebook. These texts often represent fragments of conversations or snatches of a street trader's spiel. Other prose poems are renderings of the *musique de la rue,* the *baratinage* (chants and shouts to attract customers) of a butcher on the rue Mouffetard, for instance:

Ah it's so good today, madame, this fine meat—
To have fine children, eat the best veal, ladies.
Come closer—the beast is dead, today he can't bite anymore,
he's as tender as my heart when I was twenty.

It is possible to see the influence of both Cendrars and Prévert in these (undated) poems. In an unpublished text constructed in a more conventionally

308

309

308. Lumière et beauté (Light and Beauty), *Paris, 1955. Maurice Baquet was the model for this brochure for Simca automobiles.*

309. *Doisneau with Leica, sitting on his Simca, near St. Céré, Lot, 1954.*

310. Fox terrier sur le pont des Arts (Fox Terrier on the Pont des Arts) *with the painter Daniel Pipard, Paris, Fifth Arrondissement, 1953.* "The picture of the pont de Arts, for example, is a completely staged photograph. There was a gang of us in a café on the rue de Seine, all a bit drunk. There was a girl with us. I suggested to her boyfriend, who was a painter and was going to work on a picture of the girl on the pont des Arts, that he paint her as if she were naked, to see how people would react. So that gave me the idea of the picture of the guy with the fox terrier."

311. Le Peintre du pont des Arts (The Painter on the Pont des Arts) *with the painter Daniel Pipard, Paris, 1953.*

310

311

poetic form, *La Vieille Tzigane de Montreuil,* Doisneau evokes memories of his childhood in the *zone* and perhaps more recent visits to the gypsy encampments outside the porte de Montreuil with Robert Giraud, also a poet:

I see something in your eyes, give me your hand
You are nervous, you are doing your work so quickly
You want the others to work quickly as well
When you're in Paris you want to go to the country
If you're in the country you want to return to Paris
You went on a trip, it didn't give you what you expected
It wasn't a good trip for you
Before marrying, you went with another woman and since then
You have no self-confidence, you are too good, you don't see others
Now think carefully about something you desire
Give me your handkerchief, I'll show you the sign
But don't tell the others about it

Robert always claimed that it was literature rather than painting that exercised the most influence on his photography. From the early 1950s onward, he became more secure in his profession of *photographe-illustrateur indépendant,* and his whole philosophy of life became more developed. His sophisticated photographic philosophy, which played on literary inspirations, began to express itself in his approach:

When you come down to it, for as long as I can remember the writers I have been passionate about are those who like pictures, who are like me when I write, for I write in images. When Giono writes about the spring and says of a morning, "that morning the birds spurted out of the bushes," it is marvelous for me, an amazing idea. With photography I try to suggest. To put the observer in the same mood as you were that morning, when you had a feeling that you were a vacuum sucking up everything it found in the street, or in the studio, or on people's faces. There are moments when you are completely intoxicated.

Doisneau—a *débrouillard,* someone who sorts things out and gets on with the job—sought visual shortcuts to achieve effective results. His friendship with Albert Plécy may have something to do with this. As the 1950s progress, it is possible to see Doisneau's compositional style evolve, and certain patterns emerge. For interiors, in particular, he had developed the use of the flashgun, either open flash, or "bounced" off the ceiling, or used held at arm's length to get an oblique "modeling" light on the subject. He often used powerful flashbulbs to create a feeling of "all-over" clarity. A frequent approach to his portraits is illustrated by that of the sculptor César Baldaccini (see pl. 315), in which the subject is profiled in the far left foreground, with a symbolic element of *décor* counterposed in the right background. A fascinating version of this technique is furnished by the portrait of Louis Aragon and his wife Elsa Triolet, in which the woman at her desk and the rather haute bourgeois setting of the room compose the background to Aragon. This photograph is one of a series of portraits in which Doisneau's distaste for the Communist intellectual

312

312. Savignac aux échecs (Savignac Playing Chess), *Paris, 1950. The poster artist, Raymond Savignac.*

313. Les Chats de Léautaud (The Reclusive Writer, Paul Léautaud, and His Cats), *Fontenay-aux-Roses, 1953. Reportage for* Le Point *(no. 44). "The first time I met Léautaud he asked me how old I was. 'I'm forty, Monsieur Léautaud.' 'Forty, and you seem so thin you must be tubercular!' He was wrong, thank god. Even so I remember his diagnosis with pleasure."*

314. *Page 253: The writer Raymond Queneau, near rue Reuilly, Paris, Twelfth Arrondissement, May 31, 1956. Page of contact prints, 42810.*

313

42803

42802

42805

RAYM. QDENEAU 42800 31 5 56

42798

42814

42807

42810

42813

42806

42811

42804

315

315. César Baldaccini (The sculptor César in his workshop), Paris, 1955.

316

316. *Louis Aragon and Elsa Triolet, Paris, 1963.*

appears barely disguised. Although Aragon was a Surrealist, he was also haughty, and condescendingly referred on one occasion to Doisneau's career as *"vous faites dans le populisme"* ("working on populism").

A very interesting example of how Doisneau made use of his compositional range may be seen in twelve frames of six-by-six-centimeter negatives of the writer Raymond Queneau, made on May 31, 1956. Virtually all are impressive portraits of Queneau, but the preferred picture was negative no. 42810. By this time Doisneau was frequently turning to the thirty-five-millimeter camera in order to vary his approach, for as the Queneau series demonstrates, the fixed lens of the Rolleiflex with which he had worked most often since 1932 was becoming a limiting factor. With a thirty-five-millimeter camera such as his Leica, other lenses with different angles of view (particularly a wide angle and a "portrait" telephoto) would make possible a variation of his visual style. Both formats were used by Doisneau (in addition to five-by-four-inch and occasionally thirteen-by-eighteen-centimeter) until the 1970s, but a number of his most interesting pictures made as early as 1952–53 were in twenty-four-by-thirty-six-millimeter format with a thirty-five-millimeter wide-angle lens (for example, pl. 317) or the group of tourists in a cabaret with the *apache* dancer at their feet, *Le Petit Balcon* (pl. 254). It must however be pointed out that even the twenty-four-by-thirty-six-millimeter Leica had certain disadvantages at the time, for the maximum aperture of the thirty-five-millimeter Summaron wide-angle lens used by Doisneau was only f/3.5, and even the fastest "miniature" films available were only rated at the equivalent of 400/ASA. A "normal" fifty-millimeter lens of f/1.5 or f/2 was available, and Doisneau used both the Summitar and Summicron lenses, but he also experimented with ways of increasing film speed by chemical means in order to be able to use available light in the cafés, bistros, and nightclubs where so many of his pictures were made.

The beginnings of a change to the smaller format can be traced back to 1951–52. Friends in the Groupe des XV suggested the Leica—especially because the lens of the Rolleiflex was not very fast (its Zeiss Tessar lens then offered a maximum aperture of only f/3.5; an f/2.8 was available, but its lens had a poor, if undeserved, reputation among professional photographers). Robert recalled that it was Maurice Tabard, then director of the photographic laboratories at *Paris-Match* and a noted "art photographer," who showed him a series of photos of the same scene made with a number of lenses of differing focal lengths, all with a twenty-four-by-thirty-six-millimeter format Leica. Such possibilities captivated Robert; increasingly he also wanted to take pictures in low-light situations with his friend Robert Giraud, where the Rolleiflex was too restricting. Up until then, however, he had remained convinced that the six-by-six-centimeter format of the Rollei was best. Albert Plécy, who devoted much energy in *Point de vue* to photography as an art medium, showcased the then-current debate between those reportage photographers such as Cartier-Bresson who preferred thirty-five-millimeter, and those for whom six-by-six-centimeter was best. Cartier-Bresson (described by Plécy as a "fierce defender of the twenty-four-by-thirty-six format") wrote on why he liked the smaller format. He recently recalled that he and his colleagues in Magnum had fought a long battle with printers and publishers to get the format accepted, and Doisneau then responded with an article on the larger format:

317. *Page 257:* Les Bouchers Mélomanes (The Music-Loving Butchers), *Paris, 1953. The nocturnal promenades of the late 1940s and early 1950s with Robert Giraud included some lengthy projects, in which the friends sought to explore the way of life of the popular singers and accordionists who frequented the bars, cafés, and restaurants of the Les Halles quarter. During this period Doisneau was also beginning to experiment with the use of a camera smaller than his reliable but bulky Rolleiflex. Doisneau had used the Rolleiflex, frequently with one or two flash guns, for the vast majority of his reportage and personal work from 1931 until the late 1950s. In 1952 he began to use a 35mm Leica camera, because it offered interchangeable lenses and thus different angles of view, and was compact enough to allow "candid" photographs to be made in a relatively unobtrusive fashion with available light. Such pictures as this and* Le Petit Balcon *(pl. 254) show how Doisneau rapidly mastered the smaller camera and adapted it to his chosen subject matter.*

Giraud and Doisneau accompanied the two women who feature in this and a number of other pictures on their working route around Paris. They first encountered the women at a café both men frequented in the rue Mouffetard, Sixth Arrondissement: Les Quatres Sergents de La Rochelle. *In his autobiographical essays, Doisneau sets the scene as follows:*

> *One peaceful Sunday morning two women and an accordion turned up: "Can we sing?" One of them was rather stocky: Madame Lulu was a down-to-earth singer in the style of Berthe Silva. The other one, the accordionist [Pierrette d'Orient] was, my god, so pretty. She really put herself into her song, always the same one, the keening refrain, "You can't imagine how much I love you." Completely detached, even a little contemptuous. A magnet so strong that we followed them around for days on end, from Les Halles to the Chalon quarter [Twelfth Arrondissement], from the canal St-Martin to porte de la Villette.*

> *I never quite understood why they insisted on working in a milieu where money hardly weighed down the pocket—at the Bouillon Tiquetonne [a cheap restaurant in Les Halles], for example, where the clientele attacked the salt-beef, cap on the head and knapsack on the back.*

> *Poetic begging! It was just like Carmen. It was the Blue Angel for those on low wages, with pretty fingers encased in sheaths on the little pearl buttons of the accordion.*

> *A hand that reminded me of that of Leonardo da Vinci's* Saint John the Baptist.

> *When I said that to my friend Giraud, he chuckled over it for a long time.*

> *I was right, but what can you expect from a guy who hardly ever visits the Louvre?*

317

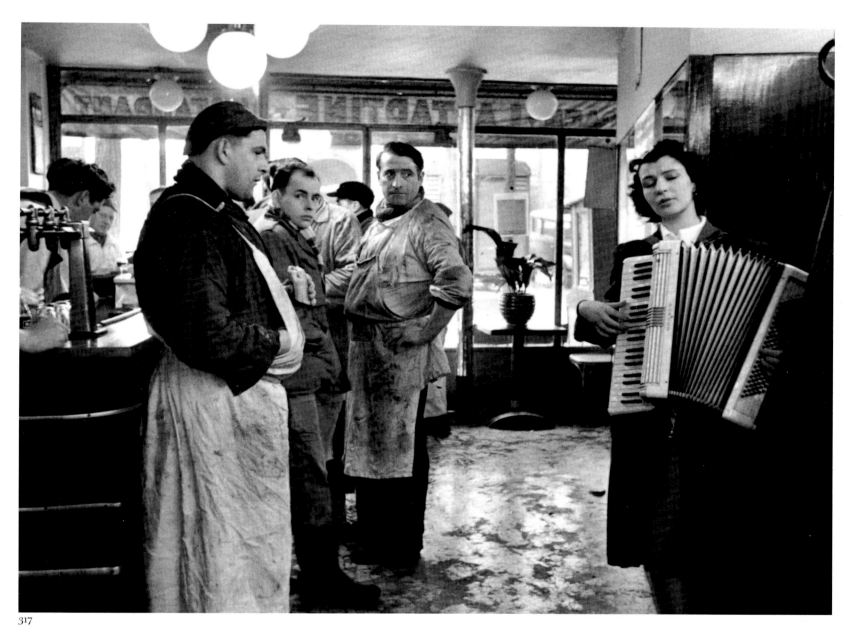

The precision of a lens, the careful registration of what it transmits, that's how photography reveals to us the beauty of an everyday subject, of an ordinary material, and it's very valuable.

To carefully cut a very fine slice from the ham of life, that's another valid use for photography.

With the current state of lenses, film, and paper, that quality and that rapidity of registration are best combined in my little six-by-six trap.

There's nothing better to close in in quite so gentle a way on the fearsome subject, camera supported on hip, to press the shutter without perceptible movement.

No case of accessories, for improvements seem always to be big chromed things that look good in camera-shop windows but are hopeless to use.

Moreover, after a year of feverish handling, the gloss has gone, the edges are worn round and the camera looks as it should.

Since 1932 I've been using a six-by-six and if I am lyrical about telling you about what I think are its good points, I also ought to warn you about its weakness. Too kind, it sins by complacency; for it shows you such pretty things on its ground glass. You put your head over it, and you see such easy things to do, views from ground level, or solemn close-ups (for more details kindly go and look at the amateur photography exhibitions).

Don't give in to this facility.

Looking carefully demands a willingness to see; with training, the spectacles of the street are numerous and ongoing. It is the role of the photographer to reveal these ephemeral treasures. The combination of several elements creates a feeling. Quickly, record the image, particularly if it is unlike any other.

(Definition—"Photographer": a solitary little gentleman who takes the busy man by the arm and shows him the free and permanent spectacle of everyday life.)[6]

The article was illustrated with two pictures, *La Noce en banlieue* (*A Banlieue Wedding;* now known as *La Stricte Intimité*) and a *photo d'ambiance* of Giraud with two *clochards* (vagrants). Revealingly, the latter, "taken without artificial light at 25th at 3.5" is described as having been "latensified after being taken." Both were made apparently at f/3.5 and of course attest to exactly the problem Doisneau faced with the Rolleiflex—the slow maximum speed of its lens. The other fascinating aspect of the article is that it shows how good a writer Doisneau had become by this point, and begs all sorts of questions about why he never made the transition from photography to writing. Perhaps the simplest answer is that he encountered so many gifted writers in his work that he felt intimidated, while his passion for photography and the need to support his family were demands so pressing as to make an alternative career difficult to envision.

In 1947, through his work in the St.-Germain-des-Prés area of Paris, Doisneau came into contact with Pierre Prévert (through Giraud) and was asked to provide a sort of photographic decoration—giant enlargements of his pictures of the area—for a club he had set up called La Fontaine des Quatres Saisons. Jacques Prévert was one of the leading figures of the Latin Quarter,

318

318. *Robert Doisneau on the footbridge over the Bassin de la Villette, Paris, Twentieth Arrondissement, 1955. Photograph made by Jacques Prévert with Doisneau's camera during one of their meanders through Paris. There is a corresponding photograph of Prévert in the same location.*

319. *Page 259: Jacques Prévert, porte de Vanves, Paris, Fourteenth Arrondissement, 1955.*

320. *Page 259: Jacques Prévert, Bassin de la Villette, Paris, Twentieth Arrondissement, 1955.*

His friendship with Jacques Prévert (which lasted from the 1940s until Prévert's death in 1979) seems to have encouraged Doisneau to find within the streets of Paris the sort of pictures that showed the city both as a machine and as a place where fantasy lay just around the corner. They fused their "imagined environments" of the city into a shared and magical vision. Doisneau and Prévert played out the role of the flâneur *in precisely the sense Baudelaire intended, and the many pictures made by Doisneau during the period of their walks around Paris together are highly revealing of this combination of modernism and Surrealism.*

What is certainly remarkable in all the portraits made by Doisneau of his friend Prévert is the way in which the subject—Prévert himself—becomes a creative stimulus. Doisneau always liked to play games with his portrait subjects, if possible. As he had discovered as early as the 1930s in his pictures of children, the game was a useful device to encourage "chance to play its part," as Doisneau would say. But the game often consisted in finding the ideal décor in which it could be played, and for this Prévert was an invaluable accomplice. His fascination with the back streets of Paris rivalled Doisneau's, and since he brought both the eye of an artist and the ear of a writer to the task, his choice of surroundings was always novel. Doisneau recalls that Prévert would ask, "Why do the worst streets have the prettiest names?" and would seek out those areas in which his Surrealist sensibilities could get to work on the banality of the place, alerting Doisneau (who probably did not need too much urging) to the possibilities of transforming the most ordinary of street scenes into images that resound with magic and mystery.

319

320

and drew around him artists, poets, painters, filmmakers and photographers. According to Gilles Ehrmann:

> He loved photographers. Although never their biographer, he brought a poetic aura to them. He always knew how to look at their work in the best light, at a time when photography was still a fairly secret language, and photographers were solitary autodidacts. Jacques Prévert, enlightened by the gleam of so many filmic images, truly interested himself in this art.[7]

The meeting with Prévert led to a number of unplanned but extensive tours through Paris, which continued until the early 1970s. As Doisneau recalls:

> Prévert would call up and say, "Do you know the street where they unroll the big lengths of plywood near the Faubourg St. Antoine?" I would say "Yes," and he would say "No you don't, come and get me and we'll go there." So we would go and look at this, there would be whole logs of this stuff, we'd take in the sound of the work, the color of the wood, the smell of the sap and the look of it as it came out. . . . Prévert taught me to have confidence in the discovery of everyday objects that people didn't see anymore, because they were contemptuous of them, too used to them. He found ordinary words, used every day, and presented them to people as if they were precious jewels. And he loved to play, to discover new things, the names of streets for example: "Why do the worst streets have the prettiest names?" he would say, and I would begin to hear the music of their names—la rue des Cinq-Diamants, la rue du Dessous-des-Berges, la rue du Pont-aux-Biches, le passage de la Main d'Or. . . .

Talking about his own preference for finding the exotic at the end of the block, Doisneau suggests that:

> Jacques Prévert used these worn-out words, which had almost lost their meaning, so everyday had they become, and made them into magical words of enchantment.
>
> His games with words consisted of finding the magic of a fairy tale in them. I believe that a scene, or the gesture of an individual, may correspond to a symbol we have known since childhood—Tom Thumb, the Monster, etc.
>
> So when Jacques said that the sewer worker was Puss-in-Boots, he had recovered the symbol of the cat with its boots. That confirmed in me the idea that the characters of fairy tales are there, in the street.
>
> You don't see them because the evidence is invisible.
>
> My walks with him were always full of revelations, rather than discoveries: "Do you know there are seamstresses who put some of their hair in the wedding dress in the hope they will marry within the year?"
>
> All these little things delighted me. I've rarely found since the density of wonder he could bring me.

Doisneau and Prévert played the roles of *flâneur* in precisely the sense Baudelaire intended when he used the term, and the pictures made during

321

321. *Jacques Prévert in a telephone booth, 1955.*

322. *Page 261:* Prévert au Gueridon (Jacques Prévert and Dog), *at a quai St. Bernard bistro, Paris, Fifth Arrondissement, 1955.*

the period of their walks around Paris together are highly revealing of this combination of modernism and Surrealism. Prévert's writing, and in particular his way of expressing things, rhymed directly with Doisneau's sensibilities:

> It was he who introduced me to the bonesetter of the passage de la Main d'Or, while I took him, so as to hold up my end, to the plywood factory for the perfume of tropical wood, a rather feminine smell, even in that workshop. Just one of our trips around Paris.
>
> He always knew the word that could sum it all up.
>
> One morning I went to meet him near the Moulin Rouge, where he lived, in my car that was rather old but still going; we stopped at a *tabac* (tobacconist) so he could buy some cigarettes. At the counter was a pale woman, her eyes very dark with makeup, a person of the night, a real flower of the night.
>
> We came out, Jacques had seen that I had been looking at her and he said: "Don't touch. It's poisonous."

The fruits of Doisneau's collaboration with Jacques Prévert are evident in the increasingly distinctive photographs he made from the late 1940s onward:

> My work is full of imperfections.
>
> But it's very good that it should be imperfect. . . . My friend Jacques Dubois with whom I work is a very meticulous man, a graphic designer. And when he makes a picture, he wants it to be controlled, in all its elements: light, gesture, graphic composition, etc. I'm quite the contrary—I think it shouldn't have all the perfection of a Swiss graphic designer!
>
> I told Prévert this one day: "You see, I always leave my foot in the door a bit, so that chance can get in, to cop or bring me something extra, something I haven't thought about." That's when he said to me: "It's always with the imperfect of the objective that you conjugate the verb 'to photograph.'" Which was the total sum of what I was trying, with difficulty, to explain to him. He had understood right away.
>
> I really like the idea that all is not completely controlled, that there might be something that comes by chance, which is really the domain of spontaneous photography. Something like what happens for watercolorists when they leave the paper a bit wet.

During the 1940s and early 1950s, Doisneau's portraiture became increasingly liberated from conventional approaches. Wherever possible, Doisneau invites his subject to play out a fantasy, pushing at the limits of social convention to invite chance to play as big a part as possible in the picture. A good example is to be found in *Les Pains de Picasso* (pl. 325), where the very reportage that brought Doisneau to Vallauris to photograph the artist began with Doisneau asking him to play a game with the bread that looked like the hands of someone in one of his own paintings. The influence of Surrealism probably played a large part in this, as is evident from the many portraits of Jacques Prévert, who seemed always to have been ready to play with the ordinary surroundings of Paris:

323

323–325. *Reportage commissioned by Pierre Betz for an issue of* Le Point. *Picasso enjoyed playing with things so much that he was an easy subject to photograph. The game with the* pains de Picasso, *which covers three negatives, is complemented by several others—the double portrait with Françoise Gilot; Picasso at a school desk; another play on the hands theme; a series where Doisneau rigged up a flower suspended from the ceiling with thread so that it appeared to grow from Picasso's hand; and portraits of him with a praying mantis. Doisneau asked Picasso to doodle on some pages from* Vogue, *and the pictures from this aspect of the session were used in the magazine in March 1953.*

Picasso and Gilot were pleased with the pictures, and the edition of Le Point *was favorably received by Daniel Kahnweiler, who wrote that "Doisneau's photos are remarkable, and permit readers to see the most recent works of Picasso at the same time."*

323. La Ligne de chance (The Line of Chance), *portrait of Picasso at Vallauris, 1952. Used on* LIFE *cover.*

324. *Picasso et Françoise Gilot, Vallauris, 1952. Reportage for* Le Point.

325. Les Pains de Picasso (Picasso's Bread), *Vallauris, 1952. When Doisneau arrived, there was no answer at the front entrance. He wandered all around the château until, hearing voices on the other side of a door, he opened it to find Picasso at lunch with Françoise Gilot.*

"Picasso immediately said, 'Won't you have a glass of beer?' On the tablecloth were two bread rolls shaped like hands.

Picasso said, 'Look at these, it's the baker's idea, they've only got four fingers. That's why he calls them Picassos.' Since he seemed to be in excellent spirits, I dared to place a roll on either side of his plate. He did exactly as I wanted, sticking his arms underneath the table as if the rolls were their extensions."

325

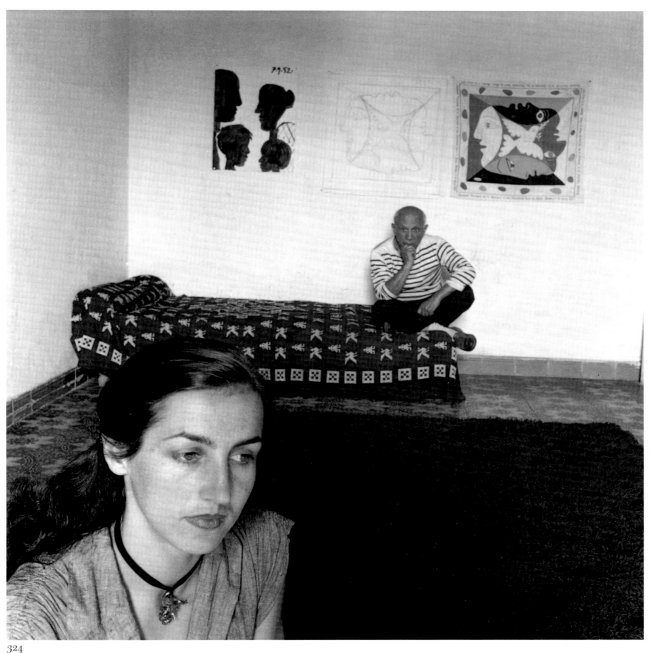

324

Sometimes we experienced situations that could have been taken straight from one of his film scenarios. One night I took him to a little bar in Les Halles where I went sometimes with Robert Giraud. Next to the bar were the regulars—some girls in brightly colored dresses and the same number of gray men. We sat down. One of the girls went over to the jukebox, put a coin in, and Prévert's song, "Les Feuilles mortes" spread through the bistro. Taken by nostalgia, the girl said to us with a deep sigh, "The guy who wrote that must have been very sad." On his paper napkin Prévert wrote a short poem, and gave it to the girl, who looked at it and said "He's crazy, your friend." Then she rolled the paper into a ball and threw it out the open door!

◆

Paris has long been entertained by its *fêtes foraines* (street fairs), some of which have a very long history reaching back to the Middle Ages. From childhood Robert was fascinated by the fairground and in particular by the people—*les forains*—who ran the sideshows.[8] It was natural that he would devote considerable time and energy to photographing this popular street entertainment, and the resulting pictures are perhaps among the most interesting of his entire output.

The mass entertainment and spectacle of the fair was one of the few types of crowd behavior that Robert was interested in photographing. He had always had a certain horror of the crowd—symbolized perhaps most clearly in his experiences at the end of the Occupation, when he saw his compatriots do some terrible things to collaborators, egged on by a maddened crowd:[9]

> You will understand, then, why I don't like the crowd: it frightens me. I am always looking for the individual within it, the glance, someone with whom one exchanges a little of one's soul. Each time I've been mixed up in a crowd, I've felt ill at ease: at school, during military service, at Renault—35,000 staff and workers, that is a crowd! A moving body, made up of molecules, none of them is what remains of one of us. It is possible to make photographs there, but you have to find the exception, and a typical example is the *fête foraine*.
>
> The *forain*? He's a marginal like the photographer or the barge people. I love the fantasy and the magic of it all. I photographed the Ménagerie Lambert, old professor Lambert, his lion Roméo. He was quite tame. I even went into his cage, but that didn't stop him from savagely clawing a dancing girl one day when he was in a bad mood.[10]

In the 1940s and 1950s there were still innumerable street fairs and sideshows around Paris, some *manèges* (itinerant roundabouts) that simply made a year-long circuit around the squares and parks of the city, and others parts of large fairs that toured the whole country and visited the capital for big events like the Foire du Trône. Doisneau always liked to think of himself as engaged in a métier akin to that of the fair people, and in his fascination with their entertainments and their way of life, he was led to befriend quite a few and to make many memorable photographs of them. One sideshow that particularly took his fancy was the Wagner family flea circus. He came across them for the first time in Montparnasse in 1951:

326

326. Les Mains de Braque (The Hands of the Painter Georges Braque), *Varengeville, 1953. On an assignment in 1953 for Pierre Betz's* Le Point, *Doisneau visited Georges Braque in his Normandy village of Varengeville. The reportage was well received, although Doisneau encountered some problems in making his pictures. Braque was a somewhat severe and rather formal person (sending Doisneau off to the nearest town to have his lunch, for example). Consequently, Doisneau, in order to appear more "serious," used the four-by-five-inch camera—it required a tripod and was a more imposing piece of equipment than the Rolleiflex he would otherwise have used for the entire reportage. The more considered and carefully framed portraits that resulted ably display Doisneau's mastery of his medium, particularly in their ability to translate the somewhat stately character of Braque into a photographic portrait. The picture that has become best known, plate 327, is accompanied by several other images of great interest and power.*

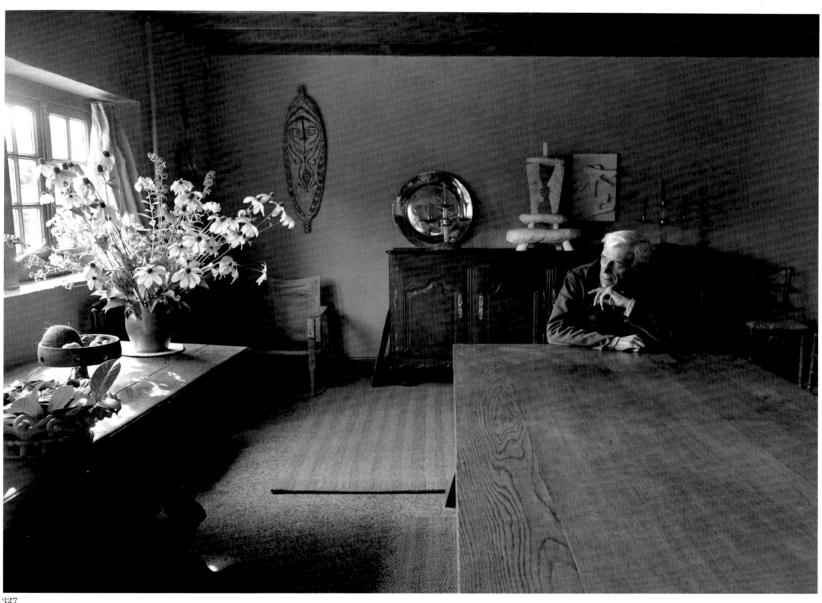

327

327. *Georges Braque at Varengeville, 1953. Reportage for* Le Point.

At the fair in boulevard Pasteur, I was brought to a stop in front of their sideshow. Theater of the Intelligent Fleas. On the signs were painted acrobat fleas, fleas fighting a duel, fleas wearing dancers' tutus.

I had to meet these people who, to earn their living, used these bugs that had been invented to make life uncomfortable.

In a theater suitable to the scale of the actors, the audience was arranged in a semicircle around a table. Because of the powerful lighting, Monsieur Wagner was wearing the sort of visor worn by the guys at casino tables and by newspaper editors in American films.

With a circular gesture, he passed a huge magnifying glass over the table. Then it was possible to see clearly a microscopic Roman chariot, a hearse, a cannon, and I can't remember what else. The livestock, harnessed by threads of brass wire, were showing signs of independence. The parade progressed along jerkily. Monsieur Wagner checked the direction with tiny tweezers, all the time reeling off his spiel in a confidential manner.

Doisneau soon became friendly with Louis Wagner, his wife Laure, and their daughter Madeleine. "I was really proud to be invited to have a cup of coffee in the Wagners' caravan. A sign of confidence not extended to everyone."

Yet for one of his most popular photographs—*Le Manège de Monsieur Barré* (pl. 334)—he was not able to establish the sort of complicity that he always sought with his subjects. On his route into Paris along the avenue du Maine, he would regularly go past a crude merry-go-round:

Every year, in the square in front of the town hall, at the beginning of summer, mushroomed a merry-go-round for the children of the Fourteenth Arrondissement.

Approaching it one discovered a multitude of vehicles that—whether locomotive, bus, airplane, or horse—were all made out of scrap metal. It was just like in Cinderella, where the pumpkin is turned into a coach by the spell of a fairy godmother. Here it was a case of the metamorphosis of the oil can or the biscuit tin.

Instead of a fairy godmother, my friends, I was confronted with Monsieur Barré, who received me as if I were a spaniel lost in a bowling alley.

"I saw you coming, who sent you? I know the game. It's to copy me, afterward I'll find myself with ten, twenty competitors in the square. Fuck off with your camera! No, that's too easy!"

I had to make four visits before I earned, or rather nearly earned, his trust.

In his autobiographical essays, Doisneau suggested that his lifelong fascination with the *forains* was intimately connected to his wish to capture the transitory and the unregarded:

It's true, I sought their company, less for the picturesque aspect of their situation than to learn from them the art of working with the temporary. And also because I drool with admiration whenever I come across jugglers and those who know how to ride a unicycle.

328

328. *Drawing-letter to Doisneau from the painter Gaston Chaissac, 1952.*

329. *Page 267: Gaston Chaissac, St. Nazaire, 1952.*

The art brut painter Gaston Chaissac was a friend of Robert Giraud. He lived in the Vendée at St. Florence l'Oie, where his wife was the local teacher.

During an assignment in 1952 at St. Nazaire on the west coast of France, Doisneau made a visit to Chaissac at Giraud's suggestion. He spent a day with him, photographing his work and the school he had painted where his wife worked, and making a portrait that has remained one of the best of the many artists he has known. Perhaps because the photographs were made as the result of a friend's suggestion, Chaissac remained in contact with Doisneau for some time, and his letters—written in an inimitable hand— were often illustrated by the curious figures that define his unique style.

Chaissac later became a prominent figure in the art brut *movement, but Doisneau was initially attracted to photographing him because, like many of the* bâtisseurs chimériques *(builders of fantasies) whose work Doisneau recorded, he had a total disregard for artistic convention, another form of* désobéissance.

329

Although he derived great satisfaction from his work on great artists of his time, such as Picasso and Braque, these pictures of those who were artists in a less established sense—"marginal thinkers," as he once described them—took on a greater importance in the construction of his own visual universe. Among this group were Frédéric Séron, who made cement animals; the painter Gaston Chaissac; Raymond Isidore, who decorated his entire house with pieces of broken china; and Gilbert Frugier, who collected and used everyday objects as props for his fantasies:

> Curiously all of these *bâtisseurs chimériques* (builders of fantasies) shared something in common, a voice that woke them, sometimes the Virgin Mary or even an ancestor. It was always imperative and so "Hop!" out of bed.
>
> Like the others, Frédéric Séron had not resisted the call from the beyond, as proved by his zoo of cement animals invading his garden at Pressoir-Prompt alongside the RN7 highway.
>
> I never count but with the doves there must have been at least fifty inhabitants. Inside each animal was sealed a steel cylinder containing his visiting card, the local paper, and sometimes a portrait of an important person. It was his pyramid, his refusal to disappear completely. "That will be found a thousand years after my death. I am not afraid but—believe me if you want to—when I look at them it's so alive I have to leave the garden." To your good health! Frédéric Séron made his own wine. It was dry—dark-colored, but natural. Today the countdown has begun. All I have left of him is a painting he gave me, painted in thin cement, of an elephant hunt.
>
> *
>
> They don't talk about Gilbert Frugier anymore in the post office. Why not? His case was perhaps too special, it would be necessary to open a new file with a grandiose title of the type: magical collector. What animated him was not simply the need to gather but rather to transform.
>
> I believe I understood the recipe: take an object that has ceased to fulfill the function for which it was conceived. Thus freed from its use, like someone retired who devotes himself to an art, make of it an element of dress or decoration. Amid the columns of stovepipes and under a candelabra made from oil lamp bulbs, you were with him in the palace of the Thousand and One Wrecks.
>
> The visit was extended late into the night, for the treasures were piled up on two floors. While I was dropping with fatigue, he was tireless, popping up as a Sun King with a wig made from wine corks, disappearing behind a screen made from post-office calendars, from which he reappeared as a knight in a breastplate made from beer caps, to be replaced immediately by the god Pan, with horns made out of the tears used to suckle young calves.
>
> I began to understand why the neighbors did not appreciate him from the day he replaced his shutters with panels representing the grimacing faces of Assyrian kings, which he'd picked up from the scenery store in Limoges theater. Whether the neighbors were obsessed or not, he

330. Page 269: Le Trépidante Wanda (The Gyrating Wanda), *Paris, Fourteenth Arrondissement, 1953. Doisneau's archives contain large numbers of photographs of fairs and fairground people, something he attributed to the fact that as a child he was always one of those turned away from the sideshows because children never had any money! "As an adult they still fascinated me, because you could go in and no one would turn you away, and you could meet the* forains *(the people who owned the stalls and rides). It's true, I even sought their company, less because of the picturesque nature of their situation than to learn from them the art of making do in a temporary setting."*

Wanda worked at her parents' stall, called "l'Escargot Turbulent" (The Turbulent Snail) as a stripper. In fact, as Doisneau recalls, it was a sort of striptease familiale, *in which the two or three girls who performed were never completely uncovered. His longstanding admiration for the* forains *came about because their life was hard, and they had to face many difficulties in making ends meet, yet they took great pleasure in their work and they performed in the street, Doisneau's preferred "studio." He prided himself on the fact that Wanda's family knew him well enough to invite him into their little caravan for a drink.*

Robert photographed "The Voluptuous Wanda" in 1953 at a street fair being held at the place Denfert Rochereau (Fourteenth Arrondissement). By a curious coincidence, the sideshow was set up very near the apartment building in boulevard Auguste Blanqui where Brassaï then lived. He also (unbeknownst to Doisneau) photographed Wanda—probably at much the same time.

The fascination of "Wanda" derives initially from the two planes on which it works: the dark interior, where the audience watches her perform her gyrations, and the bright exterior, where the people shuffle past or wait patiently in line. This points up the juxtaposition of public and private space, with which the image is playing.

The picture was made with the Rolleiflex held to Doisneau's eye, framed through the open focusing hood, and with its 75mm Zeiss Tessar lens probably set at its widest aperture (f/3.5), with a relatively long shutter speed—perhaps 1/30s or 1/60s. The slight blurring of Wanda's arms and skirt that results only adds to the attraction of the picture. It's likely that it was taken in the early evening, which helped to balance interior/exterior exposure, for the exterior is about two or three stops overexposed, though it can be printed-in to give the necessary detail.

330

331. Theatre de Puces de M. Wagner (M. Wagner's Theater of Fleas), *Paris, 1952.*

332. Forain (Barker), *Paris, 1952.*

333. *Detail of Monsieur Barré's Merry-Go-Round, place de la Mairie, Paris, Fourteenth Arrondissement, 1955.*

334. *Page 271:* Le manège de M. Barré (Monsieur Barré's Merry-Go-Round), *place de la Mairie, Paris, Fourteenth Arrondissement, 1955.*

331

332

333

335

335. Monsieur Flinois, bouquiniste (Monsieur
Flinois, Second-Hand Bookseller), *in front of
Notre-Dame, Paris, Fifth Arrondissement, 1951.*

336. *Page 273:* Chez Donio, dresseur de chiens
(Donio the Dog-Trainer), *Paris, 1948.*

was far too occupied searching through trash cans and never even glanced at them.

For those who like to travel without leaving their bedroom, the most pressing need is to make the walls disappear: Gilbert Frugier did that by covering them with objects [see pl. 337].[11]

◆

As the 1950s came to their end, the range of reportage work that could be undertaken by Doisneau began to lessen, to be replaced increasingly by commercial assignments. Yet he still tried to keep two or three personal projects constantly in progress, to inspire him to create a new range of images. One of these emanated from a long-term interest in the world of the Provençal shepherd, and the regular movement of the flocks from lowland pastures to mountains in the yearly cycle of transhumance. Inspiration for this came from his love of the literature of Jean Giono.

> After the war we were on holiday in Provence. I had a distant cousin there who owned a big house.... When I was down there I would go fishing, to a spot called Largasse. One day while I was fishing a shepherd with his herd, Monsieur Gracq, stopped to talk to me by the river. We talked and smoked some cigarettes, and he said to me, "It would be good, for a photographer like you, to come along when we leave for the Alps in the spring. I'm serious. If I leave you my address, will you send me a note? We are leaving in ten days from Lorgues."

Robert jumped at the chance of carrying out such a project. Back in Montrouge he put together all he needed for such a trip, carrying with him a Rolleiflex camera for black-and-white photographs, a Leica for color, and sufficient film for the trip. Between June 18 and 22, 1958, he accompanied Gracq and the other shepherds, their mules and their sheepdogs, as they led their flocks up to the *alpages*—the summer pastures in the mountains of the Alpes-Maritimes.

> I took the car and left for Lorgues. At dawn I was at the assembly of the herds, which took place in the big square at Lorgues, and when I saw Monsieur Gracq, he said, "I never thought you'd come." We set off slowly toward Draguignan, at about six miles an hour, and we met up with another herd that had come from another area. The sheep were put together, perhaps four hundred in all, plus the dogs and four or five shepherds, and we left for the Alps. It was essential to avoid the heat of the day, so we traveled mainly at night. There were special tracks for sheep, known as *braies*. At night we stopped the sheep, and the wives of the shepherds came to find us in cars. We made a big fire and all ate together. We went as far as the Alps, up to the ski resorts. Then there were chalets and mountain houses, it was quite high. The shepherd told me that it was much prettier when they went back down, because the animals were rather ugly, all gray and thin when they went up. But after three or four months of summer they had been washed white by the rains, and there were lambs as well.

337

337–41. *Page 274–75: Some of Doisneau's* Bâtisseurs Chimériques *(Builders of Fantasies). His fascination with these people is related to Dubuffet's concept of art brut. His concern is to connect the* art brut *product to its producers, showing their creative work in the context of their lives. The images reflect Doisneau's perception of how ordinary people can disrupt established cultural rules.*

337. *Gilbert Frugier, collector, Limoges, 1951.*

338. *Joseph Marmin, topiarist, 1952.*

339. *Raymond Fasquelle, bâtisseur chimérique, Malakoff, 1953.*

340. La Salle à manger de Raymond Isidor (The Dining Room of Raymond Isidore), 22, *rue du Repos, Chartres, 1953.*

341. *Frederic Seron at Pressoir-Prompt, 1953.*

338

339

340

341

The photographs Doisneau made during the *montée* (ascent) are essentially documentary in content. He devised the story of *Kalou*—a young lamb that gets lost and is adopted by some children who look after it on their Provençal farm—between the *montée* and the *déscente*, for he returned to Provence in mid-October 1958 to photograph the return of the flocks to their winter pastures.

In October Gracq wrote to me, "We're leaving on October 15." I went down, leaving my car below so I could go up by bus to Entrevaux. The *déscente* began. We walked all night and then all of a sudden a truck drove into the herd, killing the dogs and a dozen sheep. It was a terrible carnage. The truck driver was in big trouble; he had undoubtedly fallen asleep at the wheel. The gendarmes were called—they needed witnesses, of course. But I couldn't stay there, the charm had been destroyed. So I left.

I went to fetch the car on the Côte d'Azur. But a strange thing happened. I'd spent the night at the gendarmerie, and slept with the ewes. There was even one that'd fallen in love with me! By the morning I stank, it was hideous, the tourists in the bus kept as far away from me as possible! I had shoes full of sheepshit!

Back in Montrouge, Robert edited the pictures.[12] He assembled a photo-story, and had a text written by a friend. He made *maquettes* (dummies) of the book in various formats, titling it *Kalou* or *Calinou* (a *Provençal* word for a young lamb). In the end it was not presented to a publisher, for Robert decided that it was "*trop bête*" (too silly) (see pl. 342; these photographs have never been previously published).

Robert recounted the tragedy of the end of the transhumance project to his friend Jacques Prévert, and many years later (in the autumn of 1975) the poet would write and dedicate to Robert a short text, "Transhumance," for his last book, *La Pluie et le beau temps:*

One day in the little mountains of the Alpes-Maritimes, near Entrevaux I think, Robert Doisneau was with a shepherd, his sheep, and his dogs, when a wayward truck plowed into the flock and killed the two dogs.

"Did you take any photos?"

"No. I consoled the shepherd," replied Doisneau.

And it was as if life, in a snapshot, had made the portrait of Doisneau.

A simple exchange of worthy processes.

For what is now so long, Robert Doisneau has created such beautiful and simply astonishing images, particularly on the occasion of weddings and celebrations, of love and the humor of life.[13]

342

343

342. Kalou, *dummy made by Doisneau for children's book based on his reportage project on transhumance in the Basse-Alpes of Provence, 1959. The book was never published.*

343. *Monsieur Gracq, shepherd, transhumance project, Alpes-Maritimes, 1958.*

344. *Jacques Robion, shepherd, transhumance project, Alpes-Maritimes, 1958. It was soon after this photograph was taken that a lorry careened out of control into the herd.*

344

CHANGING PERSPECTIVES

1961–1978

"When you're free, when you don't depend on authority, it's perfect. The guy who makes photos in the street is rather shady. You're asked, 'Do you have permission to do that?' The science of written things does not accept the image. It's something that eludes it, so it's worrisome. Apart from that I was completely free—I never worked out how much time I was spending. I often had a discussion with my fellow photographers who billed for their 'waiting time'—at 150 francs an hour—but 'waiting time' was my material! I couldn't estimate the price, it was a gift from heaven."

BY THE BEGINNING OF THE 1960s, humanistic photography was beginning to look more and more outdated to those who controlled the major print media, whatever the real value of its content. This was in part due to a certain devaluation of the photographic image itself. Paradoxically, the very success of humanistic forms of photographic expression—as evidenced by the global popularity of Steichen's *Family of Man* exhibition—coincided with an increasing belief, beginning at least in the early 1950s, that visual images created by photography constituted a new and distinctive language that could function without any textual support. The writer François Cali summed this up as: "One hundred good photographs explain immediately, and infinitely better than one hundred pages of text, certain aspects of the world, certain current problems."[1] Doisneau may well have been as prey to this idea as the majority of photographers and picture editors of the time.

In France, the diffusion of ideas about photography as a universal language was encouraged by a number of events during the 1950s, including the major exhibition at the Grand Palais in Paris in 1954, the Biennale Photo-Cinéma, launched by the magazine *Photo-Monde* and organized by Doisneau's mentor of the early 1940s, Maximilien Vox. To accompany this exhibition, the magazine published an album entitled *Cent Photos sans paroles (A Hundred Photos Without Words);* Vox's introduction affirms that "photography will enter the history of language. It will be accepted that photos are the words which make up sentences, which constitute books." Later, a volume marking the tenth anniversary of the United Nations was published to coincide with a major UNESCO conference in Paris on the role of the image in contemporary culture; it featured eighty-four photographs of people from thirty-six countries, presented completely without captions.

Steichen went further in his *Family of Man* exhibition: all the pictures in the show were made from copy-negatives of the originals, were in many cases blown up as giant enlargements, and were printed on mat paper bonded to wood. The installation completely ignored any possibility of presenting the fine print as an art object in itself, and simply reinforced the notion that photographic images were a common resource (universal language) that could be employed by picture editors as a sort of raw material.[2] By the late 1950s and early 1960s many commercial uses of photography had developed that copied Steichen's print presentation form in the *Family of Man*—trade exhibitions increasingly employed large photoenlargements, shop window displays used the same idea, and photographic presentations even began to appear in the entrance halls of factories and offices.

The emphasis had shifted from photographer to photography: it was now more important that the photographer could present his images in a certain style than that he could invest them with a special quality born of his or her perception. Everything now depended on the *style* of image that could be produced. As photography was increasingly seen as a universal language, the personal vision or perspective of individual photographers was downgraded. The rapid development of small camera technology in the period between 1958 and 1965, which saw Japanese manufacturers introduce a welter of new models to European and American markets, accelerated this process, for it implied that the practice of photography was also being universalized and no longer

345. *Page 279:* Epouvantail (Scarecrow), *Lot, 1953.* "Ah, the scarecrows, they were a bit of a gift, like the street signs. It's the same method—I look in the streets, I look in the countryside—always the décors." *The little book,* Epouvantables épouvantails *(1965) has an intimate connection with Doisneau's wider project and shows how his work has a direct link with major art movements of the postwar era, particularly art brut. As the introduction indicates, "A great photographer has to be interested in these sentinels of fear, to which man is so willing to give the form of man."

required complex technical skills or a heavy financial investment. Japanese thirty-five-millimeter system cameras like the Asahi Pentax and Nikon F offered photographers—amateur and professional alike—the illusion that outstanding images could be obtained through the acquisition of the requisite range of equipment, a suggestion reinforced by heavy marketing. Creativity seemed to primarily derive from the ability to use a fish-eye lens, or a perspective-cramming telephoto. The advanced camera had become the consumer good par excellence, with the implication that high-quality photography was primarily a commodity.

In 1953 Doisneau had worked with a young advertising executive and publisher who had a passion for photography, Robert Delpire, to create a small book of his portraits of Parisians, with texts by Michel Ragon and Robert Giraud. Their texts are evocative of the world in which Robert's pictures were made—*la rue, le marché, les foires*, and *le bistro*. Doisneau had allowed Delpire to lay out and cut up his images as he wished, which in many cases totally destroyed their ambience or wider meaning and negated the very relationship of person to environment that gave his photographs their most distinctive qualities. But in fact the hegemony of picture editors in respect to page layout was well established in France. Their ability to destroy or modify the integrity of an image was notorious, and it was only through the actions of photographers such as Henri Cartier-Bresson, who refused to allow his images to be reframed or cropped in any way, that the habitual control of the editor over the visual presentation of the image was eventually limited.

The book—*Les Parisiens tels qu'ils sont*—is thus an early example of Robert's willingness to lend his imagery to other creative purposes and to play around with its presentation. It is further evidence of a mounting desire to break with existing conventions, perhaps as a result of the straitjacket into which he felt he was being placed by the overwhelming need to carry out advertising and industrial work. Some interesting photography did arise from such assignments, however. For Simca, the car manufacturer, he produced a number of advertisements, brochures, and publicity photographs, which came about through his friendship with Jacques Chaboreau, whom he had known since the Renault period in 1935. Chaboreau worked as a freelance designer, and one of his clients was Baumgartner, advertising director of Simca, with whom both of them had worked before the war. One of the projects on which Chaboreau and Doisneau collaborated, involving experimentation with color special effects, was in association with the painter Enrico Pontremoli, whom Doisneau had met during the Occupation.

There were also plenty of industrial assignments, some fashion work from time to time for *Vogue* and other magazines, and a number of book projects. One of these worthy of some note is a photographic study for *Gosses de Paris*, published in 1956 and based on a school in the Sixth Arrondissement with commentary by a young teacher, Jean Donguès. Despite its marvelous pictures, the book was a commercial failure, for it was an era when few photographic books proved a success. Yet when it was reprinted with essentially the same selection of images and a new text by François Cavanna in 1989, it became a runaway best-seller.

Such assignments allowed some creative scope, although the commercial work became increasingly onerous for Doisneau. In 1962, for instance, we find him writing to Pierre Betz:

346

346. *Paris, street scene, 1959.* "*The other way of doing it is to let the fellow approach, with the camera on your hip. You calculate that on his third step, he will be the right distance from you. Hey presto, the photo's taken and he's not sure that he's been photographed. I like it when I go out and then, all of a sudden, where I've been a hundred times and never seen anything, something appears and I capture it.*"

347

347. *Chaussée d'Antin, 1951.*

348. *Tourist, Eiffel Tower, Paris, Seventh Arrondissement, 1950.*

349. Le Vert Galant, *banks of the Seine, Paris, 1947. Used as part of a reportage for* Regards *in July 1947 on how Parisians were reacting to the heatwave then affecting the city, and headlined "One Hundred Degrees in the Shade in Paris."*

348

349

350. Le Muguet du métro (The Lily-of-the-Valley in the Metro), *Paris, 1953.*

351. *Florist, Paris, 1953.*

352. *At the hairdresser, Paris, 1948.*

353. *Page 285: Two ladies in their Sunday best, rue de Buci, Paris, Sixth Arrondissement, Sunday, March 22, 1953.*

353

354

354. La Pendule (The Clock), *Paris, Fifth Arron-*
dissement, 1956.

355.

355. L'Information (Knowledge), *Paris, Fifth Arron-*
dissement, 1956.

356

358

356. Le Lance-Pierres (The Stone-Thrower), *1956. Made as part of a series on street-games for* Gosses de Paris, *a collaboration between Doisneau and a teacher, Jean Donguès, documenting a school in the Fifth Arrondissement on the edge of the Latin Quarter.*

357. Les Écoliers de la rue Buffon (The School-children of the Rue Buffon), *Paris, 1956. For* Gosses de Paris.

358. Les Flèches (Archers), *1956. For* Gosses de Paris.

359. Mathématiques (Mathematics), *Paris, 1941.*

360. *Page 289:* Enfant sage dans cour de récréation (Sissy on the Playground), *Paris, Fifth Arrondissement, 1956.*

357

359

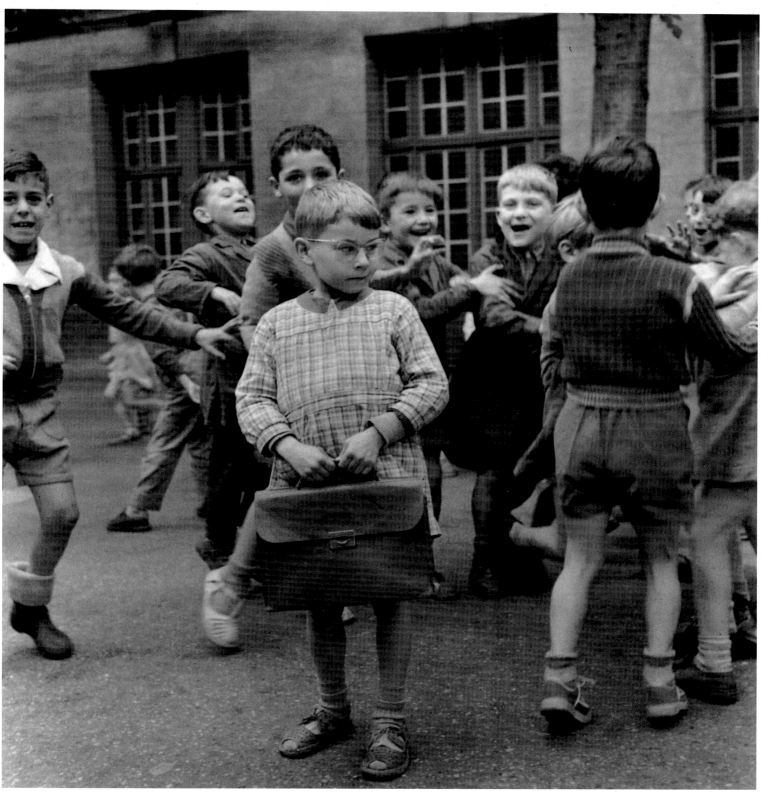

360

Now I have made my little revolution, bored stiff as I was by the photos for the advertising industry . . . and so I have begun to wander about the streets again and to see at last the people and the scenery. It's only a reprieve, but optically I'm guzzling it in. I really believe I was made for that, but the problem is this: could I live and keep the household going with three hundred photos a year? One photo a day is not impossible and then it all makes sense. To become a pedestrian without engagements or a telephone is really tempting. I did a rough calculation showing me that it was a mad idea, so only betting on horses is left. It's the national pastime, thus rather risky—if you have an idea share it with me, I am looking for some kind of good fortune.

The reasons for the diversity of Doisneau's output during the period from 1960 to about 1977–78 are simple enough to enumerate: changes in the uses and visual styles of photography itself; declining demand for illustrative reportage of the type with which he had made his name; the emergence of a younger generation of photographers; replacement of the photographic print image by the video image; and finally the trend to increasing specialization in the métier, which a "do-it-all" like Doisneau was ill-equipped to pursue.

The number of television sets in French households passed the one million mark in 1960. As in other Western countries, the inevitable rise of television during the 1960s dealt a fatal blow to the illustrated press, and many magazines went into a terminal decline. Advertising revenues dropped and the number of pages devoted to editorial photography was consequently reduced. The demand for humanistic photography fell, for another generation exploiting new styles of reportage and new forms of "creative photography" was emerging to compete for ever-declining magazine pages. Virtually all of the great photographers of Doisneau's generation suffered more or less from these assaults. Some photographers made the move into television work, as producers, directors, and cameramen. For a brief period Doisneau worked with the new medium, translating some of his "human interest story" projects into TV programs; a number of his *bâtisseurs chimériques*, for instance, were filmed in the early 1960s. But such initiative on his part did not lead to any sustained involvement.

◆

In the early winter of 1960, Robert received a postcard from his friend Maurice Baquet, then appearing in *La Plume de ma tante*, a successful musical produced by Robert Dhéry, in New York:

There are great buildings falling down, others replacing them quickly with enormous cranes and a lot of noise. There is also some natural scenery where I could go with my cello, there are photos to be made in this town, very long ones. Come if your work allows.

Despite his attachments to Paris and his reticence about New York, Robert decided to try out the idea—but only if the ticket provided for him was return rather than one-way. Through RAPHO's New York partners—Charles Rado's RAPHO-Guillumette agency—a number of commissions were arranged for *Fortune* magazine and for *LIFE*. They included assignments in

361

361. Quatre-vingt pour cent des accidents se produisent à l'atterrissage (Eighty Percent of Accidents Happen on Take-Off). *Photographic montage, 1972, one of the* truquages et jeux photographiques *(fakes and photographic games) produced for the Doisneau-Baquet project "Violoncelle Slalom" (published as* Ballade pour violoncelle et chambre noir). *This composite image combines studio performance shots of Maurice Baquet with distorted images of the cello. The latter were made with the modified Speed Graphic and a turntable, resulting in a twisted image (see Appendix, "Doisneau on Technique").* Quatre-vingt *is representative of Doisneau's turn toward a form of photography conceived of as a universal language, in which the image alone can be used to tell a story or explore a theme.*

362. *Page 291: Maurice Baquet on the Brooklyn Bridge, New York, 1961. Photograph made for* Ballade pour violoncelle et chambre noir. *Doisneau's introduction to the book offers an insight into the attractions of this collaboration for the photographer:*

It's evident, in our forbidden books, there are the molecules and the atoms, enough protons and neutrons, in sum all the pieces of the kit necessary to make a Maurice Baquet. So there it is, straight out of our comic books. . . . All the legendary characters dance to the music that is constantly playing in their heads and that allows them, in all moderation, to blissfully avoid all the traps that the dolts that meddle in the realm of comedy fall into. . . .

Another thing, it seems that when making stringed instruments you must never dry the wood for the making of a cello too quickly, by steaming it or putting it in an oven. . . . This book has followed the same principle. A book that has many other deficiencies or omissions: for example, it could also be criticized for being anachronistic and for not taking into account the different fashions in photography. I want to speak about more than signifying images, creative photos, metaphors, subjective photographs, and sequences, all that seems very complicated.

362

Hollywood to photograph the comedian Jerry Lewis, and in Palm Springs to photograph a golf tournament. The American magazines paid for the tickets: Maurice Baquet suggested that at that point Doisneau had a greater reputation in the United States than in France. When Robert arrived in New York, he was met by the picture editors of the most important illustrated magazines of the time.

Robert and Baquet enjoyed themselves enormously in New York, producing a great series of pictures that would be invaluable for their book, and some images of the cellist which appeared as a double-page spread in *LIFE* magazine. But Robert's inability to converse with the natives was, as always, a hindrance to him in trying to make "his" photographs in a foreign country. Yet America deeply impressed itself on his visual imagination. From Palm Springs, Robert wrote to Baquet on November 23, 1960:

> Since my arrival in Palm Springs I've been enchanted, particularly in the evening—facades of verdigris, orange roofs, and lilac-colored palms, there are an infinite number of other combinations of course but all are ravishing, moreover everybody is very happy. I have the impression of coming from another age, like a Louis XV chair on an airfield or a cello in front of the *LIFE* building. There's an image we should do, the front of a building in the evening with your silhouette in a window and other silhouettes of people phoning and rushing around in all the other windows, and, speaking of telephones, a businessman with three telephones, the Statue of Liberty, the street of cinemas—a terrace with NY lit up. At the moment I'm beginning to meet the millionaires and there are a lot of them. I've got a little white electric car so I can drive around the green and tomorrow I'll have a helicopter so I can get a general view. I've been introduced to millionaire golfers under the name of Robert-of-Paris—How-are-you! as they all say with the air of being so pleased to see me that it's quite flattering both for the métier and for Montrouge (Seine) and this is only the start. There are nineteen golf courses here, I will end up with relations in oil, the cinema, and the automobile industry....

> to you from your photographer,
> Robert-de-Paris

The attempts to get a decent set of pictures out of Jerry Lewis lasted almost a week, but in the end Robert managed to extricate himself from this difficult assignment and rejoin his friend in New York. For a couple of weeks in December 1960, after his return from California, Robert and Maurice were able to devote some more time to their joint project and put some more images in the magic box. Their book project, which was at that stage in one of its *maquette* (dummy) stages, had passed from publisher to publisher; in New York, Robert and Maurice Baquet had even interested Charles Rado, to the extent of playing with the idea of creating a children's version. Meanwhile, back in Paris, Raymond Grosset was doing the rounds of the *maisons d'édition*. All this effort was without success, however.

363. *Page 293: Jerry Lewis, Hollywood, 1960. To fund his trip to America in 1960, Doisneau undertook assignments in Hollywood and Palm Springs for* LIFE. *One of these was to photograph the comic actor Jerry Lewis. But as Doisneau acknowledged, the possibilities of getting Lewis to "play" with him and produce some interesting images were limited by their mutual incomprehension of each other's language. "You mustn't tell Charles [Rado], but I'm going to try and do Jerry Lewis quickly (Doisneau to Baquet, November 1960)."*

364. *Page 293: Jerry Lewis, Hollywood, 1960.*

"Yesterday visit to the Paramount studios—saw Jerry Lewis—I saw him work. He is far, far too over-the-top, but he's not lacking in self-confidence. It was all very nice but I had to find some vague gag for the photos—I was also distracted by the people who had come from the other sets to watch me, the ingénue. There were four red Indians (real ones) with feathers and all the accoutrements, some English soldiers, some policemen, and a few cyclists. 'No camera,' said the sign on the entrance, I was quaking in my boots. I wanted to get a couple of photos done quickly and return to N.Y. (Doisneau to Baquet, December 1960)."

363

364

365

Since at least 1931 when he bought his first camera, Doisneau had been making photographs of the *"imagerie de la rue"*—street signs, shop signs, street furniture, statues, architectural details, graffiti, posters, etc. He had started with photographing window displays and the *enseignes* (painted signs) traditional for certain trades—those of butchers, bakers, cobblers, etc. Initially some of this interest was focused on collecting bizarre or amusing *panneaux publicitaire* (advertising signs) such as "here we replace bad heads" for a doll-repairer, or on simply recording interesting forms—the shape of a gaslight, the sparkle of the light in a gutter.

In the 1960s, however, the pace of urban change in Paris accelerated rapidly, leading to the disappearance of much of what had been the traditional decor of the Parisian streets. An urban infrastructure that had last been modernized in the 1930s—and in many areas much earlier—was undergoing a massive transformation, which was to alter its whole character. Old shops and houses were pulled down to be replaced with modern edifices, exteriors were given new revetments to replace a rotting plaster facade that might have dated from the nineteenth century. Modern and intrusive street signs appeared, and cars began to clog the tiny and narrow back streets of Paris, just as they had already commandeered the *grands boulevards*.

Robert felt that the new Paris was sweeping away so much of what he had come to love about the city that his natural response was to *inscrire* as much as possible before it was destroyed. He therefore set out on a detailed and almost obsessive documentation of the vestiges of *le vieux Paris*. There is an interesting link here to Atget's similar enterprise of the early part of the century: consciously or not, Doisneau's project situates him in a long and honorable tradition of Parisian photographers, stretching back to Marville, Bayard, and even Daguerre, who stamped their own interpretive cast upon images of the great city, fixing it within a visual frame at key stages in its development.

One of Doisneau's responses to what was happening was to take pictures that increasingly mock certain consequences of urban change: the individual, for instance, is commonly portrayed as the victim of a voracious and dehumanized power, as cars, stark buildings, and skyscrapers take over the city. Cars prey on pedestrians, hunting them down as they try to cross the place de la Concorde, while lovers on a motorcycle are hard pressed to grab a fleeting kiss, surrounded by cars and made clumsy by the helmets they are wearing. The traditional icons of the city—its heroic statues—are overwhelmed by the mass of vehicles. To take many of these photographs Doisneau used a long telephoto lens (five-hundred-millimeter), whose main effect was to compress perspective and to make certain juxtapositions more telling. Many of these shots necessitated the use of a tripod in order to obtain the small stop required for depth of field sufficient to render the image sharp all over the frame. The images work on the basis of a carefully selected "decisive moment," but they are constructed out of a method of working wholly different from those for which Robert had become best known in the 1940s and 1950s. It is an approach in which the photographer has no contact with his subjects, for he is often hundreds of yards away from them. Despite the fact that these are images of great graphic power, they required Robert to break with the methods he

365. Coal-merchants' sign, 208, rue Raymond Losserand, Paris, 1966. Made as part of Doisneau's documentation of the "imagerie de la rue," a project begun in the early 1960s, when he felt that the new Paris was sweeping away so much of what he had come to love about the city. His natural response was to inscrire as much as possible before it was destroyed. He therefore set out on a detailed documentation of the vestiges of le vieux Paris.

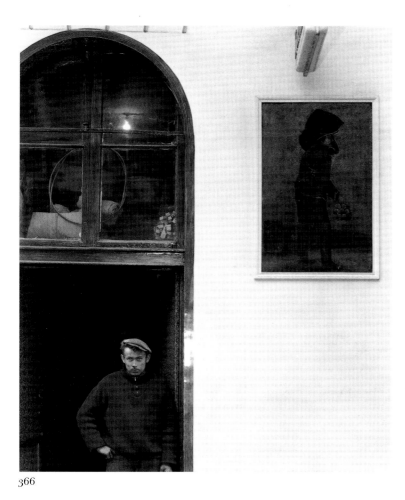

366

366. Bois et Charbon (Wood and Coal), 7, *rue Charles V, Paris, 1965. For* Imagerie de la rue.

367. Au Nègre de Charonne, *155, rue de Charonne, 1966. For* Imagerie de la rue.

368. Maison de Confiance (House of Confidence), *Paris, 1967. For* Imagerie de la rue.

367

368

had always used to make his best pictures of people in their environment. The telephoto images necessarily sacrifice the particularity of the individuals shown in them to their role as symbols of humanity oppressed by modernity. Despite the humor that plays around them, they are quite pessimistic in their view of the fruits of modernism.

Imagerie de la rue was a book project that, like so many of those in this period, proved difficult to realize. Robert nearly always felt it essential to have a writer to produce a complementary text for his images, despite his pronounced ability to provide interesting captions and to express his ideas in print.[3] In this case, he was associated with Jacques Yonnet, a novelist for whose book Doisneau had created a jacket cover image and who had shown interest in collaborating on a book on *"enseignes de Paris."* Robert described him as "charming but not very practical." The project was very close to Doisneau's heart: in it he saw the perfect expression of his type of photography: "I always worked like a photographer-*forain*. I don't have a studio, I work best in the street. It's normal—everything in the street—not to mention the people—attracts you."

The failure of Yonnet to complete his text did not stop Doisneau from assiduously photographing as many of the *enseignes* as he could. The prints were delivered to the publisher, who then seemed to lose interest in the book. Nonetheless, Doisneau continued with what was in effect a personal project and prepared several maquettes for another book with the title *Imagerie de la rue,* in which a much wider range of pictures could be used. This would eventually appear as *Le Paris de Robert Doisneau et Max-Pol Fouchet* in 1974. Although the book uses some of the work carried out for the earlier project, it is also a mélange of material from at least two other distinct projects: one on the demise of Les Halles, and the other on the decorative work of the designer Benoist and his confrères, who from the 1880s to the 1930s painted the tiles and plasterwork of many food shops in Paris—bakeries, butcher shops, charcuteries, and some bistros. By the 1970s, so many of these beautifully decorated shops were being renovated or demolished that it seemed as if an entire chapter in the popular culture of Paris was being rewritten, and the evidence of this once-proud craft totally obliterated. Doisneau studied the work of Benoist, perhaps the best exponent of this trade: no doubt he felt an affinity with the artist, regarding him as another *forain* whose atelier was the city itself. Robert's research included attempts to find out more about Benoist from those who could recall his work. As his notebooks attest, in Boulogne-sur-Seine he even found an old charcutier who recalled commissioning him in the 1930s, just before this form of decor went completely out of fashion.

This project fit in with Doisneau's role as a *badaud* (idle observer), recording what lay in front of him as he meandered around Paris:

> When you're free, when you don't depend on authority, it's perfect. The guy who makes photos in the streets is rather shady. You're asked, "Do you have permission to do that?" The science of written things does not accept the image. It's something that eludes it, so it's worrisome. Apart from that I was completely free—I never worked out how much time I was spending. I often had a discussion with my fellow photographers who billed for their "waiting time"—at 150 francs an hour—but waiting time was my material! I couldn't estimate the price, it was a gift from heaven.

369

369. Les Piètons de la Concorde (The Pedes-
trians at Concorde), *place de la Concorde, Paris,
Eighth Arrondissement, 1971. Montage of telephoto
lens photographs showing the* chasse aux piètons
(run of pedestrians) *at this famous crossing point
between the Champs-Elysées and the jardins des
Tuileries. Part of Doisneau's documentation of the
"*imagerie de la rue.*"*

From the time he first began to use a Rolleiflex in 1931, Doisneau had been attracted to Les Halles in the center of Paris. Indeed one of his earliest pictures, of two young women on a porter's *diable* (cart) was taken near the église de St.-Eustache, at the heart of the market area, in 1932. By the 1950s, the Halles Centrales, which provided all of the wholesale food markets of the Paris region, had become woefully inadequate. A fundamental problem was the lack of access for trucks, and it was decided in 1959 that new markets at Rungis on the outskirts of the city should be constructed. When this occurred, it became clear to Robert that Les Halles would die, and from the early 1960s he began a detailed photographic study of the markets and their inhabitants, so that the memory of this place would not be lost.

His work also had a political dimension, for the plans being formulated during the 1960s for the redevelopment of the Halles Centrale began increasingly to focus on destruction of the neighborhood as a living and working entity, in favor of speculative office, commercial, and residential development. The battle for Les Halles was in essence a struggle between the left, which wanted to retain the "popular" character of the area, and the right, which sought to create a new "bourgeois" Paris, dominated by office and leisure development.

From late 1963 until the final clearance of the Halles Centrales in 1969–71 and its replacement by the Centre Beaubourg and the Forum des Halles, Robert made regular trips there, to record as many aspects of the community as he could. He made both color and black-and-white images, devoting a considerable amount of film to the enterprise. The pictures that resulted are intriguingly diverse, and he used the whole gamut of his technical expertise to create a unique record of a disappearing world. There are for instance a number of large-format views, taken by Robert from a high viewpoint and designed to situate the market within its urban context. Then there are pictures of the internal architectural structure of Baltard's *pavillons,* again made in large format in order to record as much detail as possible of the imposing structures. During his regular night visits to the markets in 1968–69 Robert took many photographs of the people who worked in the various sections of the market—meat porters, fish-sellers, *marchands des quatres saisons* (fruit and vegetable dealers), the various ancillary trades such as truck drivers, even the garbage collectors. Then there are pictures of the bistros, refreshment shops, and snack stalls that fringed the Halles Centrales, where the market people would come to eat and drink. Some photographs that concentrate on social life Robert made in six-by-six-centimeter format with a Rolleiflex, although the majority were made in twenty-four-by-thirty-six-millimeter, the smaller camera with its interchangeable lenses being better suited to his desired variety of close-up, middle-distance, and long-distance pictures.

After the move to Rungis, Robert went there to see what had happened to the market people. It was a disappointment:

> I went to Rungis to see how it worked, to find a woman who was a vegetable-seller in front of the church of St. Eustache at Les Halles, who ended up in a little square space at Rungis. Les Halles was not comfortable at all, but at Rungis it was more concentrated, not at all the same system, and I never went back. There was no longer any point to photographing that.

370

370. Venus prise à la gorge (Venus Held by the Throat), *specialists from the firm of Gougeon installing Maillol statues, jardins des Tuileries, Paris, 1964. Doisneau was on his way to an advertising assignment when he saw this work going on, supervised by Maillol's widow, the model for the statue. "Sometimes my best pictures have been made by stealing a bit of time from my clients."*

371. Page 299: Vice et Versailles (Vice and Versailles), *Paris, 1966.*

372. Page 299: Les Bulles du faubourg Poissonière, *Paris, 1971.*

373. Page 299: Buste de Raffet, *quai du Louvre, Paris, 1971.*

371

372

373

374

374. *Rodin*—Le Penseur (The Thinker), *Musée Rodin, 77, rue de Varenne, Paris, 1973.*

375. Les Embarras de Petits-Champs (The Kiss at Rue Petits-Champs), *Paris, 1969. A fine example of Doisneau's use of the perspective-cramming telephoto lens to make telling juxtapositions for his study of the "imagerie de la rue." He focussed a considerable amount of attention on the impact of the car and its accompanying isolation of the individual, which he saw as responsible for the mostly negative changes afflicting Paris. The street was being taken over by the car and could no longer function as a theater of spectacle and amusement. "It's true that the street has become less interesting. . . . The city was meant for pedestrians. Now it's meant for cars. So you no longer have time, by car, to take in the sights—that's dangerous."*

376. *Page 301:* La Danse de carpeaux (The Dance of the Young Carp), *Paris, 1972. For* Imagerie de la rue.

375

376

The only thing of interest that I found was the truck park used by young kids from the banlieue for motorbike races—they were very dangerous! Young people seem to want to kill themselves....

From the early 1960s, Robert realized a number of book projects designed expressly for children, commissions from the publisher Nathan, designed to help young people decide upon a career. He also produced much fine color work in this period, but the approach is one that his audience seems to like best in black and white, where the viewer's concentration on the subject is not compromised by another visual register and the involuntary emotive associations that color generates. Perhaps that is why a book made with Maurice Chevalier in the early 1970s, which contained a good deal of color, proved a disappointment. At the end of his life Doisneau dismissed it in derisive terms as "that rubbish!" Despite his disillusionment with the whole enterprise, it was the first book to bring his color work to the fore.

The book was produced by Macmillan, the American publishing house. Chevalier was known in the English-speaking world through his film roles in Hollywood productions, and for many foreigners he personified Paris. Doisneau was the most "Parisian" of photographers: perhaps it seemed a sensible idea to put the two together for a book aimed at a non-French market. But the collaboration with Chevalier was not a happy experience for Doisneau, who considered the actor one of "the people who rub their thumbs across a visiting card to see if it's engraved or not."

A project much closer to Doisneau's heart—*L'Enfant et la colombe (The Child and the Dove)*—proved a disappointment for other reasons. Like many of his most carefully pursued personal commissions, this one began with a chance meeting—with a man called Pierre Derlon.

> He was a wonderful guy who had had thirty-six jobs in his life. He had even been a clown. When I met him he was a gypsy chef, a *tzigane*. He was also a painter and decorator. At the end of his life he was a faith healer. But he was so good-natured, and fabulously generous. He had two handsome little boys. We did a book together and I have a terrible guilt about it, because an American publisher came here and stole the thing from him. He didn't deserve that from me.

The idea for the book came from Derlon, who had originally thought it up in order to increase his income, for at the time it began he was unable to pay his rent, and the electricity had been cut off by the landlord. He trained doves for the ballets of the marquis de Cuevas, in which they would fly around a group of dancers, who carried imitation rifles and pretended to shoot the birds, at which point they landed on the muzzles of the guns. In the evenings the doves were let out of the cages in Derlon's apartment and allowed to fly around: since the apartment could only be lit by candles, the sight of the birds flying through the air and putting out the candles with their wings charmed Doisneau.

> We started to take photos. Then he said to me, "I will make up a story around this, about a magic dove that is not like the others, because it has a special thing around its neck." He wrote a rather complicated tale—we

377

378

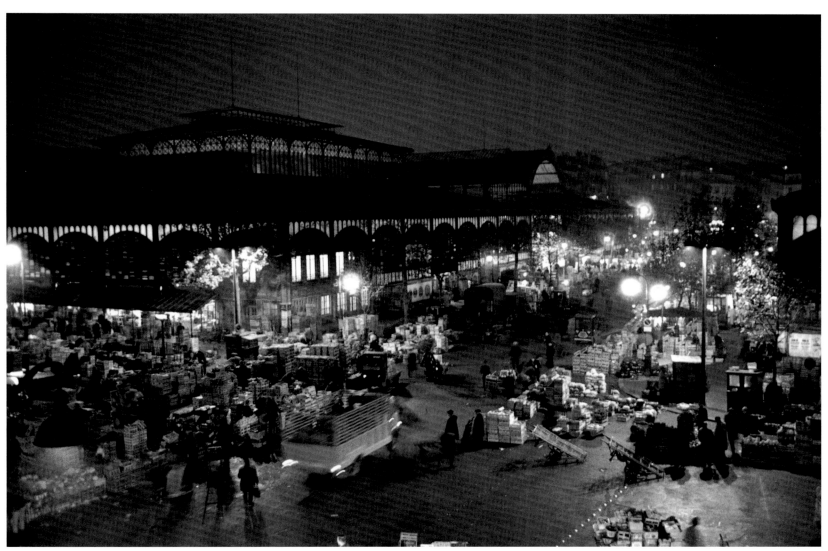

379

380

380. *Charcuterie, 4 bis rue Parrot, Paris, 1971. It was decorated by the designer-artist Benoist, who worked on many shops and bistros from the 1880s to the 1930s. By the 1970s, so many of these beautifully decorated shops were being renovated or demolished that it seemed as if an entire chapter in the popular culture of Paris was being rewritten, and the evidence of this once-proud craft totally obliterated. Doisneau studied and documented the work of Benoist, perhaps the best exponent of this trade: no doubt he felt an affinity with the painter-tiler, for he may have seen him as another* forain *whose atelier was the city itself.*

381. *Page 305:* L'Echaudoir de la rue Sauval (The Slaughter House of Rue Sauval), *Les Halles, Paris, Fourth Arrondissement, 1968.*

382. *Page 305: Woman Selling French Fries at an Outdoor Stall, Les Halles, Paris, Fourth Arrondissement, 1969.*

381

382

went nearly everywhere to do the photos. And then the story hung around for a long time.

Robert's photographs telling the story of the child, Patrick Derlon, and his magical dove, began in late 1963 and continued until mid-1964, yet the book did not appear until 1972 in an American edition (*The Boy and the Dove*) and 1978 in a French edition. While some of the images have been highly successful in recent years as postcards, the books themselves were a commercial failure.[4] This finally persuaded Doisneau that the desire to recount a story in a visual form, as he had done in his children's books, was a format that was ultimately rather limiting for his photography.

◆

The little book on scarecrows that appeared in 1965—*Epouvantables épouvantails (Scary Scarecrows)*—may seem a minor detour in Doisneau's work, but it has an intimate connection with his other projects and a direct link with major art movements of the postwar era, particularly *art brut*. Doisneau, via his friendship with Robert Girard, had known several of those involved in the movement. Asked why he had devoted so much energy and film to photographing scarecrows as he drove about the countryside, he said:

> It's an extraordinary peasant madness.... In the Lot I came across a sort of big vegetable garden where there was a good scarecrow. Well, I stopped, I went to take a look ... there was a lady hoeing. I said, "It's funny that scarecrow, will it bother you if I take a photo?" "No, but why are you doing that?" I said, "For a number of years I've been photographing them during my trips, if it's of interest to you it's what we call naïve art." She said "That's not naïve art, it's *art brut*!" To think a housewife could tell you that! It had never been used to frighten birds. It was a means of expression.

To express the type of motivation that lay behind this project Doisneau returned to his idea of photography as a form of *braconnage* (poaching) or even *glanage* (gleaning)—both popular forms of acquisition of material or in this case cultural objects. Producing the little book on the scarecrows was "a pleasant trip, like making a bouquet from flowers you collect by the side of the road."

As described in Chapter Six, in the 1940s and early 1950s Doisneau's immersion in the cultural scene around St.-Germain-des-Prés and in particular his friendship with Robert Giraud had brought him into close contact with important figures in contemporary art and culture. Jean Dubuffet, for whom Giraud worked as a secretary and assistant, developed influential theories about the importance of the art produced by those living on the edge of society—marginals like *clochards* (compare Doisneau's photographs of the painter Duval and the sculptor Jean Savary) and the insane. Dubuffet praised the art of the mentally ill, but only where it was produced for personal rather than therapeutic reasons; and he also paid attention to those who created objects and representations with no self-conscious "artistic" purpose—graffiti, for instance, or the constructions of people like the *facteur* Cheval or Frederic Séron, for example. Doisneau's fascination with these people, whom he called

383

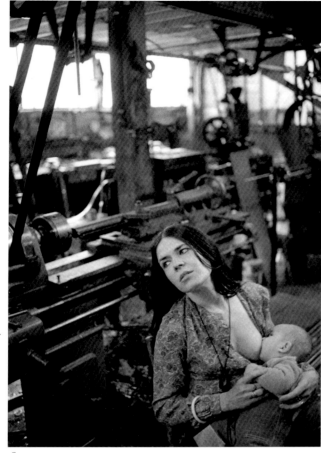

384

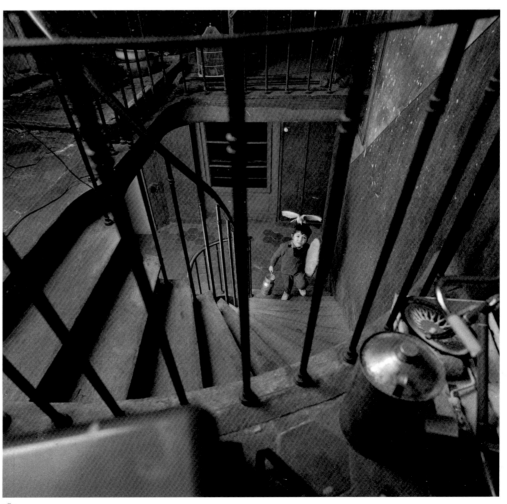

385

bâtisseurs chimériques (builders of fantasies), may thus be seen in the context of the influence of and debate around Dubuffet's concept of *art brut*. The particular twist that Doisneau gives it lies in his concern of revealing the relationship of the *art brut* product with its producers: to situate their creative expression within the context of their lives. The *Epouvantails* project thus slips neatly into this wider set of concerns, for it reflects Doisneau's constant fascination with how ordinary people express themselves in ways *désobéissant* of established cultural rules.

◆

The same year that the *Epouvantails* project was published, Robert took part in a joint exhibition, *Six Photographes et Paris* at the Musée des Arts Décoratifs.[5] The other participants were Willy Ronis, Janine Niepce, Daniel Frasnay, Jean Lattès, and Roger Pic. The exhibition was held under the auspices of the recently formed Association Nationale des Journalistes, Reporters et Photographes. Among the pictures exhibited by Doisneau was a series on the Eiffel Tower, in which his aim was to reinterpret the iconic role of the tower. To carry out the project he used a wide range of approaches, which he called *jeux photographiques* (photographic games). These included his vision-distorting modified Speed Graphic, as well as pictures where part of the image is destroyed by heating the gelatin emulsion and burning or chemically treating the film base.

However, the photographs exhibited by Doisneau at the Musée des Arts Décoratifs that provoked the most attention were not of the Eiffel Tower, but on two other subjects: a wall of photos from a series on a group of amateur photographers at the place de la Concorde, and a montage entitled *La Maison des locataires* (pl. 392). Both allude to Doisneau's fascination in the early 1960s with playing around with ways of deconstructing photography itself. In *La Maison des locataires* his fascination with the everyday is taken a step further. Made originally for an exhibition at the Art Institute of Chicago in 1962, the montage provides an idealized view of the interior of an apartment building. On a large print of the facade of a run-down building of a type to be found throughout the faubourgs, Doisneau mounted a series of images taken from some of his favorite subjects. The montage is fascinating because it offers an image of the little society of the Parisian apartment building: the binding together of a disparate group of individuals within a collectivity in which each can manifest his or her own personality. Pull away the facade of the urban armor and a magical and poetic world appears, in which ordinary people create a meaningful existence out of the banality of the everyday.[6]

Sadly, perhaps, Doisneau did not experiment much further with this creative use of the photomontage as the basis for an exhibition,[7] although he did make another in the early 1970s. Commissioned for the Mairie de Pantin and installed in the summer of 1972, this piece featured the images built around a real rather than an imagined site, the pont des Arts[8] (see pl. 402). The photomontage in this case has become more three-dimensional than the *Maison des locataires*—indeed it might even be called an "installation" in contemporary art-speak. The idea behind it is to construct a multiple image of the pont des Arts and the people who give it its special character—the only pedes-

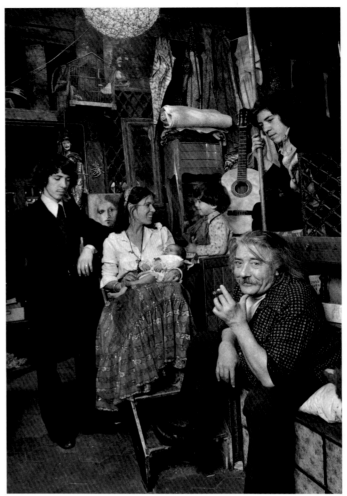

386

386. Pierre Derlon et sa famille (Pierre Derlon and Family), *Montrouge, 1978.*

387. *Page 309:* Epouvantail (Scarecrow), *on the route to Nanteau, Beauce, 1962. "The countries where* art sauvage *is still made are not so far from civilization. . . . The shepherds of Seine-et-Marne and the gardeners of our big modern cities are witness to this come springtime.*

The scarecrow—no other object better epitomizes popular art. Because of the obscure magical reasons for its existence; because it is essentially functional; and because in the end it is outside any aesthetic preoccupation and is not concerned with longevity (nobody imagines a scarecrow becoming listed as part of our national heritage)—it allows its creator to let his imagination take flight, whether it be in a humorous, sarcastic, or tragic vein.

A great photographer must be interested in these sentinels of fear to which man is so willing to give the form of man.

It is this that Robert Doisneau has recorded during his trips in the Gâtinais, the Périgord, the Rhône valley, and the banlieue parisienne *(publisher's introduction,* Epouvantables épouvantails, *1965)."*

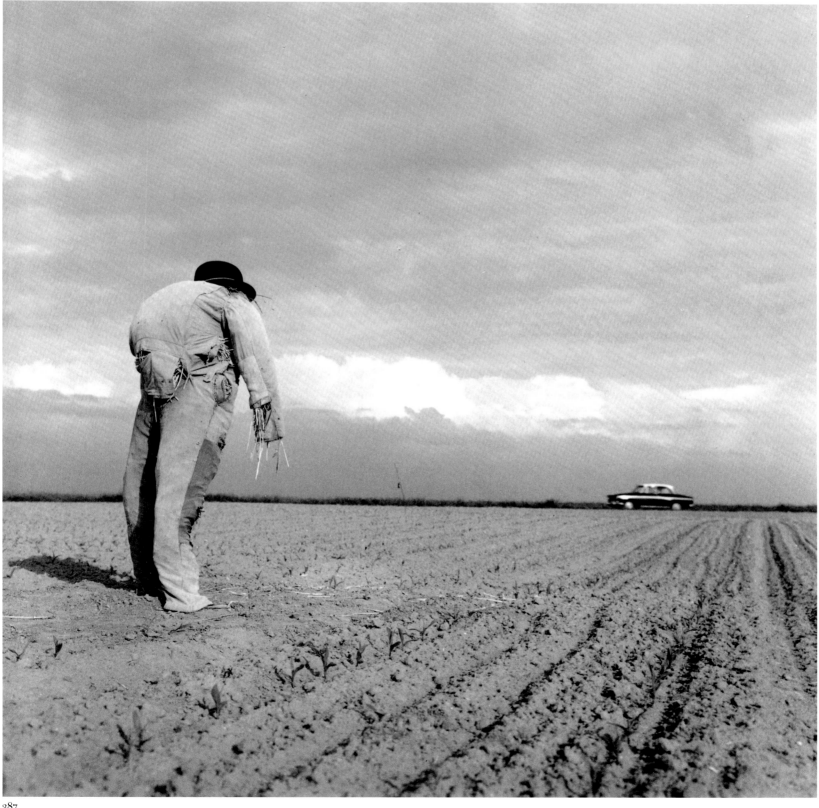

trian bridge over the Seine, long a favored site for painters, buskers, and street entertainers. Into this visual frame Doisneau placed a number of elements of photographs made from as far back as the 1940s and as recently as the 1970s. The fox terrier from the famous image of the 1950s is there, as is the painter of the upside-down landscape of the 1940s. The pictures were mounted on one-meter-square blocks and placed over the base image—a giant enlargement of a view over the bridge—so that they form parts of an incomplete grid. In some ways the work suggests the photographic experiments with multiple perspective practiced by David Hockney, although it predates them by a few years.[9] Doisneau did not persist with the work because he feared that he might end up in a creative cul-de-sac, similar to that which he believed had affected Kertész's work when the latter became fascinated with the use of a distorting lens in the 1930s. These *jeux et bricolages techniques* are symptoms of Doisneau's dissatisfaction with conventional photography during a period (1960–1975) when he was obliged to devote his time increasingly to commercial assignments to the detriment of what he considered his métier, street-photography.

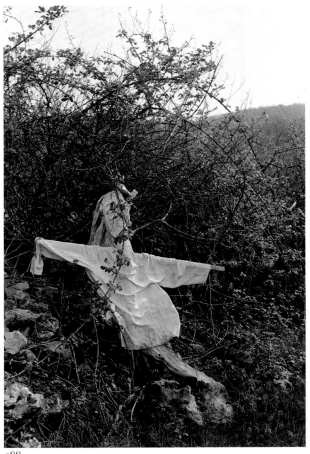

388

◆

In the summer of 1967, *La Vie ouvrière (Workers' Life)* commissioned Doisneau to undertake a major project on the forthcoming celebrations of the fiftieth anniversary of the Bolshevik revolution. They planned a special issue of the magazine, *Cinquante Ans de réalisations Sovietiques (Fifty Years of Soviet Achievements)* and sent a team of journalists and CGT delegates to the Soviet Union. Their objective was to survey the major achievements of the Communist party, and Robert joined the team as photographer. But it was difficult for him to make "his" photographs, for the level of bureaucratic control over the movement of the party meant that the possibility of any sort of street-photography was severely curtailed:

> It would have been better if I hadn't gone. I was well received, but it was a fairly big scam in the sense that you were never free, they held these ghastly conferences, you couldn't see things at all. This was 1967 and you couldn't take photos because of such or such a strategic bridge—but this was a bridge built in 1880! A total stonewall—bureaucratic, idiotic, so you couldn't do anything.

Robert's commitment to the CGT and *La Vie ouvrière* went back to the Front Populaire period, and he naturally wanted to make an interesting set of pictures for the magazine. The fact that he eventually succeeded in producing twenty to thirty good images from the six-week trip, despite the inhibitions to his free movement, was probably due to Robert's ability to inveigle images out of the periods of "free" time on the tour around the Soviet Union, outside of official visits and meetings.

◆

The quasi-revolution of May 1968 in Paris passed Doisneau by, for he was laid out at the time with an injury common for photographers—a slipped disc. Robert was asked to support photography students in their revolution

388. Epouvantail (Scarecrow), *1965.*

389. Epouvantail (Scarecrow), *1964*.

390. Epouvantail (Scarecrow), *1963*.

391. Epouvantail (Scarecrow), *1965*.

390

389

391

392. *Page 312:* La Maison des locataires (The Apartment Building), *photographic collage, Paris, 1962. A collage that attests to Doisneau's wider interest in all of the things that go to make up everyday life, the taken-for-granted activities that bind people together within French society. Made originally for an exhibition at the Art Institute of Chicago in 1962, the idea for this image may have come to Doisneau from something he saw in Hollywood in November 1960, when he photographed Jerry Lewis. In a letter to Maurice Baquet he wrote: "The scenery in which his film was produced is a marvel of the genre—firstly its size, a three-story house plus the attics, without a front. Naturally you see all the bedrooms, the living rooms, the staircases, a working elevator, lamps hidden in the ceiling. . . ."*

393–95. *Storefronts in the Lot, 1970s.*

394

393

395

397

396

396–97. *Les Halles, 1960s.*

398. *Page 315:* La Nettoyeuse de peniche (The Barge Cleaner), *pont Alexandre III, Paris, 1970s.*

399. *Page 315: Les Halles, Paris, 1960s.*

398

399

400

400. *Jardins des Tuileries, Paris, July 14, 1978.*

401. *After a demonstration, Latin Quarter, Paris,*
May 1968.

401

402. *Le pont des Arts, large photomontage made for the Mairie de Pantin, Paris, 1971.*

402

against prevailing orthodoxy, and he did what he could to help, attending meetings and discussing new ways of teaching the subject. Few of the humanist photographers of Doisneau's generation photographed the May events (although Cartier-Bresson was an exception), and its recording was largely left to the younger generation. Nonetheless there *are* some interesting pictures of the May 1968 events, made by Robert shortly after the riots: they fall in a sense under the rubric *"imagerie de la rue,"* for they illustrate the burned-out cars and paving-stone barricades in the Latin Quarter. They make an interesting contrast with his photographs of the barricades of August 1944.

The post-1968 world did, however, produce a mounting interest in photography in France, and it began to revive demand for the style of reportage work practiced by Doisneau.

<div align="center">◆</div>

During the early 1970s, Robert's work began to be constrained to some extent by the increasing ill-health of his wife Pierrette. She began to suffer from depression and to manifest other symptoms of a troubling nature. At the time he was becoming increasingly interested in the possibility of carrying out a project on the "industrial wasteland"—photographing many of the sites on which the great nineteenth- and early twentieth-century industries were established but which by the mid-1970s were under threat of destruction, as economic crisis and technological change took their toll.

> Everywhere where men have had to work hard, it's beautiful. But it's a sad memory. . . . We left, my wife and I, for a car trip to Le Creusot.[10] She wasn't very well, I thought a little trip might do her good. We stayed with the factory director, M. Evrard. All of a sudden, my wife said, "We must go, this can't go on at all." We went back to Paris. The next day we went to see a friend who was a doctor. He took me to one side and said, "There's nothing I can do, she has Parkinson's disease." It was the start of the black years, and of course I abandoned the project entirely.
>
> What I wanted to show was all these abandoned factories with their *corons* [workers' housing], where there was no work—these kids have got certification as electricians—they enjoy themselves on their mopeds but have absolutely nothing to do! It wouldn't have been very cheerful, but it would have been a sort of mission to show all that.

Pierrette's illness was a great blow to Robert, for her condition made it increasingly difficult for him to leave her unattended, and the cost of medical care became an additional burden. The consequence was that he had no choice but to accept commercial assignments, to work on subjects in which he had little personal interest at the point in his life when such exigencies should have been diminishing, and he ought to have been able to devote more time to personal projects. Robert found that it became almost impossible for him to carry out the type of assignments that in other circumstances would have been very fulfilling, such as that on the Loire and its environs, which he photographed during 1976–77.

Discussing the Loire project some years later, Robert said:

403

403. *Hand coming out of telephone. Cover photograph for article on new taxes in* La Vie ouvrière, *1979.*

404. Photo symbolique—les accidents du travail (Symbolic Photo—Industrial Injuries). *Montage for* La Vie ouvrière *of injured hands against background of steelworks, Thionville, Lorraine, 1973. On certain assignments for the CGT magazine, Doisneau was smuggled into factories and mines by local union activists to photograph working conditions.*

404

405

405. *Food market, Georgia, Soviet Union, 1967. Assignment for* Cinquante Ans de réalisations Sovietiques (Fifty Years of Soviet Achievements), *special issue of* La Vie ouvrière. *"It would have been better if I hadn't gone. I was well received, but it was a pretty big joke in the sense that you were never free, they held these ghastly conferences, you couldn't see things at all." Despite his disappointment over the problems he encountered during his visit, Doisneau succeeded in making some interesting photographs in places where he could be free of his hosts, as here in the market or in the vineyards during the grape harvest.*

406. *Wine harvest in Georgia, Soviet Union, 1967.*

406

407. *Fashion shoot and onlookers in Red Square, Moscow, Soviet Union, 1967. Assignment for Cinquante Ans de realisations Sovietiques. Doisneau photographed this scene in both black-and-white and color. The color version was used in the magazine.*

407

It was completely messed up. It needed a lot of time. You go to Puy, for instance, in the Loire, but you can't make interesting pictures by only staying two days. You've got to get to know it a bit. But this was completely out of the question, I couldn't stay any longer than that.

The project, intended to be one of a series of books on photographic journeys, offered Robert much of what he always sought in a book project. It was on a theme close to his heart: the meanderings of a river from its trickling source to its long sweep into the Atlantic Ocean. Perhaps the most intriguing aspect of *La Loire* is not Robert's photographs but the texts that he wrote to accompany them. The series was envisaged by Denoël as offering photographers "the means to realize the dream trip that they have never had the time or the resources to undertake during their professional life" and looked forward to "the creation of works that have nothing to do with tourist guides, the trip being only an alibi and the place chosen a pretext for images and thoughts."[11] Robert was asked to write a journal of his voyage along the Loire. His text is idiosyncratic and poetic, full of insight and humor, for he had found his own style of magical realism:

> During an already rather lengthy career how many images have I made, which are now aging with pleasure thanks to a dose of innocence and happy chance—one hundred perhaps, let's say with benevolent indulgence a hundred and fifty, which, with an average exposure time of 1/100th of a second, constitutes only a second-and-a-half of success.
>
> Has all the time apart from that been devoted to mistakes? No, because one must deduct the hours given over to sleep. Where the nocturnal life is concerned, I do know that on certain nights, when all agitation has ceased, when there is no longer any witness, the river congeals under the moon. For the lappings, little waves and eddies, it's the "keep still." In certain places the river has put away its fish like money in a till.
>
> I've said that there must not be any witnesses, the river is on the lookout with all its eyes—the phenomenon is rare on a river like the Loire, which has such a long route to cover. This is logical reasoning, like all that has gone before. Because there is always somewhere, on a bank, on a bridge, some night owl or some drunk wandering stupidly, while they would be much better off in their beds.
>
> It's very sunny today.
> And I've left my cap in the car....

408

408. *Loire project, 1976.* "*She didn't like photography very much, this lady with her dogs coming down the* petite rue Saint-Michel *below the château of Saumur. In her icy stare was the confirmed opinion, 'the better I know men, the more I like animals.'*"

409. *Page 323:* Pepère et Memère (Grandpa and Grandma), *M. and Mme. Château-Body at Parnay, Indre-et-Loire, 1977.*

410. *Page 323:* Les Pompiers de Langeais (The Firemen of Langeais), *Indre-et-Loire, 1977.*

411. *Page 323:* Les Chevaliers de Chambord (The Knights of Chambord), *Loire Project, 1977.*

409

410

411

RETURN TO THE BANLIEUE

1978–1994

"After the war all the people who came to Paris had to be housed. They didn't build new houses, but abominable filing cabinets for workers. They were piled up in them as if they were dead matter, without any thought being given to whether they could put up with the presence and the noise of those who were next to them. That's what I came back to find, and in addition I saw that the gray banlieue that I knew had become multicolored as if to excuse the fact that it had been built on so large a scale."

"I like people for their weaknesses and faults. I get on well with ordinary people. We talk. We start with the weather, and little by little we get to the important things. When I photograph them it is not as if I were examining them with a magnifying glass, like a cold and scientific observer. It's very brotherly. And it's better, isn't it, to shed some light on those people who are never in the limelight?"

ROM THE LATE 1970S ONWARD, the riches that lay gently maturing in Doisneau's archive began to be decanted and consumed as a wave of nostalgia for the 1940s and 1950s swept over France. He became celebrated in his own country as the author of a body of work increasingly regarded by the public as a sort of collective family album of the postwar era. For many French people, Paris symbolizes France, and the Paris seen in their mind's eye was that of Robert Doisneau's photographs. He was rediscovered by a larger and more visually sophisticated audience than was available for his work in the 1960s or 1970s.

The establishment of new cultural institutions devoted to the development of photography accelerated after the victory of the Left in the elections of 1981. The appointment of the Communist deputy Jack Lang as Minister of Culture proved to be of great importance for the arts generally and for photography in particular. Lang's perspective may be summed up by his policy statement: "photography everywhere, photography by everybody, photography for everybody."[1] The previous Gaullist administration had already begun to take more notice of the increasing cultural centrality of photography. But this was only in response to the initiatives of committed individuals. As early as 1969, the *Rencontres d'Arles*—inaugurated by photographer Lucien Clergue, writer Michel Tournier, and museum curator Jean Rouquette—was established as an annual photography event, rapidly gaining international status. In 1974 the photographer Jean Dieuzaide founded the Château d'Eau gallery in Toulouse, the first in France devoted specifically to photography. Others followed. Museums began to devote more attention to the medium, and a Fondation Nationale de la Photographie was created with state funding in 1976, symbolizing the rediscovery of photography by the political class. The ferment within the photographic profession led to the founding of new agencies such as Viva, Gamma, and Sipa, which—complementing established organizations such as Sygma, Magnum, and RAPHO—helped make Paris the center of the world for photojournalism. On an intellectual level photography also entered the discourse of the academy, with the publication of important texts by Roland Barthes and Pierre Bourdieu—*Camera lucida,* and *Un Art moyen* (co-authored by Luc Boltanski), respectively.

In 1975 Claude Nori, a photographer and activist for the medium, established the organization Contrejour, to serve as a publishing and exhibition facility and as a showcase for the new photography of the post-1968 era. It is significant that Doisneau—whose work might have been regarded by younger photographers as outmoded—was rediscovered with enthusiasm by his younger confreres. Contrejour published the first retrospective volume of his work, *Trois Secondes d'éternité,* in 1979. This was followed in 1983 by a *Photopoche* volume produced under the auspices of the Centre National de la Photographie (CNP), which had been formed in 1982 under the direction of Robert Delpire. Jack Lang was concerned that a national "maison de la photographie" should be inaugurated, and in 1984 the Palais de Tokyo in Paris became a permanent site for continuous photographic exhibitions.

One effect of these initiatives was to enlarge the market for photography and to make Robert's work far better known. By 1992 the *Photopoche* series of books published by the CNP had sold more than one million copies of all its titles, with the Doisneau volume leading the sales list. Myriad exhibitions,

412. *Page 325:* Zouc au Bataclan (The Singer Zouc at the Bataclan Theater), *Paris, 1987.*

books, and articles followed, and in the last years of his life Doisneau became a media figure, as his great ability as a raconteur came into its own in the realms of television and radio. A number of programs based on his life and work were made for French TV between 1972 and 1993. These include *Bonjour Monsieur Doisneau* (1992), a fifty-minute film directed by the movie actress Sabine Azéma, a close friend of Doisneau; and *Doisneau des villes, Doisneau des champs (Doisneau of the City, Doisneau of the Country)*, a pair of twenty-four-minute films made in 1993 by Patrick Cazals for FR3.[2] In these and in the earlier films, the format of the television documentary is ideal for presenting Robert's personality in the context of his images and the settings in which they were produced.

Part of Doisneau's appeal to the French public derived from his fascinating ability to present his experiences in a literary form that was quite unusual—an ironic, poetic, metaphorical style that he had developed over many years, first appearing in his letters and in certain of his captions. In a number of conversations with the author about literary influences, Robert made it quite clear that given the opportunity, he would have been delighted to earn his living by writing. Toward the end of his life this began to happen. His texts for *La Loire* (1978) and for the introduction to *Trois Secondes d'éternité* (1979) served notice of his literary skills, and in the early 1980s he began to write a series of autobiographical essays, which began in the form of letters sent to the editor and photographic print dealer Jean-Luc Mercié, who had encouraged him to prepare the text. The letters—many of which were written during visits to his beloved Lot between 1983 and 1988—covered all of the phases of Robert's life and work. They include pen portraits of many of his most famous subjects, from Picasso to Monsieur Wagner of the flea-circus, and provide fascinating insights into his personal philosophy. When the book was published in early 1989, Doisneau took as his title *A l'Imparfait de l'objective*, the aphorism Jacques Prévert had earlier used to describe Robert's approach to photography.

In the 1980s Doisneau was also involved in a series of projects that finally allowed him the type of sustained study of an area or theme that his previous lack of resources had prohibited. In 1979–80 he photographed most of the remaining nineteenth-century *galeries* (shopping arcades) in Paris, and with Maurice Baquet completed the work for *Ballade pour violoncelle et chambre noir (Ballad for Cello and Camera Obscura)*. In 1984–85 he undertook a major study of the "new" banlieue for the DATAR (see below), while in 1985–87 he photographed intensively in St.-Dénis. From 1989–93 he returned to Gentilly, where he had made his first images, to carry out a documentary project for the municipality. Throughout this period of intense activity he also found time for occasional assignments for his friends on *La Vie ouvrière;* an impressive number of portraits of celebrities, writers, artists, musicians, and intellectuals for magazines (especially *Femme* and *Actuel*); to photograph a number of films on location; the occasional advertising assignment; a book of autobiographical essays in 1987–88; and even a short film in the autumn of 1992.

This remarkable burst of creativity was interrupted in 1990 by a serious illness. Robert contracted Legionnaires' disease, probably from the ventilation system of his darkroom in Montrouge. Up until that point he had carried out the vast majority of his own processing, frequently staying up until 2 A.M. to complete print orders. The illness, from which he nearly died, led him to give

413

413. *Passage du Grand-Cerf, from project on* galeries *and* passages *of Paris, 1976. In the urban and social development of modern Paris, the* galeries *played an important role, but by the time Doisneau photographed them they represented a moribund feature of the city, a vestige of the spectacle of modernism that they once exemplified. Nonetheless he was attracted to both the architectural details of the* galeries *and the curious mix of people found there: "In this aquarium light, all of these people were preserved as if under glass. . . ."*

414. *Page 329:* Plisses (Pleats), *Galerie Véro-Dodat, Paris, First Arrondissement, 1980. In* Passages et galeries du 19ème siècle *Doisneau's collaborator Bernard Delvaille writes: "The* galerie *Véro-Dodat, silent and aristocratic, has kept its distance from the mysteries of the offices and the big department stores. Between the Louvre and the Banque de France, it has retained a narrow seriousness, which illuminates the patios and umbrellas of the cafés on the rue Jean-Jacques Rousseau." In photographing the* galeries*, Doisneau played the role of* flâneur: *"The magical side of things is invisible for people who are in a hurry, who are more interested in mechanical things."*

414

up this aspect of his photography but hardly arrested the pace of his work, which only began to falter in the summer of 1993 when the first signs of an eventually fatal heart disease began to make themselves felt.

◆

The project on the *galeries* of 1980 was a continuation of earlier work, evolving into a photographic essay exploring and illustrating the present condition of some key sites of modernism: the Parisian *galeries* built primarily between 1800 and 1850, which symbolized a new approach to life in the modern city. With their glazed and airy thoroughfares, their walkways artificially lit by gaslight, the piles of beautiful goods on display in the windows of their luxury boutiques, the *galeries* seemed epitomes of a new urban rationality. Yet there was an interesting dualism to these arcades, and when the poet Charles Baudelaire coined the term *modernité* in the 1850s he defined it quite precisely as a quality to be found in particular spaces characterized by "the transitory, the fleeting, the contingent"—of which he felt the *galerie* was a prime example. They were the places where Baudelaire's *flâneurs* congregated, those "strolling observers of the landscapes of the great cities," whose natural milieu was the anonymous ebb and flow of the urban crowd. Suggesting that modernity has both a rational and a mystical side, Baudelaire provided some key ideas for later commentators on modernism, especially the German social critic Walter Benjamin (1892–1940), who developed these ideas in his celebrated essay on nineteenth-century Paris, the *Passagenwerk*.[3] Benjamin wanted to show how the modern city is as much a spectacle, a phantasmagoria, as the outcome of rational planning. He singled out the arcades as the original temples of commodity capitalism, their shop windows laden with food and drink, fine clothes, or jewelry, their galleried upper floors offering the purchase of sexual pleasures. The Parisian *galeries* enjoyed a period of great success until the appearance of the first *grands magasins* (department stores) in the second half of the nineteenth century. Gradually luxury shops gave way either to the workshops of artisans such as engravers and musical-instrument makers, or to highly specialized shops and dealers in secondhand goods or antiques. In a 1992 interview Robert talked about what had attracted him to the *galeries*:

> These were rather desolate shops. . . . They had bizarre trades in them. Antique shops, that's reasonably normal, but there were engravers, for example, who made paper with coats of arms on it. It was magical. But you had to be patient, you couldn't move too quickly. There was a model agency there even then. That was a modern business, contemporary even. It's odd, in this very old place [*passage Choiseul*] one saw these very elegant, highly made-up young women, the models, who were like walking magazine pages. And then at the side of that there was a little shop selling rubber beauty products, in other words there were chin-straps, things for wrinkles, cheeks, contraptions for the forehead.
>
> In the Galerie Vivienne, which is the most beautiful, there is the best wine merchant that can be found. If you are allowed into his cellar it's marvelous. In particular, there's a grocer who still sells traditional things, like packed cakes, madeleines from Commercy, petit-beurre biscuits

415. *The director Bertrand Tavernier during filming of* Un Dimanche à la campagne (Sunday in the Country), *1983. It was during this project that Doisneau met Sabine Azéma. Their friendship flourished because of a happy accident: Tavernier provided a car to take Robert to and from the film set, and he often shared it with Sabine Azéma. The couple of hours spent every day on the journey provided ample opportunity for them to get to know each other. Robert produced a fascinating set of images that are in effect a reportage on the making of* Un Dimanche à la campagne, *pictures which demonstrate his great affinity with the medium.*

415

416

416. *Scene on the set of* Sunday in the Country, *1983.*

417. Sous le regard de Sabine Azéma (Under the Eye of Sabine Azéma), *from the project on* Sunday in the Country, *1983.*

417

from Nantes. Nowadays there's an American tearoom in the same *galerie,* that's new. Once upon a time here, there was a laundry, a woman who ironed lace; inside there was a stove with irons all around it. That can't still be going, perhaps they've got electric irons now. I hope so for their sake![4]

Within this account, it is possible to detect a theme common to so much of Doisneau's photography: the desire to record a place and its people in terms of a set of sentiments and feelings.

> People hurriedly buy something to eat. The young salesgirls eat a cake as they're passing. There are toys, electric train sets. . . .
>
> There's a light different from that of the city, and a completely different sound. One hears the sound of steps on the mosaic. Toc, toc, toc. There are people who are rather different as well, different from those who live in the bright light. For example, my friend Cappia [antique dealer, Galerie Vivienne] always says, "I can't stand nature, leaves make me sick." He's a funny guy, completely mad. It's his precious dust that interests him a lot. He'll often be dressed in a big gray coat, touching the ground. He's a really crazy guy, but quite charming. He is the typical man of the *passages.* It's his style of life, the old collector who is afraid of the brutal light of the exterior. One is protected. It's maternal. One is in the big nursery. You are protected from the hum of the city; there's no risk of being stabbed. . . . But look, I don't go often now. I don't know what will become of them. I don't know where they are going. But they'll certainly be taken over by more violent business.[5]

After literature, film is the medium par excellence where the potential for fusing the rational and the magical is most clearly realized. There can be little doubt that the great "poetic realist" films of the late 1930s and mid-1940s—those of Marcel Carné and Alexander Trauner in particular—had a profound effect on Doisneau's approach, and echoes of them are clearly evident in *La Banlieue de Paris,* for instance. His first experience of work on a film set was his photography for René Clair's *La Silence est d'or (Silence is Golden)* in 1945. From time to time he would make photographs of actors and directors—his 1954 portrait of Jean Renoir gracefully "twirling" is a classic of the genre. His later experiences as a casual *photographe de plateaux* (cinema photographer) for Truffaut (on *Tirez pas sur le pianiste* [*Please Don't Shoot the Piano Player*]), for Chabrol (on *Les Bonnes Femmes*), and for other directors, including Nicole Védrès *(Paris 1900),* were for him suggestive of pictorial motifs. His fascination with the portrait style, involving a foregrounded figure and a contextualizing backdrop, is his own photographic adaptation of a widely used cinematic technique.

The opportunity to carry out a reportage assignment on the filming of Bertrand Tavernier's *Un Dimanche à la campagne (A Sunday in the Country)* in 1983 was a particularly important event, for it introduced Robert to the actress Sabine Azéma, who became both a sort of muse and the subject of a large number of important photographs. From 1983 to 1993, Robert photographed Azéma regularly both for his personal archives and for magazines and other publications. When Tavernier made *La Vie et rien d'autre (Life and Nothing Else)* in 1988, with Phillipe Noiret and Azéma in the leading roles,

418

418. *DATAR Project, boulevard Heloise, Argenteuil, 1984. This mural appears to be a copy of one of Doisneau's portraits of Georges Braque made at Varengeville in 1952.*

419. *Page 333: DATAR Project, overpass at Maisons Alfort, Parc de la Fontaine, Paris, 1985.*

"After La Banlieue de Paris, *which I'd really rather have left behind, I worked more on Paris. The years went by, and then all of a sudden I was asked again to show that the environment of this banlieue that I detested had changed—that the banlieue that I had wanted to be transformed had been transformed. And so I worked for the DATAR, which was very important. I had to open my eyes again. It was no longer just memories: cement had replaced the plaster walls and the wooden sheds."*

420

421

420. *DATAR Project, Place des Miroirs, Evry-Ville Nouvelle, 1984.*

421. *DATAR Project, Château d'Eau, Evry Autoroute du sud, 1984. The sense of isolation and despair evident in many of the DATAR photographs accurately translates Doisneau's feelings about the failure of modernist architecture. For years he kept pinned on the wall of his Montrouge studio extracts from the writings of Le Corbusier, whose work he had first encountered in 1931. The ideas of the new urbanism fascinated him precisely because they offered another view of what the banlieue could be, a view that was not fulfilled in reality.*

422. *DATAR Project, Place du 8 Mai 1945, Ivry, 1984.*

422

423

423. *DATAR Project, from the Tour Mercuriales, porte de Bagnolet, 1984.*

424. *DATAR Project, Place de la Trille, Grigny-La Grande Borne, 1984.*

424

425

425. *DATAR Project, Petit Nanterre, Passerelle des Peupliers, 1984.*

426. *DATAR Project, quartier du pavé Neuf,*
Noisy-le-Grand, 1984.

Robert once more worked as *photographe de tournage* (set photographer) (see pls. 415–17). And in 1992–93, during the making of Alain Resnais's film *Smoking/No Smoking*, based on the play by the English writer Alan Ayckbourne, Robert made regular visits to the set to photograph Sabine and her fellow actor Pierre Arditti at work. He created a special file for his archives, titled *CinémAzéma*, containing all of the images he made during their decade-long association.

Robert confided to the author that he would have loved to have been a film director. But he was perhaps too much the individualist, too dependent on chance, as he explained in 1991:

> I think I would have enjoyed being a film director. To create stories with massive resources. But I know I wasn't made for that. You need the qualities of a general during a campaign! I'm a foot soldier, I lack authority. Nowadays there are other ways of making films: video. If I had to start all over again, I would try to get into that technique. You can play with movement, with sound it's very interesting. But be careful: it has nothing to do with photography, you have to learn things in a completely different way.[6]

In the 1980s, Robert experimented with a video camera, making a short film for the Rencontres d'Arles. In 1992 he was given the opportunity to make a short film— *Les Visiteurs du square*—for which he wrote the screenplay, selected the locations, and directed, using a full film crew that included Alain Resnais's regular cameraman Renato Berta. Robert clearly enjoyed working with a young and enthusiastic crew, composed mostly of young people from film school. But while *Les Visiteurs du square* is effective at telling its story, the form Robert adopted might have seemed restrictive; it was that of the silent movie, in the sense that there is no dialogue, although there are sound effects and music. For Robert, it was a project difficult to bring to a satisfactory conclusion. The question of how to translate his conception of the image to the crew was one he never resolved to his own satisfaction, because its technical complexity always seemed to get in the way of the simplicity of his visual creativity. The fundamental problem was time. Robert's métier was always the fugitive glance, the image snatched after hours of waiting on a street corner; filmmaking does not allow the luxury of such an undisciplined use of time.[7]

◆

The newfound respectability of photography in France, and a generous level of public funding from the Socialist government of the era, led to the setting up in 1983–84 of a large-scale group project on the French landscape for a state body concerned with urban and rural planning, widely known under the abbreviation DATAR.[8] This enterprise was inspired by an important prewar documentary project in America, usually referred to simply as the FSA (Farm Security Administration).[9] The achievements of this grand attempt to use photography to record processes of social and economic change—particularly the work of Walker Evans and Dorothea Lange—have long stood as examples to committed photographers of the successful melding of documentary photography with a modernist aesthetic, and radical sociopolitical theories.[10]

The inspiration of the FSA—as well as earlier examples of grand photographic enterprises such as the French Mission Héliographique of the 1860s—

427

427. *Gentilly, 1990.*

428

428. Le Reflex logement (The Housing Response), *pont de Bondy, 1984. Black-and-white photograph for DATAR project.*

suggested to the photographer François Hers and the planner Bernard Latarjet the idea of a similar project that would take the pulse of France in the 1980s. The majority of those commissioned for the DATAR project were young, creative photographers, and to be a member of this team was a turning point and a rejuvenating experience for Robert.

The DATAR enterprise as a whole is fascinating for two reasons: firstly because it attests to the high status that photography had achieved in the cultural policy of the French Socialist government; and secondly, because the aesthetic scale of the project was so ambitious—some thirty-six photographic commissions were given, of which few had a recognizably documentary objective.

By defining their project much more loosely (and in more self-consciously "artistic" terms) than had Stryker back in the 1930s, the DATAR photographers were left to grapple with an imprecise "subject"—for the choice of what to photograph was forced back upon their own imaginations. They were concerned with the landscape of France, but what indeed was meant by the term? Some chose straightforward landscape photography, à la Edward Weston or Ansel Adams; some experimented with new techniques such as use of the wide-field "panoramic camera," while others concentrated on portraiture, office interiors, and even montage and other deformations of the photographic image. Some non-French photographers were brought in (Gabriel Basilico, Lewis Baltz, Franz Gohlke) to provide an outside perspective. Yet the results, as lavishly published in 1989,[11] seem to add up to a curious mix of images that demonstrate the lack of an underlying objective or philosophy in the whole project. Because a "documentary" objective was considered to be an aesthetic limitation, the opportunity to provide a sort of snapshot of France in the mid-1980s was lost.

Robert found himself enmeshed within the cultural ferment of this fascinating if flawed enterprise. He agreed to carry out a project that allowed him to continue his photographic analysis of Paris and its banlieue, while at the same time settling some accounts with certain architectural theories that he had taken to heart. It was a project that would not take him away from home for long periods, so he could also ensure that Pierrette was properly looked after. This was why he chose to return to the banlieue and the new towns on the outskirts of Paris, to explore what had happened to the area for which he had such great expectations when he met Le Corbusier in 1944, whose writings he had pinned up on the wall in his atelier at Montrouge. The postwar experience seemed to dash such high hopes, as reflected in an interview with Doisneau in 1992:

> After the war all the people who came to Paris had to be housed. They didn't build houses, but abominable filing cabinets for workers. They were piled up in them as if they were dead matter, without any thought being given to whether they could put up with the presence and the noise of those who were next to them. That's what I came back to find, and in addition I saw that the gray banlieue that I knew had become multicolored as if to excuse the fact that it had been built on so large a scale. They daubed the buildings with the worst colors they could find—pinks, mauves, bright greens, whole neighborhoods, and using ultra-powerful construction methods; in a few months they could put up a mountain of buildings. So I had to do it quickly, in color, and in addition it was necessary to eliminate the inhabitants completely, showing that they served uniquely as dormitories—

429

430

429. Le Petit Marcel, *Fête du Lendit, St.-Denis, 1986.*

430. Un Muscadin heureux (The Little Napoleon), *Gentilly, 1989.*

431

431. *Gentilly, 1990.*

432. *Gentilly, 1991. The ex-HBM buildings of Gentilly, now known as the cité Gabriel-Péri, were still standing sixty years after Doisneau first photographed them. Part of project on Gentilly commissioned by the municipality.*

432

that the people went to work in the city or the factories of the outer banlieue—they did not live around these filing cabinets where they had been put. Thus I mocked this décor. Before, the miserable banlieue trapped the light in interesting ways, with its wooden fences, or its deformed corrugated iron roofs. Now it's covered with these huge things, perfectly rectilinear, there's nothing to catch the light, they are just smooth concrete surfaces. So it was essential to show the differences, to work with a bigger camera, on a tripod. It's the work of a jester who mocks authority. Architects have incredible arrogance, they create some idiotic things, buildings of terrible ugliness, with a complete disregard for the human being. Not all of them are like that, but in this case that is what I wanted to show. It was also about building things in repetitive series—each one alongside another with no other concern other than getting the maximum number of people into the minimum space.

Some of the work on this project took Robert back to the areas traversed in the 1930s and 1940s for *La Banlieue de Paris,* but he also went much further afield to trace the postwar expansion of the *région parisienne,* in particular exploring areas of the east and west of Paris that he knew little about. It was a real voyage of discovery into a new world that had grown up since the 1940s, but with accelerating speed in the 1960s and 1970s. This time, however, he was making many of the pictures in color and focusing on the built environment. As he emphasized in 1992, "I was really interested in doing it. Moreover, it was the only state commission I've had in my life!"

Some of the coldness of these pictures comes directly from Robert's determination to put over his point of view on the forms of urban development that he was recording. Jean-Paul de Gaudemar, director of the DATAR, discussed the ideas in play within each photographer's project, suggesting that Doisneau's concern was the opposition of two models of the banlieue: the *banlieue pavillonaire,* and the urbanism of the *barres*—the housing projects described above as "filing cabinets"—an opposition exemplified by his photograph *Cité champagna Argenteuil* (Val-d'Oise), 1984:

> Against the background of an immense *barre* whose limits extend beyond the image, a little house stands out proudly. . . . large porch, metal fence, bell, little garden, the street number plaque, etc. Evidently two ages of the city confront each other. But Doisneau delivers more than the juxtaposition of two urban contexts. He describes a social relationship. . . . This villa deliberately turns its back on the great construction, as others turn their back on a cliff, a railway line, a factory. . . . The traditional banlieue built *pavillons.* The banlieue of the sixties, helped by social policy, built its own antithesis: these *barres* where the individual is dissolved in the collective, where the recurrence of simply modules is a counterpart to the repetition of modes of life, modes of work, difficulties in gaining access to a culture.[12]

In the presentation of his work for the DATAR, Robert interspersed a small selection of images made in the 1940s, including *Vingt Ans de Josette* (*Josette's Twentieth Birthday;* 1949), an image of a group of youngsters dancing the farandole in the foreground, with the *HBM* buildings at Gentilly in the

433

433. Madame Nenette et Monsieur Antoine, *Chez Antoine, Gentilly, 1990. Made for Gentilly project.*

434. Les Deux Garagistes (The Two Mechanics), *Gentilly, 1990. Made for Gentilly project.*

434

435

435. Le Jardinier (The Gardener), *Gentilly, 1991.*
This house faces the apartment building where
Doisneau lived from 1922 to 1934.

background. By contrast most of the DATAR pictures show an urban landscape of seclusion and isolation: when people occasionally appear in these images they are dwarfed by the architecture. Where in "his" banlieue of the 1930s and 1940s the intensity of social and communal life in public spaces overcame the oppressive character of the urban habitat, in the *nouvelle banlieue* and *villes nouvelles* Doisneau finds that sociability itself has been eradicated from the streets. The deep sensation of sadness emanating from these pictures is the feeling Doisneau had while making them:

> An impression of great loneliness, even if there were certain times when it was a bit more lively. People go to work in the morning and come back in the evening. There are also the Saturdays, the Sundays, you see families going off to the supermarkets. There are no longer any small shops or traders, only the huge shopping centers.

The selection, and more precisely the *use* of the six-by-seven-centimeter-format camera, planted on a tripod, requiring a careful framing and viewing of the scene before exposure, thus translates the political and social perspective Doisneau was adopting in his DATAR photographs:

> It needed to be done with great precision. . . . It was a manner of photography that was very precise; this meant the content would be fairly cold. I think that if I had done it on twenty-four-by-thirty-six-millimeter [35 mm] —why not?—it would not have had the coldness of the six-by-seven-centimeter. If I had been able to do it on eight-by-ten-inch it would have been colder still and even better. But those cameras are really heavy to carry around.

The pictures are intentionally presented in highly geometric compositions, in which the spontaneity that had always seemed to characterize Doisneau's pictures of the street and of living spaces is rigorously excluded. He chose to work mainly in color, for he wanted to capture the intense colors so rampant in the new architecture. He made a smaller number of monochrome images of the same settings and also worked in twenty-four-by-thirty-six-millimeter when focusing on the more fleeting aspects of the place where he was working—for example, the children. Yet it is the color pictures of the DATAR project which are by far the most impressive. Those used to Doisneau's softer and more humorous work frequently shy away from such images, for their clarity and great compositional power seems infused with an overwhelming sense of pessimism. Yet the opportunity to collaborate on a team project with a number of younger photographers proved a turning point for Robert.

The experience of the DATAR project sparked off a "return to the banlieue" in Doisneau's work that continued until his death. The photographs of this period progressively reveal a more humanized environment, as if to revise the judgment of the DATAR pictures. In the two long-term projects that he carried out between 1984 and 1993, one on St.-Denis, the other on Gentilly, we find Doisneau portraying again the children, couples, workers, street entertainers, and popular festivals that had animated his earlier vision of the banlieue. (It is also quite fascinating to find him using

436

436. *Robin Cook, writer, Paris, Twentieth Arrondissement, 1988. When Doisneau was commissioned to make a portrait, his approach was first to find a setting where he could place his subject; he then tried to elicit a look or attitude on their part that would best reveal the link between place and person.*

437. *Alberto Moravia, Paris, 1989.*

437

438

438. *Renaud Sechan, singer and film actor, Paris, Thirteenth Arrondissement, 1988.*

some of the *villes nouvelles* backgrounds as sites for his "celebrity portraits." In the case of St.-Denis, a book commission for a series published by Calmann-Lévy—*Portrait de la France*—allowed him to use work carried out during the DATAR project, together with some earlier images and pictures made during a number of exploratory trips around the area. In these images and in his last pictures of Gentilly, it is as if the story of the *classe populaire* had been resumed, as if our "author" had found again in the modern world the vitality that had enchanted him when he first explored the *zone* in childhood.

While Robert was carrying out his project on St.-Denis, the whole of France was becoming increasingly concerned with the problem of the *banlieues chaudes* (suburban unrest). Housing estates and whole suburbs periodically erupted into outright insurrection, with pitched battles between police and mobs of young people. Since the banlieues posing the biggest problems tended to be dominated by a Maghrebin or African population, the problem was connected with wider currents of racism in French society and with the rise of Le Pen's neo-fascist Front Nationale. Robert fully understood the political context of his work:

> The great strikes, the great social movements, in reality they began in the banlieue. Because that was where the factories were, and the workers too. The terrain of the banlieue is still—because everything is temporary there—the terrain of experiments. Where do you go to see the most challenging theater? To Nanterre, to St.-Denis, or to Aubervilliers! These towns are also those that help painters and writers by providing them with spaces, where quite simply it's not too cold to live and work in the winter! I also know that new things occur in the banlieue. I understand so well that these young people are ready to revolt! They are given enough reason to do so.[13]

Robert's fascination with what had become of the banlieue of his childhood brought him back full circle at the end of his life, when the mayor of Gentilly asked him to prepare a set of photographs of the area to compare with those he had made in the 1930s and 1940s. Gentilly also wished to set up a "Maison Doisneau"—a gallery and meeting place, in a nineteenth-century house that had once been a hotel, situated a few hundred yards from the street where Doisneau had lived in the 1920s—which would eventually house part of his archive and provide an exhibition space. The project saw him return to many of the places that had figured in earlier pictures, including the HBMs on the hill above the town. He spent weeks trailing through the streets, photographing how the suburb had changed.

◆

The conviction that "his" photography required a close identification with his subjects did not stop Robert from taking on commissions to photograph people who were in the public eye—but then he had always carried out this sort of portraiture. He reveled in the heterogony of the types of individuals that chance brought in front of his lens. They included the members of bands such

439

439. *Jack Lang, French minister of culture, 1981–89, in his office, Paris, First Arrondissement, 1984.*

440. *Julien Gracq, Paris, 1986.*

440

441

441. *Mickey Rourke, American actor/boxer, Paris, 1992.*

442

443

442. *Les Nonnes Troppos, Paris, Fourth Arron-dissement, 1988.*

443. *Sandrine Bonnaire, actress, Paris, Fourteenth Arrondissement, 1990.*

444

445

446

444. *Juliette Binoche, actress, Paris, Fifth Arron-dissement, 1991.*

445. *Jean-Paul Gaultier, fashion designer, Paris, 1985.*

446. *Christian Lacroix, fashion designer, with mannequin, Paris, 1987.*

447

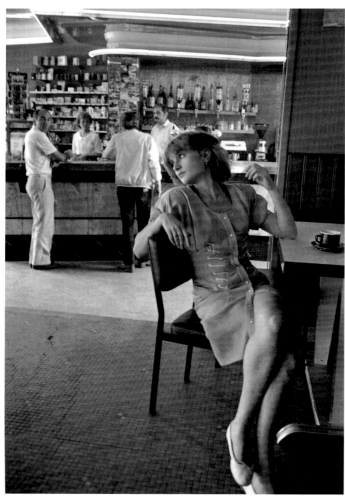

448

447. *Jean Paul Favraud, collector of carousels and fairground attractions in his museum-store, Gentilly, 1991.*

448. *Isabelle Huppert, actress, Paris, 1987.*

449. *Page 351: Régine Chopinot, La Villette, Paris, Twentieth Arrondissement, 1990.*

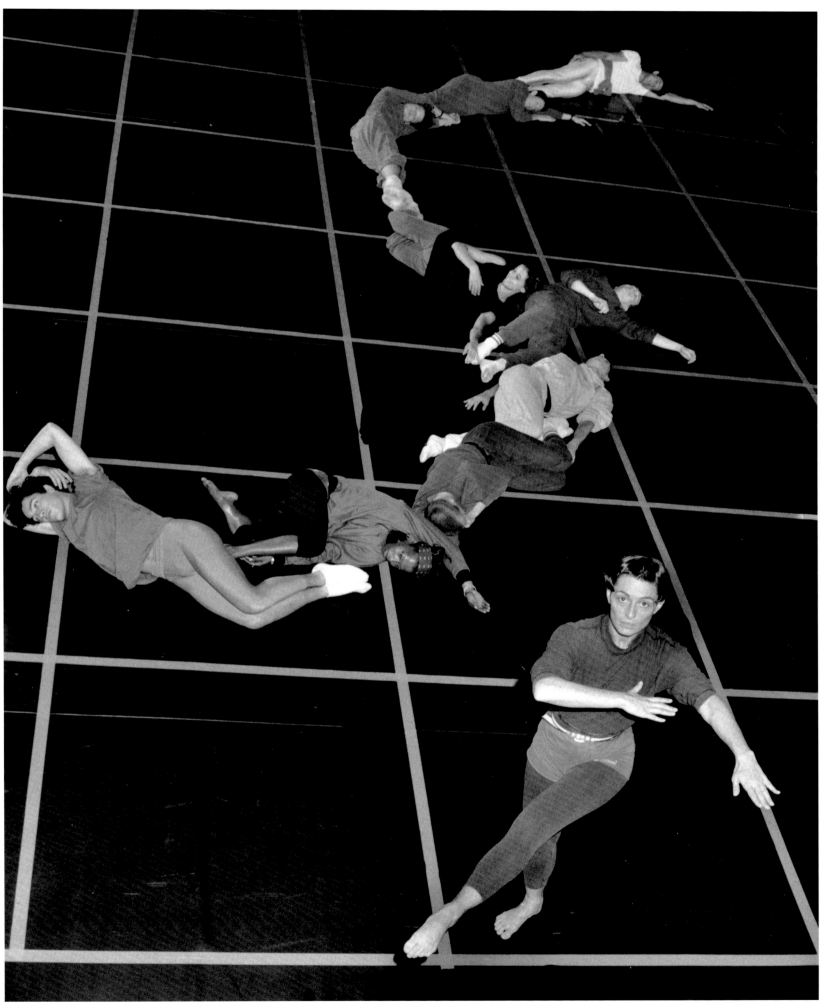

as Les Rita Mitsouko, Les Nonnes Troppos (pl. 442), and Les Négresses vertes, the singers Renaud, Jacques Higelin, and David MacNeil, the comedian Coluche, the intellectual Bernard Henri-Levy, beautiful young actresses such as Juliette Binoche (pl. 444), reformed gangsters such as Charlie Bauer,[14] media stars like Antoine des Caunes, and even foreign film stars such as Mickey Rourke (pl. 441). Such commissions increased during the last few years of his life, as his work was diffused ever more widely. His association with the publisher Lionel Hoëbeke from 1989 onward brought him collaborations with two writers who shared his humor and outlook on life—François Cavanna and Daniel Pennac. Of his affinities with such writers he once said:

> I like people who have given themselves the troubles to live first and write later. Examples: Cendrars, Prévert for his poetry, and Cavanna as well, who is a bad lad and who learned everything in the street. I far prefer this sort of writer, because they awake in me dormant harmonies that I collected during my childhood.[15]

The two books he produced with the novelist Daniel Pennac—*Les Grandes Vacances* (*Summer Vacation;* 1991) and *La Vie de famille* (*Family Life;* 1993) represented a form of personal expression Robert had rarely known: many of the photographs used in these two books were images of his family holidays and domestic life. Though Doisneau had never shrunk from using his family and friends as subjects of photographs destined for publication, the selection of images for these two books seems to reveal how thin the line always was between the personal and the public in Doisneau's life.

> I like people for their weaknesses and faults. I get on well with ordinary people. We talk. We start with the weather, and little by little we get to the important things. When I photograph them it is not as if I were examining them with a magnifying glass, like a cold and scientific observer. It's very brotherly. And it's better, isn't it, to shed some light on those people who are never in the limelight?

Much of the quality of his work derives from the fact that he photographed his own experiences, his own "private" life. Though it may have differed from that of the people with whom he felt the deepest affinity—the *petit peuple des banlieues et faubourgs*—this life was nevertheless fairly similar to that of the mass of French people of his generation. He photographed those aspects of his life which most people considered quite ordinary and everyday, but in fact he managed to make pictures of something that has rarely if ever been the subject of photography by those who are regarded as "great" photographers. Robert was fond of deflecting his fascination with the recording function of the medium by describing himself as an "unreliable witness"—for the image he wanted to portray was a positive one, in a certain sense a sort of propaganda on behalf of the "worthless people."

> I strongly believe that truth is not standardized, but that its profile can be infinitely modified if one dares to abandon the more comfortable observation posts.[16]

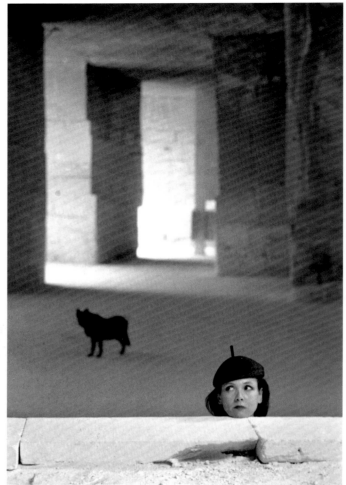

450

450. *Sabine Azéma, Baux-de-Provence, 1991.*

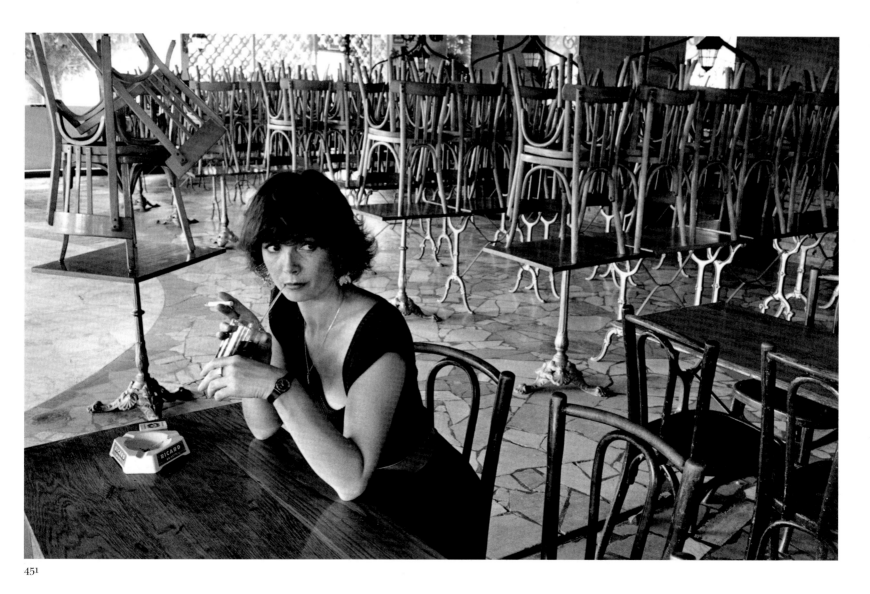

451

451. *Sabine Azéma, chez Gegène, Joinville-le-Pont,*
1985.

452

In a conversation with the author on October 1991, Robert revealed some of what he felt about the motivations behind his work, the constant struggle to *inscrire* fugitive moments in his relations with others, to capture those instants of time in which he had seen a fascinating face, a curious object, an amusing juxtaposition of people, things, and backgrounds:

> I've never examined why I make photos. In truth it's a hopeless struggle against the idea that one will die. It's something I'm more prepared for, because one shouldn't think that every action is temporary and momentary. I try obstinately to stop this time that is passing.

Robert's last year was marked by his mounting worries over a lawsuit that had received public attention throughout the world. He was sued by a couple who thought they were the *amoureux* in his now famous picture *Le Baiser de l'Hotel de Ville (The Kiss at l'Hotel de Ville)*. For Robert this image was only one of several successful mise-en-scènes made for the *LIFE* assignment of early 1950. Yet since the mid-1980s, when Editions du Désastre published *Le Baiser* as a poster, its ubiquity as a symbol of Paris, young love, innocence, and nostalgia for a lost era had transformed this photograph into a commodity that could be exploited in almost any medium. At the height of its success it adorned the rooms of students throughout the Western world, figured in advertising campaigns, and was sold in countless bootleg editions in the tunnels of the Paris metro and on street corners in countless towns. The success of the image provoked a phenomenon of identification: strangers contacted Doisneau, convinced that they had been its subjects. As many as fourteen or fifteen presented themselves as *les amoureux* between 1985 and 1992, and Robert found himself unable to disabuse those for whom the illusion of their presence in this now-omnipresent image was overwhelming. Tragically, his kindness backfired. Convinced that they were indeed the subjects of the photograph, one couple decided to use the law to prove their case. To make matters worse, one of the actual models in the original picture also sued, seeking a share of the royalties that the photograph had earned in its short but illustrious period of notoriety. She had in fact received payment at the time of the *LIFE* assignment, as Doisneau was able to confirm, a key piece of evidence in his defense. The case came to court under the gaze of the world's media in April 1993 and was decided in Robert's favor in June 1994. Yet the decision of the tribunal was contested by the couple, and the cloud of court action persisted; the case profoundly troubled Doisneau.

◆

This book was begun in optimistic spirits. Robert was still active as a photographer, energetic in his pursuit of new projects, delighted to meet the ever-increasing and international public that so enjoyed his work. We started the book as collaborators on a joint project, supposed to be the "definitive" monograph. Robert would joke with others about his newfound status: like Louis XIV, his entourage now included a personal biographer! I also had the great pleasure of being at his side when the major retrospective of his work that we had put

452. *Robert Doisneau photographing the abbé Pierre, 1992. Photo Gilles.*

453. *Robert Doisneau and Renaud Sechan, 1988.*

453

454

454. *Robert Doisneau with children at the cité Gabriel-Péri, the ex-HBM buildings in Gentilly, photographed by Peter Hamilton, September 1992.*

together was presented in Oxford, England, in April 1992, traveling to Manchester in March 1993.

Yet the enterprise was completed under the worst possible circumstances. As I was researching and writing it, Doisneau fell ill. He had long suffered from insomnia, and by the late spring of 1993 found himself feeling tired and listless for much of the day. In July, while staying with friends in the Dordogne, Robert collapsed in the street in St.-Céré. The doctors who treated him after he was rushed to the local hospital made the obvious diagnosis—heart failure.

Back in Paris, Pierrette was entering the final phase of her own illness, and on September 3 she died. She was laid to rest in the tiny cemetery at Raizeux, the little village in the Beauce, not far from Chartres, where she and Robert had met as teenagers over sixty years earlier.

In October 1993, little over a month after Pierrette's death, Doisneau underwent a heart bypass operation and suffered postoperative complications, leading to six months of intensive care. Robert Doisneau died at about eleven o'clock on the morning of April 1, 1994, April Fools' Day, in the Broussais hospital, not far from Gentilly.

On April 5, 1994, Robert came back to the Beauce to join Pierrette in the plain churchyard near the forest of Rambouillet. He was carried into the church in Raizeux where he must have attended mass as a boy, a typical village church of the Ile de France, almost Protestant in its asceticism, but filled to overflowing with three hundred and fifty of his friends and family.

As we stood in the churchyard, lining up to pay our final respects to Robert, each of us was alone in his own recollections. I thought of the last line of Doisneau's autobiography: "There is always the same haunting question that comes to spoil my pleasure: how many more times will I see the marvelous chestnut trees of the boulevard Arago flower again?" Someone had thought to gather these flowers and strew them on Doisneau's coffin as it was lowered. How many of us there thought of Robert's words, which had finally come true? "To freeze time, to hold on to youth, this business makes no sense. It's always time that wins in the end."

455. *Robert Doisneau in his studio at place Jules Ferry, Montrouge, September 16, 1993, photographed by Peter Hamilton.*

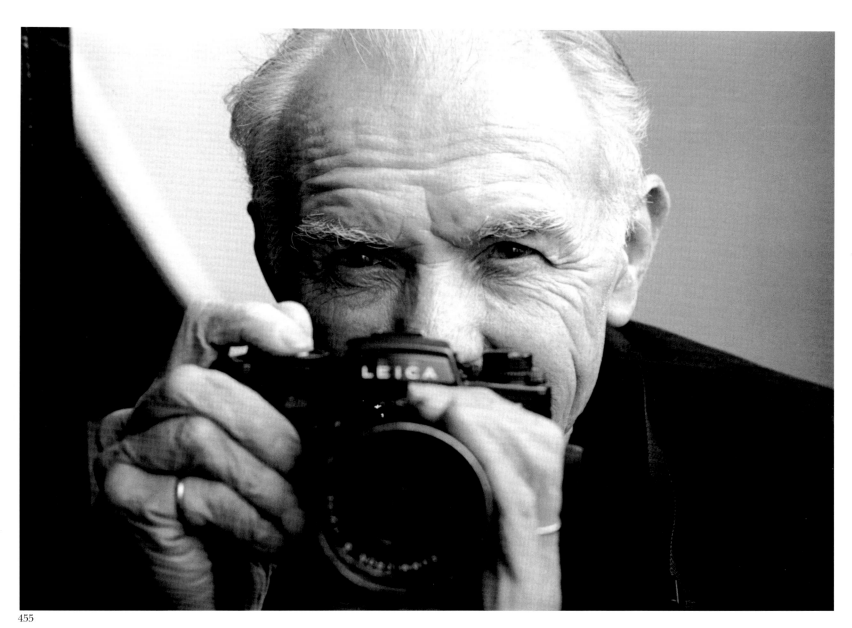

455

APPENDICES

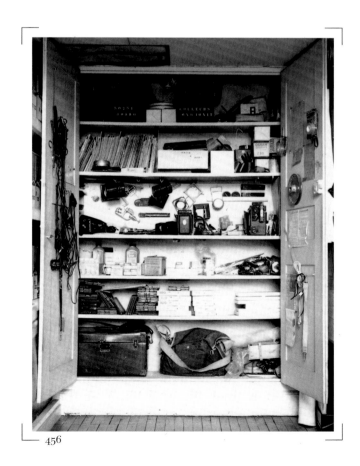

Acknowledgments

A book like this could not have been written without the help of so many people, whose role in its production is difficult to acknowledge in an appropriate manner.

To begin with, I owe a debt of thanks to those who have given invaluable material support to the project. In its early stages the Faculty of Social Sciences of the Open University were generous in providing grants that got the project underway, and have since been understanding about the huge amounts of time required. More recently, the provision of grants and equipment from the Media, Communications, and Identity Research Group has helped in the final stages of the work.

Leica Camera Ltd., and especially Uli Hintner and Phil Bass, kindly loaned some of the best photographic equipment in the world from the Leica M range, which was used both to document the project and for several photographs reproduced here.

Air France, in the person of Bernie McCoy and Annick Breed, helped to arrange the many requisite trips to Paris.

Raymond, Kathleen, and Mark Grosset of the RAPHO agency in Paris provided invaluable support to the project —without their generous help it simply could not have been completed. The kindness of Francesca Dupêchez, Vernice Klier, Sylvie Languin, and many others at RAPHO contributed to its success. At Publimod in Paris, Hervé Hudry worked his customary magic on Robert Doisneau's negatives, ensuring that the reproductions printed here had the best possible starting point.

It goes without saying that many of Robert Doisneau's friends made vital contributions to this book. Without the enthusiastic help of Raymond Grosset, Maurice Baquet, Robert Giraud, Miriam Gilou-Cendrars, Jacques and Nicole Chaboureaux, Jacques and Yvonne Dubois, Pierre and Andrée Delbos, Daniel Pennac, Sabine Azéma, Willy Ronis, Edmonde Charles-Roux, Patrick Cazals, Gilbert Khemais, Mme Figon, Marie de Thèzy, and so many others, there would not have been the material to complete the book.

My son Toby worked on this book at a number of vital phases in its gestation, and his skills and sympathetic help made a substantial contribution to its successful completion. We worked closely with Jean-Marc Pias and Massin, who designed the book so well, though he seemed always to be wondering why it took me so long to finalize my text. Lionel Hoëbeke was crazy enough to commission such a book from a foreigner, though it is only now that he must realize how mad a decision that was. I think it is remarkable that we only once had a falling out over it, and that was due to a misunderstanding. I was delighted that the book brought me into contact with Sylvère Monod, its celebrated translator: his father had been instrumental in launching Doisneau's career, which seemed propitious to the success of the publication. On the other side of the Atlantic I was fortunate to have Barbara Einzig as my editor at Abbeville Press, for she proved a sympathetic translator of my English into acceptable American.

There is no way of knowing whether Robert Doisneau would have been satisfied with this book, but I hope that he would not have been too displeased with how it has turned out. I owe him an enormous and undischargeable debt of gratitude for opening up his archives so generously for my research, but mostly for the priceless hours spent in his company, and for the chance to share in small part his vision of the world.

Robert Doisneau's daughters—Annette and Francine, and their families—lived through a terribly difficult time while this book was in its final stages, for they were Robert's last years. But I owe a tremendous debt to both of them. Without their aid, their help, and their hospitality, my work could not have been completed. They made my task so much easier, working tirelessly to collect, check, and prepare so much of the material necessary to both this book and the exhibition that preceded it.

Peter Hamilton, Oxford, May 1995

456. Robert Doisneau's photographic equipment cupboard in his studio apartment at Montrouge.

Doisneau on Technique

"You're always the prisoner of your equipment."
—ROBERT DOISNEAU

When Robert Doisneau made his first photographs around 1928–29—of scenes in the *terrains vagues* of Gentilly—they were taken with a nine-by-twelve-centimeter "folding" bellows camera belonging to his stepbrother Lucien Larmé. It is possible that his very first images were developed and printed by others, perhaps by a photographic shop or studio offering a photo-finishing service. However, he soon began to make prints himself, contact-printing in daylight on "printing-out" paper from the nine-by-twelve-centimeter glass negatives—a process similar to that employed by Eugène Atget. But where and how did he learn the "science" of photography? He first began to acquire knowledge of it at the Ecole Estienne where J-P. Clerc, a noted author of technical works on the science and practice of photography, was one of his teachers. Robert owned a copy of Clerc's famous textbook on the subject. Since part of his course at the Estienne involved the study of photolithography, he would have acquired the general principles of photographic processing. He was also getting more interested in photography at this time because of his frustration with drawing—hence the desire to borrow his stepbrother's "folding" to take pictures in the street.

Soon after he left the Estienne, in late 1929 or early 1930, Robert started work at the Atelier Ullmann, and was introduced to the use of a large-format studio camera, to film and plate processing, and to enlarging and printing to professional standards, by Lucien Chauffard, who then looked after the atelier's photographic requirements. It was around this time (1930 to 1931) that Robert first used the new Rolleiflex six-by-six-centimeter format twin lens reflex camera—borrowed for a series of pictures of Gentilly for the local *Bulletin Municipal*. This type of camera was launched in 1929; the importer lent several to French photographers to promote their acceptance on the market. Robert must have used one of the first models available (perhaps it was lent to Ullmann, or more likely to Vigneau, whose status as a leading fashion and advertising photographer would have provided an endorsement), because he clearly recalled that it only took six pictures per roll, a characteristic of the original model made during 1929–32, which could only take 117 film.[1] Shortly after he carried out this commission, Robert used the proceeds from it to buy his own Rolleiflex camera, and he made a self-portrait with it that clearly shows the characteristic cruciform sports-finder, indicating that it was the new model launched in 1932, which used 120 film and took twelve exposures per roll. It was with this camera that he produced his first published reportage, on the flea market at St.-Ouen.

The impact of the new cameras for the photography of everyday life was enormous. The Franke und Heidecke *Rolleiflex,* the six-by-nine-centimeter format Zeiss *Ikonta,* and the much smaller twenty-four-by-thirty-six-millimeter format Leitz *Leica* and Zeiss *Contax* were now on the market—small, handy cameras that allowed photographers to make *instantanés* (snapshots) on the street, viewing the scenes they were photographing with either direct optical viewfinders such as used by the Leica and Ikonta, or a full-size six-by-six-centimeter reflex image on a ground-glass screen (upright but laterally reversed), as on the Rolleiflex. Such cameras were equipped with high quality lenses offering good definition and high contrast (Zeiss Tessar f/3.8 or f/4.5 on the Rollei and Ikonta; Leitz Elmar f/3.5—a similar design—on the Leica). Speed of operation, quality of image, the ability to make a series of exposures via rapid film-winders and film rolls—all contributed to the realization of a new vision of the world, the capturing of the fugitive quality of modern urban life. For the first time photographers were liberated from the need for heavy and bulky equipment and a studio. Their cameras could now be held in the hand, their film kept in the pocket, and their studio replaced by the street.

The particular advantage of the Rolleiflex was that it had separate taking and viewing lenses, with focusing and composition carried out on a relatively bright screen: what the photographer saw on the screen was what the negative recorded. The six-by-six-centimeter format also ensured that even with the fastest available films of the time, plenty of detail was registered in the negative. A contact print was easily "readable," and prints could readily be enlarged to give a good-quality result. By comparison the 35mm film used by the smaller and costlier Leica was more tricky to process, and demanded great care and special enlarging equipment to produce a good print for reproduction. It was not until later in the 1930s that 35mm film became widely commercially available in cassettes for rapid loading, and the first Leica photographers therefore had to load their own film cassettes from bulk cinema film. The Rollei had an immediate advantage, because it used commercially available film rolls. In the early 1930s, much of this film was still only orthochromatic (sensitive to blue and green light) and many photographers working with such film placed a yellow filter over the lens for daylight photographs, to render skin tones more normally and to make blue skies appear darker. By the end of the 1930s, panchromatic films (with increased sensitivity to red light) had become more commonplace, but many photographers still used a yellow filter, for it had the effect of rendering the image in higher contrast under certain lighting conditions. With a Rolleiflex, the slight reduction in film speed that this entailed was less of a handicap than with the Leica. Since film was generally quite slow—the equivalent of 32–40 ASA, although by the end of the 1930s films with speeds of about 320 ASA could be found—a larger negative would minimize the effects of having to use a correspondingly slow shutter-speed in average lighting conditions.

Robert's passion for photography began at the dawn of this revolution in camera technology, and developed with the possibilities that it opened up: by 1930 it was possible to photograph nearly every aspect of life, to take the camera into places and settings that had been previously off-limits. The Rolleiflex was Doisneau's preferred camera from 1932 until the mid-1950s: he once explained to the author that the camera fitted well with his style of photography and that he would use it:

. . . often up to the eye, with the direct vision viewfinder. The Rollei is really useful because it's not aggressive at all. When you photographed people in the street, you weren't looking at them so nakedly as with a 35mm camera. The 35mm with a telephoto or long lens looks a little bit like a weapon. I loved the Rollei because there was a certain politeness inherent in the gesture of looking down into the viewfinder.

Throughout the 1930s Robert used his Rolleiflex for all of his personal photographs, and on occasion for pictures made for his employers such as Renault during 1934–39. One of the drawbacks of the first Rolleiflexes he owned—separate film-advance and shutter cocking—helped him make, inadvertently, one of his more memorable photos of the 1930s, a double-image of the Caudron-Renault airplane at the Coupe Deutsch. In the summer of 1937, Franke und Heidecke began selling a new model of the Rolleiflex, the Automat, which combined film-advance and shutter cocking in the same mechanism for the first time. This design became the standard form of the Rolleiflex, and a version recognizably similar to the Automat (the Rolleiflex 2.8GX) was still in production when this book went to press.

Robert continued to use a Rolleiflex six-by-six-centimeter camera for the vast majority of his work until the early 1950s. Indeed, a high proportion of his most famous pictures was made with this type of camera, for it was not until 1952 that he began to use 35mm equipment for the occasional reportage assignment. He made photographs in both formats until the early 1970s, when he began to concentrate more on the 35mm camera for his street and reportage work. He was not just a "street" photographer, however, and the increasing amount of commercial and industrial work he was obliged to carry out from the late 1950s to the mid-1970s led him to acquire and use two other types of equipment—a single lens reflex six-by-six-centimeter format Hasselblad camera, and a four-by-five-inch Linhof Technika "technical" camera.

The shift to 35mm equipment began in 1952, when Robert acquired a rangefinder Leica IIIC, carefully noted in a notebook of the period as "Leica IIIC no. 515326, Summitar f/2 50mm 795, 175." Among freelance reportage photographers, there seems to have been a general move away from the ubiquitous Rollei toward the smaller format at that time. Robert recalled that many of his colleagues—no doubt impressed by the fact that leading figures in the Magnum agency, such as Cartier-Bresson, Capa, and Chim, were working exclusively in 35mm—began to acquire Leicas and Contaxes. In Robert's case, he was particularly impressed by a demonstration given by a fellow photographer, Maurice Tabard.[2] Tabard used a standard Leica advertising approach of the time, which involved the comparison of photographs taken from the same position, with different lenses and thus varying fields of view. As a result Robert bought what was probably a used near-current model, the Leica IIIC. This camera would not have been quite as rapid in normal use as the Rolleiflex—for rangefinder and direct vision viewfinder were separated, and film was wound on with a knob rather than a lever. But the direct vision viewfinder made the camera easier to use in the dim light of Les Halles, in cafés, bistros, and even the occasional *bordel,* than the Rollei. The

fast 50mm f/2 Summitar lens would have been ideal in such conditions—and this is where Robert seems to have found it most valuable, although he disliked the very small viewfinder and the inherent problem in focusing longer lenses. But it was the low-light possibilities of the small camera that really attracted him:

> As soon as I could get hold of equipment that allowed me to work in low light—the twenty-four-by-thirty-six [Leica]—I wanted to try it out in some experiments in Les Halles. But the first photos aren't very good. They were done with the 50mm and its lens hood, which wasn't too brilliant because you can see some flare around the edges of the frame.

After the "what you see is what you get" of the reflex-viewing Rollei, the Leica was small and unobtrusive, but took some getting used to. The interchangeable lenses had to be screwed on and off the camera, there was a wind-on knob for film advance, and the need to use a special supplementary viewfinder for lenses of lesser or greater focal length than 50mm, which meant that its adaptability and lens speed came at a certain price. But Robert took to the new camera well and in 1953 bought the latest version, a Leica IIIF, no. 632045—probably on "10 Oct 53," as this is written in the notebook. There are quite a few pictures and self-portraits of Doisneau with one or the other of these cameras—at a masked ball in Venice, sitting on the roof of his Simca, photographing himself in the mirror at home in Montrouge—which suggest that he was happy to be seen with this new tool of the trade.

Most significantly, use of the 35mm Leica extended Doisneau's vision and enabled him to play with two aspects of photography that had been ruled out by the single fixed lens of the Rolleiflex. The availability of interchangeable lenses now made possible both extreme telephoto images, in which visual juxtapositions could be emphasized by the flattening of perspective that such lenses create; and at the other end of the scale, by using wide-angle lenses to include people within their environment. Robert used both of these to good effect, in that the false perspective created by a long telephoto lens (for example, the 500mm lens that the RAPHO agency obtained for their photographers to use) allowed for new representations of Paris and its monuments. It also allowed him to make pictures he had dreamed of making, which had hitherto been impossible; the statues and pigeons set *Vogue* used in 1956 is one of the first examples. Being able to use a wider angle lens than the "normal" focal length available on the Rolleiflex gave Robert another option for varying the ways in which he placed his subjects within their *décors:* as for instance in *Les Buchers melomanes* and *Le Petit Balcon*—outstanding early examples of the use of the wider-angle 35mm lens on the Leica.

By early 1956 Doisneau had acquired one of the new Leica cameras launched in 1954, a Leica M3. The guarantee card for no. 777082 is still carefully taped into his notebook. It seems he had two of this particular new model, for alongside the card is written, "777083 25 Janvier 56"; the consecutive manufacturer's number—so perhaps two bodies were bought at the same time? In any event he only lists one lens, "Summicron F2 50mm 1235814," although he retained a 35mm f/3.5 Summaron in his equipment cupboard

until the end of his life. The big advantage of the new Leica M3 over the earlier models was its bayonet-mount lenses, which could be changed very rapidly; its rapid wind lever (although it required two strokes to advance the film); and its large viewfinder/rangefinder system with brightline frames for several focal lengths, with automatic parallax adjustment. But although he used this new camera for a considerable amount of work, Robert confided to the author later in life that he had always found the camera slightly difficult to work with, because with lenses longer in focal length than 50mm the image size was very small, and the rangefinder focusing less than ideal.

Doisneau acquired a knowledge of large-format studio cameras—then almost universally employed for commercial work—at Ullmann, subsequently in Vigneau's studio during 1931–32, and further while working for Renault. A photograph made of his friend Chauffard at work with a nine-by-twelve-centimeter or four-by-five-inch reflex camera indicates that Robert would also have been required to use such equipment while at Renault and bears out his remark that the period spent there taught him most of what he needed to know about professional photography. Recently discovered among his archives, some thirteen-by-eighteen-centimeter negatives of street scenes in Paris made in the late 1930s (reminiscent of work carried out by his brother-in-law Marc Foucault) show that even at this early stage in his career he was using large-format equipment for personal work. They demonstrate his desire to break out of the constraints of his job for Renault and that he was sufficiently interested in providing illustrative photos for use in books and magazines as to happily spend time and effort on lugging a big camera and tripod around the city. They also show that Robert was never content to confine himself to one format in his work, always seeking to use what was most appropriate to the creative demands of his visual imagination. Large-format images were the best for recording architectural or landscape scenes, where visual interest is generated by a picture *fourmillant de détails* (crawling with detail), as Robert put it.

When Robert was fired by Renault in July 1939, he used his severance pay to complement his medium-format equipment, buying one of the new Rollei Automat cameras, with a Zeiss Tessar f/3.5 lens. He also purchased a thirteen-by-eighteen-centimeter wooden-stand camera and large tripod similar to the ones he had used at Renault. The lens for the wooden camera was an old brass-bound 24cm Zeiss Tessar without shutter, which he had bought from the Montrouge aviator Marcel Riffard. It was still in his possession when he died. Films were slow enough at this time for much large-format work to require long exposures, the shutter being provided by Robert's beret! From the mid-1930s he sought private work, carried out to supplement the household income, and this largely consisted of copying and reproduction work (often of paintings made by the little artistic community of Montrouge), for which the thirteen-by-eighteen-centimeter wooden-stand camera was ideal. He continued to use it for much of the rest of his life, for one comes across thirteen-by-eighteen-centimeter negatives from time to time in his archives, and latterly they were used for the *truquages et jeux* (fakes and games) with which he played around in the 1960s and 1970s.

Around 1947–48 he acquired a four-by-five-inch format Meridian 45A press-camera and two lenses, a 127mm f/4.7 Ektar, and a 8.5 inch (approximately 215mm) f/6.3 Ektar. Later in the 1950s he acquired another press camera, a Graflex Speed-Graphic of the same format, which was eventually modified as the basis of the "periphery camera" with which he made the *couple tire-bouchon* image and the distorted Eiffel Tower photograph.

The large number of four-by-five-inch negatives in Robert's files demonstrate two things. The first is his concern with creating images in which a vast range of detail is brought into clear graphic order. A classic example would be the downward-looking street scenes from a high viewpoint, where detail is vital to give the image its impact. Second, they are evidence of commercial necessity—the fact that he could not live off his reportage and magazine work alone, especially from the late 1950s until the latter half of the 1970s. Raymond Grosset came to an arrangement with Robert when things were getting hard in the mid-1960s, to in effect put him on the RAPHO payroll and find commercial assignments that would pay better than press work. RAPHO also purchased a "technical" camera for Robert to use, a Linhof Technika four-by-five-inch with 90mm, 135mm, 150mm and 240mm lenses, with which he carried out many advertising and industrial assignments, and which he used extensively in 1970–72 for his work on the collections of regional museums, a project carried out with his friend Jacques Dubois. Interestingly, given the rather unwieldy nature of the camera, Robert also used it to make quite a large number of street photographs, including the wonderful portrait *Un homme heureux* (*A Happy Man;* 1964), and certain of the pictures of *bougnats*. But Robert was in any case a fan of large-format portraits for certain subjects—for instance, Picasso and Braque, Mme Rayda, Monsieur Nollan, and several of the concierge series of the early 1950s.

From the mid-1960s to the mid-1970s, Robert increasingly relied on 35mm, leaving the Rolleiflex and the Hasselblad cameras in the cupboard except for commercial assignments where a larger negative was necessary. (Interestingly, however, he also used a Hasselblad SWC with a very wide angle 38mm Biogon lens for industrial work, and in particular for some reportage assignments in mines for *La Vie ouvrière*.) From the early 1960s to the late 1960s, Robert used Asahi Pentax 35mm cameras, with 28mm, 50mm and 105mm lenses. These were later modified as the "periphery cameras" for his museum work in 1970–71.

Robert left a fascinating account of his photographic approach in his book on the Loire, made in 1977–78, the entire text of which follows.

♦ How strange it is to be required to complete this page with technical information, for I have the feeling of having to go into reverse, going back to a time when manufacturers were handymen offering solutions completely devoid of modesty, as well as a choice of bizarre image-making machines.

All this perplexed photographers; you could always experiment to eliminate the excessively utopian proposals, while another tactic was to collect the little secrets that were whispered from one photographer to another. A good source ensured, for a brief period, a higher quality of work, while at the same time providing the pleasure of seeing one's colleagues go green with envy.

Nowadays, things seem different. It's a long time since the investigative journalists managed to insinuate themselves into the obscure dispensaries where, like the wagon-drivers of the Beauce, they made the initiates suffer a harsh interrogation in order to worm out their deepest secrets. It's all been published a hundred times, and a good thing too. Even if they lead to solid convictions, unhappy experiences make you lose time that could be much better employed.

To affect an offhanded contempt toward such technical matters is to reveal a charming ingenuity. A lot of loudmouthed newcomers have been tested out by this trick, which has become as classic as a clown's appearance on stage. Allow me to offer you this statement inspired by either craft or innocence: "For me a good picture is one where the graphic signification overlaps exactly with the subjectivity of my fantasies!" Before such elevated thought, any mention of technical equipment would appear obscene.

These propositions are not insignificant, for they are informative about the ravages of the photographic press, which is equally (and it's a lesser evil) responsible for the standardization of equipment. You need only observe the tools of a group of press photographers working at no matter what event. From the length of their neck straps to the whirring of their motor-drives, passing on the way by the choice of lenses, it is obvious that their equipment is interchangeable. Afterward, it is probable that all the films will be soaked in tanks identically formulated, like pharmaceutical specialities. This standardization of equipment is not just the result of the barrage of advertising but is justified by an advantageous percentage of average quality results. You would have to be a masochist to deprive yourself of the services of these intelligent little cameras. But perhaps you don't know that these greedy micro-mechanisms have a tendency toward cannibalism?

I've seen on many occasions that the glass eye, when it imposes its vision, can devour the human eye, because man is infinitely more fragile than this mechanism that is the object of all our concerns—more fragile, better articulated, and thus more endearing. It is surprising that the photographic press that publishes hundreds of pages on the anatomy of cameras never talks about the elements necessary to the benign receptivity of the photographer.

During a trip, it is sensible to look around for whatever can maintain a certain well-being and can make one sensitive to the impressions one receives.

After looking for what I would need to help me understand the climate, the light, the earth, and the work of men in the country-side crossed by the Loire, I could find nothing better than the wine. Thanks to its euphoric action I have ceased to be a foreigner. Throughout my journey, I never lacked this raw material. I've had a bit of luck in this, for speaking personally I would not have proposed the idea of a book on a desert: the valley of thirst, for instance. Because it helps make contact with people, wine acts like a developer. The quantities must thus be judiciously dosed according to the time of day, the region traversed, and the requirements of the job. The use of a 105mm lens at 1/30 second is incompatible with a morning's tasting of Muscadet.

You must not drink any old wine, in any old way. I understood that at Parnay, drinking white wine in an underground cave with roots hanging from the ceiling. They had come through sixty-six feet of limestone, while up above the wind ruffled the acacia leaves. In such conditions, it seemed to me that the ceremony of drinking a glass of white wine was not to be taken lightly. In fact, where white wine is concerned I would not advise its use before eleven o'clock in the morning, except for taking photographs outside, which require physical effort. A glass of Sancerre or Pouilly can help with the climb over the ramparts of La Charité sur Loire. For a visit to the Priory of Saint-Côme, the adjacent Vouvray can help to put you in good spirits, while in the afternoon guided visits to chateaux—which require more intellectual application—become very acceptable if you have taken care to accompany lunch with some Bourgueil or Chinon.

It is not possible to give strict advice; everything depends on personal preferences. The wine list is sufficiently extensive that it should be possible to find on it the product most precisely adapted to each individual. As a reminder, here is a brief list that can improve experiences in the Val de Loire: Muscadet, Anjou, Savennières, Coteaux-du-Layon, Quarts-de-Chaume, Saumur, Rosé d'Anjou, Cabernet d'Anjou, Cabernet de Saumur, Champigny, Bourgueil, Saint Nicolas-de-Bourgueil, Chinon, Vouvray, Montlouis, Sancerre, Pouilly, Pouilly-Fumé, Reuilly, Quincy, Menetou-Salon, etc. This list is not restrictive. It's obvious that you shouldn't take too much, and to reduce the dosage when you begin to speak to yourself and when you can't find your camera bag.

Speaking of the camera bag, I don't have much space left to tell you about its contents. Two well-worn Nikons, one for black and white, the other for color. Four lenses: 105-50-35 and a 28mm shift. Some Tri-X film, some Kodachrome 25, two Ekta H.S. [Kodak High-Speed Ektachrome] and Ekta X 64 [Kodak Ektachrome-X]. Four glass filters: K - 1A - 81A - 85B, a half-dozen gelatin filters. It's not much but heavy enough, particularly in the evening. The black and white were developed in Microdol X, fourteen minutes at twenty degrees or in D76, nine minutes at twenty degrees. Prints were on Kodabrom paper, Dektol developer, the enlarger an Omega in good condition.

Now you know everything!

♦

For the DATAR project of 1984–85, Robert turned to a new format, six-by-seven centimeters, in order to give his images more intensity and a certain "coldness," which agrees with the seemingly

"objective" views that they disclose. He chose a Zenza Bronica GS1 camera, with 50mm wide-angle, 80mm "normal," and 150mm telephoto lenses to make this series. The interchangeable magazines of the single lens reflex medium format camera (a copy of the Hasselblad) made it possible to make black-and-white pictures of the same scene. The selection, and more precisely the *use* of the six-by-seven-centimeter format camera, planted on a tripod, requiring a careful framing and viewing of the scene before exposure, thus translates the political/social perspective that Doisneau was adopting in his DATAR photographs:

> It needed to be done with great precision. . . . It was a manner of photography that was very precise; this means the content would be fairly cold. I think that if I had done it on twenty-four-by-thirty-six-millimeter [35mm]—and why not?—it would not have had the coldness of the six-by-seven-centimeter. If I had been able to do it on eight-by-ten-inch it would have been colder still and even better. But those cameras are really heavy to carry around.

Robert continued with essentially the same type of equipment until the end of his life. With his newfound celebrity in the mid-1980s came the resources to invest at last in the finest equipment available, and from 1985 he used two Leica R5 single lens reflex cameras, with 24mm, 35mm, 50mm, 90mm and 180mm lenses. For many of his portraits of this period he relied on the 24mm or 35mm lenses, which allowed him to set his subject within his chosen context. As he said to the author, "At last I have really good equipment. When I was younger I refused to borrow money to buy cameras, and I just made do with what I had. This meant that very often the cameras went wrong or broke just when you didn't want them to, which would frighten people like Raymond Grosset, who used to come with me if I was doing an important portrait of a big company boss for a commercial assignment. But I always muddled through somehow."

The Modified Speed Graphic and Periphery Cameras

Toward the end of the 1950s Doisneau began to experiment with manipulations and deformations of the photographic image, often for commercial assignments but also due to a frustration with conventional picture-making. He had played with *truquages,* such as photomontage, since the early 1930s. From around 1960 this developed into a more sustained and coherent attempt to create new forms of imagery, new ways of expressing his visual interests. He described it as *"jeux et bricolage technique."*

Some of this work was collaborative with his friends, such as Jacques Dubois, Jacques Chaboreaux, and Enrico Pontremoli. Their work included a lavishly produced brochure for the Simca automobile company, involving color photographs using effects suggested by Pontremoli and realized by Doisneau:

> All that was work that really put me out, but I did it to live. For young people who think that I wandered around all my life, it's amazing—but so many of my photos made in the street were only possible because I'd stolen time from my employer.

In the early 1960s Doisneau perfected an innovative *truquage*—his version of the periphery camera. In an article about the "corkscrew-couple," its operation is described:

> The camera is a Speed Graphic equipped with a regulator similar to those used in music boxes, which allows it to be slowed. The shutter slit was made horizontal and reduced by a mechanic, Jean Brouard. It takes six seconds to descend, of which five are the exposure, while the dancers, standing still, revolve on the turntable. As the image is upside down, the bottom is exposed first. The turntable continues to turn, and the legs appear in profile, then the bottom of the dress, and the dancer comes around to the front. The most delicate part is to be able to stop at the right moment to get the heads in position. Robert Doisneau made a mark. Four seconds standing still at the start, five seconds of exposure. With an enormous stopwatch, rehearsals were done until the dancers were face on at seven-and-a-half seconds, which left a two-and-a-half second interval. The synchronization between the turntable and the Speed Graphic must be precise. Pointless to go on about the ingenuity of the system.

Doisneau used it with and without the turntable, for an advertising campaign for Lesur fabrics, and in test shots for Simca cars. If the vehicle moved faster than the shutter slit, it appeared to be compressed, while if it moved slower it would appear "stretched." Later, in the early 1970s, Doisneau devised a variant to make peripheral pictures of the relief images on pots he was photographing in a Bréton museum, for a project carried out with Jacques Dubois. Thuiland the potter was a sort of *batisseur chimérique,* who produced these fascinating objects between the 1880s and 1916.

457

457. *Modified Speed Graphic, four-by-five-inch bellows camera.*

458. *Robert Doisneau with modified Asahi Pentax camera, turntable, and Thuiland pot, 1971.*

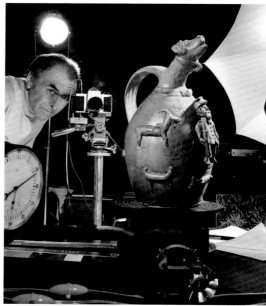

458

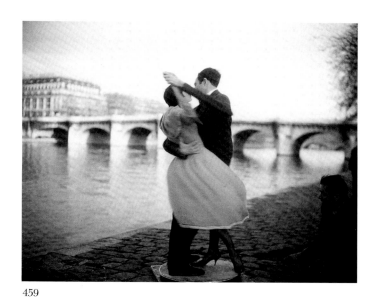

459

elle tourne... elle vole... elle vire

461

459. *Test shot for "corkscrew-couple" on the quays of the Seine [original in color], 1961. Made on modified Speed Graphic.*

460. *Thuiland pot, 1971. The wife holds a net, her woodman-husband an axe. In a normal photograph, only one of these two people would be visible. Such is also the case for the distiller, his tools, and the animals around him. The object is placed on a turntable synchronized with a motor mounted on an old Pentax. The shutter has been replaced with a plate on which a narrow slit has been cut. The transmission of the image of the turning object occurs via this slit. When the two movements (pot and film) are precisely synchronized, the image is recorded on twenty-four-by-thirty-six-millimeter film without stopping, allowing Doisneau to make frescoes of these pots. "The story of the periphery camera went on for a year, making the things synchronize, making the film turn at the right speed—I really enjoyed it."*

461. *Corkscrew-couple advertising photograph for Lesur fabric company, 1961.*

460

Doisneau's Systems of Classification

Thematic Classification

In his apartment at 46 place Jules Ferry, Montrouge, Robert Doisneau organized the archive of his approximately 350,000 negatives according to a classification system developed over the course of his career. In order to make it easy to find pictures representing the subjects, Robert pasted contact prints from his negatives onto file cards, which were then stored in alphabetical order in filing cabinets. Each card could contain six images from six-by-six-centimeter negatives: up to twenty from twenty-four-by-thirty-six-millimeter, two four-by-five-inch images, or one thirteen-by-eighteen-centimeter. These images were selected for inclusion on the file cards either because they were unique or because they represented a sub-theme of the wider classification.

The range of subject titles reflects two important things in the development of Doisneau's photography: first, the commercial need to create a picture-library that could provide an image to answer the requirements of book publishers, the press, or advertising agencies who were looking for an illustrative photograph. Second, it represents the key themes on which Doisneau worked at different stages in his career, and those subjects in which he was particularly interested. The section on *enfants,* for instance, is very large, taking up perhaps one hundred file cards: not surprisingly, *famille* takes up almost as much space. The file cards are thus an insight into Doisneau's working methods, and into the subjects and themes that organized his photographic career. *Pêche,* for instance, probably never a big seller, but a great interest of Doisneau's, is another large section. The photographs of Paris and its banlieue were held in a separate file, presented according to the same principles.

The titles are presented below, shown as ordered by Robert Doisneau:

1. A-Ci

Agriculture
Ameublement
Animaux
Animaux—le mouton
Arbres—forêts
Architects
Architects—Le Corbusier
Architecture
Artisans
Automobiles
Automobiles—Courses
Aveugles
Aviation
Bateaux
Bibliothèque
Bijouterie
Camping
Cafés-restaurants
Célébrités
Céramiques
Chemins de fer
Chevaux
Ciel
Cinéma acteurs

2. Ci-En

Cinéma technique
CinémAzéma
Cirque—Music Hall
 inc. "Cirque
 Pinder" reportage
Clergé
Clochards
Coiffure
Collectionneurs
Commerçants
Concierges
Conseils
Couture
Danse
Enfants
 bébé
 école
 dans la rue
 avec petits animaux
 vacances

3. Ep-Lu

Epouvantails
Expositions

Famille
Femmes
Fêtes foraines
Foules
Francine
Gastronomie
Gaz petrole
Gitans
Hommes
Illustration
Imprimerie
Industrie
Industrie—Automobile
Industrie electricité
Inventeurs
Jeunes
Jeunes filles
Jeux
Luterie

4. Ma-Ph

Macro photo
Manifestations
Marchés
Mariages
Marionnettes
Médicine
Mer
Métiers bizarre
Mineur
Mode
Mondanités
Montagnes
Musées
Musique
 Renaud
 l'accordéoniste
 Brassens
 Baquet
Neige
Noël
Nuit
Objets
Occultisme
 adventists
Oiseaux
Optique
Ouvriers
Ouvriers—apprentis
Oeuvres sociales
Or et argent

Parfumerie
Pasteur
Pêche

5. Pl-Vi
Plantes
Plume
Police
Politique
Ports
Prisonniers-refugiés
Publicité
Radio-TV
Réunions
Rivière
Route
Sculpteurs
 César
 Niki de Saint Phalle
 Tinguely
 Arp
 Giacometti
Services publiques
Soldats
Sports
Sportif
Tapisserie
 Gobelins
 Tapisserie Lurçat
Tests
Théatre—acteurs
Théatre—les artisans

Traditions populaires
Vacances
Vin

6. Sciences
 etrangers
Sciences
 astronomique
 chimie
 chirurgie
 labo de l'évolution
 maths
 medicine et test
 Musée de l'homme
 Muséum
 Optique
 physique et chimie
 nucléaire
 physique et science
 du globe
 Poids de mesure
 zoologie
Pays etrangers
 Belgique
 Espagne
 Fêtes populaires
 Italie
 Londres
 USA
 Yougoslavie

Paris, Banlieue et Province

1. Les Monuments:
 La Tour Eiffel
 La Seine
 Ile St. Louis
 Les Quartiers
 chics

2. Paris
 Les Parisiens
 Les Parisiens chez
 eux
 Les Halles
 L'Été
 L'Automne
 L'Hiver

3. 14 juillet
 Les Jardins
 Metró-autobus
 Les Faubourgs
 Paris sentimentale

4. Paris: Passages et galeries
 Les touristes
 étrangers
 Paris nouveaux
 Paris occupation
 Paris Libération
 Paris—les rues

Paris par hasard
St.-Germain-des-
 Près

5. Paris
 Imagerie de la rue
 Enseignes et
 vitrines
 Les Parisiens

6. Banlieue
 Décors
 Banlieusards
 St.-Denis

7. Banlieue
 Gentilly
 Photos personnels
 Photographes
 (cf. Atget)

8. Province
 Alsace
 Côte d'Azur
 Ardeche
 Auvergne
 Marseille
 Bretagne
 Centre
 Provence

Negative Numbers

Up until the end of 1945, Doisneau had used an alphabetical system for negative numbering with letter prefixes followed by numbers and occasionally letter suffixes as well (e.g., A46B). The prefixes stood for subject matters or themes: "G," for instance, was "industrie." However, once it became apparent to Doisneau that his taxonomy of subject matter would become extensive, he abandoned the earlier system in favor of a strictly numerical system. This began with 2000 for the six-by-six-centimeter Rolleiflex negatives, and 50000 for thirteen-by-eighteen-centimeter and four-by-five-inch negatives, in either late 1945 or early 1946. It is likely—as Doisneau told the author—that he renumbered some earlier work to correspond with the new system.

The earlier alphabetical system does not permit any given negative to be easily dated, but the numerical system does. Although there is some confusion in Doisneau's own dating of negatives pre-1949 (he was only asked for dates for these pictures as the archive began to be more consistently exploited from the late 1970s), the listing of negative dates given below is reasonably accurate.

In 1952, twenty-four-by-thirty-six-millimeter negatives (always known to Doisneau as "Leica" negatives, whatever the camera actually used) were numbered as follows: "1.NN. 1" stood for the file, containing 50 *bandes* or strips of 6 negatives. Thus in 1987, for instance, the negatives on series 187 were numbered from 187.01 to 187.50, that is, approximately 300 twenty-four-by-thirty-six-millimeter frames in all.

In September 1963, six-by-six-centimeter negatives numbered up to 69750 are then restarted from 170000, so as not to cause confusion with the four-by-five-inch numbering system, which contains two sequences: from 50000–50201, and 70000 to 80000, then 177000 on.

Year	6×6 cm and 6×7 cm	4×5 in. & 13×18 cm	24×36 cm
1945	2000		
1946	3000		
1947	6200	50201	
1948	10000	70000	
1949	15000	70150	
1950	19300	70350	
1951	24550	70700	
1952	29000	71000	1
1953	31650	71650q	2.5
1954	34650	72150	6
1955	37401	72700	10
1956	40900	73050	16
1957	44550	73500	18
1958	47800	74100	19
1959	51000	74650	21
1960	54800	75100	22
1961	58450	75700	23
1962	63200	76200	25
1963	67700	76750	27
1964	171500	77200	29
1965	173700	77600	33
1966	175000	77800	40
1967	175300	77850	50
1968	176100	78100	60
1969	176800		67
1970		78350	83
1971		78750	93
1972		79000	104
1973		79250	112
1974		79300	120
1975			126
1976			136
1977		79350	143
1978	176950		152
1979		80000	156
1980			159
1981			162
1982			167
1983			171
1984			175
1985			179
1986		177000	182
1987			187
1988			192
1989			199
1990			206
1991			213
1992			220
1993			221–228

Notes

Chapter One

1. Maurice Crubellier, "Les Citadins et leurs cultures," *Histoire de la France urbaine*, ed. G. Duby, et al., vol. 4 (Paris: Editions du Seuil, 1983), p. 382.
2. Robert Doisneau, *A l'Imparfait de l'objective* (Paris: Editions Belfond, 1989), p. 15.
3. Cited in Jean Francois Chevrier, *Robert Doisneau* (Paris: Editions Belfond, 1983), p. 33.
4. Robert Doisneau, "Bonjour Monsieur Doisneau," interview by Sabine Azéma, Antenne 2, Riff Productions, 1992.
5. Ibid.
6. Ibid.
7. Chevrier, *Robert Doisneau*, p. 34.
8. Doisneau, *A l'Imparfait*, p. 135.
9. Doisneau, "Bonjour Monsieur Doisneau."

Chapter Two

1. Robert Doisneau, *A l'Imparfait de l'objective* (Paris: Editions Belfond, 1989), p. 46.
2. For the best available account of Atget's method of working and the contemporary use and appreciation of his photography, see Nesbit, *Atget's Seven Albums* (New Haven and London: Yale University Press, 1992.)
3. Quoted in Nesbit, *Atget's Seven Albums*, pp. 14–15.
4. Florent Fels, "Le Premier Salon indépendant de la photographie," *L'Art vivant* (1 June, 1928), p. 445.
5. Pierre Mac Orlan, "Préface," in *Atget Photographe de Paris* (Paris: Jonquières/New York: Weyhe, 1930).
6. Pseudonym of Dora Phillipine Kallmus, 1881–1960.
7. Daniel Masclet, *Le Photographe* (20 August, 1951), 287.
8. *Vu*, no. 4 (11 April, 1928).
9. *Vu*, no. 228 (27 July, 1932).
10. Pseudonym of René Giton, b. 1908.
11. Pseudonym of David Szymin, later known as David Seymour, 1909–1956; one of the founders of the Magnum agency.
12. Renée Albisser, Vigneau's first wife.
13. Robert Doisneau, "Souvenirs de Vigneau par Robert Doisneau," *Photographies* (1984), p. 115.
14. Roger Grenier, "The First Lesson in Darkness," in *Brassaï* (Paris: Centre Nationale de Photographie, 1987).
15. Doisneau's word: *choux-fleurs*.
16. Doisneau, "Souvenirs de Vigneau," pp. 114–15.
17. Although the negatives have long since disappeared, there remains a vestige in Doisneau's archives—a little stapled booklet of the thirteen-by-eighteen-centimeter glazed contact prints, filed neatly under "Aviation."
18. Marc Foucault, 1902–1985, best known for his architectural views of cathedrals, monuments, and Paris for the publisher *Tel*.
19. Internal Memorandum, No. 38, 26 July, 1937. Robert Doisneau Archive.
20. The word RAPHO was suggested to Charles Rado by the writer Henri Calet. The photographic and literary milieus had close links at this time.

Chapter Three

1. Information supplied by Mme Nicole Chaboreau. Mme Chaboreau met Robert Doisneau in 1934, when he joined Renault. She and her husband Jacques were close friends of the Doisneaus and spent many holidays with them, including this one.
2. Robert later told the author: "When I told Jacques Prévert I was taking the metro at Alésia, he said to me, 'Don't cry, big animal, you're going to Noblet's.'" (This was the slogan of a well-known charcutier, Noblet, whose shop near Alésia station had a sign showing a fat pig going off to be made into sausages.)
3. In total he made perhaps 1,500 sets of these postcards, of which only one (incomplete) set survives (pl. 95).
4. Vox was a nom de plume: his real name was Maximilien Monod, b. 1894.
5. Many of these photographs can be found in *La Science de Doisneau* (Paris: Hoëbeke, 1990).

Chapter Four

1. A fascinating presentation of the symbolic field of Parisian geography (which elucidates the sociopolitical location of various types of monumental and statuary art) is provided by Maurice Agulhon, "Paris: la traversée d'est en ouest" in *Les Lieux de la mémoire*, ed. Pierre Nora, vol. 3 of *La France: De l'archive à l'emblème* (Paris: Gallimard, 1992), pp. 869–909.
2. As were those of Charles Rado's RAPHO agency—and no doubt many others. Raymond Grosset recalled that when he returned to Paris in 1945 and decided to reopen RAPHO, he eventually found the pre-war RAPHO archives in a building in the rue de Chateaudun. They had been taken in as part of the stock of an agency operating during the Occupation, whose owner was imprisoned at the Liberation.
3. Ylla, pseudonym of Kamilla Koffler, b. 1911, Vienna, d. 1955, India.
4. See page from *Point de vue*, "Notre photographe a fait le même reportage" (September 1947).
5. "The French Vote," *LIFE* (May 21, 1945); Doisneau's pictures are on pages 47, 48, and 50.
6. *Picture Post* published a number of Doisneau's pictures, including an entire article on the town of Aubusson, the work of Jean Lurçat, and the *manufacture de tapisserie*. "Where an Old Art Blooms Again," *Picture Post* (March 22, 1947), pp. 14–17. Similar photographs also appeared in *Le Point* (see discussion later in this chapter) and *Vogue*.
7. From a notebook of Robert Doisneau, "Textes livre Baquet…etc."
8. Vercors was the *nom de guerre* of the writer Jean Bruller (1901–

1993), a key figure in the underground presses of the Occupation. He wrote *Le Silence de la mer* (1942), the first of twenty-five slim volumes for Les Editions du minuit.

9. Paul Léautaud (1872–1956), an eccentric and ephemeral writer and theater critic, whose *Journal litteraire* is seen as one of the most fascinating sources on Parisian literary life in the first half of the twentieth century.

10. See A. Zanner, ed., *Neorealismo e Fotografia* (Udine: Art & SRL, 1987).

11. A classic example is Eugene Smith's *Country Doctor* photo-essay for *LIFE* (September 20, 1948), pp. 115–26. See also Glenn G. Willumson, *W. Eugene Smith and the Photographic Essay* (Cambridge, England: Cambridge University Press, 1992).

CHAPTER FIVE

1. Peter de Francia, *Fernand Léger* (New Haven and London: Yale University Press, 1983), p. 18.

2. From Blaise Cendrars, "Contrasts," in *Blaise Cendrars: Complete Poems*, translated by Ron Padgett (Berkeley, Los Angeles, Oxford: University of California Press, 1992), p. 58.

3. Robert Doisneau, "Le Regard de Robert Doisneau," text on Cendrars for *Pour saluer Cendrars* (Arles: Actes Sud, 1987). Taken from author's printed proof.

4. Ibid.

5. Ibid.

6. Ibid.

7. Ibid.

8. Presumably this refers to the black American soldier shown on the contact sheet as S235. However, there is only one negative now remaining in Doisneau's archive.

9. It is unclear what Doisneau refers to here, but it may well be about the visit to the "harness-maker," with "the three quinces" and "the foot of the whip" being figures made with the whip.

10. Miriam Cendrars, *Blaise Cendrars* (Paris: Editions Balland, 1993), p. 544.

11. Blaise Cendrars, *L'Homme foudroyé* (Paris: Editions Denoël, 1945), p. 204. In French; translation here by author.

12. The photographs are numbers 12 and 62 in *Photographie 1947* (Paris: Editions des Arts et Métiers Graphiques, 1947).

13. Miriam Cendrars, *Cendrars*, p. 553.

14. Author's interview with Raymond Grosset, May 1991.

15. Mermoud would later (1950) publish a very successful album-style photographic book by Izis (*Paris des rêves*), which eventually sold over 170,000 copies.

16. Personal communication, May 1994.

17. Miriam Cendrars, *Blaise Cendrars*, p. 543.

18. Analysis of probable dates of photographs used in *La Banlieue de Paris*:

Date	Number
1930–39	9
1940–44	9
1945	1
1946	21
1947	47
1948	29
1949	14

19. Some of the images illustrating this article were made by Willy Ronis, who by this stage had joined the RAPHO agency.

20. Doisneau, "Le Regard."

21. It is possible Doisneau was referring to the use of "latensification," a technique using mercury vapor to increase the speed of films. Both he and Willy Ronis were then regularly using and experimenting with this technique for night and low-light photography where a flash was inappropriate. Ronis describes the process as he and Robert used it in his *Photo-reportage et chasse aux images* (Paris: Publications Paul Montel, 1951), p. 8.

22. Blaise Cendrars and Robert Doisneau, *La Banlieue de Paris* (Paris: Seghers/Lausanne: Guilde du Livre, 1949), pp. 15–16.

23. Doisneau, "Le Regard."

24. Ibid.

25. Ibid, p. 5. This is entirely in keeping with Cendrars's own principles: he never systematized his approach, starting a new genre and style for each work. His judgment may have been too severe, however, for Doisneau was in fact in the process of making a series of photographs containing many fine images, in some of which is evident Doisneau's growing fascination for finding a magical or mysterious quality in banal scenes.

CHAPTER SIX

1. She acknowledged in her diaries that it was not until 1949 that she had any contact with members of the "proletariat."

2. This work is used extensively in Boris Vian, *Manuel de St.-Germain-des-Prés* (Paris: Editions du Chêne, 1974).

3. Letter Robert Doisneau to Pierre Betz, July 27, 1948.

4. Robert Giraud, *Le Royaume d'Argot* (Paris, Editions Denoël, 1965), p. 260.

5. Much of the above is taken from Robert Giraud's writings on *la cloche*. He deserves far wider recognition for the depth of his research on this now-vanished world, and for his fascinating writings on such subjects as the argot of Paris.

6. Robert Doisneau and Jacques Dubois, "Conversation autour d'un Livre," *L'Auvergnat de Paris* (October 20, 1990), pp. 1, 18-19.

7. Robert Doisneau, *Trois Secondes d'eternité* (Paris: Contrejour, 1979), unpaginated.

8. Robert Giraud, "Richardo, l'homme le plus tatoué du monde" in *Le Royaume*, p. 53.

9. Until the present (see pl. 252), the portraits have never been published full-frame. Richardo's tattoos below his waist were highly pornographic and were always cropped out of any prints made for publication by Robert. No doubt the clientele had to pay more to see them!

10. Doisneau, *Trois Secondes*.

11. Robert Giraud's book about his life among the *bas-fonds*, *Le Vin des rues*, which Prévert was instrumental in getting published in 1955, was reissued by Denoël in 1983 with a number of Doisneau's photographs of the period. See "Works Cited."

12. Martin Harrison, *Appearances: Fashion Photography Since 1945* (London: Jonathan Cape, 1951), p. 42.

13. She would later marry Gaston Deferre, mayor of Marseilles and a central figure in the renaissance of the Socialist party of the 1970s and 1980s.

14. *Paris-Match* (14 April 1994), p. 90.

15. Ibid.

16. Roland Barthes, *The Fashion System* (London: Jonathan Cape, 1985), pp. 3–4.

17. *Vogue* (November 1949).

18. Penn recalls that it was an idea of Alexander Liberman's, which Edmonde Charles-Roux took up enthusiastically. See Irving Penn, *Passage* (London: Jonathan Cape, 1992), p. 88, and photographs, pp. 88–93.

19. Penn, *Passage*, p. 88.

20. For a detailed account of the Groupe des XV, see Marie de Thèzy, *Paris 1950 photographié par le Groupe des XV* (Paris: Bibliothèque Historique de la Ville de Paris, 1982). J-C Gautrand's *René-Jacques* (Paris: Belfond, 1992) is also fascinating on this period. René-Jacques (b. 1908; pseudonym of René Giton) was a member of both *Rectangle* and *XV*.

21. André Garban, "Le Groupe des XV," in *Photo-Cinéma*, June 1950, p. 127.

22. Marie de Thèzy, Paris.

23. Doisneau, *Trois Secondes*.

24. Area in the Loire region known for its lakes, forests, and game —the setting for Alain Fournier's famous novel of 1913, *Le Grand Meaulnes*.

25. Jacques Prévert (1958) "Portrait de Doisneau," *Vogue*, March 1958, p. 143.

26. Doisneau, *Trois Secondes*.

CHAPTER SEVEN

1. Boutique de la Hôtel de Ville, a famous Paris department store renowned for its stock of do-it-yourself goods.

2. Personal communication from Maurice Baquet, April 1994, of a text by Prévert.

3. A literal translation would be "It's said to be veal." *On dirait du veau*, which Baquet would eventually use as the title of his autobiography in 1981, was a common saying in French, in times of hardship, to describe a meal of obscure origin.

4. Maurice Baquet, *On dirait du veau* (Lyon: Editions Jacques-Marie Laffont et Associés, 1979), pp. 132–33.

5. Paris, Editions Herscher, 1981.

6. Robert Doisneau, "La Défense du 6x6," *Point de vue*, 1950.

7. Fondation Nationale de la Photographie, *Jacques Prévert et ses amis photographes* (Lyons: FNP, 1981), p. 13.

8. The fascination with such things persisted with him to the end of his career, for even in mid-1993, when his health was deteriorating, he found the energy to photograph the *Guignol* (puppet theater) of the Champs-Élysées, then under threat of being closed down to make way for a redevelopment project. This work is thus far unpublished.

9. Doisneau seems aware in this of the irrationality French thought attributes to crowd behavior, a tradition stretching back to the nineteenth century and the ideas of Gustave Le Bon.

10. Doisneau quoted by Jean Leroy, "Robert Doisneau," *Photorevue* (February 1975), p. 78.

11. Doisneau, *Trois Secondes*.

12. The negatives of the reportage indicate that Doisneau in fact made three shots of the aftermath of the tragedy, by the lights of a car or lorry, probably to serve as records of the event in case of a legal dispute.

13. Jacques Prévert, *La Pluie et le beau temps* (Paris: Gallimard, 1981), p. 219.

CHAPTER EIGHT

1. "Albums photographiques ou livres d'heures du monde," in *Le Courrier graphique*, no. 86, p. 41.

2. Doisneau's friend Albert Plécy, long an advocate of the "photography as universal language" thesis, was often accused of treating photographs as a sort of visual raw material, and he even acknowledged doing so. See "La Photo est-elle un materiau . . . ?" in *Journalistes reporters photographes* 13 (1967).

3. This timidity led him to ally himself on occasion to writers who let him down, either because they were unable to produce the necessary material, or because their texts when published were a disappointment. This is partly due to the fixation with *locomotives litteraires* on the part of both publishers and photographers: the idea that photographic books will not sell unless there is a felicitous association between a well-known writer and a photographer.

4. The fact that an English language edition appeared first was due to a misunderstanding that effectively prevented Derlon from involvement—though it was his story, his family, and his doves that figured in the book. Once the mistake had occurred, Doisneau sought to ensure that a French edition would benefit Derlon, and indeed made sure after Derlon's death in the early 1980s that all royalties relating to these images and their uses would go to his widow.

5. Paris, January 15–February 28, 1965.

6. Sylvain Roumette undertakes a much more lyrical and detailed analysis of *La Maison des locataires* in his *Lettre à un aveugle sur des photographies de Robert Doisneau*, 1990. Roumette suggests that there is a close affinity between the writings of Perec and this work by Doisneau. It is not impossible that this photomontage was seen by the writer Georges Perec, whose *La Vie mode d'emploi* of 1978 (*Life: A User's Manual*, translated by David Bellos [Boston: David Godine, 1987]) uses a very similar narrative image, that of the building whose facade is removed so that each room is immediately and simultaneously visible in cross-section. Perec constructs what he called a *"roman total"* from the lives of those who he imagines are its inhabitants.

Another intriguing suggestion is that the idea for this image may have come to Doisneau from something he saw in Hollywood in November 1960, when he went to the Paramount studio

to photograph Jerry Lewis. In a letter sent a few days later to Maurice Baquet he wrote: "The scenery in which his film was produced is a marvel of the genre—firstly in its size, a 3-story house plus the attics, without a front. Naturally one can see all the bedrooms, the living rooms, the staircases, a working elevator, lamps hidden in the ceiling."

7. By contrast there is a considerable amount of photomontage employed as a basis for photographic prints, notably Doisneau's collaboration with Maurice Baquet.

8. According to Doisneau, the piece was broken up in the 1980s and no longer exists.

9. Hockney started this work in 1982. See Anne Hoy, "Hockney's Photo-collages" in *David Hockney: A Retrospective,* Los Angeles County Museum of Art/Thames and Hudson, 1988, p. 55.

10. Le Creusot, where the huge foundries of the Schneider firm, dating from the first half of the nineteenth century, were being converted into an industrial museum.

11. Robert Doisneau, *La Loire: journal d'un voyage* (Paris: Filipacchi-Denoël, 1978). p. 4

CHAPTER NINE

1. See *La Photographie: Etat et culture* (Paris: La Documentation Française, 1992), p. 77.

2. The French TV channel: France Regional 3.

3. Walter Benjamin, "Passages and Galeries of 19th Century Paris," in *Reflections,* translated by E. Jephcett (New York: Harcourt, Brace, Jovanovich, 1978).

4. Rosi Huhn, "Promenades dans les passages de Paris avec Robert Doisneau: entretiens avec Rosi Huhn" in Walter Benjamin, *Passagenwerk* (Paris: 1992), p. 19.

5. Robert Doisneau, as quoted in Rosi Huhn, "Promenades."

6. From Marc Pivois, "C'est toujours son enfance qu'on photographie, entretien avec Robert Doisneau," in Robert Doisneau, *Portrait de Saint-Denis* (Paris: Editions Calmann-Lévy, 1991), p. 15.

7. The film was screened privately during his life, but received a public showing on the French TV channel A2 in the month following his death.

8. *Délegation à l'aménagement du territoire et à l'action régionale.* The project was an initiative of the photographer François Hers and the planner Bernard Latarget.

9. The use of the abbreviation FSA to describe all of this work is slightly misleading, for the photographic project begun by Roy Stryker was at first situated within the independent Resettlement Administration headed by Rexford Tugwell in 1935, an organization later incorporated into the Department of Agriculture and renamed the Farm Security Administration in 1937, before finally moving to the Office of War Information in 1942–43. The initials FSA are conveniently used to refer to the whole range of photography carried out by Stryker's photographers over the eight year period during which he ran the photographic unit, and they include a wide range of urban as well as rural subjects—although it is mainly for the latter that the archive, and the project that generated it, are most commonly known.

10. See Carl Fleischhauer and Beverly W. Brannan, eds., *Documenting America, 1935–1943* (Berkeley and Los Angeles: University of California Press, 1988).

11. Mission Photographique de la DATAR, *Paysages photographies: En France les années quatre-vingt* (Paris: DATAR/ Editions Hazan, 1989).

12. Jean-Paul de Gaudemar (1989) "Le Territoire aux qualités" in Bernard Latarjet and François Hers (1989) "L'Experience du paysage" in Mission Photographique, *Paysages*, pp. 64–5.

13. From Pivois, "C'est toujours," p. 14.

14. After meeting Bauer, a Marseillais gangster who had spent the majority of his life in prison, during a commission to make his portrait for the *Nouvel Observateur*, a project was developed for Robert to photograph the city of Marseilles as a backdrop to Bauer's reminiscences of his upbringing and criminal career. The project was uncompleted at Robert's death, largely because Bauer had suddenly disappeared.

15. Robert Doisneau, "Le Regard de Robert Doisneau," in *Pour saluer Cendrars* (Paris: Actes Sud, 1985).

16. Robert Doisneau, *A l'Imparfait de l'objective* (Paris: Pierre Belfond, 1989), p. 14.

DOISNEAU ON TECHNIQUE

1. Ian Parker, *Rollei TLR—The History* (Jersey, England: Jersey Photographic Museum), p. 47.

2. Tabard was in charge of the laboratories at *Match* magazine until 1939, and it is possible that Doisneau knew him then. Perhaps he met Tabard when he was trying to find a way out of Renault in 1937–39.

Exhibitions

1947 Salon de la Photo, Bibliothèque Nationale, Paris.

1951 Exhibition with Brassaï, Willy Ronis, and Izis, Museum of Modern Art, New York.

1960 Solo exhibition, Museum of Modern Art, Chicago.

1965 Exhibition with Daniel Frasnay, Jean Lattès, Jeanine Nièpce, Roger Pic, and Willy Ronis, *Six Photographes et Paris,* Musée des Arts Décoratifs, Paris.
Exhibition with Henri Cartier-Bresson and André Vigneau, Musée Réattu, Arles.

1968 Solo exhibition, Bibliothèque Nationale, Paris.
Exhibition with D. Brihat, J. P. Sudre, and L. Clergue, Musée Cantini de Marseilles.

1972 Solo exhibition, International Museum of Photography at George Eastman House, Rochester, New York.
Exhibition with Edouard Boubat, Brassaï, Henri Cartier-Bresson, Izis, and Ronis, French Embassy, Moscow.

1974 Solo exhibition, University of California at Davis.
Solo exhibition, Galerie du Château d'Eau, Toulouse.

1975 Solo exhibition, Witkin Gallery, New York; Musée des Arts Décoratifs, Nantes; Musée Réattu, Arles.
Solo exhibition, Galerie et Fils, Brussels.
Solo exhibition, Fnac, Lyons.
Group exhibition, *Paris, la rue* at the BHVP.
Solo exhibition, *Expression de l'humour,* Boulogne Billancourt.
Solo exhibition, Galerie Neugebauer, Basel.

1976 Exhibition with Brassaï, Cartier-Bresson, Jean-Philippe Charbonnier, Izis, and Marc Riboud, Kraków.

1977 Solo exhibition, Brussels.
Exhibition with Guy le Querrec, Carlos Freire, Claude Raimond-Dityvon, Bernard Descamps, and Jean Lattès, *Six Photographes en quête de banlieue,* Centre Georges Pompidou, Paris.

1978 Solo exhibition, *Ne Bougeons plus,* Galerie Agathe Gaillard, Paris.
Solo exhibition, Witkin Gallery, New York.
Solo exhibition, Musée Nicéphore Niépce, Chalon-sur-Saône.

1979 Solo exhibition, *Paris, les passants qui passent,* Musée d'Art Moderne de la Ville de Paris.

1980 Solo exhibition, Amsterdam.

1981 Solo exhibition, Witkin Gallery, New York.

1982 Solo exhibition, *Portraits,* Fondation Nationale de la Photographie, Lyons.
Solo exhibition, French Embassy, New York.
Solo exhibition, *Robert Doisneau, Photographe de banlieue,* Town Hall, Gentilly.

1983 Solo exhibition of 120 photographs, Museum of Fine Arts, Beijing.

1984 Solo exhibition, Robert Doisneau, *Photographe du dimanche,* Institut Lumière, Lyons.

1986 Group exhibition, *De Vogue à femme,* Rencontres Internationales de la Photographie d'Arles.
Solo exhibition, *Un certain Robert Doisneau,* Crédit Foncier de France, Paris.
Solo exhibition, *Portraits,* Maison de Balzac, Paris.

1987 Solo exhibition, *St.-Denis,* Musée de St.-Denis.
Solo exhibition, The National Museum of Modern Art, Kyoto.

1988 Solo exhibition, *A Homage to Robert Doisneau,* Villa Medicis, Rome.

1989 Solo exhibition, *Doisneau-Renault,* Grande Halle de la Villette, Paris.

1990 Solo exhibition, *La Science de Doisneau,* Jardin des Plantes, Paris.

1992– Solo exhibition, *Robert Doisneau: A Retrospective.* 1992:
1995 Museum of Modern Art, Oxford, England; Aberdeen Art Gallery, Scotland; The Mead Gallery, Warwick Arts Centre, Coventry. 1993: The Summerlee Heritage Trust, Coatbridge, Scotland; Royal Festival Hall, London; Manchester City Art Gallery; *O Mes da Fotografie* Festival, Convento do Beato, Lisbon, Portugal. 1994: Musée d'Art Contemporain de Montréal, Canada; Galway Arts Centre, Ireland.
Solo exhibition, *A Homage to Robert Doisneau,* Galerie du Château d'Eau à Toulouse.
Solo exhibition, *Doisneau 40/44,* Centre d'Histoire de la Résistance et de la Déportation de Lyons, Lyons, France.
Solo exhibition, *Robert Doisneau ou la désobéissance,* Ecomusée de Fresnais. 1995: Musée Carnavalet, Paris.

1996: Solo exhibition, Montpellier Photo-Visions, Galerie Municipale de la Photographie; Isetan Museum of Art, Tokyo; Daimaru Museum, Osaka, Japan.

Works Cited

Agulhon, Maurice. "Paris: La traversée d'est en ouest." In *Les Lieux de la mémoire,* vol. 3 of *Les France: De l'archive à l'emblème,* edited by Pierre Nora, pp. 869-909. Paris: Gallimard, 1992.

Baquet, Maurice. *On Dirait du veau.* Lyon: Editions Jacques-Marie Laffont et Associés, 1979.

Barthes, Roland. *The Fashion System.* London: Jonathan Cape, 1985.

Cendrars, Blaise. *L'Homme foudroyé.* Paris: Editions Denoël, 1982.

Cendrars, Miriam. *Blaise Cendrars.* Paris: Editions Balland, 1993.

Chevrier, J.-F. *Robert Doisneau.* Paris: Belfond, 1982.

Crubellier, Maurice. "Les Citadins et leurs cultures." In *Histoire de la France urbaine* by G. Duby, et al., vol. 4. Paris: Editions du Seuil, 1983.

Doisneau, Robert. "Souvenirs de Vigneau par Robert Doisneau." *Photographies,* 1984.

Doisneau, Robert, and Jacques Dubois. "Conversation autour d'un livre," *L'Auvergnat de Paris,* October 20, 1990, pp. 1, 18–19.

Durand, Robert. *La Lutte des travailleurs de chez Renault racontée par eux-memes, 1912–44.* Paris: Editions Sociales, 1971.

Fels, Florent. "Le Premier Salon independant de la photographie," *L'Art vivant,* June 1, 1928, p. 445.

Fleischhauer, Carl, and Beverly W. Brannan, eds. *Documenting America: 1935–1943.* Berkeley and Los Angeles: University of California, 1988.

Fondation Nationale de la Photographie. *Jacques Prévert et ses amis photographes.* Lyon: FNP, 1981.

de Francia, Peter. *Fernand Léger.* New Haven and London: Yale University Press, 1983.

Garban, André. "Le Groupe des XV," *Photo-Cinéma,* June 1950, p. 127.

Gautrand, Jean-Claude. *René-Jacques.* Paris: Belfond, 1992.

Giraud, Robert. *Le Vin des rues.* Paris: Editions Denoël, 1955.

——. "Richardo, l'homme le plus tatoué du monde," in *Le Royaume d'argot.* Paris: Editions Denoël, 1965.

Grenier, Roger. "The First Lesson in Darkness" in *Brassaï.* Paris: Centre Nationale de Photographie/London: Thames and Hudson, 1987.

Gunter, Thomas Michael, and Marie de Thèzy. *Alliance Photo.* Paris: Bibliothèque Historique de la Ville de Paris, 1988.

Harrison, Martin. *Appearances: Fashion Photography Since 1945.* London: Jonathan Cape, 1991.

Heinrich, André, ed. *Album Prévert.* Paris: Bibliothèque de la Pléiade, Editions Gallimard, 1992.

Hicks, Wilson. *Words and Pictures: An Introduction to Photojournalism.* New York: Harper and Row, 1952.

Huhn, Rosi. "Promenades dans les passages de Paris avec Robert Doisneau: entretiens avec Rosi Huhn" in Walter Benjamin, *Passagenwerk.* Paris-Musées, 1992.

Larkin, Maurice. *France Since the Popular Front: Government and People, 1936–1986.* Oxford: Clarendon Press, 1988.

Leroy, Jean. "Robert Doisneau," *Photorevue,* February 1975, p. 78.

Mac Orlan, Pierre. "Préface." In *Atget photographe de Paris.* Paris: Jonquières/New York: Weyhe, 1930.

Masclet, Daniel. *Le Photographe,* August 20, 1951, p. 287.

Mission Photographique de la DATAR. *Paysages photographies: en France les années quatre-vingt.* Paris: DATAR/Editions Hazan, 1989.

Perrault, Gilles, and Pierre Azéma. *Paris Under the Occupation.* New York: The Vendome Press, 1989.

Phillip, Christopher, ed. *Photography in the Modern Era.* New York: Museum of Modern Art/Aperture Inc., 1989.

Poivert, Michel. *Le Pictorialisme en France.* Paris: Editions Hoëbeke/Bibliothèque Nationale, 1992.

Nesbit, Molly. *Atget's Seven Albums.* New Haven and London: Yale University Press, 1992.

Nori, Claude. *La Photographie Francaise des origines à nos jours.* Paris: Contrejour, 1978.

Penn, Irving. *Passage.* London: Jonathan Cape, 1992.

La Photographie: Etat et culture. Paris: La Documentation Française, 1992.

Photographie 1947. Paris: Editions des Arts et Métiers Graphiques, 1947.

Plécy, Albert. "La photo est-elle un materiau . . . ?" *Journalistes reporters photographes* 13, 1967.

Prévert, Jacques. "Portrait de Doisneau." *Vogue,* March 1958, p. 143.

——. *La Pluie et le beau temps.* Paris: Gallimard, 1981.

——. *Jacques Prévert: Œuvres complètes.* Paris: Bibliothèque de la Pléiade. Editions Gallimard, 1992.

Ronis, Willy. "Le Reporter et ses batailles," *Photo-Cinéma,* February 5, 1948, pp. 36–40.

——. *Photo-reportage et chasse aux images.* Paris: Publications Paul Montel, 1951.

Roumette, Sylvain. *Lettre à un aveugle sur des photographies de Robert Doisneau,* Paris: Le Tout sur le Tout/Le Temps qu'il fait, 1990.

de Thèzy, Marie. *Paris 1950 photographié par le Groupe des XV.* Paris: Bibliothèque Historique de la Ville de Paris, 1982.

de Thèzy, Marie, ed. *La Photographie humaniste.* Paris: Contrejour, 1992.

Willumson, Glenn G. *W. Eugene Smith and the Photographic Essay.* Cambridge, England: Cambridge University Press, 1992.

Zanner, A., ed. *Neorealismo e fotografia.* Udine: Art & SRL, 1987.

Bibliography

The publications listed here include those that contain substantial contributions by Doisneau, either of photographs (noted in brackets) or text.

1942. *Les Nouveaux Destins de l'intelligence française.* Paris: Edition du Ministère de l'Information/Union bibliophile de France. [18 photographs]

1944. *La Semaine Héroique 19–25 août 1944.* Paris: SEPE. [12 photographs]

1944. *Paris delivré par son peuple.* Paris: n.p. [8 photographs]

1945. "Imprimeries clandestines," *Le Point.* Lot: Souillac.

1945. "Aubusson et la renaissance de la tapisserie," *Le Point.* Lot: Souillac.

1946. "Henri Laurens," *Le Point.* Lot: Souillac.

1948. "Le Corbusier, l'unité d'habitation de Marseille," *Le Point.* Lot: Souillac.

1948. *La Pêche à la truite,* text by Marius Mermillon. Mulhouse-Paris-Lyon: Collection Initiations, Les Éditions Braun & Cie.

1948? *Le Boule,* text by Marius Mermillon. Mulhouse-Paris-Lyons: Collection Initiations, Les Éditions Braun & Cie.

1949. *La Banlieue de Paris,* text by Blaise Cendrars. Paris: Editions Pierre Séghers; Lausanne: La Guilde du Livre.

1951. "Colette," *Le Point.* Lot: Souillac.

1952. *Sortilèges de Paris,* text by Francois Cali. Paris: Arthaud. [13 photographs]

1952. "Picasso," *Le Point.* Lot: Souillac.

1952. *Paris.* Paris: Flammarion. [29 photographs]

1953. "Paul Léautaud," *Le Point.* Lot: Souillac.

1953. "Georges Braque," *Le Point.* Lot: Souillac.

1954. *Les Parisiens tels qu'ils sont,* text by Robert Giraud and Michel Ragon. Paris: Delpire.

1955. *Instantanés de Paris,* preface by Blaise Cendrars, introduction by Albert Plécy. Lausanne: Editions Claire-Fontaine.

1956. *Pour que Paris soit,* text by Elsa Triolet. Paris: Editions du Cercle d'Art.

1956. *Gosses de Paris,* text by Jean Donguès. Paris: Editions Jeheber.

1956. *1,2,3,4, compter en s'amusant.* Lausanne: Editions Clairefontaine and Editions du Guild du livre.

1960. "Bistros," with texts by Jacques Prévert and Robert Giraud. *Le Point.* Lot: Souillac.

1962. *Nicolas Schöffer,* introduction by Jean Cassou, text by Guy Habasque and Dr. Jacques Ménétrier. Neuchâtel: Editions du Griffon. [30 photographs]

1965. *Marius le forestier,* text by Dominique Halevy. Paris: Fernand Nathan.

1965. *Le Royaume d'argot,* text by Robert Giraud. Paris: Editions Denoël. [40 photographs]

1965. *Epouvantables épouvantails,* texts chosen by Jean-François Chabrun. Paris: Editions Hors Mesure. [25 photographs]

1966. *Catherine la danseuse,* text by Michèle Manceaux. Paris: Fernand Nathan.

1966. *Métiers de tradition,* preface by Georges-Henri-Rivière, art direction by Jacques Dubois. Private edition (Crédit Lyonnais). [60 photographs]

1966. *La Banlieue de Paris,* reduced edition, text by Blaise Cendrars. Paris: Editions Pierre Seghers. [24 photographs]

1971. *Témoins de la vie quotidienne,* with Roger Lecotte and Jacques Dubois. Private edition (Crédit Lyonnais). [286 photographs]

1972. *Mon Paris,* text by Maurice Chevalier. New York: Mac-Millan Co.

1972. *The Boy and the Dove,* text by James Sage. New York: Dover Press.

1974. *Le Paris de Robert Doisneau et Max-Pol Fouchet.* Paris: Les Editeurs Français Réunis.

1974. *Le Manuel de St.-Germain-des-Près,* Boris Vian. Paris: Editions du Chêne. [60 photographs]

1978. *L'Enfant et la colombe,* James Sage sur une idée de Pierre Derlon. Paris: Editions du Chêne.

1978. *La Loire: journal d'un voyage.* Paris: Filipacchi-Denoël. [42 photographs]

1979. *Trois Secondes d'éternité.* Paris: Contrejour.

1979. *Le Mal de Paris,* text by Clement Lepidis. Paris: Arthaud.

1981. *Ballade pour violoncelle et chambre noire,* with Maurice Baquet. Paris: Editions Herscher.

1981. *Passages et galeries du 19ᵉ siècle,* text by Bernard Delvaille. Paris: Balland.

1982. *Robert Doisneau,* J.-F. Chevrier. Paris: Belfond.

1982. *Robert Doisneau Portraits.* Lyon: Fondation Nationale de la Photographie.

1983. *La Banlieue de Paris,* 3rd ed. Paris: Editions Denoël.

1983. *Le Vin des rues,* text by Robert Giraud. Paris: Editions Denoël. [56 photographs]

1983. *Robert Doisneau,* text by Sylvain Roumette. Paris: Collection Photopoche, Centre Nationale de la Photographie. (English language edition published by Thames and Hudson, London, 1991.)

1986. *Un Certain Robert Doisneau.* Paris: Editions du Chêne.

1987. *Pour Saluer Cendrars,* text by Jerome Camilly. Arles: Editions Actes Sud. [50 photographs]

1988. *Doisneau-Renault.* Paris: Editions Hazan. (English language edition published by Dirk Nishen, London, 1990.)

1988. *Bonjour Monsieur Le Corbusier,* text by Jean Petit. Zurich: Hans Grieshaber Editeur.

1988. *60 artistes, 60 photographies de Robert Doisneau,* Galerie Arteba, Zurich: Hans Grieshaber.

1989. *La Science de Doisneau.* Paris: Editions Hoëbeke.

1989. *Paysages photographiés: En France des années quatre-vingt.* Paris: Editions Hazan/DATAR. [21 photographs]

1989. *Les Doigts pleins d'encre,* text by François Cavanna. Paris: Editions Hoëbeke.

1989. *A l'Imparfait de l'objectif: Souvenirs et portraits.* Paris: Editions Pierre Belfond.

1990. *Trois Secondes d'éternité,* 2nd ed. Paris: Contrejour.

1990. *Les Auvergnats,* with Jacques Dubois. Paris: Editions Nathan Images. [40 photographs]

1990. *Lettre à un aveugle sur des photographies de Robert Doisneau,* Sylvain Roumette. Paris/Cognac: Le Tout sur le Tout/Le Temps qu'il fait. [41 photographs]

1991. *Les Grandes Vacances,* text by Daniel Pennac. Paris: Editions Hoëbeke.

1991. *La Compagnie des zincs,* text by François Caradec. Paris: Seghers.

1991. *Portrait de St.-Denis.* Paris: Calmann-Levy.

1992. *Robert Doisneau: Retrospective,* Peter Hamilton. London: Kea Publications/Tauris Parke.

1992. *Mes Gens de plume,* texts chosen by Yvonne Dubois. Paris: Editions de la Martinière.

1992. *Rue Jacques Prévert.* Paris: Editions Hoëbeke.

1993. *La Vie de famille,* text by Daniel Pennac. Paris: Editions Hoëbeke.

1993. *Un Dimanche à la campagne,* text by Daniel Serceau. Ville d'Orsay. [24 photographs]

1993. *Les Enfants de Germinal,* text by François Cavanna, photographs by J.-P. Charbonnier, Robert Doisneau and Willy Ronis. Paris: Editions Hoëbeke. [19 photographs]

1993. *Question de lumière,* conversation with Henri Alekan. Paris: Editions Stratem.

1994. *Doisneau 1940/1944,* text by Pascal Ory. Paris: Editions Hoëbeke.

Photography Credits

All photographs are from Archives Rapho Paris and © Doisneau/Rapho, Paris, except the following (numerals refer to plates):

Bibliothèque Historique de la Ville de Paris: 59
Doisneau Archives: 5–9, 11–14, 16–31, 40, 94, 95 (all), 98, 107, 146, 180, 308, 328
Jersey Photographic Museum: 47
Laurent Gilles: 452
© Paris/SPADEM Photo Archives: 2–4
Peter Hamilton: 10, 454–457
Renault Archives: 79, 80, 85, 87, 88, 89

Index

Page numbers in *italic* refer to illustrations.